POSTCARD HISTORY SERIES

Along the Ohio River

Cincinnati to Louisville

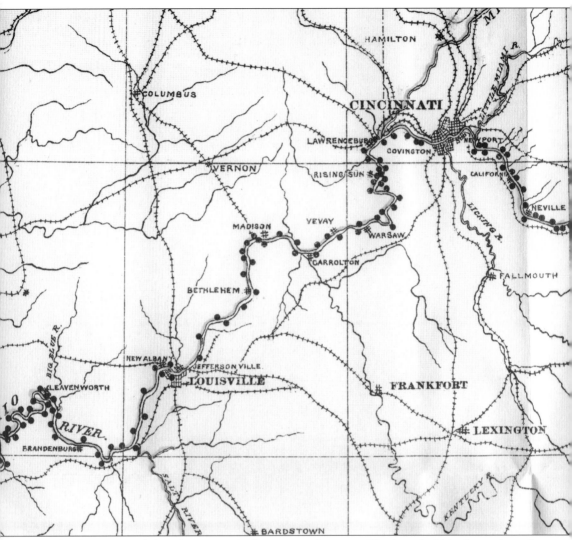

The above map of the Ohio River is the segment between Cincinnati, Ohio, located on the right bank, and Louisville, Kentucky, which is located on the left bank. It is taken from the 1896 "Fourteenth L. H. District" map, which shows the location of the navigational lights along the river from Pittsburgh, Pennsylvania, (mile 0) to Cairo, Illinois, (mile 981). The Ohio River mile designations always indicate the number of miles below Pittsburgh. Right bank and left bank are always designated headed downriver. Coming upstream, the right bank is actually on the left (port) side of the boat, and the left bank is on the right (starboard) side. In the early settlement period, the right bank was known as the "Indian bank" and the left bank the "Kentucky bank."

ON THE COVER: On the front cover is the *Belle of Louisville*. James Rees and Sons Company built the boat in 1914 for the West Memphis Packet Company in Pittsburgh. The boat's name changed several times from the original *Idlewild* to *Avalon* and finally to *Belle of Louisville* in 1962. The back cover is a shot of the Roebling Suspension Bridge in Cincinnati before skyscrapers appeared in the skyline.

POSTCARD HISTORY SERIES

Along the Ohio River

Cincinnati to Louisville

Robert Schrage and Donald Clare

ARCADIA
PUBLISHING

Published by Arcadia Publishing
Charleston SC, Chicago IL, Portsmouth NH, San Francisco CA

Printed in the United States of America

Library of Congress Catalog Card Number: 2006925723

For all general information contact Arcadia Publishing at:
Telephone 843-853-2070
Fax 843-853-0044
E-mail sales@arcadiapublishing.com
For customer service and orders:
Toll-Free 1-888-313-2665

Visit us on the Internet at www.arcadiapublishing.com

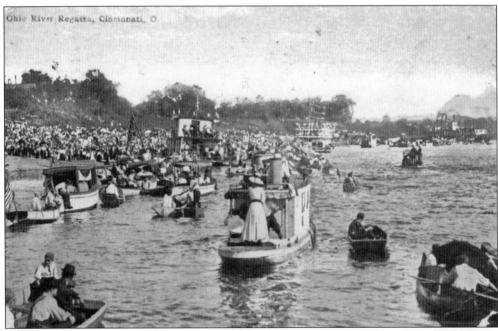

Entitled "Ohio River Regatta, Cincinnati, O.," this early-20th-century picture postcard is a good example of the German expertise in colorizing images. The Germans were ages ahead of other nationalities in the field of lithography and printing. The large immigrant German population in Cincinnati explains why so many of these cards were published there. The image depicted in this postcard is from the 1908 regatta sponsored by the Ohio River Launch Club.

CONTENTS

Acknowledgments 6

Introduction 7

1. Cincinnati 9

2. River Towns 29

3. Louisville 51

4. Commerce and Recreation 65

5. Steamboats 97

ACKNOWLEDGMENTS

The authors wish to thank Sue Clare and Ann Schrage for their support during this project and our children, Andrew and Ethan Schrage and Callie and Caitlyn Clare. Thank you also Karen Domaschko, Mayor Ann Deatherage, Tom Gaither, and Tall Stacks™ for supplying some of the images used in this book.

There have been many men and women over the years who have explored, grown up, raised families, and lived and died on the great Ohio River. This book is dedicated to them all. Finally we would like to acknowledge all the people and companies that have helped preserve the steamboats and their heritage of helping to build America. Today these individuals, companies, and events, such as Tall Stacks™, have brought the past alive and saved this great part of our history.

Special thanks and acknowledgments also go to the Delta Queen Steamboat Company for their permission to use images of the *Delta Queen*, *Mississippi Queen*, *American Queen*, and the boats of Greene Line Steamers, Inc., and to Jefferson County, Kentucky, Fiscal Court and Waterfront Development Corporation, Port of Louisville, Kentucky, for the images of the *Belle of Louisville*, *Avalon*, and *Idlewild*.

To Richard J. Schrage (1917–1984), who, except when serving his country during World War II, lived his entire life in an Ohio River town. Thanks again.

INTRODUCTION

So, what is it about the Ohio River? There seems to be a fascination and a reverence all throughout history connected to this 981-mile artery through our country's midsection. The Native Americans called it by several different names depending on the different dialects. The Iroquois called it "Oyo," which the French translated as "the beautiful river" and named it La Belle Riviere. Thomas Jefferson declared it "the most beautiful river on earth." And Zadoc Kramer, in his famous early-1800s river navigation guide, deemed it "the most beautiful river in the universe." And generation after generation of Americans have admired and enjoyed this same beauty, so much so that its history and heritage have been recorded and preserved in many forms. But one of the most unlikely or unusual media of recorded Ohio River history is the postal card, today's postcard.

Deltiology is the study and collecting of postcards. Originally a product of the United States Postal Service, the postal card was a convenient, self-contained, and less-costly means of conveying a note or message to someone, somewhere. In the 1890s, these cards reserved the back side for the address only. Only the front could be used for the message. Right after 1900, private concerns began to produce and publish postcards with pictures on the front. Still the message had to be on the front also. That is why some of the images in this book have writing on the front picture. Later in the first decade of the 20th century, the postal service came up with the divided-back postcard, on which the right side was reserved for the address and the left side was available for the written message. Postcards now featured a full-picture front, and the subject matter was endless. Regional landscapes and architecture were very popular.

We, the authors of this book, have chosen to portray a specific section of the beautiful Ohio River, from Cincinnati to Louisville, using privately published picture postcards of river and river community scenes as our medium source. Cincinnati has a very strong German settlement heritage. The German lithographers and printers were eons ahead in the technological aspect of publishing postcards in the early 1900s. Consequently there were a lot of these river scenes published in Cincinnati by German companies. Kraemer Art Company is one such publisher and is well represented as a publisher of many of the postcard images featured in the book.

The Ohio River is not just a river of scenery and beauty. It is also a river of opportunity. It is a river of journey and exploration. It is a river of dreams, personal and private as well as public and regionally based. It is a river of commerce and enterprise. It is a river of peaceful relaxation and recreation. And just about the time travelers or residents become one with the river, endearing all its positive qualities, the river can turn. Ravenous floods and destructive crushing ice have many times taken lives, businesses, homes, dreams, and the very opportunities that lured folks

there in the first place. And remember, the Ohio always returns for the things it left behind the previous time.

Some people say the river is fickle, that it will lure you and tease you with peace and tranquility and a sense of security. Then about the time you feel safe and satisfied, it will snatch it all away in one ravenous display of dominance. Consider this: maybe it is man who has been the fickle one, and the river is not fooled by his insincerity. After all, over the years, man has used, exploited, and taken from the river. He has depended on the Ohio for travel and mobility, for food and subsistence, for profit and livelihood, and for rest and relaxation. Then in return, he turns his back on it and builds concrete walls to keep it away and out of sight. He diverts his own personal waste and that of his fellow townsmen directly into the river's very soul. He poisons it with his industrial toxins and then complains when his drinking water tastes like chlorine. And he litters its banks and tributaries with his unwanted solid refuse, because he knows that the river will eventually deal with it. Perhaps it's not vengeance after all. Perhaps this self-catharsis is really self-healing and self-mitigating. When the fish come back to the river, the people do, too. And another generation of river appreciation takes hold. Time will only tell, but despite the repetitious trends of history, there is hope and promise.

There is a new generation of Ohio River consumer, a new environmentally correct commerce and industrial mind set, a new generation of pleasure boater and outdoorsman, a new page of solid waste ethics and opportunities, cleaner burning coal, and more benign gaseous and liquid discharges.

This renewed interest and appreciation of the Ohio River is well underway, and it is showing itself in the form of contemporary postcards. Big city riverfront scenes, excursion steamboats and modern diesel party boats, river scenery, river architecture, scenery of the working river, Tall Stacks™, and river recreation and history are just a few examples of the subject matter available now. These postcard views of contemporary Ohio River scenes are virtually everywhere along the 981-mile length of our national history and heritage.

More times than not, the images that really appeal to the senses and project that warm pleasurable sensation of a better time or good old days long past are in fact images of places and objects no longer in existence. The only reminder of that particular scene or object is the card in hand. Unfortunately the historic resources along the Ohio River are disappearing at an exponential rate, sometimes faster than it takes to advance the film in the camera. The medium of postcard documentation of Ohio River history is a very real and viable record of the fragile and dynamic Ohio River history and a tool for its continued, documented preservation.

The hand-colored photographic images so artfully produced by the Kraemer Art Company of Germany and Cincinnati are a thing of the past as far as contemporary production is concerned. But they are still available to collectors and to Ohio River historians. Sometimes an extra few dollars will produce a priceless image of a long-lost scene or object that is crucial to the recorded history of the river for the sake of posterity and documentation. Today's images are equally important and valuable in the river's recorded history. There is not a more dynamic natural resource than a river in motion. And there is not a more dynamic river than the Ohio. It changes with the weather, and it changes with the seasons. It is this when at its normal depth, and that when in flood stage. It is this in hot, humid August summer weather, and that in the sub-zero January assault of destructive ice. This or that, it never fails to affect the life along its banks one way or another.

We hope you enjoy your experience seeing the sights as you proceed down the river on the front of a postcard. Take time to study and ponder each image, because most of these sites are long since gone or destroyed, and all that is left is the card itself.

One

CINCINNATI

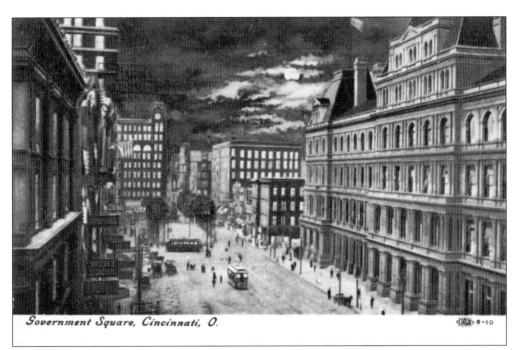

Government Square, Cincinnati, O.

Cincinnati's Government Square is a major bus transportation center for the city. This vintage image shows the square that has been reconstructed many times over the years. In 2006, the latest revamping updated the area with new shelters, lanes, landscaping, and aesthetics. Government Square is located on Walnut and Fifth Streets and was named because of its location to the federal office and courthouse buildings and a Federal Reserve branch.

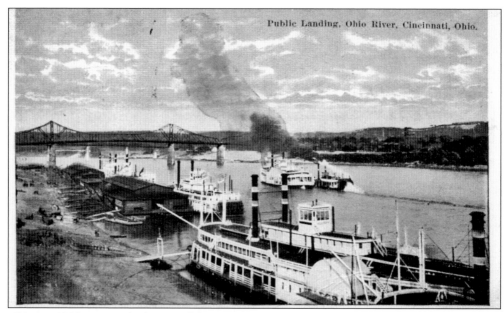

This is a 1923-postmarked view of the Cincinnati public landing looking upriver. The wharf boat facilities indicate that the river trade was still very much alive in the years before the Great Depression. Notice that this scene features mostly side-wheelers, whereas a scene 20 years earlier would feature stern-wheelers. Whether traveling upstream or down, these boats always landed or docked into the current, or facing upstream.

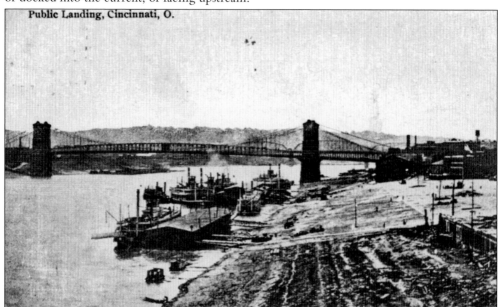

Postmarked 1910, this card again provides the image of the Cincinnati Public Landing but looking downstream toward the Roebling Suspension Bridge in the background, connecting Cincinnati, Ohio, with Covington, Kentucky, on the left bank. John Roebling began his type specimen wire suspension bridge in 1857. Delayed and interrupted by this nation's infamous Civil War, it finally opened to traffic in 1867, reducing the physical communication between two cities and two states to just minutes in travel time.

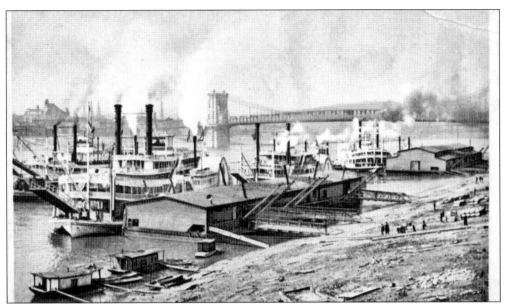

Entitled "Along the Levee, Cincinnati, Ohio," this 1907-copyrighted "Phostint" card was published by Detroit Publishing Company. Looking downriver toward the Roebling Suspension Bridge, the last steamboat on the far right docking on the downriver wharf boat is one of the passenger packet boats owned by Louisville and Cincinnati Packet Company. She is either the *City of Cincinnati* or the *City of Louisville*, identified by the two white collars on each of the stacks. Both boats were side-wheelers.

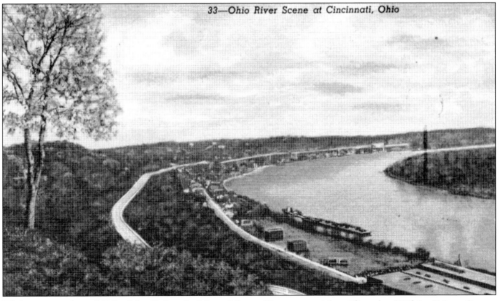

This postcard, published by J. Louis Motz News Company, identifies the "Ohio River Scene at Cincinnati, Ohio" as follows: "The Ohio River is completely canalized and puts Cincinnati at the hub of a 15,000 mile system of inland waterways. This river is navigable the year 'round. The river is used both by passenger lines and freight carriers." This scene is one of Cincinnati's several bluff-side public parks, looking down upon Columbia Parkway and the East End. Opposite is Dayton, Kentucky.

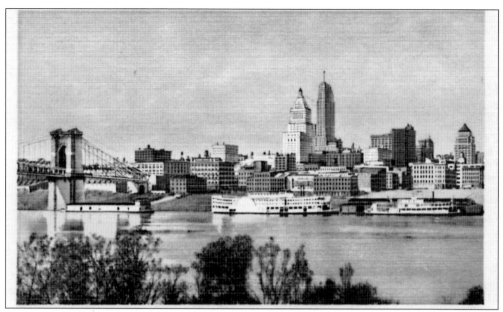

Another colorized Curteich-Chicago postcard shows the Cincinnati skyline and public landing from Covington, Kentucky. This scene encompasses two National Historic Landmarks—the Roebling Suspension Bridge and Carew Tower. The Carew Tower is an entire city block in area and includes a luxury hotel complex plus businesses. Crews working 24 hours a day, 7 days a week completed the tower in just 13 months. Construction began in September 1929, just one month before the great stock market crash.

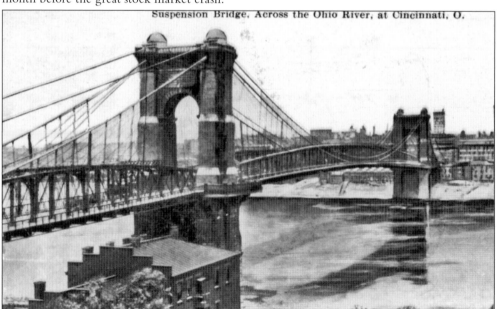

This postcard is an impressive image of the Roebling Bridge before skyscrapers appeared on the skyline. A typical question is "How did they build the foundations for those bridge piers out in the middle of the river?" The answer is given right here. When the bridge was built, the piers were actually built on dry land. They weren't located out in the river channel until the current navigational system of locks and dams raised the normal pool level to what it is today.

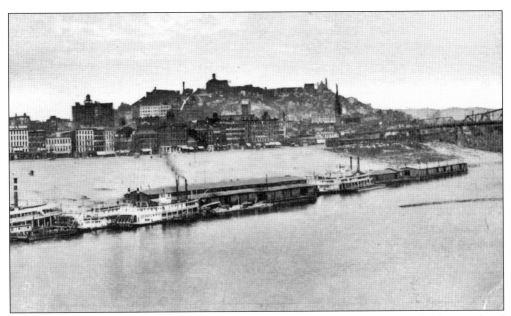

This colorized photograph card, postmarked 1911, shows Mount Adams in the background and identifies it as "Art Hill." Founded in 1880 by Marie Longworth Nichols, Rookwood Pottery was located atop Mount Adams, overlooking the city and the river. At one time, in its heyday during the early 20th century, Rookwood employed over 120 artists, potters, and designers. Their products were considered the best this country or any other country had to offer.

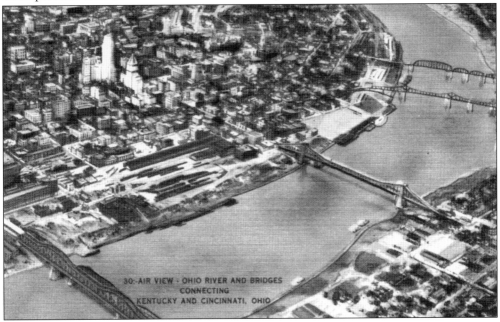

This is another hand-colorized photograph card by Kraemer Art Company. In plain sight, from left to right, are the C&O Railroad Bridge, the Roebling Suspension Bridge, the Central Bridge, and the L&N Railroad Bridge. Along the right border of the photograph is the mouth of the Licking River, directly across from the public landing. The Licking River is one of only two north-flowing rivers in the Ohio Valley.

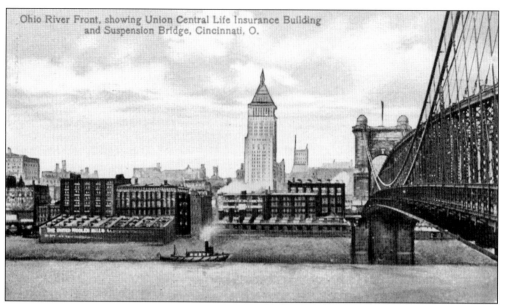

Ohio River Front, showing Union Central Life Insurance Building and Suspension Bridge, Cincinnati, O.

This rare view of the Cincinnati skyline shows the city's tallest building before the even taller and more famous Carew Tower. It was completed in 1913 (the year of one of Cincinnati's worst floods, before the 1937 flood topped them all) to serve as the home office of the Union Central Life Insurance Company, which was founded in 1867 by the Methodist Church, encouraging preachers to become agents of the company as well. This postcard is postmarked 1914.

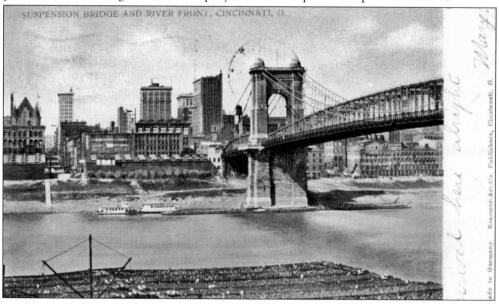

SUSPENSION BRIDGE AND RIVER FRONT, CINCINNATI, O.

Again using the Suspension Bridge as a point of reference, this 1906 Kraemer Art Company card entitled "Suspension Bridge and River Front, Cincinnati, O" shows the Cincinnati cityscape before the arrival of either of the two famous skyscrapers. In the forefront is an area now called Covington Landing, a floating barge that held many businesses in the 1980s and 1990s. Covington Landing closed, and in 2006, the barge was dismantled and sank shortly after being transported to Owensboro, Kentucky, for scrap. In 2005, beautiful murals were completed on the floodwall in this area depicting life on the Ohio River.

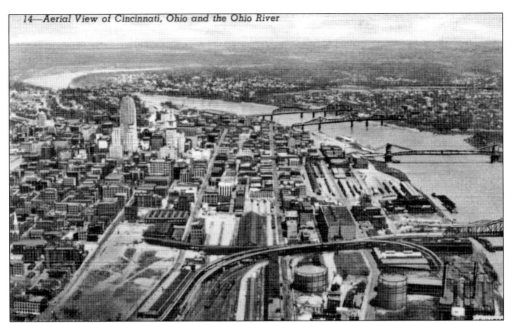

This C. T. Art-Colortone, Curteich-Chicago postcard, serial number 14, is entitled "Aerial View of Cincinnati, Ohio and the Ohio River." This viewpoint, looking east from the western side of the city, highlights the serpentine course the Ohio takes through this Ohio–Kentucky stretch of its meanderings. There is no date on this unused postcard, but it is definitely after 1929 because of the presence of the Carew Tower.

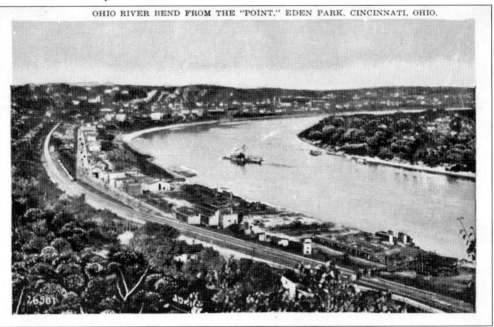

This postcard is a closer view of the previous image, highlighting the upper-left-hand corner. Years later when Yeatman's Cove was developed as a riverfront park, a serpentine wall was created that is the main meeting spot for large activities taking place on the river. Highlighting the curves of the river, the park is beautifully designed to complement the river.

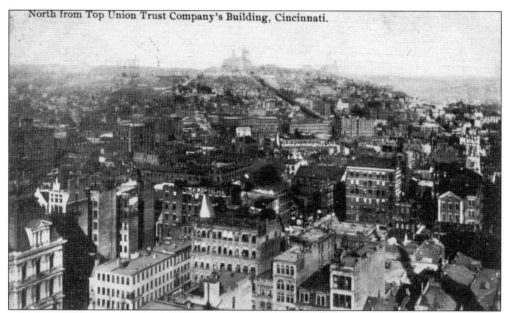

North from Top Union Trust Company's Building, Cincinnati.

This early-1900s postcard image looks north from atop the Union Trust Company Building in Cincinnati. One of the many hills of Cincinnati can be seen in the background. Current views of Cincinnati show a larger downtown than seen in this almost-100-year-old postcard. However, this vintage image still shows just how developed Cincinnati was as a community back then. There were many jobs in downtown, and a large number of citizens lived in areas on top of the hills. This picture provides a good indication of the relationship between the hills and downtown.

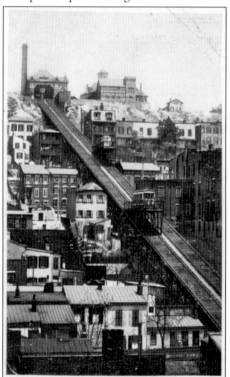

Named for Pres. John Quincy Adams, Mount Adams today is a trendy area of businesses and homes. Located on one of Cincinnati's many hills, Mount Adams has a long history and offers spectacular views of downtown. This image shows the Mount Adams Incline, which was completed in 1872. Of the five inclines in Cincinnati, it served the longest time, remaining in operation until 1948.

16

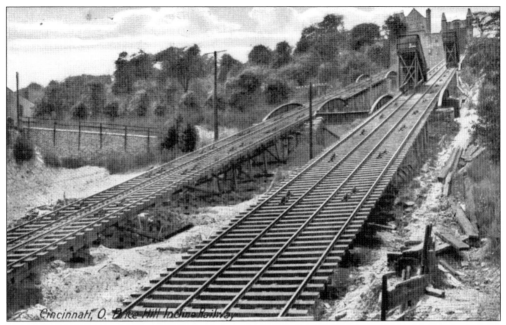

This image of the Mount Adams Incline shows good detail of the tracks and the steep elevation of the incline. The Mount Adams Incline was 945 feet long and, in the 19th century, was a convenient means of transportation for German and Irish immigrants who lived in Mount Adams and worked downtown. Mount Adams, originally called Mount Ida, was once one of the top wine-making areas in the country.

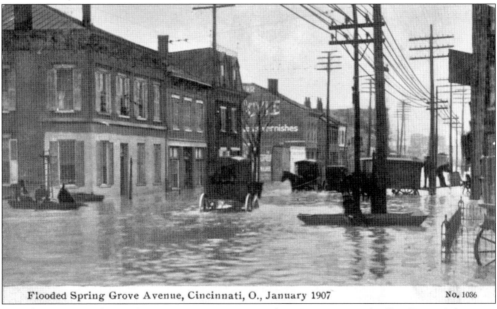

Flooded Spring Grove Avenue, Cincinnati, O., January 1907 No. 1036

One thing certain about Ohio River communities such as Cincinnati is the flooding. High waters can be seen in this 1907 image of Spring Grove Avenue. Labeled as January 1907, this postcard places this flood a couple months before the large flood of 1907. More than four inches of rain fell in southern Ohio in March, causing floods up and down the Ohio. Thirty-two people were reported killed in Ohio.

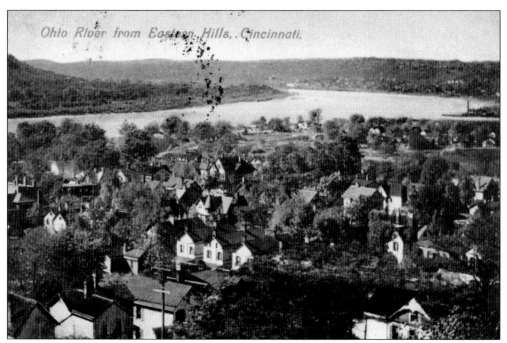

The Ohio River and one of its major curves can be seen from the Eastern Hills area of Cincinnati. This early-1900s postcard shows housing along the river and the undeveloped Kentucky shoreline. Cincinnati started as a part of the Miami Purchase of 1788. The first settlement was Columbia on the east side of Cincinnati in an area near the sites in this image.

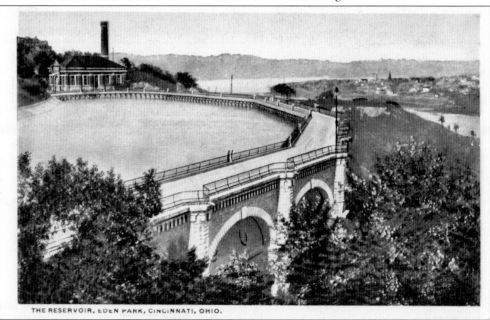

The Reservoir at Eden Park is no longer, but this once-important source of water appears in this unique view. Today park land covers the city's reservoir and is an area used for walking and relaxing. The Ohio River can be seen under the eastern hills of Cincinnati. Some of the remnants of the reservoir wall still exist and are easy to spot when driving or strolling through the park.

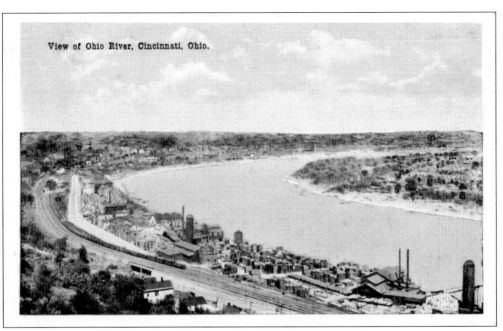

This close-up view of the Ohio River is taken from the Eden Park area of Cincinnati and looks east. It shows one of the most distinct curves on the Ohio River at Cincinnati. What is today known as Columbia Parkway can be seen as a roadway along the left side of this postcard. This east-west corridor has been an important transportation link for quite some time.

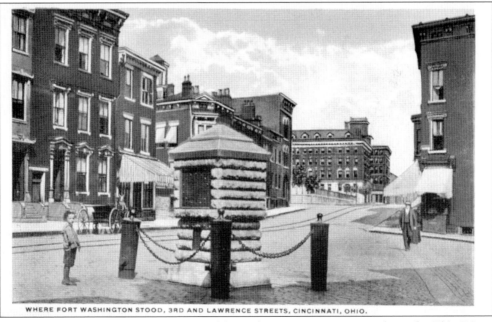

When the Northwest Territory was opened for settlement, easterners came down the Ohio River, and many settled in the area that became Cincinnati. Fort Washington was a military garrison constructed to protect the new city, especially from Native American attacks. This vintage postcard shows the monument at the spot of the fort, located at Third and Lawrence Streets. It is just a short walk from the site of the first landing at Cincinnati, now called Yeatman's Cove.

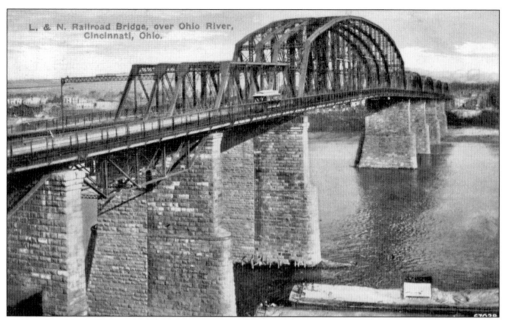

Opened in 1872, the L&N was Cincinnati's first railroad bridge over the Ohio River. Originally called the Newport and Cincinnati Bridge, it was renamed the L&N when the Louisville and Nashville Railroad bought the bridge in 1904. In 1987, rail use of the bridge stopped and it was then used for automobiles. Closed in 2002 to automobiles, it was soon bought and turned into a pedestrian walkway and is now called the Purple People Bridge.

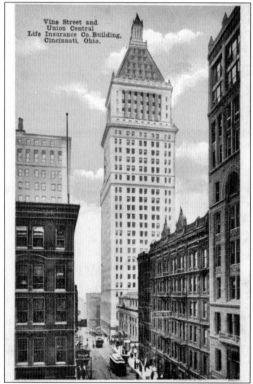

Built in 1913, the Union Central Life Insurance Building was the tallest building in Cincinnati for about 16 years until, in 1929, the Carew Tower was built in a total of 13 months. The facade of the first three stories is marble, then white terra-cotta on up. It was built on the site of the chamber of commerce building after it burned in 1911. Before that, the post office occupied the site until 1884.

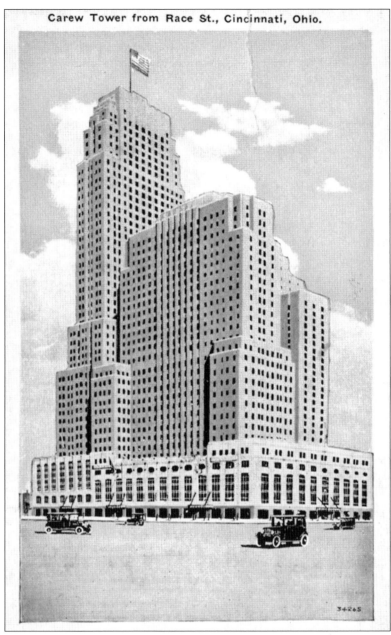

Carew Tower from Race St., Cincinnati, Ohio.

Proudly dubbed "Cincinnati's Tallest Skyscraper," the Carew Tower was a square city block in size and a virtual city within. Begun in 1929, just one month before the great stock market crash, it was completed 13 months later in 1930, as workers labored 24 hours a day and 7 days a week. Its 48 stories and observation deck rise 574 feet above street level. A two-story arcade runs through the entire building, from the black marble and bronze–decorated entrances of Vine Street to Race Street. On the Fifth and Race Streets side of the tower was the luxurious Netherland Plaza Hotel, which offered 800 luxury rooms and featured an automatic car-parking garage under street level, by which unoccupied automobiles were towed along a system of tracks and parked. Department stores, specialty shops, offices, restaurants, barber and beauty shops, and other businesses accounted for the remainder of retail space.

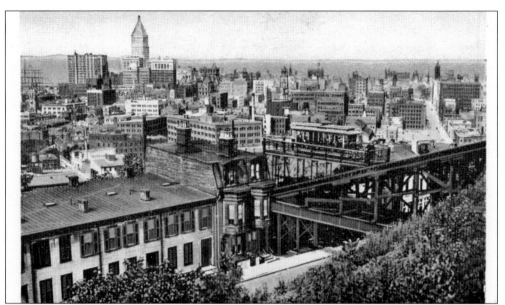

At one time, Cincinnati supported five different inclines as a means of rapid transportation for people commuting from surrounding neighborhoods to the city. In the 1940s, two of these inclines remained in operation, and Mount Adams was one. Completed in 1876, it initially carried wagons and pedestrians, and as time and technology progressed, it eventually carried electric streetcars. Looking down upon the city, the meandering Ohio River, and the gentle Kentucky hills, it was a favorite attraction for sightseers.

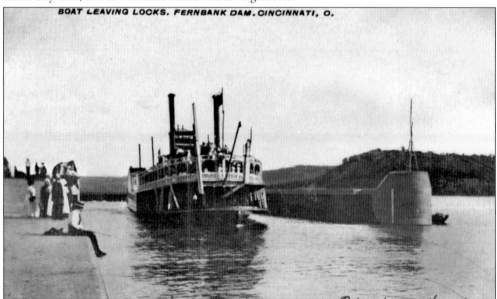

Seen here is a side-wheel packet boat leaving Fernbank Dam, or Dam 37. Fernbank Dam was one of 49 wicket dams that dotted the length of the Ohio River. Their purpose was to maintain a nine-foot, year-round navigational depth, as mandated by Congress in 1878. The Army Corps of Engineers completed Fernbank Dam in 1911. Fernbank Dam was destroyed in 1963 after the construction of another series of 19 high-water dams necessary to create the current 25-foot-minimum pool depth.

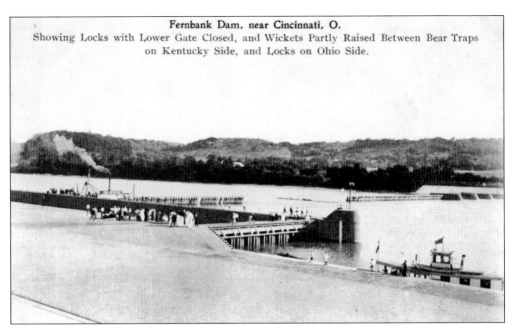

Fernbank Dam, near Cincinnati, O.
Showing Locks with Lower Gate Closed, and Wickets Partly Raised Between Bear Traps
on Kentucky Side, and Locks on Ohio Side.

A wicket dam was a wooden and steel movable barrier resembling a series of ironing boards, which in the neutral position lay flat along the bed of the river. In times of low water, these wickets were raised manually to a vertical positioning, which formed a barrier to the downriver flow of water, thereby creating a back-water pool of a certain desirable depth. In times of high water, the wickets were tripped and lowered back down.

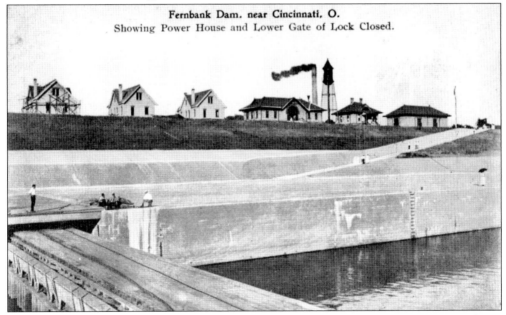

Fernbank Dam. near Cincinnati, O.
Showing Power House and Lower Gate of Lock Closed.

At Fernbank Dam, the locks were located on the Ohio side. This is how the packet tow boats with barges passed from pool to pool. The bear traps were on the Kentucky side. Bear traps were gates for discharging excess water volume without having to lower the wickets. The entire operation was primitive, very efficient, and labor intensive. Each of the river's locks and dams featured a collection of work buildings similar to those in this image.

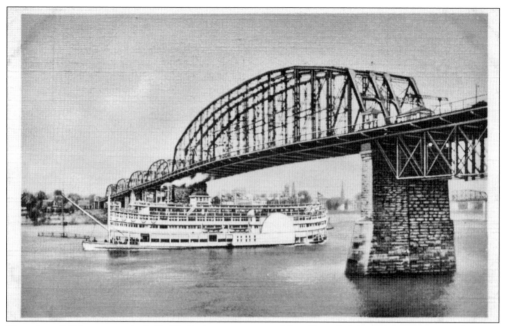

Here is a 1933-postmarked C. T. Colortone art card by Curt Teich and Company, Chicago, featuring the *Island Queen* passing under the L&N Railroad Bridge, on her way upriver to Coney Island. Curiously the *Island Queen* logo is not present on the wheelhouse in the image, apparently intentionally left off by the publisher.

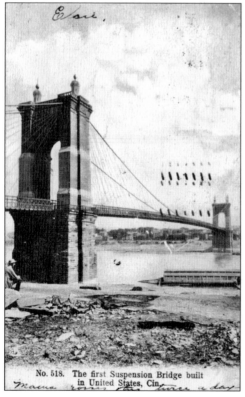

No. 518. The first Suspension Bridge built in United States, Cin,

This early-1900 Kraemer postcard is a fine example of the high-quality work done by this company, having business locations in Cincinnati, Ohio, as well as in Germany. Postmarked 1907 from Cincinnati, this card exemplifies the type of card produced when the message could only be written on the front of the card. The reverse was reserved for the recipient's address and the postage stamp. Again the river pool level here shows the piers of the Suspension Bridge having been built on dry land.

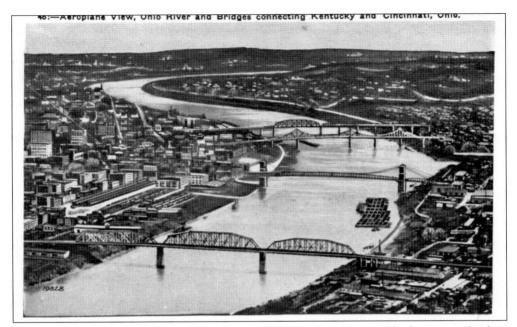

This aerial image shows three cities and the meeting of two rivers. The lower two bridges connect Cincinnati, Ohio, and Covington, Kentucky, while the upper two connect Cincinnati with Newport, Kentucky. The Licking River meets the Ohio River on the right side of the image. Cincinnati was originally called Losantiville, meaning city across from the mouth of the Licking River.

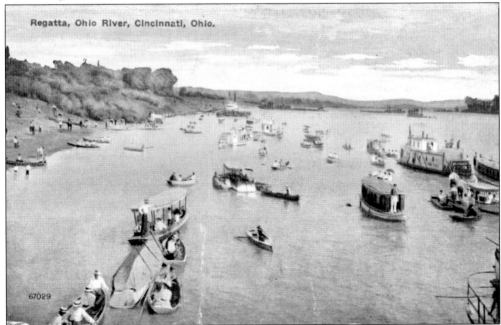

This view of the 1908 regatta sponsored by the Ohio River Launch Club shows another view of the boats at this event that is famous in Cincinnati history. Three classes of boats participated in this regatta depending on size, speed, and engine. The longest race of the day was 16 miles for class C boats, those classified as speed boats.

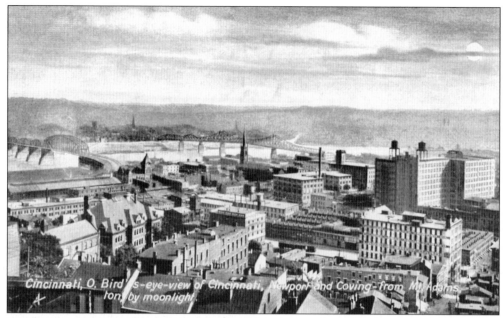

Cincinnati, O. Bird's-eye-view of Cincinnati, Newport and Coving-from Mt Adams, ton by moonlight.

Imagine standing atop Mount Adams looking down upon the urban basin of Cincinnati and across the soft, peaceful current of the Ohio into the gently rolling landscape of the Licking River valley. Illuminated by the eerie light of a full moon, this image does just that. Imagine how the moon shadows transform this view from an ordinary, common, daytime scene into a mystical and romantic stimulus for awe and inspiration.

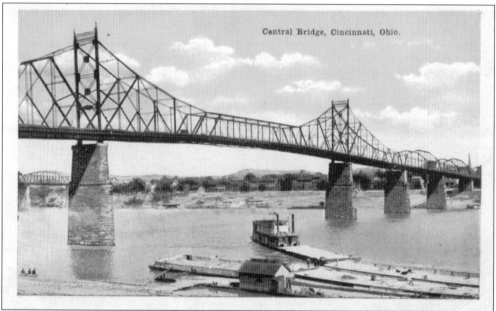

Central Bridge, Cincinnati, Ohio.

The Central Bridge connected Newport, Kentucky, to Cincinnati for 102 years. It was the third major bridge spanning the Ohio River between Cincinnati and Northern Kentucky, completed in 1890 and located between the Roebling Suspension Bridge and the L&N Railroad Bridge. Like the suspension bridge, it was another "singing bridge," so named for the high-pitched humming sound produced by automobile tires as they rolled across the perforated steel deck.

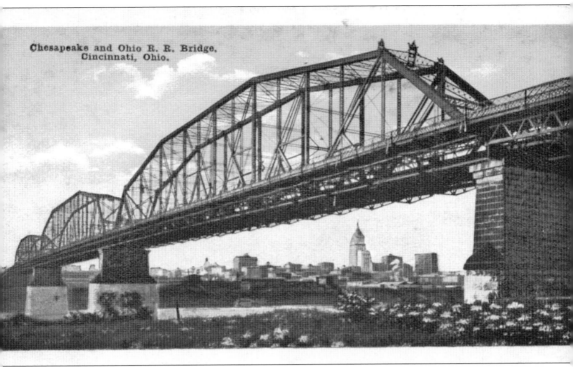

Chesapeake and Ohio R. R. Bridge,
Cincinnati, Ohio.

The C&O Railroad Bridge was completed in October 1889. Construction began in 1886, after the Covington and Cincinnati Elevated and Transfer and Bridge Company issued bonds. A damaging 1888 flood delayed the opening date until 1889. It was the city's first double-track railroad bridge and boasted the longest center span of any other railroad bridge in the world at 545 feet. At a cost of $5 million, it was the most expensive bridge per lineal foot ever built. In its day, it was considered an engineering feat, but after 30 years' use, obsolescence rendered it inadequate, since railcars were carrying double the gross weight that this bridge was designed to handle. In the 1920s, plans were discussed to replace the C&O. What transpired was the construction of another two-track railroad bridge next to the original structure, even sharing some of the extant stone bridge piers. When the new bridge opened to train traffic in 1929, the original bridge was purchased by the commonwealth of Kentucky and converted into an automobile bridge.

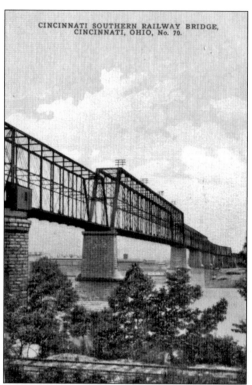

CINCINNATI SOUTHERN RAILWAY BRIDGE, CINCINNATI, OHIO, No. 70.

The Cincinnati Southern Railway Bridge opened in 1877. It remains the only railway company built by a municipality. The railway line, tunnels, and bridges were built with funds generated from two separate $10-million bond issues. The bridge spanning the Ohio River from the western end of Cincinnati to the Kentucky city of Ludlow turned out to be the single most expensive element of the entire proposition. The 350-mile line terminating in Chattanooga, Tennessee, was completed in 1880.

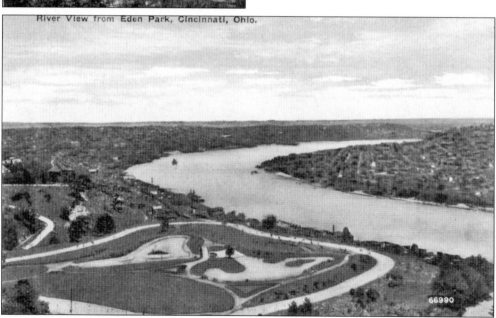

River View from Eden Park, Cincinnati, Ohio.

This image, entitled "River View from Eden Park, Cincinnati, Ohio" demonstrates the reason early Cincinnati philanthropists purchased and pooled together properties featuring prime vistas and scenery for the purpose of creating passive parkland for the citizens of Cincinnati. Purchase of the nearly 187 acres began in 1859. Nicholas Longworth, who owned one of the central major parcels, named it after the Garden of Eden. Pictured in the left center is the Twin Lakes area, which at one time was an old stone quarry.

Two

RIVER TOWNS

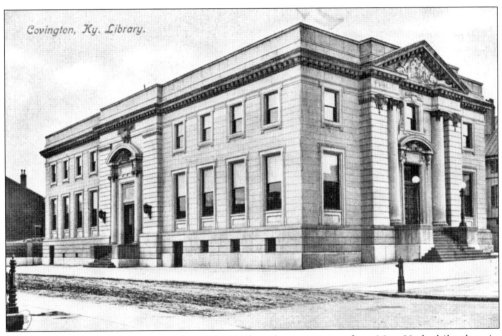

Covington, Ky. Library.

The first Covington Library opened in 1904. Built with grant money from New York philanthropist Andrew Carnegie, this library is the only one of about 16 other Carnegie libraries in this area of the country to feature a theater and stage. Approached by Covington mayor Joseph Rhinock, Carnegie agreed to an additional $35,000 grant for the theater in addition to the $40,000 for the library, something he rarely agreed to. The theater was designed after a European opera house, with a stage, balcony, and orchestra pit in the Beaux-Arts style. Built on the corner of Scott and Robbins Streets, the library served the citizens of Covington until the early 1970s, when it outgrew its usefulness. In 1972, the Carnegie Theater Library was listed on the National Register of Historic Places, and in 1973, the building was closed down. The new Kenton County Library opened in 1974. Today this building serves as the Carnegie Arts Center.

Post Office, Covington, Ky.

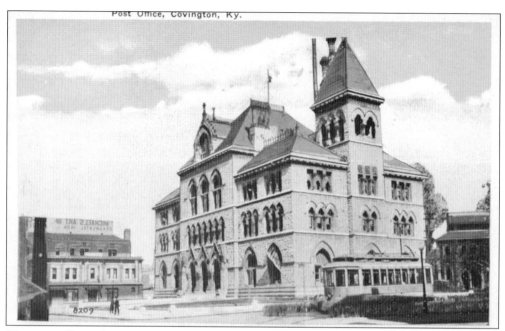

The post office of Covington, Kentucky, can be seen in all its glory in this vintage image. Covington is the largest city in Northern Kentucky and sits at the point where the Licking River meets the Ohio. In fact, this spot was often referred to as "the Point" and was popular with explorers, especially when starting an expedition. Covington became a city by act of the Kentucky General Assembly in 1815.

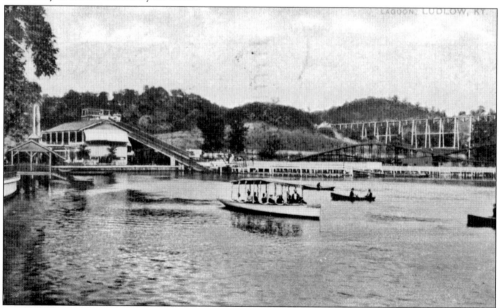

The Ludlow, Kentucky, Lagoon Amusement Park was the major spot for recreation in the greater Cincinnati area for about 25 years. Built in 1895, the major attraction was the Lagoon Lake. There were many attractions at the park, but the lake, as seen in this 1908 Kraemer Arts Company postcard, was special. This image shows men and women enjoying an afternoon of leisure on the lake.

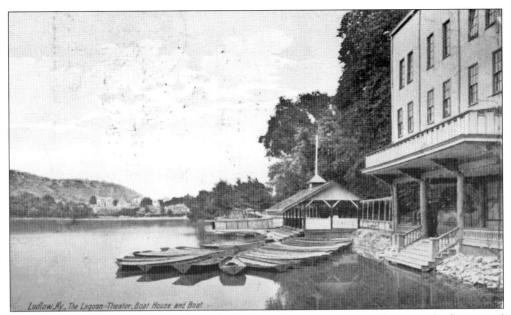

Another beautiful Kraemer image shows the Ludlow, Kentucky, Lagoon-Theater in the foreground and the Boat House in the background. In front of both structures are many canoes used by patrons to enjoy the lake. The Lagoon Lake was known to have clear water that was excellent for both boating and fishing. A white, sandy beach was used for swimming. The theater was known to show some of the best acts of the day.

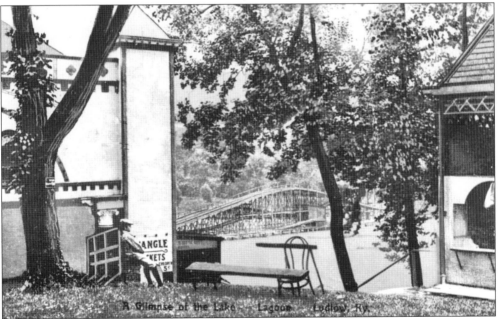

The Ludlow, Kentucky, Lagoon Roller Coaster can be seen in this Hugh Leighton Company postcard. The roller coaster went across the lake and back. The park closed in 1920 as a result of several unfortunate events, including the 1913 flood; a financial crisis caused by the flood resulting in needed investment; an accident on the motordrome when a driver lost control of his motorcycle and hit a gas lamp, burning down the grandstand; and a 1915 tornado.

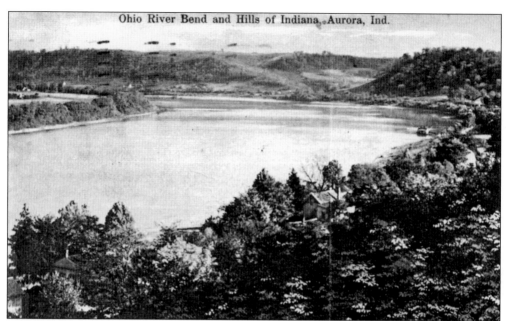

Ohio River Bend and Hills of Indiana, Aurora, Ind.

Aurora, Indiana, is located on the right bank of the Ohio River at mile number 496.7. As early as 1796, the first river travelers to settle in what is now Aurora came down the Ohio River looking for land when they stopped at the mouth of Hogan Creek. This area of the country was still a vast wilderness and part of the Northwest Territory. Gen. Arthur St. Clair, stationed at Marietta, Ohio, governed it. In 1800, Congress established the Indiana Territory and appointed Gen. William Henry Harrison as the new territorial governor.

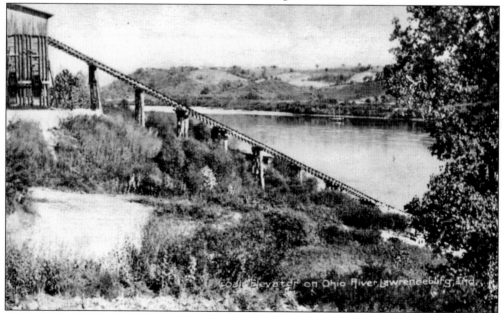

Coal elevators, such as this one in Lawrenceburg, Indiana, were common sites along the Ohio River. Barges would bring coal to small towns and load or unload the coal via long elevators. The coal was then picked up by residents for home use or by businesses owners. Just down from Lawrenceburg, such an operation still operates in Petersburg, Kentucky.

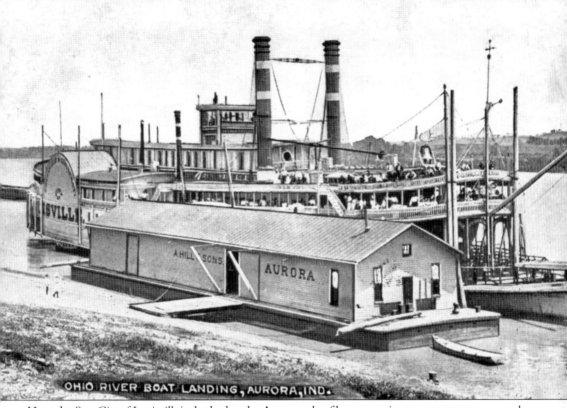

OHIO RIVER BOAT LANDING, AURORA, IND.

Here the Str. *City of Louisville* is docked at the Aurora wharf boat carrying passengers, cargo, and the mail. Here to load and unload people and mail, it appears the boat is on her way downriver and back to Louisville. The two white collars on the smokestacks indicate ownership by the Louisville-Cincinnati Packet Line. If she were landed here for any particular length of time, the boat would have been docked against the downriver current. The position in this picture suggests just a brief stop. The city of Aurora sits just west of Lawrenceburg, Indiana, and is a short drive to Rising Sun. Petersburg, Kentucky, lies directly across from Aurora and is the oldest settlement in Boone County. The Aurora Ferry served both of these communities for many years and was an important means of transportation for the area.

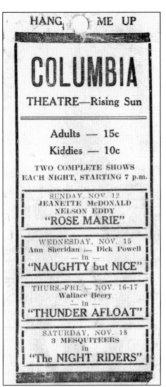

HANG ME UP

COLUMBIA

THEATRE—Rising Sun

Adults — 15c

Kiddies — 10c

TWO COMPLETE SHOWS
EACH NIGHT, STARTING 7 p.m.

SUNDAY, NOV. 12
JEANETTE McDONALD
NELSON EDDY
"ROSE MARIE"

WEDNESDAY, NOV. 15
Ann Sheridan — Dick Powell
— in —
"NAUGHTY but NICE"

THURS.-FRI. — NOV. 16-17
Wallace Beery
— in —
"THUNDER AFLOAT"

SATURDAY, NOV. 18
3 MESQUITEERS
in
"The NIGHT RIDERS"

As steamboats traveled down the Ohio River, they would often stop at small towns and residents could watch the entertainment that was appearing on the boat at that time. This was a source of entertainment well before television. After the showboats stopped, theatres were built that provided the small towns with community rooms for plays and screens to watch movies. The Columbia in Rising Sun was such a theatre, as this early ticket hanger indicates.

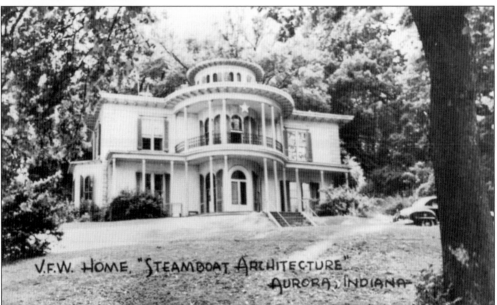

This is an example of a mixture of Italian Renaissance style and steamboat architecture created by Isaiah Rogers, a renowned architect known as "the father of the modern hotel," and built for the Aurora business and financial magnate Thomas Gaff in 1853–1855. Gaff's love of steamboats was incorporated in the design of his personal residence, Hillforest Mansion, built on a hillside overlooking Aurora and the Ohio River. In the late 1940s, it became the local VFW hall and headquarters. In 1992, it was designated a National Historic Landmark.

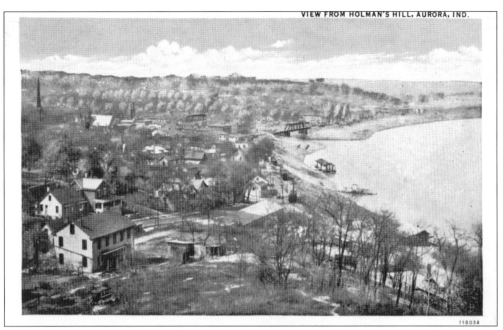

Entitled "View from Holman's Hill, Aurora, Ind.," this Curteich-Chicago postcard looks down on the Aurora wharf boat and the Aurora Ferry. The bridge over Hogan Creek (mile 496.6) can be seen just toward the top of the image. This quaint image shows the uniqueness of living in a small town on the Ohio River. Using imagination, one can see kids like Tom Sawyer playing near the river and getting into trouble.

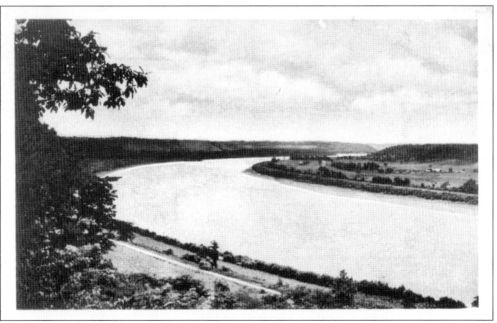

Traveling down the river by boat, or even today via automobile, images such as the one shown here are typical. The Ohio River has many bends that are spectacular in their beauty. They provide a special view that in many places is not much different from this early-1900s image.

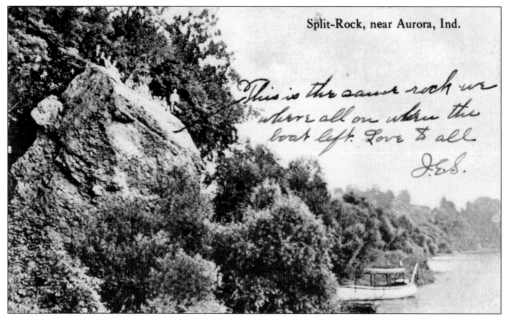

Split-Rock, near Aurora, Ind.

This is the same rock we where all on where the boat left. Love to all J.E.S.

A group of Sunday boaters pose for a picture on Split Rock. This glacial conglomerate is believed to have been deposited by the Illinoisan Glacier over 150,000 years ago. As the ice melted and retreated, the runoff eventually established the present course of the Ohio River. In the late 1800s and early 1900s, excursion steamers made regular trips down to Split Rock to provide their patrons the opportunity to hunt for emeralds within the cemented conglomerate.

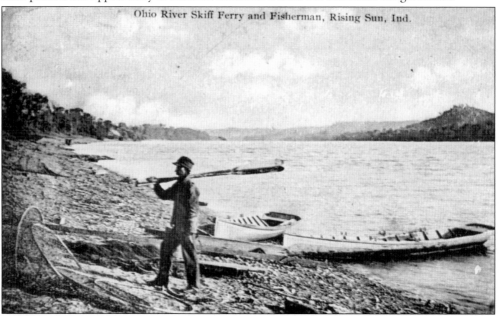

Ohio River Skiff Ferry and Fisherman, Rising Sun, Ind.

This view shows a typical scene found at any number of spots along the 981-mile-long Ohio River and its shores. Fishing was more than a pastime or recreational diversion in former generations of river folk. It was more a subsistence modality. Fish was food. Fish was barter stock. Fish was money. But yes, getting out into the river in a light skiff was also a relaxing and enjoyable alternative to the hard manual labor that consumed most days.

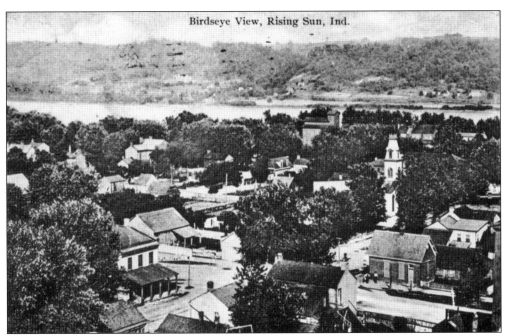

Birdseye View, Rising Sun, Ind.

This bird's-eye view of Rising Sun, Indiana, at Ohio River mile number 506.0 highlights the epitome of sleepy little Ohio River towns. Solely dependent upon the river and its related commerce, Rising Sun has been thoroughly ignored by modern commercial growth and exploitation. The railroad was the death knell of the river trade, and many of its ancillary supportive affiliates left Rising Sun high and dry. As a result, farming became much more prevalent.

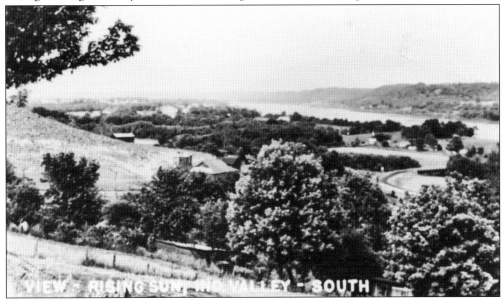

Downriver from the town was another area of river commerce. It was North's Landing, located on the right bank of the great East Bend. Established by the patriarch Thomas North, and carried on by his sons, North's Landing was a significant destination for steamboats with coal, lumber, or other raw materials. This view overlooks the approach to the North's Landing stretch of the river. The agricultural neighborhood of East Bend Bottoms is seen on the Kentucky bank.

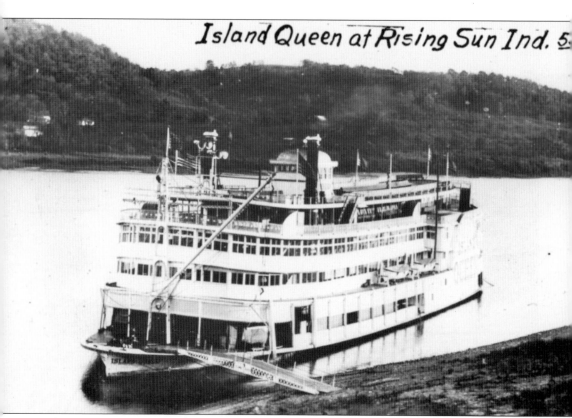

Island Queen at Rising Sun Ind. 5

This is a very rare real-photo postcard of the *Island Queen* at Rising Sun, Indiana, with Rabbit Hash, Kentucky, in the background. It's not rare because it is an image of the *Island Queen* but because it is landed at Rising Sun. Almost exclusively, all her trips were from the Cincinnati Public Landing (mile 470.2) upriver to Coney Island (mile 461.5). Occasionally the boat made trips to Aurora and Rising Sun to provide her Indiana neighbors an enjoyable steamboat experience and a pleasant day at a very popular amusement park. These special trips were always noted in the respective local newspapers.

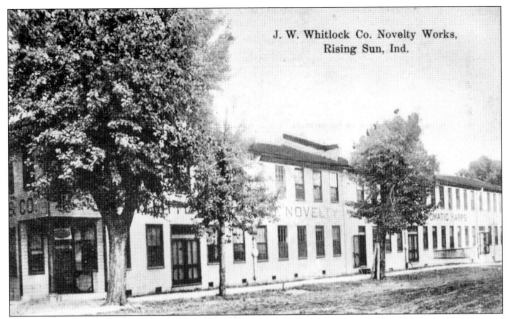

J. W. Whitlock is Rising Sun's favorite native son. Known as "Row" Whitlock, his love of precision woodworking, designing and inventing, the Ohio River, and speedy watercraft all combined to make him a local legend with national impact. His pastime and hobby were to create, set, and break speed records in the fastest watercraft. This image shows the J. W. Whitlock Company, Novelty Works, in Rising Sun. A portion of this building today houses the Ohio County Historical Society.

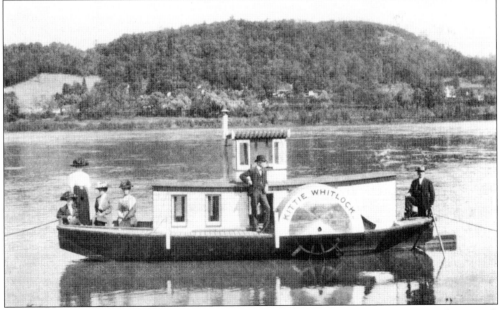

As fast as Row's famous speed boats could go, some of his other watercraft was meant for a much slower pace, as seen in this image of the Kittie Whitlock, a scaled-down version of a steam side-wheeler, obviously designed for pleasure and leisure. The man standing in the center is J. W. Whitlock himself.

From 1914 to 1966, the J. W. Whitlock Company was the major employer in Rising Sun, Indiana, and people were able to purchase stock in the business. With several factory buildings in the middle of town, the J. W. Whitlock Company was comprised of a furniture factory and a state-of-the-art machine shop accompanied by all the other ancillary outbuildings, sheds, and warehouses. Besides being an astute businessman, Whitlock was also an inventor, a boat builder, and a water-racing enthusiast who contributed much knowledge and expertise to the young and upcoming sport of hydroplane racing. His stepped-hydroplane Hoosier Boy U-7 to this day holds the all-time water speed record from Cincinnati to Louisville and back. In 1924, he and his mechanic made the 267-mile round-trip in a time of 267 minutes and 49 seconds. This speed and distance record still hold and will never be broken because he completed the run when the river was in flood stage, which allowed him to simply run over the flooded old-style wicket dams. That couldn't be done now with the new locks and dams.

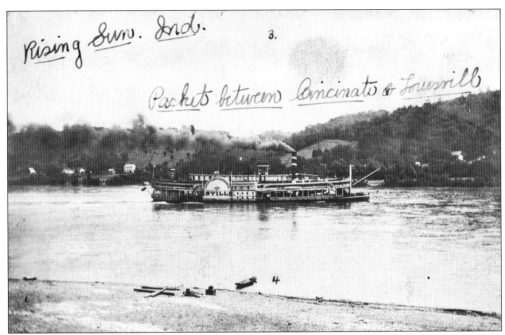

The packet *City of Louisville*, carrying passengers, freight, and the mail, is seen here passing Rising Sun, Indiana, on the right bank and Rabbit Hash, Kentucky, on the left bank, having left Cincinnati about five or six hours earlier and heading for Louisville.

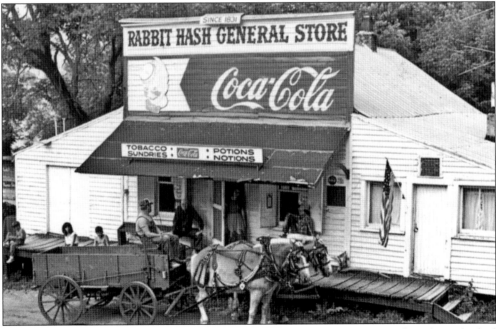

Barney and Jim, these two horses, look completely worn out. Not to worry, they always looked this way; morning, noon, or night. In this 1979 postcard, Red Fair stops at the general store for his afternoon six-ounce Coke, just like the sign suggests. The Rabbit Hash General Store has been in continuous operation since 1831 and has sported a Coca-Cola sign ever since the first salesman offered to paint one on the store "for free."

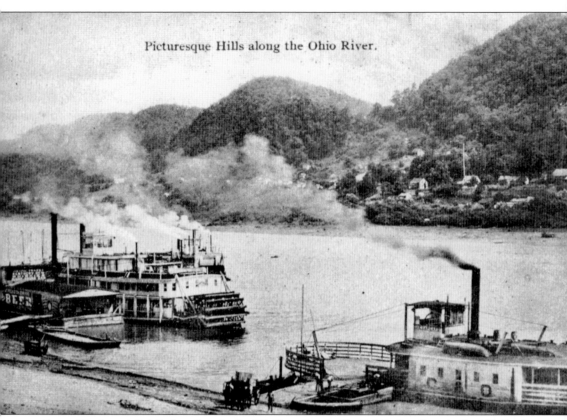

Picturesque Hills along the Ohio River.

From Cincinnati Public Landing (mile 470.2) to Louisville Public Landing (mile 603.9), the entire 134-mile-long left bank is Kentucky shore. The Big Sandy River (mile 317.1) divides West Virginia from Kentucky, beginning the Kentucky shoreline on the Ohio River left bank, which goes all the way to Cairo (Kay-row), Illinois, where it meets the Mississippi River at mile 981.0. Scenes like this one were encountered frequently along this 664-mile-long Kentucky border throughout the steamboat era. The "Picturesque Hills along the Ohio River" are of course due to the actions and sequelae of the several prehistoric advances and retreats of epochal ice age glaciers. Their meltwater essentially established the Ohio's course. Generally speaking, the deeper river channel tended to occur on the right bank, with the sand and gravel deposits leaving shallower water depths on the Kentucky shore. This accounted for the majority of steamboat destinations and stopping points occurring on the Ohio/Indiana shore, which resulted in the larger, more commercial towns and cities developing on the right bank. With that said, Louisville turns out to be the major exception to this generality.

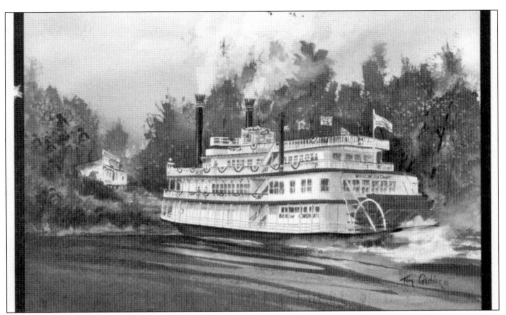

River happenings and isolated events luckily get noticed and captured by artists and preserved for future historians. That is precisely why this very book was possible. Early-1900s artisans enhanced common, simple images of the day and preserved them in postcard format. Here Ludlow, Kentucky, artist Tom Gaither captured a rare 2003 Ohio River occurrence when the *Belle of Cincinnati*, on a day trip back from Louisville, stopped at Rabbit Hash, Kentucky. (© Tom Gaither.)

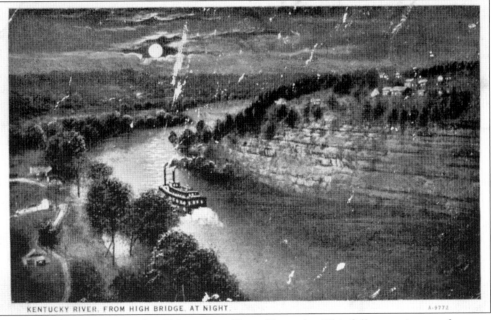

KENTUCKY RIVER, FROM HIGH BRIDGE, AT NIGHT. A-9772

The Kentucky River joins the Ohio at Carrollton, Kentucky. This full moon image of a steam stern-wheeler from High Bridge, in Jessamine County, Kentucky, on its way to the Ohio gives an indication of its height. When built in 1877, High Bridge was the highest trestle railroad bridge in the world. It towers 280 feet over the Kentucky River Palisades. In 1986, it was designated an Engineering Landmark by the American Society of Civil Engineers.

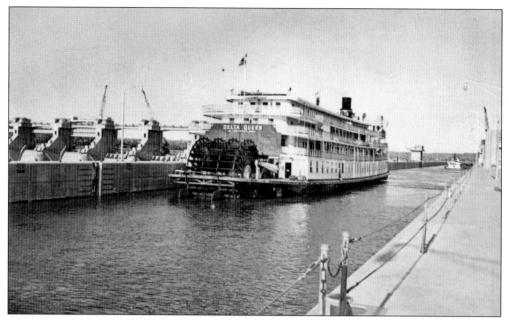

In modern-day travel from Cincinnati to Louisville on the Ohio, only one lock has to be negotiated. Markland Lock and Dam was completed in 1964 by the Army Corps of Engineers to replace the obsolete wicket dam locks 35, 36, 37, 38, and 39. Since the *Delta Queen* is an overnight passenger vessel and a carrier of the U.S. mail, she is given special preference over other river craft when locking through. The boat automatically jumps to the front of the line.

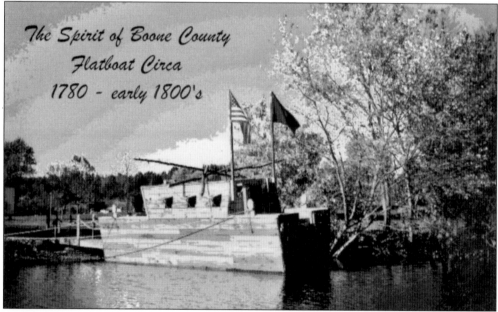

In 1803, Meriwether Lewis descended the Ohio River with William Clark and was instructed by Pres. Thomas Jefferson to stop in Cincinnati to study a collection of fossil specimens from Big Bone Lick in Kentucky. In commemoration of the 200th anniversary of this visit, citizens of Boone County, Kentucky, built this replica flat boat as a bicentennial tribute. It is now permanently displayed on the banks of Big Bone Creek at Jane's Saddle Bag Heritage Center.

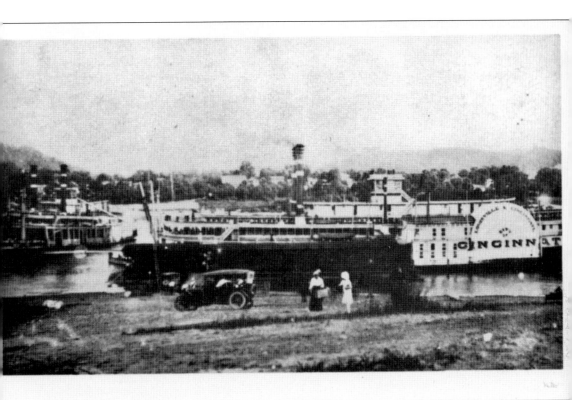

The *Cincinnati* stops in presumably Vevay, Indiana, in this early-1900s image. Vevay is an Ohio River town founded in 1802 in Switzerland County. The town was founded by immigrants from Vevay, Switzerland, and they created the first winery in the United States. Over 300 buildings still exist in Vevay from the 1800s, taking visitors back to the age of steamboats. Vevay is home to the Ohio River Museum, with a collection of river documents, artifacts, and other items of interest. The city also houses the historic Hoosier Theater, built in 1837 and used to entertain the traffic and visitors from the Ohio River. It was later converted to a movie theater and now has been saved as a theater for stage performances. To honor Vevay's heritage, an annual wine festival is held on the riverfront.

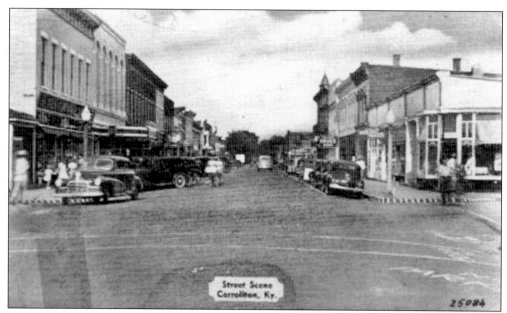

The city of Carrollton, Kentucky, sits on the meeting of the Kentucky River with the Ohio. Established in 1794, the city was originally named Port William, but the name was later changed to Carrollton when it was a part of the newly created Carroll County. The street scene in this postcard shows a vibrant downtown within a stone's throw of the Ohio River.

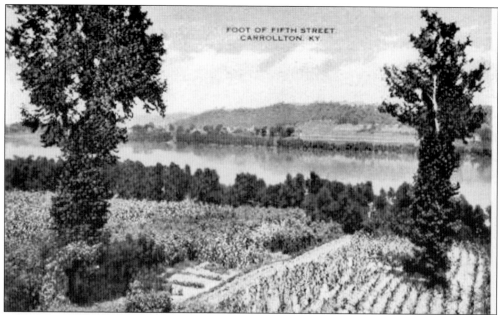

At the foot of Fifth Street in Carrollton, Kentucky, is the Ohio River. Later the Fifth Street ramp allowed showboats and a ferry to land at Carrollton. Carrollton and Carroll County were named after Charles Carroll, who was the last surviving signer of the Declaration of Independence. He died on November 14, 1832, a little more than six years after the other two surviving signers, Thomas Jefferson and John Adams, who both died on July 4, 1826.

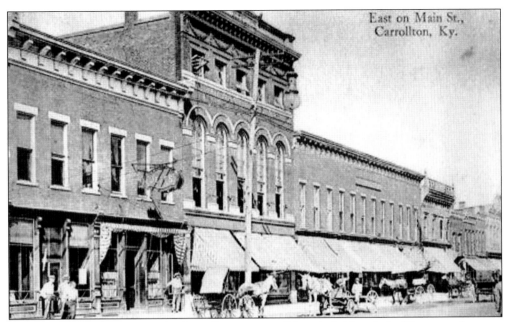

Looking east on Main Street in Carrollton, many of the city's historic buildings can be seen. Today Carrollton still has some of the historic buildings surrounding the county courthouse. At some points during the 1900s, Carrollton was the "third largest burley tobacco market in the world," according to the Carrollton tourism bureau. The worst flood of the Ohio River Valley, the great one of 1937, hit 79.9 feet in Carrollton.

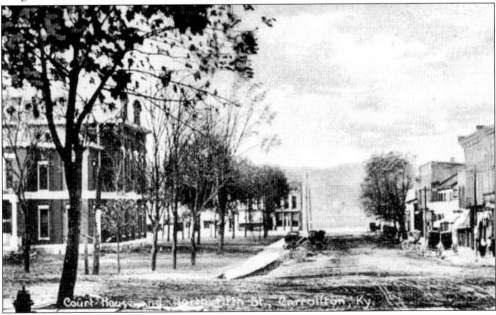

This image from the 1800s shows Carrollton looking down Fifth Street toward the Ohio River. On the left of the town square is the courthouse. There have been four courthouses in Carrollton, and this image shows the current one, built in 1884 by the McDonald brothers of Louisville, Kentucky. Amazingly much of this image remains the same today. The courthouse still is surrounded by a large yard, and most, if not all, of these building still exist.

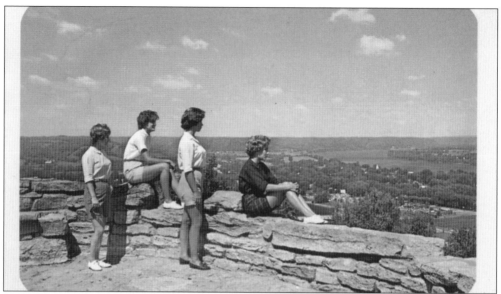

General Butler State Park at the Ohio River in Carrollton, Kentucky, is named after William O. Butler. The Butler family has a long line of military experience, dating back to the American Revolution, the War of 1812, the Mexican War, and the Civil War. The Butler-Turpin House at the park was built in 1859, and the entire park enhances the Ohio River experience of this community. In this 1970s Kentucky State Parks postcard image, the overlook at Butler shows the beautiful Ohio River at Carrollton as four visitors enjoy its beauty and restfulness.

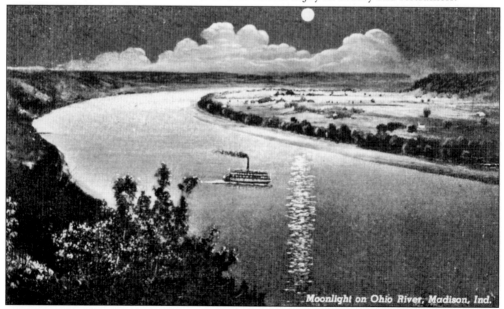

Moonlight on Ohio River, Madison, Ind.

Illuminated by the light of a full moon, this bluff view at Madison takes on a whole different feeling from the daylight image on the following page, creating a sleepy, romantic ambiance reminiscent of Madison's heyday as the major entry point into the Indiana territory and along the Old Michigan Road. The decline in river commerce was followed by a short-lived railroad economy that left Madison frozen in time, preserving an unprecedented collection of 19th- and early-20th-century residential, commercial, and industrial architecture.

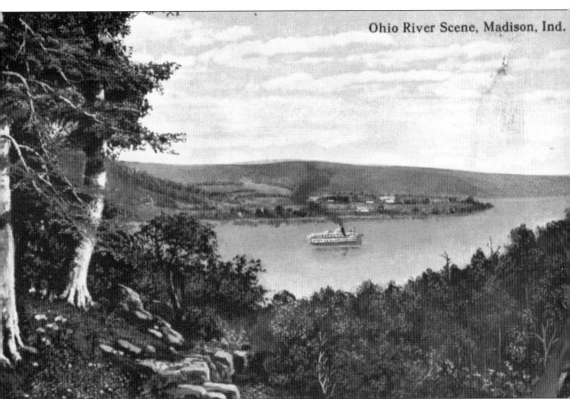

Ohio River Scene, Madison, Ind.

At mile 557.7 on the right bank is Madison, Jefferson County, Indiana, across from Milton, Trimble County, Kentucky. Again the city, which prospered on the right bank, overshadowed the town on the left. Madison was established in 1809 and is the county seat of Jefferson County, Indiana. It is 88 miles downriver from Cincinnati and 46 miles above Louisville. High upon a bluff overlooking the city and the river is the celebrated liberal arts–focused Hanover College.

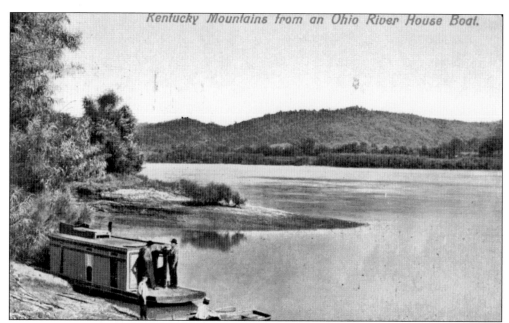

Houseboats and shanty boats were a common site along the Ohio River. But there was a definite class distinction and social caste involving the two. A shanty was indeed a permanent living quarters for an individual or a family, even though the location often changed. Subsistence consisted of fishing, vegetable gardening, and bartering of trades or talents. Drifting with the current was their mode of power and seasonal opportunity dictated their schedule. Whims also played a role. A houseboat was usually a higher-style and quality craft owned by individuals or families of the middle or upper class who also owned a residence on land. The more ornately decorated houseboats were usually used for leisurely relaxation and entertainment, the forerunners of today's mammoth pleasure houseboats. As seen these images, there was always a small skiff of some type accompanying the shanty for the purpose of mobility and local transportation.

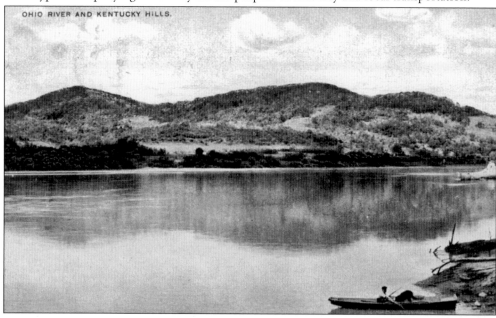

OHIO RIVER AND KENTUCKY HILLS.

Three

LOUISVILLE

Louisville, Kentucky, was established in 1778 by Gen. George Rogers Clark. William Clark was asked by Meriwether Lewis to serve as cocaptain with him on the famous 1803 exploration expedition of the uncharted Pacific Northwest, which was orchestrated by then-president Thomas Jefferson. The close association of the Clark and Jefferson families, along with the association of these names with major historical events and accomplishments of the times, accounts for the multiple surname uses in the naming of local towns, cities, counties, creeks, streets, buildings, and other landmarks honored with the Jefferson or Clark name. In 1875, Meriwether Lewis Clark Jr., a grandson of William Clark, founded the Louisville Jockey Club horse racing track, which he built and modeled after the famed tracks in Europe, in order to showcase the quality of Thoroughbred horse breeding in Kentucky. He built the track on land owned by his uncles, John and Henry Churchill. After a few seasons of racing, it became known as Churchill Downs, home to America's most prestigious horse race, the Kentucky Derby, which is this country's longest continually run sports event.

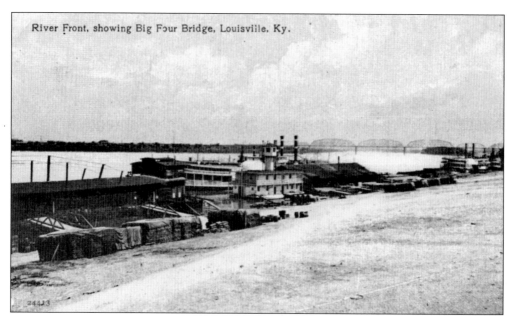

River Front, showing Big Four Bridge, Louisville, Ky.

This Louisville riverfront view confirms that "a picture is worth a thousand words," as it visually sums up the age-old freight and commerce competition struggle between the river packets and the railroads along all of America's major western river systems. Before the existence of the Big Four Bridge (named for its owner, the Cleveland, Cincinnati, Chicago, and St. Louis Railway) in the background, this riverfront scene would have featured dozens of packets at any given time.

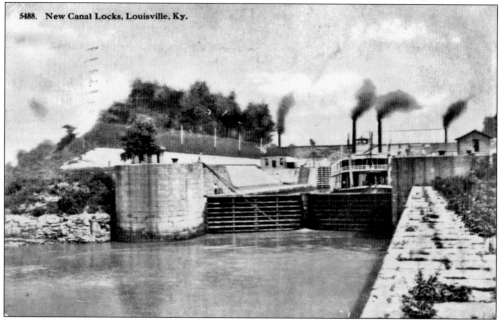

5488. New Canal Locks, Louisville, Ky.

For boats headed upstream, the Falls of the Ohio, a natural rocky obstruction to navigation, was a mandatory stopping place. Cargo and passengers were portaged over land to a point above the falls, where another boat could resume the trip. Eventually this landing spot developed into the town of Portland, laid out *c.* 1814. Proposed in 1825 and completed in 1830, a navigable canal around the falls eventually opened to navigation.

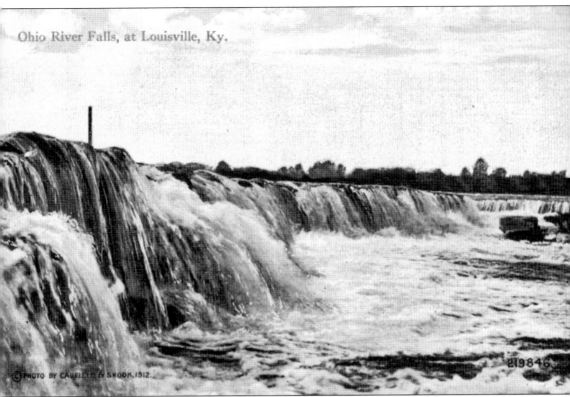

Ohio River Falls, at Louisville, Ky.

The Falls of the Ohio consists of a natural deposit of 400-million-year-old Devonian Age fossil beds, forming the only natural obstruction to navigation along the entire 981-mile course of the Ohio River. The falls encompass a length of three miles, with a total extreme drop of 25-and-a-quarter feet. Since it necessitated a mandatory termination of any boat traffic in order to portage around the falls, many people simply stayed and settled here, explaining the origin and settlement of at least six towns and cities—Louisville, Portland, and Shippingport in Kentucky, and Jeffersonville, Clarksville, and New Albany in Indiana. The 1830–1831 Louisville and Portland Canal was enlarged and refitted with new and larger locks in 1872. Initially privately owned by stockholders, in 1874, the federal government took over ownership and control of the canal and reduced the toll from 50¢ to 5¢ per ton. By 1880, passage through was free.

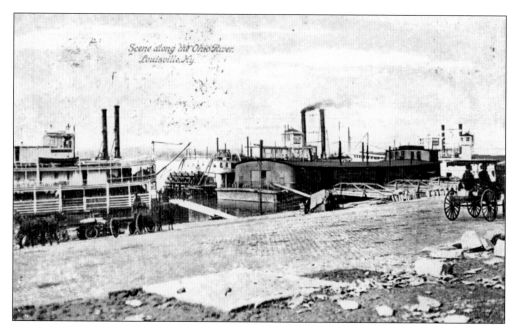

When river commerce was still in control of moving goods and products to the myriad destinations of demand, the Louisville riverfront looked like this for a length of 10 to 12 blocks. Off loaded by hand and transported away by horse-drawn drays and wagons, the business at hand was continuous and steady, assuring employment opportunities for anyone looking.

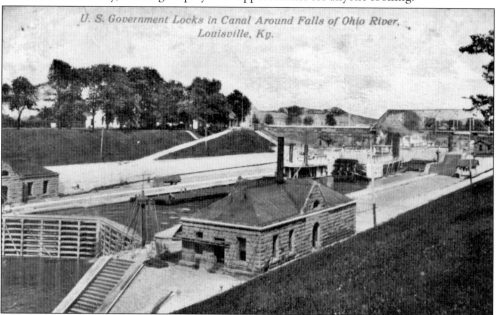

The title of this card specifically states "U.S. Government Locks." As early as 1775, Congress authorized the formation of an army with a chief engineer and two assistants. In 1779, Congress created a separate Corps of Engineers. Besides the responsibility of building and maintaining defensive fortifications, the charge of building roads and maintaining navigability of the country's rivers and streams was assigned to the corps, making every lock and dam in the country property of the federal government.

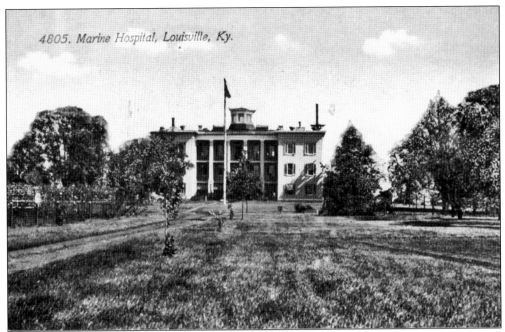

4805. Marine Hospital, Louisville, Ky.

The United States Marine Hospital dates back to the steamboat era. This prototype for seven such facilities was built in Portland in 1845–1852 and was oriented toward and overlooking the Ohio River. It was not built for the military veterans but for the health needs and care of the working river men on the country's western watercourses. It purposely included the widow's walk on top because it was felt that being able to see the river would assist in the river men's recovery.

Moonlight on the Ohio River, Louisville, Ky.

Apparently in the postcard industry, scenes of steamboats under the light of a full moon were very popular and big sellers. Almost every river town and city was featured in this manner. Louisville was no exception, as seen in this hand-colorized, German-crafted art card.

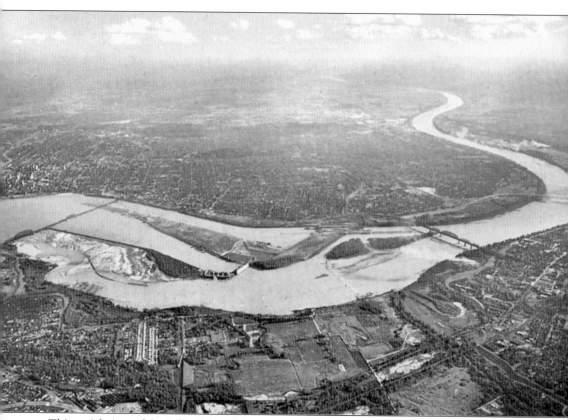

This aerial view of the Falls of the Ohio area gives a good retrospective idea of what can happen to a major navigational waterway having an impassable, natural obstruction impeding any further progress. It results in the largest metropolitan city in the commonwealth and a bi-state regional population center. The long, meandering S-curve that terminates into a broad crescent almost resembles the aerial view of the river at Cincinnati. People stopped at Cincinnati because they wanted to. They stopped at Louisville because they had to. Early on, before the 1811 introduction of successful steam-powered navigation, Cincinnati (first settled in 1788) was a chosen destination for the flatboats and keelboats coming from Pennsylvania down the Allegheny and Monongahela to Pittsburgh where the two rivers form the Ohio. Cincinnati was safer from Native American threats, it offered a more permanent environment, it had established commerce and business, and it generally considered itself cultured. Louisville, on the other hand, was settled 10 years earlier in 1778 by Gen. George Rogers Clark but did not have the population base Cincinnati enjoyed (359 in 1800 compared to Cincinnati's 750). Louisville was still close to the fringes of the wilderness and subject to Native American attacks.

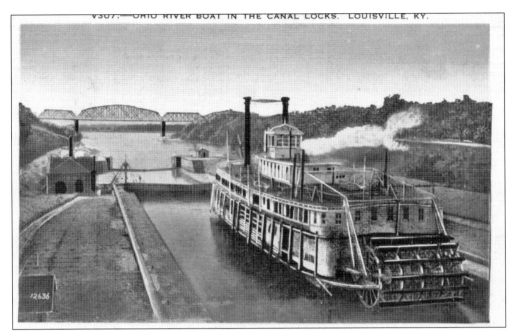

When the falls dam and hydroelectric generating plant were built in 1927 for the purpose of maintaining at least a navigable depth of nine feet the entire length of the Ohio, an additional lock, 600 feet long and 110 feet wide, was constructed and the canal widened to a total of 200 feet. These changes resulted in an easier lockage for the wider boats and longer tows.

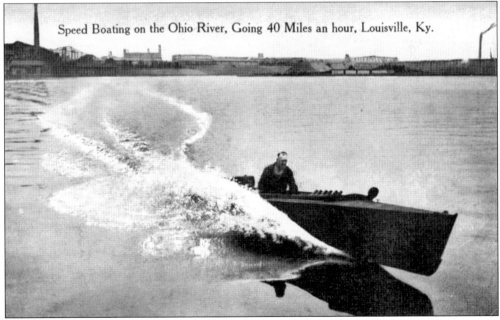

Speedboat racing was a very popular Ohio River pastime, and the competition was fierce up and down the river. J. W. Whitlock's famous boat, Hoosier Boy No. 3, won the 1924 championship cup with speeds of 62 miles per hour. This boat, the precursor to the modern hydroplanes, claims to be going 40 miles per hour.

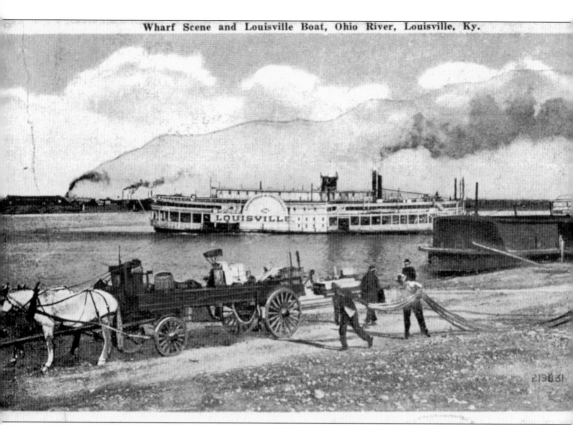

It appears here that the *City of Louisville* is pulling into the city of Louisville, heading for the wharf boat, as workers on the landing scurry about with lines. A boat is said to land when she pulls up to the shore or landing. She docks when she pulls up to a wharf boat or ancillary dock. The *City of Louisville* was built across the river in Jeffersonville, Indiana, at the Howard Ship Yard in 1894 expressly for the Louisville–Cincinnati trade for the Louisville and Cincinnati Packet Company. The boat had a total of 72 staterooms and could sleep 160 people. The excursion permit was issued for 1,500 souls. She was launched on April 2, 1894, and on April 18 of that same year, she made a record run from Louisville to Cincinnati in 9 hours and 42 minutes, which has never been equaled. Two years later, on April 5, 1896, the *City of Louisville* set the downstream record from Cincinnati to Louisville in 5 hours and 58 minutes. The very last trip was on May 16, 1917, from Louisville to Cincinnati. On the next day, the boat was laid up across the river in Covington, Kentucky, where she remained until her January 30, 1918, demise, when the ice tore her apart.

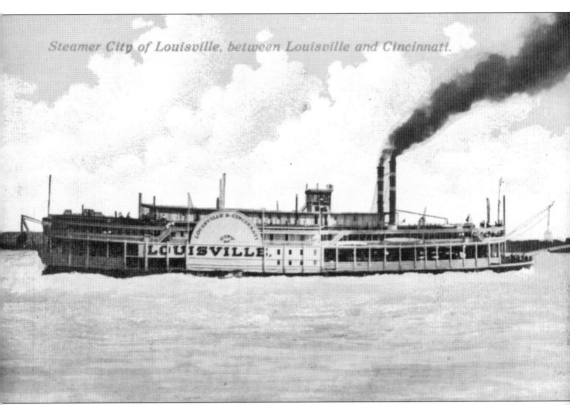

Steamer City of Louisville, between Louisville and Cincinnati.

The *City of Louisville* was just as famous on the Ohio River as the *Robert E. Lee* was on the Mississippi. During her entire career, she had only three different captains. For many years, the numbers 9–42 were displayed on the sides of its pilothouse. This was an unequalled record time for making the trip from Louisville to Cincinnati in 9 hours and 42 minutes, just 16 days after the launching and trial run. The *City of Louisville*'s partner in the Louisville–Cincinnati trade was also built at Howard Ship Yard in Jeffersonville, Indiana. The *City of Cincinnati* was also a powerful side-wheeler packet and was five years younger than her sister, having been built in 1899. Both the *City of Louisville* and the *City of Cincinnati* perished together in the January 1918 ice in Covington/Cincinnati.

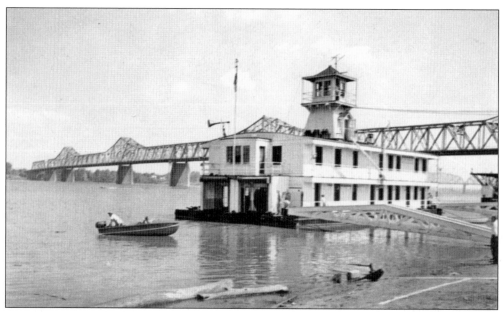

Coast Guard Station No. 10 is the only remaining lifesaving station in the United States. It was built in 1928 in Dubuque, Iowa, to replace an earlier station (*c.* 1881) at the falls. John F. Gillooly served at this station for 47 years and is credited with saving 6,312 lives and $5 million of cargo, and he recovered 40 bodies from this station. It now serves as wharf boat and business office for the *Belle of Louisville* and the *Spirit of Jefferson*.

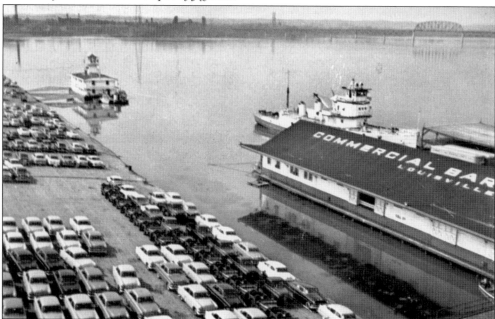

Rather than public parking at the Louisville public landing, this appears to be an off-loaded shipment of automobiles via barge transport to the commercial barge wharf boat. Barges can carry such an exponentially greater amount of cargo than trains or trucks can transport. During World War II, goods transported by barge made a huge comeback and continued into the postwar era.

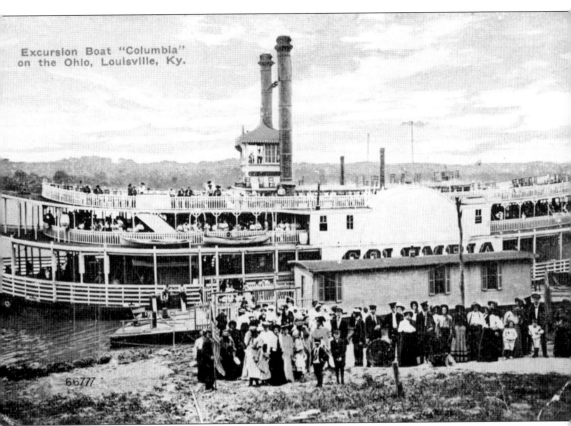

Excursion Boat "Columbia"
on the Ohio, Louisville, Ky.

The "Excursion Boat 'Columbia' on the Ohio, Louisville, Ky.," was built in 1892 by the Howard Ship Yard in Jeffersonville, Indiana, for the Louisville and Jeffersonville Ferry Company. In 1913, she burned down to the water line at the foot on Watt Street in Jeffersonville. This real-photo postcard features a posed scene of the boat and her patrons.

Wharf Scene, Ohio River, Louisville, Ky.

18507

The cobblestone paved public landing in Louisville appears deserted except for the two Model Ts parked at the wharf boat waiting for a docking steam packet. Undoubtedly they are picking up passengers. This image of everyday life in Louisville is enhanced by the bridge in the background, highlighting several forms of transportation.

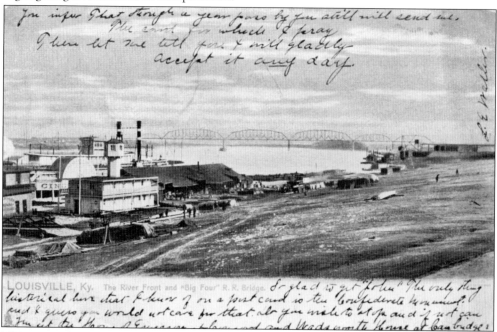

LOUISVILLE, Ky. The River Front and "Big Four" R.R. Bridge.

This postcard predates the divided-back cards, which allowed the message to be written on the left side of the back. In this case, only the address could be written on the back side. The message was therefore squeezed onto the image on the front of the card. Docked here at the wharf boat is the *City of Cincinnati*, waiting for her return trip back to Cincinnati.

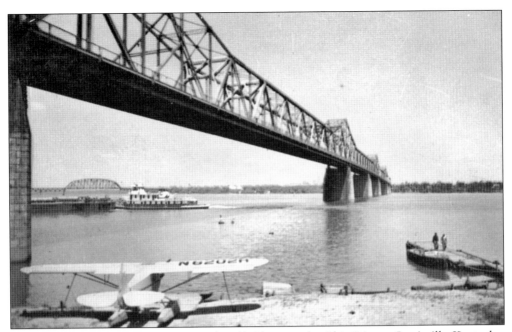

As a towboat shoves its barges under a railroad bridge over the Ohio River at Louisville, Kentucky, the pilot and copilot of a private seaplane surveys the river as they make ready to resume their airborne adventure along the course of the river.

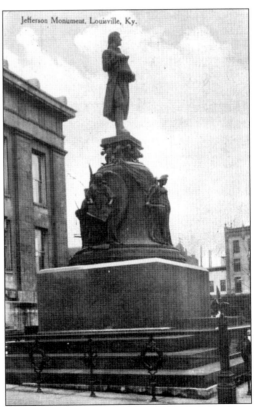

Jefferson County, Kentucky, was named in honor of Thomas Jefferson, governor of Virginia when Jefferson County was formed in 1780. Moses Ezekiel created this sculpture of Thomas Jefferson in 1899, commissioned to be one of two sculptures exhibited outside of the Jefferson County Courthouse in Louisville. The other sculpture is that of Louis XIV, for whom Louisville is named in recognition of the role France played in the realization of the colonists' victory in the Revolutionary War.

63

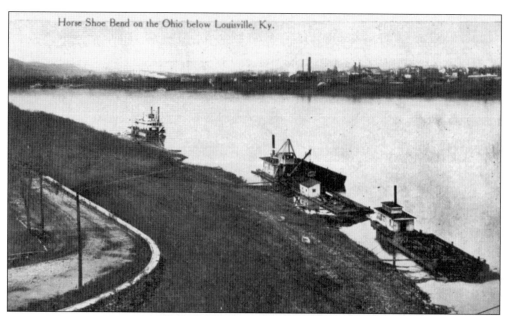

Horse Shoe Bend on the Ohio below Louisville, Ky.

The winding meanders of the Ohio River are not as dynamic as those of the Mississippi, which can change the river's course between regular trips. But the bends can be just as extreme, changing east to west, or north to south in the course of a mile or less. Horseshoe or hairpin turns require strict attention and concentration when navigating a steamboat or tow as well as flanking maneuvers known only to experienced river pilots in order to realize a safe negotiation of a potentially deadly and devastating passage.

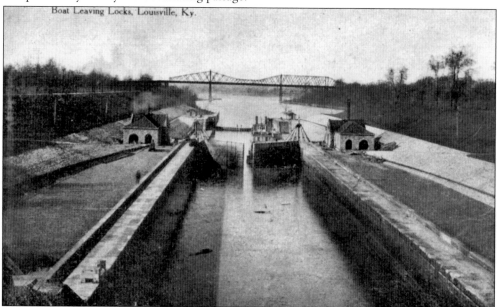

Boat Leaving Locks, Louisville, Ky.

The filling and emptying of lock chambers is regulated and controlled by the opening and closing of valves, relying on the property of liquids to seek their own level. This applied principle and law of physics negates the need for any kind of pumping machinery and allows for minimal machinery failures and downtime for repairs, thus increasing the performance efficiency of the numerous locks across the navigable waterways of the United States.

Four

COMMERCE
AND RECREATION

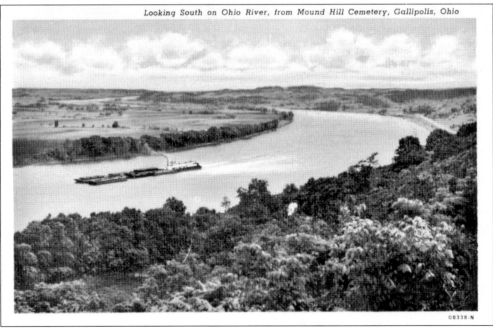

Looking South on Ohio River, from Mound Hill Cemetery, Gallipolis, Ohio

This is a typical scene anywhere along the course of the Ohio, a towboat pushing a load of coal up or downriver. Transport of coal is the number-one river commerce activity. Before the diesel boats came on the scene, towboats like this one were stern-wheelers pushing a string of wooden barges. The boat providing the pushing power is called a towboat.

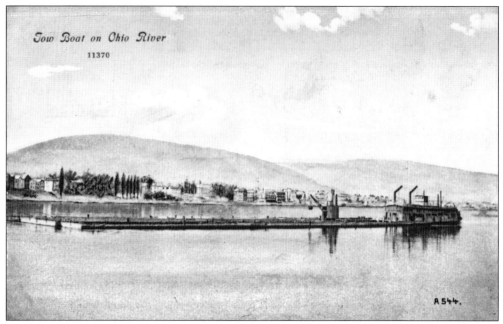

This stern-wheeler towboat seems to be pushing loaded barges containing some material that can be unloaded by the clamshell steam shovel on board. Note the smokestacks on the towboat. The stacks were usually hinged so they could be manually lowered for the purpose of clearance while going under bridges when the river is up.

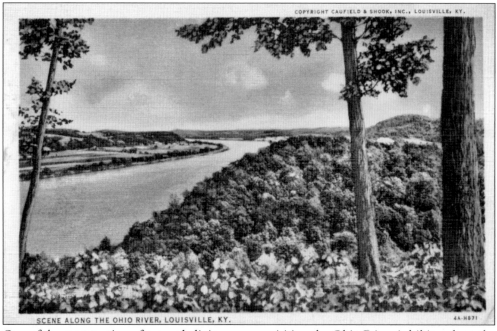

One of the great pastimes for people living near or visiting the Ohio River is hiking along the beautiful overlooks. This image is a reminder of the beautiful areas that are perfect for walking in order to enjoy the river. Numerous parks and other venues along the Ohio River provide an excellent opportunity to hike.

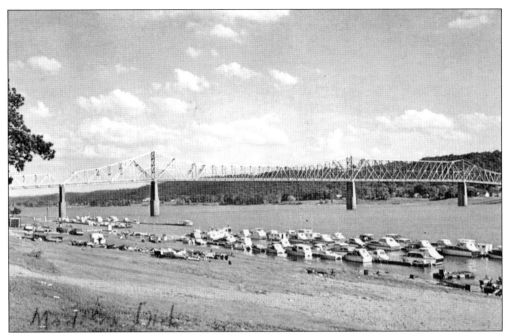

Recreational use of the river increases every year, as demonstrated by scenes like this up and down the river. Examples include marinas, boat storage facilities, fuel docks, restaurants and bars, public docks at towns and cities, private docks for riverside homes along with other water recreation related commercial businesses and services. This late-1960s to early-1970s view is at Madison, Indiana.

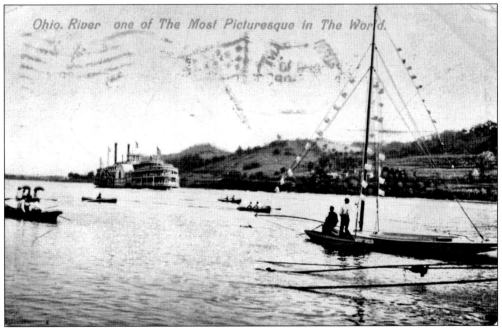

As the *Island Queen* heads upriver from the Cincinnati public landing with a load of Sunday afternoon patrons headed for a day of fun and entertainment at Coney Island, pleasure boaters are attracted by her to get a closer look. These craft rely on muscle and wind to get around.

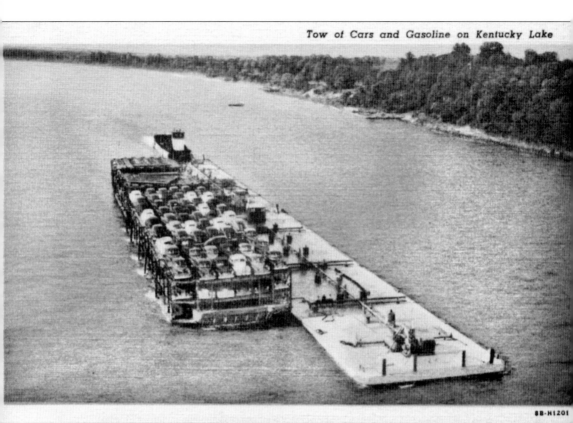

88-H1201

This most interesting view shows how river transportation can move volumes of cargo more efficiently and economically than by road or rail. This tow of vintage, late-1940s automobiles on Kentucky Lake is headed toward the Ohio River for destinations like Louisville and Cincinnati. In 1938, the Tennessee Valley Authority (TVA) began construction on the Kentucky Dam across the Tennessee River, backing up that river for 184 miles and impounding waters of that drainage system to create the largest man-made lake in the eastern United States. The project was completed in 1944. Unlike the lock and dams along the Ohio River, which were built solely to provide year-round navigation, Kentucky Lake was constructed to control flooding on the Lower Ohio and the Mississippi Rivers. Secondary uses from the project include hydroelectric generation, private and commercial water supply, and recreational boating, fishing, camping, and vacation tourism. The dam is 22 miles from Paducah, Kentucky, where the Tennessee River enters the Ohio.

The ferry has always been a long-running affair, spanning the time from the first man-powered ferries using oars, poles, or ropes; to the ever-popular oral tradition of a "blind horse on a treadmill" powered ferry; to the steam-powered side-wheelers and stern-wheelers; to the internal-combustion gasoline engine models; to today's diesel-powered craft. The upper image is a 1936 real-photo postcard image of the *Robt. T. Graham*, which was a stern-wheeler built in 1918. She operated between Ghent (Carroll County), Kentucky (mile 537.6), and Vevay (Switzerland County), Indiana, until 1942, when she was crushed by ice and subsequently dismantled. She was replaced by the 1942 diesel-powered side-wheeler *Martha A. Graham* (lower image). The Ghent–Vevay ferry operated until the summer of 1977. It closed the very day that the new Markland Dam Bridge opened.

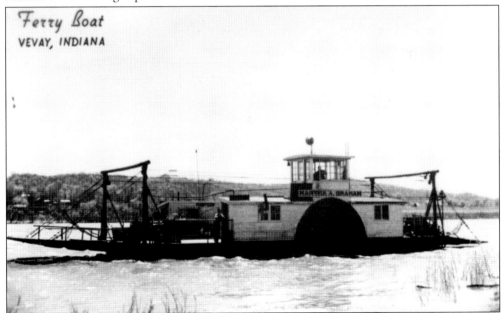

Ferry Boat
VEVAY, INDIANA

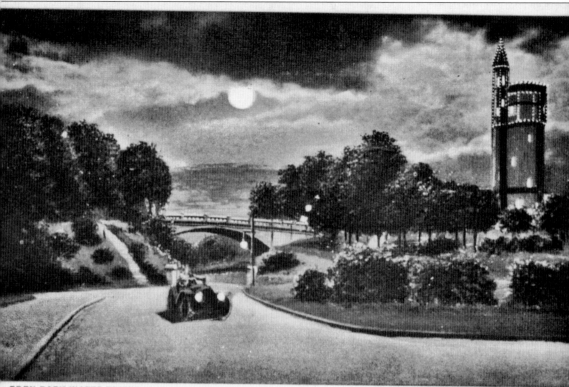

EDEN PARK WATER TOWER, BY NIGHT, CINCINNATI, OHIO.

This beautiful postcard, released by the Feicke–Desch Printing Company, shows Eden Park in the evening. A full moon shines above the historic water tower. Eden Park is one of the most special in the Cincinnati Park System. Starting in 1859, the park grew through individual purchases of land; however, Nicholas Longworth gave the city a large tract that makes up the vast majority of the park. Some of Cincinnati's most treasured institutions call Eden Park home, including the Art Museum, Playhouse in the Park, and the Krohn Conservatory. The Seasongood Pavilion, Presidential Grove, Heroes Grove, Authors Grove, Mirror Lake, and the Ohio River Monument are also located in Eden Park. The water tower shown in this image was completed in 1894 and stands at 172 feet. Today the Vietnam Veterans Memorial, dedicated April 8, 1984, stands just below the water tower. Also seen is the Melan Arch Bridge, built in 1894 and considered a fine engineering accomplishment.

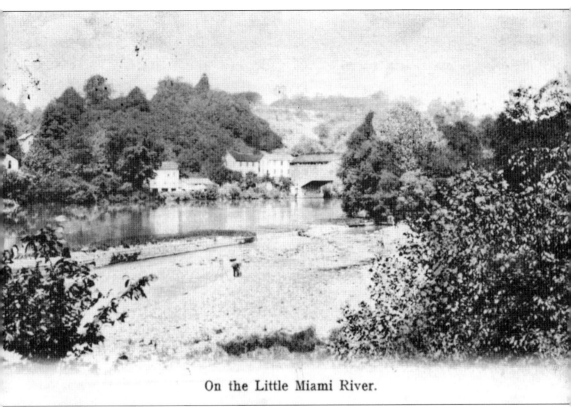

On the Little Miami River.

In this Kraemer Art Company postcard, postmarked 1912, the Little Miami River can be seen. The Little Miami is one of many tributaries that feed into the Ohio River, and it provides a wide range of recreational activities such as canoeing, fishing, and hiking. It is both a state and nationally designated scenic river, and before ending at the Ohio River above Cincinnati, it has flowed for around 100 miles. Its headwaters are in Clark County. Many of the tributaries of the Ohio River are naturally beautiful. The Little Miami has an abundance of wildlife, including 87 species of fish. As it flows to the Ohio River, the Little Miami increases in size and goes through various nature preserves. Many of these tributaries were home to Native Americans, as was the Ohio River.

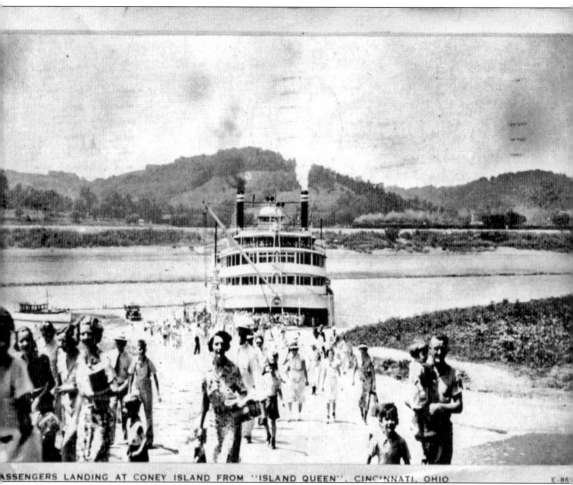

ASSENGERS LANDING AT CONEY ISLAND FROM "ISLAND QUEEN", CINCINNATI, OHIO E-86

This throng of smiling passengers just enjoyed a pleasant *Island Queen* steamboat trip upriver from the Cincinnati public landing to Coney Island Amusement Park for a day of fun and relaxation. Coney Island was not really an island, but the name invoked a feeling of seclusion and separation from the real world to enjoy a day of fun and fantasy. There were several similar such amusement parks along the course of the Ohio using the island moniker. Notice also in this mid- to late-1950s view the boat pulled up to shore on the left edge of the picture. This was the Coney Island passenger ferry that shuttled people from the Kentucky side in Melbourne (Campbell County) across to Coney. This ferry eventually became part of the fleet of BB Riverboats, Incorporated, in Covington, Kentucky, as a workboat. In the late 1970s, she was revived for passenger ferry service on weekends between Rising Sun, Indiana, and Rabbit Hash, Kentucky, under the name Rabbit Transit Authority.

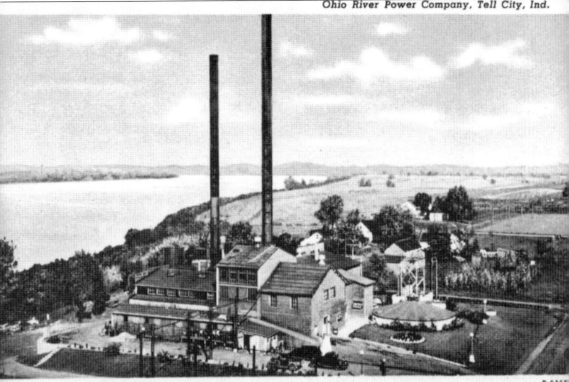

D-5255

Long used for commerce, the Ohio River was a natural place for the establishment of industry and the development of power facilities. Many plants such as water and power can be seen up and down the Ohio River. The Ohio River Power Company Plant in Tell City, Indiana, is a fine example of an early river facility. The transportation system offered by the river provides a convenient means to get coal to the plants. Today modern facilities can be found that are much larger than this example, such as the Zimmer Facility near Cincinnati, Ohio, and the East Bend Power Plant about 40 miles south. Many river communities obtain their water supply from the river, and it is common to see water facilities when traveling down the river. Often these are stately buildings that were built many years ago. Industry also has long found the Ohio River as a convenient way to ship products.

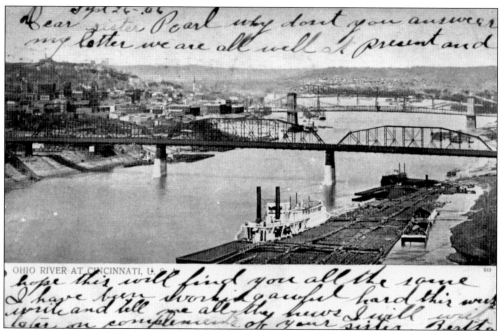

This early-1900s postcard shows the Ohio River at Cincinnati including coal barges docked to the shore. Several bridges linking Ohio and Kentucky are evident. Note the postcard is written on the front. This card was used during a time when it was illegal to write notes on the back of postcards. However, in the early 1900s, the post office changed the law. Postcards were then redesigned to have a line down the back to separate the area for writing from the address.

Coming from Wheeling, West Virginia, this steamboat and barge hauls coal to a location somewhere up or down the Ohio River. Pictured in this image is a fine example of a well-used stern steamboat, which means the paddle is in the back. Note the boat in this picture has two hardy stacks that bend back to go under bridges, such as the one in the far background.

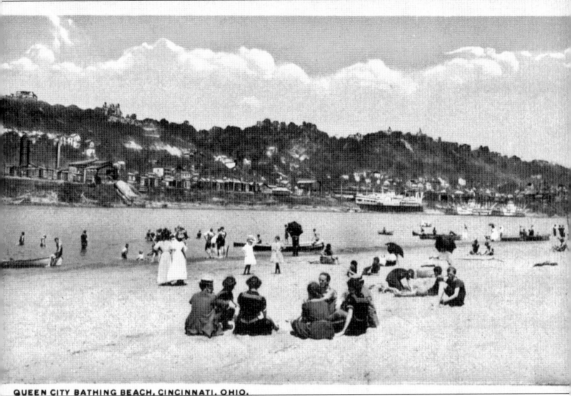

QUEEN CITY BATHING BEACH, CINCINNATI, OHIO.

The Queen City Bathing Beach was a very popular spot located in Bellevue, Kentucky, directly across from Cincinnati. It was especially popular for residents of the small Kentucky towns in the area of the beach, particularly Bellevue and Dayton. In the background of this postcard image, a couple of steamboats can be seen. They are being built at a location on the east side of Cincinnati where a business operated building steamboats.

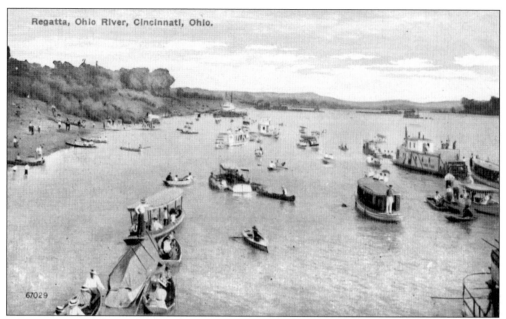

Regatta, Ohio River, Cincinnati, Ohio.

67029

The Regatta on the Ohio River at Cincinnati was held for the first time on Saturday, August 29, 1908. This postcard shows the day and the many spectators that watched from their own boats. The Ohio River Launch Club, founded in 1898, is one of the oldest yacht clubs in the United States and was home to the 1908 Regatta. The launch club was created just as the interest in pleasure boating on the Ohio started to flourish.

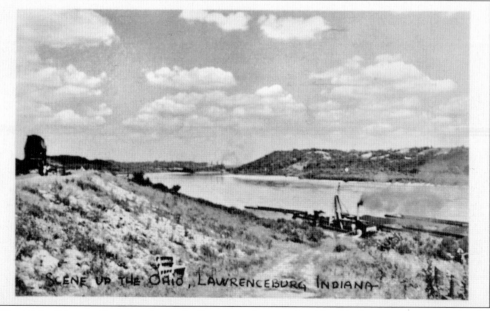

SCENE UP THE OHIO, LAWRENCEBURG INDIANA

The Ohio River at Lawrenceburg, Indiana, can be seen in this old photograph postcard. The river city of Lawrenceburg is about 25 miles downriver from Cincinnati, Ohio, and has long been called "Whiskey City" because of the distilleries that operated in town. Joseph E. Seagram and Sons still operates in Lawrenceburg and has done so since 1851. Often hit by floods, the city is better protected as a result of flood water impoundment areas and a modern levee.

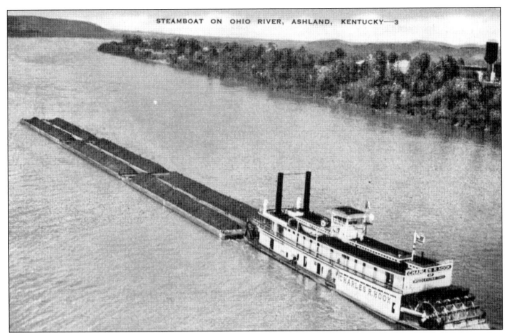

Another fine example of a coal tow being pushed down the Ohio River near Ashland, Kentucky, can be seen in this image. The steamboat in this photograph is the *Charles R. Hook*, originally called the *Destrehan*. Built in 1922, she operated on the Mississippi River until being sold to Armco Steel. She later became a floating restaurant in Cincinnati for a short period of time.

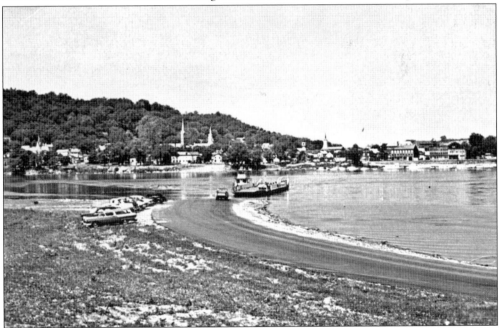

This image from the late 1960s or early 1970s shows the Aurora Ferry that served the communities of Aurora, Indiana, and Petersburg, Kentucky. The ferry was the second-longest running ferry in Boone County, Kentucky, running from the 1800s to the 1970s. Like many ferries, the Aurora Ferry closed because of a new bridge and better road systems.

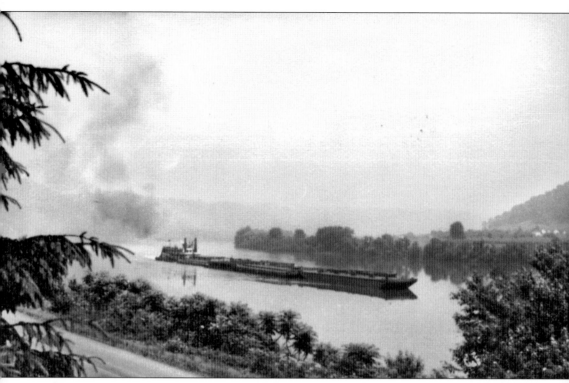

This vintage photograph shows coal barges being towed on the Ohio River. While there are many small and some large towns on the river, much of the Ohio River is captured in images like this one. Many of the states bordering the river, like Kentucky and Indiana, are rural in nature. The peaceful and perhaps at times lonely ride up and down the river can be seen in this image of commerce featured on a quiet part of the Ohio. Pushed by a steam stern-wheeler, the tow of barges travels the Ohio near Ashland, Kentucky. It is easy to image the captain, quiet in his thoughts, as he handles his duties.

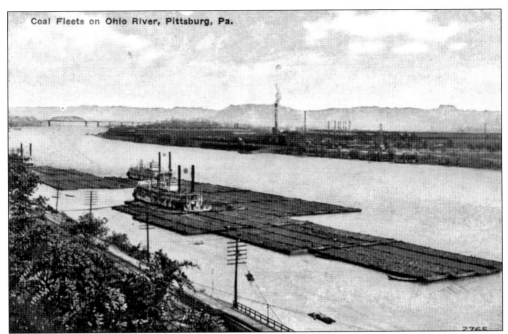

Coal Fleets on Ohio River, Pittsburg, Pa.

Coal sits in a fleet of barges on the side of the river at Pittsburgh, Pennsylvania. Coal shipped from Southern states, such as Kentucky and West Virginia, were the lifeblood of industrial Northern cities, such as Pittsburgh. The stern-wheeler pushing these barges of coal has two stacks and a paddle wheel, not exactly the kind of boat most people think of when imagining a towboat.

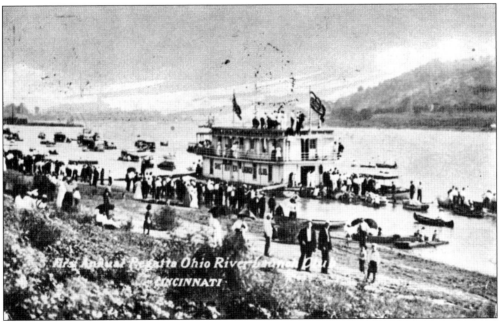

The Ohio River Launch Club of Cincinnati held its first annual Regatta in 1908. Seen in this vintage postcard, the regatta was a huge success, drawing, some say, as many as 10,000 spectators. The club was started by a group of individuals drawn by their love of the river and a strong desire to enjoy the pleasures the Ohio had to offer. The Regatta was an extension of this love.

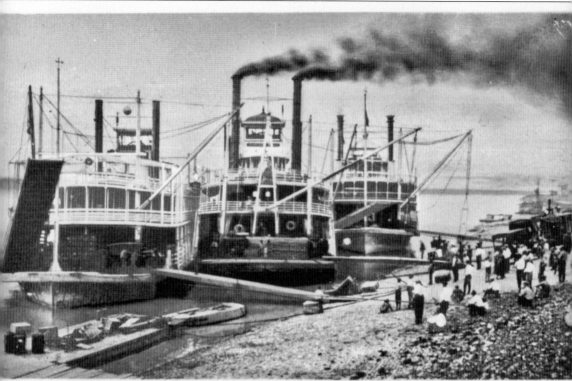

River Scene of by-gone days

This picture postcard called "River Scene of by-gone days" shows a time about 100 years ago. Three steamboats are pulled to the side of the river, most likely for excursions. People dressed in their best clothes wait on the shore to board and enjoy a relaxing day on the river. Perhaps they are being transported to a relaxing destination to be dropped off and picked back up later in the day. Boats such as the ones depicted in this image were used for other reasons than just relaxing excursions. In the 1800s, when America was expanding, they also provided the best means to transport goods up and down the river with a lot less effort than ever before. Prior to the creation of dams and the deepening of Ohio River channels, these boats often had navigational problems on the river. However, despite these early problems, the boats survived and became more efficient, and the Ohio River became the first of America's superhighways.

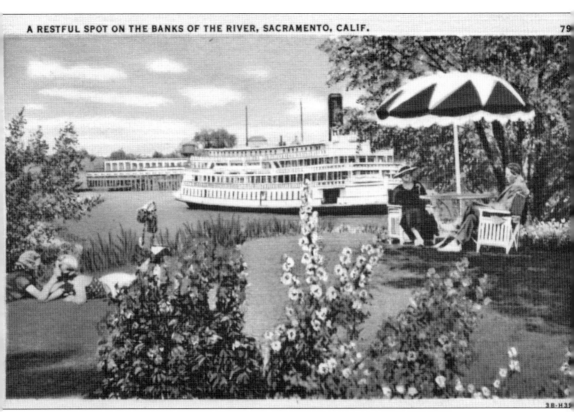

In this image entitled "A Restful Spot on the Banks of the River, Sacramento, Calif.," a steamboat is pictured, but she has only one smokestack, quite unlike the steamboats on the Ohio. California-built steamboats had just one stack. There had to be a reason in the beginning, but it quickly became a tradition. The single stack, however, had two separate flues, one for each boiler. Built in Stockton, California, on the banks of the San Joaquin River between the years 1924 and 1927, the *Delta Queen* (as seen here) had her maiden voyage in 1927 on the Sacramento River, where she partnered with her twin boat, the *Delta King*, in the overnight passenger service between San Francisco and Sacramento. Running opposite trips each night from both ports, the boats would leave every evening at 6:30 and arrive at their destination at 5:30 the next morning, passing each other during the night.

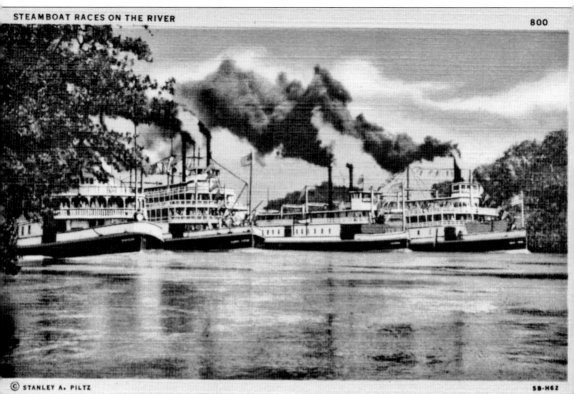

© STANLEY A. PILTZ

5B-H62

This 1930s postcard called "Steamboat Races on the River" is staged. It was staged for the movie *Steamboat Round the Bend*, starring Will Rogers. Filmed in 1935, it was the last movie of Will Rogers's career. It also starred Anne Shirley and Irvin S. Cobb as Captain Eli. In this film, directed by the great John Ford, Rogers plays Dr. John Pearly, an owner of an old, worn-down steamboat. The steamboat hurries downriver trying save a man found guilty of murder from being hanged. On this postcard image, taken in California, are four steamboats. The two in the middle have two stacks, and trees hide the fourth steamboat. The steamboat on the far right, with one stack, is most likely either the *Delta Queen* or the *Delta King*. The movie is all-American and typical Will Rogers.

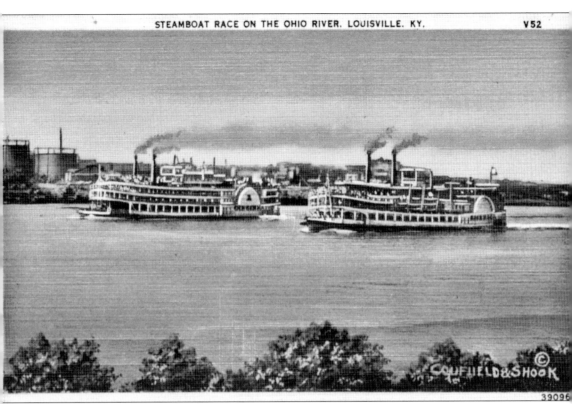

39096

Steamboats are not an exception to the idea that if something is built for transportation, it will be tested to see how fast it can go. With steam engines came power and the desire to always take that power to a new level. Early on, captains of steamboats would take risks with their boats in order to see how fast they could make a journey or set a record. Often these races were dangerous, but people loved them, often watching from the shore. This postcard shows two steamboats racing on the Ohio River at Louisville, Kentucky. Louisville and Cincinnati are home to the most famous race today between the *Delta Queen* and the *Belle of Louisville*. This race began in 1963 when a Louisville judge challenged Letha Greene of the *Delta Queen* to a race. It has been going on ever since as a part of the pre-race festivities of the Kentucky Derby.

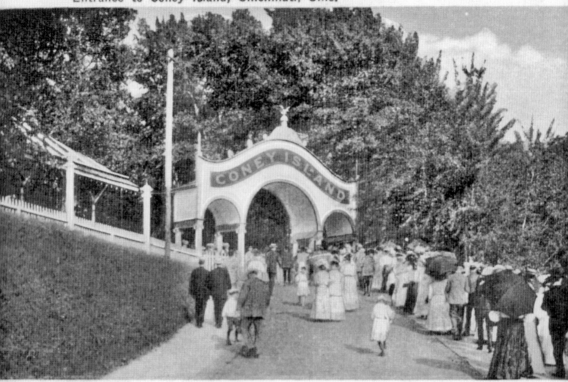

Coney Island, Cincinnati's most famous amusement park, was located on the Ohio River on the eastern side of the city. The amusement park opened on June 21, 1886, and closed in the early 1970s, when Kings Island was developed in Mason, Ohio. Located on the banks of the Ohio River, it was prone to flooding; however, it remained very popular up until the time it closed. This postcard shows the entrance to Coney Island from the Ohio River landing. A steamboat company, later called the Coney Island Company, started Coney Island. Daily trips from Cincinnati to Coney Island would transport travelers to what was advertised as "the most beautiful all day summer resort in America." Coney Island was home to the "largest recirculating swimming pool in the world," and today the pool anchors a park that has a small number of rides and is a fun place for company picnics and a day of swimming and play.

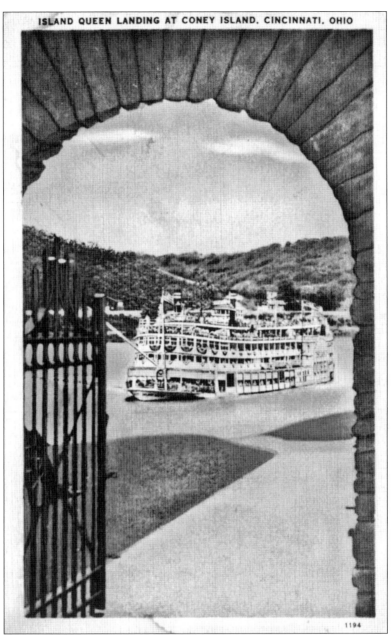

ISLAND QUEEN LANDING AT CONEY ISLAND, CINCINNATI, OHIO

1194

The first *Island Queen* pulls up to the landing at Coney Island amusement park in Cincinnati, Ohio. The first *Island Queen* was originally called the *Saint Joseph* and, when purchased by the Coney Island Company, was renamed the *Island Queen*. The *Queen* would travel from Cincinnati to Coney Island. Going to Coney Island on the *Island Queen* was an experience in and of itself because it was not merely transportation. The *Island Queen* made the several daily trips to Coney Island for 17 years. She was destroyed by fire, along with several other boats, in November 1922. A second *Island Queen* was built, but she was not wooden like the original. The second *Island Queen* made the rounds to Coney Island until 1947, when she was destroyed when her fuel tanks exploded. Nineteen people were killed. The *Island Queen*, to this day, remains one of the most popular stories and memories for many Cincinnatians to recall.

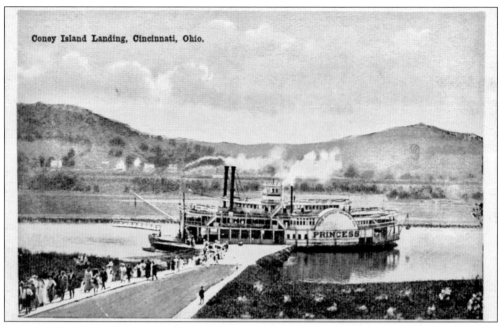

Coney Island Landing, Cincinnati, Ohio.

The *Princess*, built in 1900 at Marietta, Ohio, as the *Francis J. Torrance* to run excursion trips on the upper Ohio and Monongahela Rivers, was purchased in November 1905 by the Coney Island Company to team up with the *Island Queen* in the Cincinnati–Coney Island trade from 1906 to 1917. The 1917–1918 ice broke her loose from her winter moorings at the mouth of the Kentucky River and deposited the boat upside down at Madison, Indiana.

Because of the 1966 passage of the "Safety of Life At Sea Act," the *Delta Queen* was going to have to cease operations because her wooden superstructure was suddenly determined to be a fire hazard. Congressional dispensation extended her career until 1970, when the "Farewell Forever" trip was planned for that October. The *Delta Queen* was saved and, of course, still operates today.

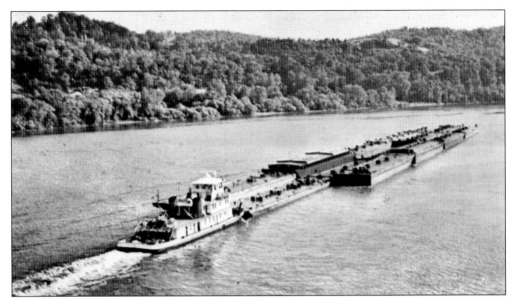

When a group of barges is put together, such as in this image, it is called a tow. The boat pushes the barges as opposed to pulling them as the name implies. Prior to the advent of railroads in the late 1900s, coal was shipped exclusively by river. Until the railroads arrived, questions about the navigability of the river and a lack of investment in river navigation hurt the coal industry for almost a century.

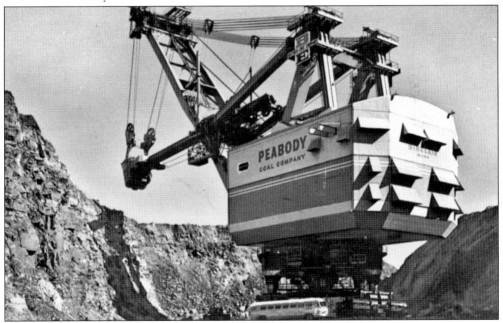

This 1970s postcard shows a piece of Peabody Coal Company machinery in Kentucky. The Ohio River has long served as means of transportation for coal extracted from Kentucky, and it is still a common site to see coal barges traveling up and down the river. However, the coal industry has had many ups and downs over the centuries, including the question of how to best transport the product to market. While the Ohio River has been steadfast, other options such as rail have played their part in transportation of coal.

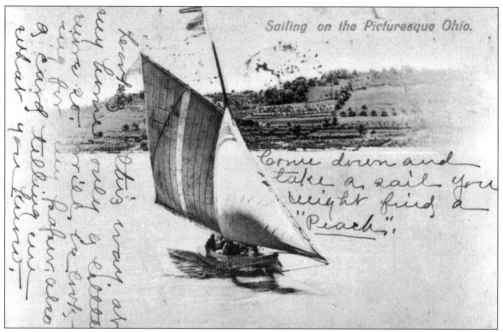

If it will float, it will eventually appear on the Ohio River. Ocean-going ships have been built in shipyards as far up as Pittsburgh and Marietta and taken to New Orleans. Newspaper accounts in the 1920s followed the progress of a pirate ship descending the river. So a sailboat shouldn't seem out of place in this early-1900s postal card.

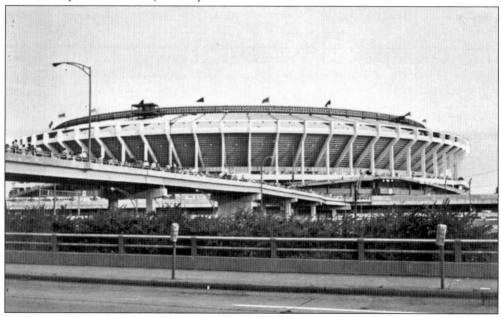

This 1970s postcard shows Riverfront Stadium, later called Cinergy Field. Riverfront Stadium, completed in 1970, was home to the Cincinnati Reds (1970–2002) and NFL Bengals (1970–1999). With an original capacity of 51,050, it was completed at a cost of $48 million. Although Riverfront Stadium had a short life span, it saw many historic events, including the Big Red Machine teams of the 1970s. It was imploded in 2002 and sat immediately west of Great American Ballpark.

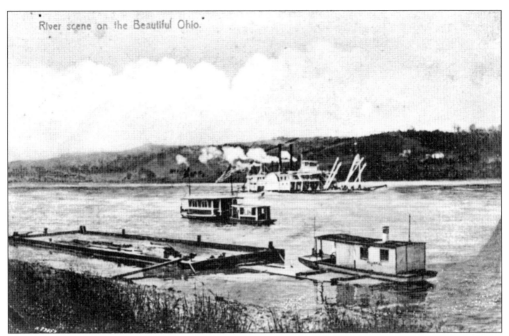

On the beautiful Ohio River, a steamboat makes her way downriver either on an excursion or hauling goods. Near the shore, another type of vessel works its way out, as yet another lags behind. The beauty of the river is evident in this photograph and made clearer by hills that are often found when traveling the majestic Ohio.

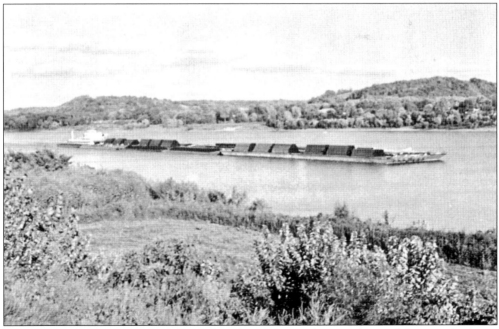

A barge in tow is being pushed down the Ohio River with cargo destined for some business. Unlike many images of barges on the Ohio, this one is hauling product other than coal. Much of the river is surrounded by flatlands at the shore that then grow into hills, as can be seen in most of the backgrounds of these images.

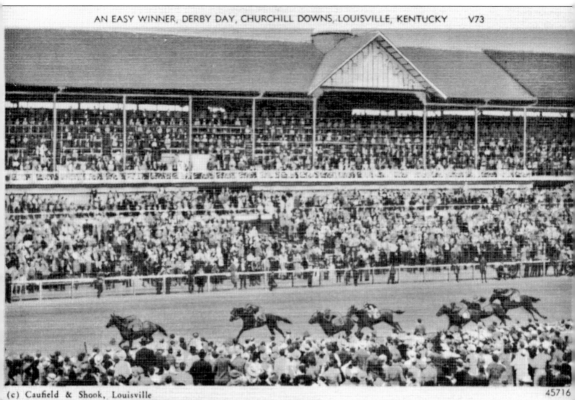

(c) Caufield & Shook, Louisville 45716

Along this stretch of the river, professional horse racing has long been a local tradition and pastime, not to mention an industry supporting many offshoot businesses. River Downs at Coney Island, Latonia Race Course in Northern Kentucky, Churchill Downs in Louisville, and Keeneland in Lexington are all prestigious proving grounds for the hopefuls who have their sights set on the ultimate prize, the Kentucky Derby, without which all hopes of the coveted Triple Crown are dashed. The Kentucky Derby has been run continuously since 1875. To date, there have been only 11 Triple Crown winners. Three of the 11 winning jockeys are from Northern Kentucky: Eddie Arcaro on Whirlaway in 1941 and again on Citation in 1948, and Steve Cauthen on Affirmed in 1978. Eddie Arcaro is the only jockey in the history of the sport to win two Triple Crowns.

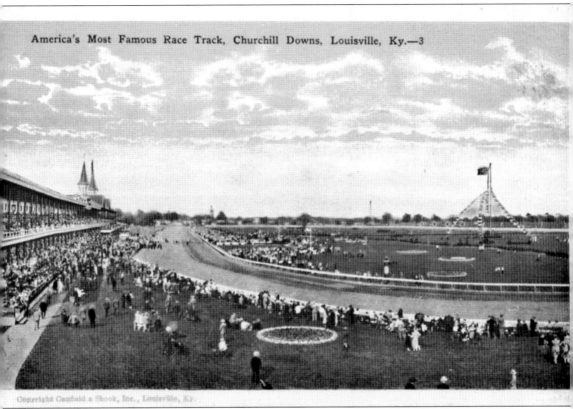

America's Most Famous Race Track, Churchill Downs, Louisville, Ky.—3

Copyright Canfield & Shook, Inc., Louisville, Ky.

When considering Kentucky's current economic and business ranking, there is this geographical phenomenon known as the "Golden Triangle," which is the area comprised of Northern Kentucky, Louisville, and Lexington at the heart of the commonwealth's business and economic activity. Back in the early decades of the 20th century, there was a golden triangle of horse racing that consisted of top-ranking racetracks in Louisville, Lexington, and Latonia. Madison Avenue in Covington originated at the Ohio River and ran south through Covington where it turned into Madison Pike, passing the backside of Latonia Race Track, and continued south. This was the pike to get to Lexington and Louisville. The reason it was called 3L Highway was in reference to the three major tracks at Latonia, Louisville, and Lexington. As this card clearly states, Churchill Downs in Louisville was America's most famous track, home of the longest continually run sports event in America.

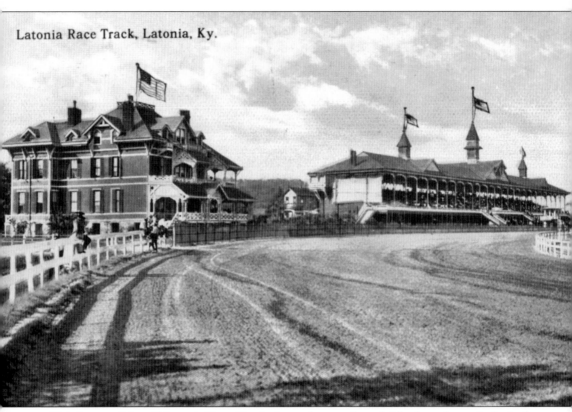

Latonia Race Track, Latonia, Ky.

This image of the old Latonia Race Track shows the grandstand. The large house is the Jockey Club, which bought the track in 1919. Built in 1853, Latonia Race Track served the Northern Kentucky community until 1939 and was located on Winston Avenue in Covington. The main entrance was at the beginning of Latonia Avenue. At the time of its closure, Latonia had fallen on hard times and was a lot less successful than the other tracks in operation in Kentucky. It had accumulated large amounts of debt during the 1930s. The final Latonia Derby had been held in 1937, and the last Latonia Cup was held in 1939. In 1927, Man O' War's record for the one-and-a-half-mile distance was broken at Latonia by Handy Mandy. On July 29, 1939, eight horses raced in the eighth race for the final contest at Latonia.

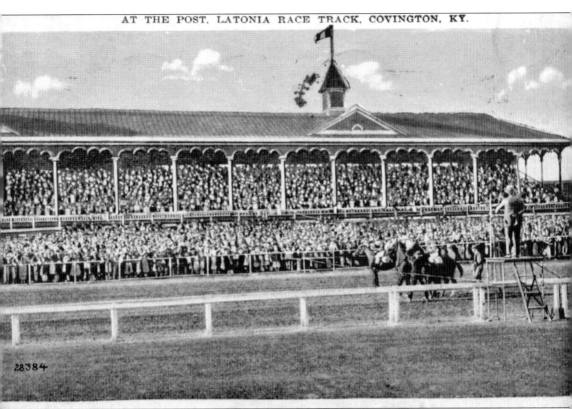

28384

This postcard, called "At the Post," is also from the old Latonia Race Course in Covington, Kentucky. In this image, the stands are packed with spectators, which was often the case at the once successful course. Before it ran into financial trouble, Latonia held races with very good purses, and according to the historic marker now at the site, some of the greats of horse racing appeared at the track, including Epinard, Clyde Van Dusen, Zev, Black Gold, and Equipoise. Latonia held two meets per year, spring/summer and fall. The Latonia Derby was the biggest race to run at the track and Broadway Jones was one of the winners. In this postcard image, it is interesting to note that at the start of the race, horses are held back by a rope, which was used before the advent of starting gates.

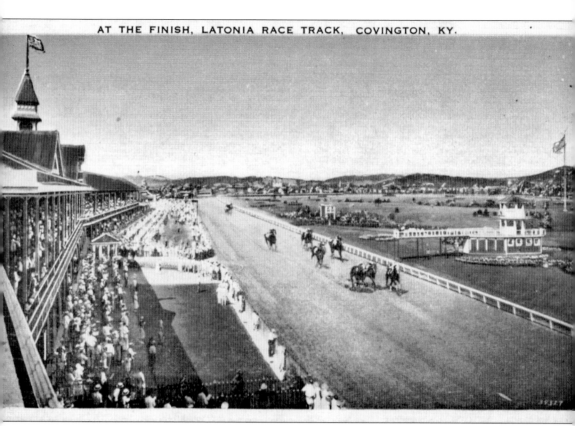

"At the Finish" is a vintage image of Latonia Race Course showing eight horses coming down the stretch. After Latonia Race Course was closed in 1939, an oil refinery was built on the site. Today it houses commercial businesses. A new Latonia Race Course opened in 1959, 20 years after the closure of the original track. However, it was built in Florence, Kentucky, a city about 10 miles to the south. The new track eventually changed its name to Turfway Park and has been home since 1972 to the Spiral Stakes. Long a Kentucky tradition, horse racing has seen its share of ups and downs. Clearly Churchill Downs, home of the Kentucky Derby, and Keeneland Race Course in Lexington are the most famous in the state, but other courses, such as old Latonia and the newer Turfway, are unique and have long histories of contributing to the great tradition of Kentucky horse racing.

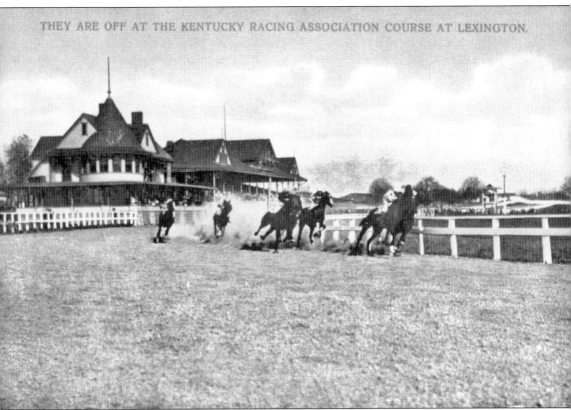

"They are off at the Kentucky Racing Association Course," reads this card. Lexington, Kentucky, is located in the heart of bluegrass country. The first racecourse in Lexington goes back to 1789, almost 100 years before the famous Churchill Downs. However, Louisville was already established and had its own track before Lexington. The racing association track in Lexington was the city's first course and opened in the 1830s. It operated for more than 100 years and was located in what is now downtown Lexington at approximately Fifth and Race Streets. Tradition says that this was the course that coined the term "purse" to describe the cash won by the winning horse. A woman would hang her purse at the finish line for the winner to receive. On October 15, 1936, Keeneland Race Track opened and held its first meet for nine days. It drew 25,337 people.

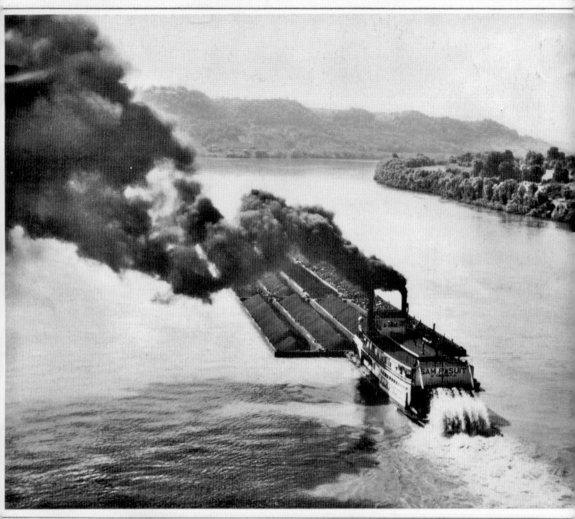

Photo: Courtesy Mr. Karl W. Smith.

It is hard to imagine black smoke from a boat on the Ohio River being beautiful, but perhaps it is at times. This paddle-wheeler pushes a tow of barges up the majestic Ohio River between the shores of two states. Sitting on the shore, one cannot help but feel the rhythm of the paddle wheel, the flow of the water, and the power of the engine. It can be both relaxing and beautiful.

Five

STEAMBOATS

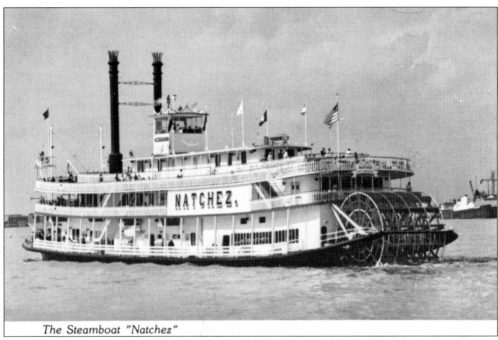

The Steamboat "Natchez"

The *Natchez*, seen here, is one of only six authentic steam-powered stern-wheelers remaining on the inland river system. She was built in 1975 for the New Orleans Steamboat Company, designed by marine architect Capt. Alan Bates (longtime mate on the *Belle of Louisville*). Her classic steamboat design and architecture adds to her authenticity. The boat's two steam engines were made in 1925 and were taken from another boat. Her inaugural captain was and remains the river veteran and master Capt. Clarke C. Hawley, known affectionately in the steamboat circles as Capt. "Doc" Hawley. When Doc was 15 years old, the steamer *Avalon* (now the *Belle of Louisville*) pulled into his hometown of Charleston, West Virginia, minus her calliope player. Doc asked the captain if he could try it out and was offered a job. Now over 50 years later, he is still a full-time river man.

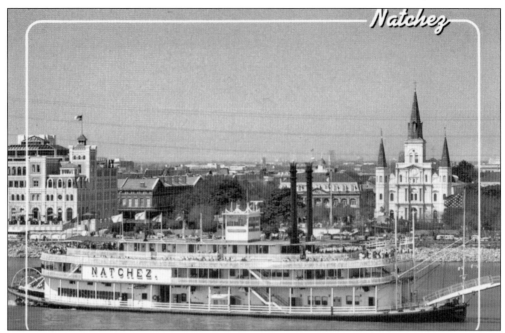

The *Natchez* seen here is the ninth boat by that name. Her home port is New Orleans, where she has run excursion cruises every day for the past 30 years. After the devastation of Hurricane Katrina essentially left the boat without a port, she initiated a "tramping" trip up the Mississippi and Ohio Rivers in 2005, during which she would spend a few days in each port and offer sightseeing and luncheon or dinner cruises to raise money for hurricane victims.

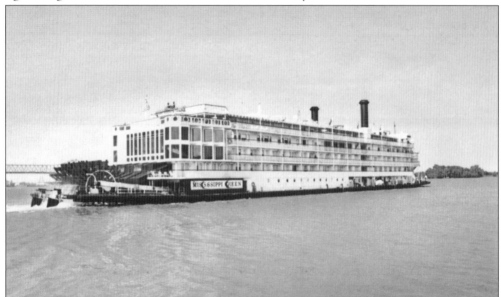

The *Mississippi Queen* was built for the Delta Queen Steamboat Company at Jeffboat Incorporated, Jeffersonville, Indiana, from 1973 to 1975. She is an authentic, steam-driven paddle-wheeler with the capacity for carrying 400 overnight passengers. In response to the pending removal of the *Delta Queen* from the overnight passenger service due to restrictions placed by the Safety of Life at Sea Act of 1966, the company wanted a boat that met all the requirements.

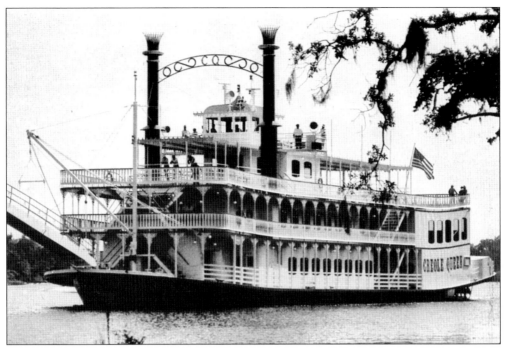

The *Creole Queen* is an authentic stern-wheel paddle-wheeler but not steam powered. She has a diesel engine, which powers the wheel. Built in 1983 for the New Orleans excursion trade, the boat features three elegantly Victorian–decorated dining rooms. She has been a regular participant in every Tall Stacks™ festival, held every 3–4 years at the Cincinnati riverfront.

The nostalgia associated with steamboats and the history of the river accounts for hundreds of smaller-scale local excursion boats like this one up and down the river systems. They offer patrons fun and relaxation at a reasonable cost. A diesel or gasoline engine and outdrive powers boats like this one. The paddle wheel is not functional.

The *Valley Gem* was built in 1897 for the packet trade on the Muskingum River. She ran a round-trip each day from McConnelsville to Zanesville from 1898 until 1917, when she was sold to run the Pittsburgh–Fairmont trade on the Monongahela. Like many others, the ice of 1918 destroyed her. The winter of 1917–1918 was one not quickly forgotten in the Ohio River Valley because of two separate events. In the Cincinnati area, the influenza epidemic had reached staggering proportions, killing thousands of people. Then when the ice from the frozen river broke loose, it literally splintered everything in its clutches. The loss of life and loss of property was tragic.

These two steam packets out in the channel at Rising Sun, Indiana, seem to be in a gusty wind coming out of the southeast, laying the steam and smoke on a horizontal plane. The side-wheeler in the foreground is the *Bonanza*, built in Cincinnati in 1885 and operated by the White Collar Line, running between Portsmouth and Cincinnati. In 1904, the boat was acquired by the Greene Line in Cincinnati and used as a backup boat. She was dismantled at the Greene Line Wharf in 1909. In the background is Rabbit Hash, Kentucky. A huge sand bar was located at Rabbit Hash, which prevented the landing of these large packets there but was a great boon for the ferryboat business. The stern-wheeler is not identified.

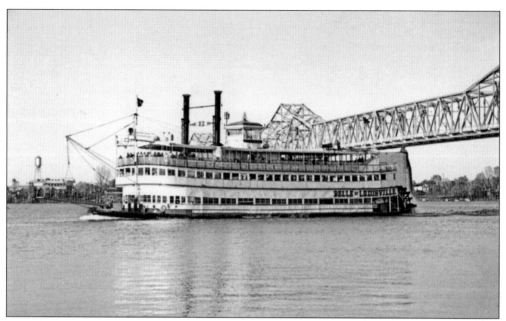

James Rees and Sons Company built the *Belle of Louisville* in 1914 in Pittsburgh for the West Memphis Packet Company. The boat left Pittsburgh in January 1915 for Memphis then named the *Idlewild*. She performed well in various capacities: as a packet boat, an excursion boat, and a ferry. In 1928, she was purchased by an Illinois packet boat company and remained in that trade until April 1947, when the boat was sold to another Illinois interest. In early 1948, the name was changed to *Avalon*. The year 1950 saw her come to Cincinnati under the new ownership of the Steamer Avalon, Incorporated. The boat remained based in Cincinnati as she tramped on many other western rivers as an excursion boat until 1962, when she was purchased by the Jefferson County Fiscal Court and renamed the *Belle of Louisville*. The name and home port have remained the same for the past 44 years.

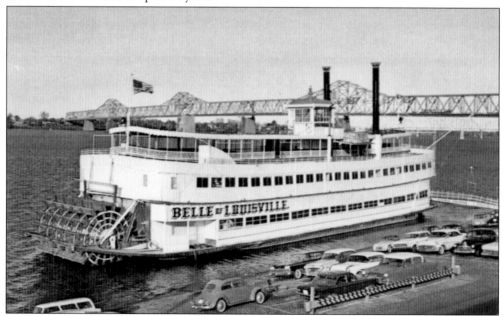

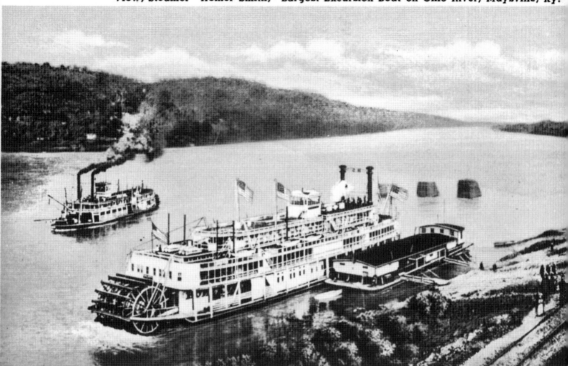

58322-N

The *Homer Smith* was built in 1914 at Jeffersonville, Indiana, at the Howard Ship Yard. The owners recognized that the packet boat business was on the decline due to rail and trucking domination in the freight hauling business. So they specifically ordered up a boat that would serve the tourist and excursion trade, which was on the upswing. The populace was seeking out the river for recreation and entertainment activities, and the Security Steamboat Company of Point Pleasant, West Virginia, was ready to fill that need. The boat was able to accommodate a payload of freight, 125 overnight tourists, and a couple of thousand excursionists. She made her mark in the excursion business and built a reputation on it. The *Homer Smith's* tramping trips seemed to be financially successful, traveling up and down the river and its tributaries offering people the kind of excursions they wanted. She was the first boat to ever outline her decks with electric lights. At first the boat used colored lights, but they were soon outlawed due to the potential confusion to other boats depending on the red and green navigation lights. From then on, white lights were exclusively used.

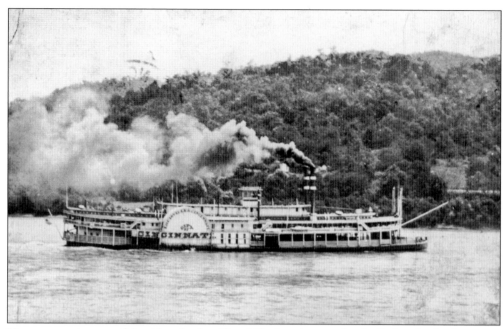

Here are two images of the side-wheeler *City of Cincinnati*, a wooden-hulled packet built in 1899 at the Howard Ship Yard in Jeffersonville, Indiana, for the Louisville and Cincinnati Packet Company. She was built expressly for the Louisville–Cincinnati trade, working in tandem with her cohort, the *City of Louisville* (1894). The top view shows the boat underway with a full head of steam, belching out the thick, black smoke, which is the by-product of the energy needed to turn the water in the boilers into the pressurized steam to power the machinery that turns the wheel. The bottom image shows her landed at Madison, Indiana, loading and unloading passengers and maybe some freight, keeping her steam up for her departure and continuation of her trip.

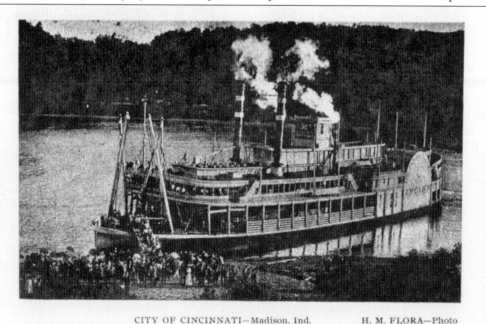

CITY OF CINCINNATI—Madison, Ind. H. M. FLORA—Photo

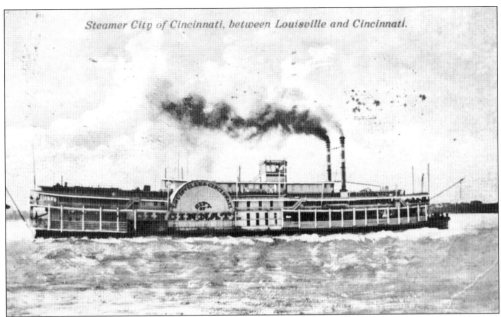

Steamer City of Cincinnati, between Louisville and Cincinnati.

When considering the Cincinnati–Louisville trade during the packet boat era, two boats come to the forefront, the *City of Louisville* and the *City of Cincinnati* (pictured). Both were wooden hulled side-wheelers built in Jeffersonville, Indiana, at the Howard Ship Yards. The *City of Louisville* came first, built in 1894 expressly for the packet trade for the Louisville-Cincinnati Packet Company. She was outfitted for freight, overnight passenger service with 72 staterooms, and an excursion capacity permit for 1,500 passengers. The boat held both speed records for the upriver and downriver trips between the two cities. The *City of Cincinnati* was built in 1899 also by Howard Ship Yard and outfitted similarly for the packet and passenger trade. Packets dominated the river during the mid-1800s through the 1890s, then reappeared in a more elaborate style but fewer numbers in the first two decades of the 20th century.

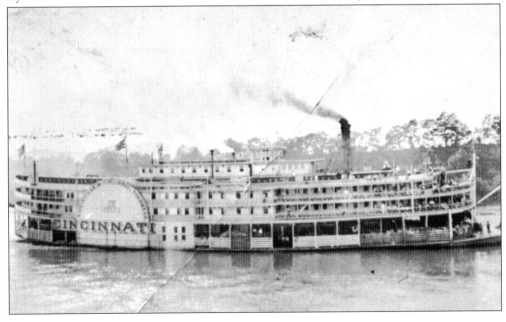

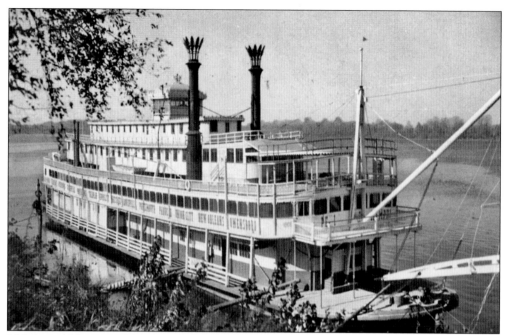

This beautiful image shows an unidentified steamboat at a shore of the Ohio River. It was via such steamboats that very small river towns would get visitors. They would stop to deliver supplies or visit. It was such visits that made for great river stories, books, and movies.

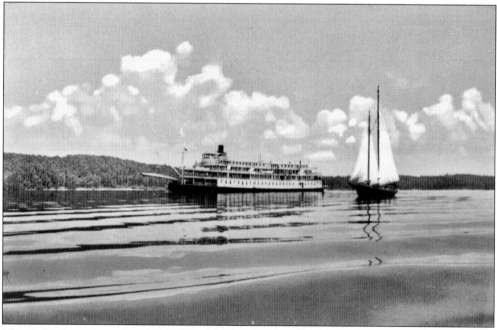

The *Delta Queen* is used to being followed and flanked by pleasure craft, but this scene is not seen too frequently. The sailboat of course welcomes the wind, which it directs to its advantage for advancing the boat's progress. But to a shallow-draft steamboat, with much more surface area above the water line than below, sometimes the wind can be very disrupting to the handling of the craft.

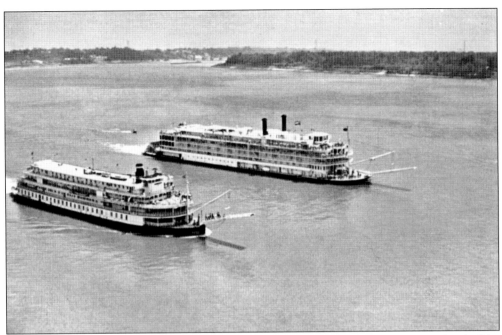

The *Delta Queen* is always looking for a good race. In the top image, the boat is just ahead of the much younger *Mississippi Queen*. Notice the people perched out on the stage of the *Delta Queen*. That would never happen nowadays. In the bottom image, the *Delta Queen* is considerably ahead of the *Belle of Louisville* in their annual Kentucky Derby Week race in Louisville. No, the winner is never determined ahead of time.

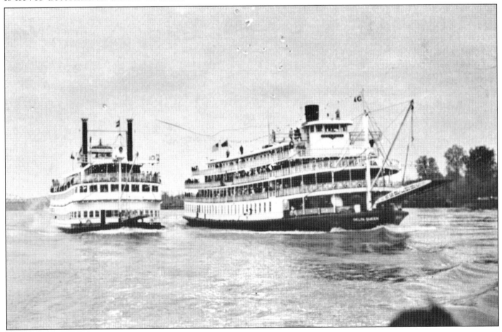

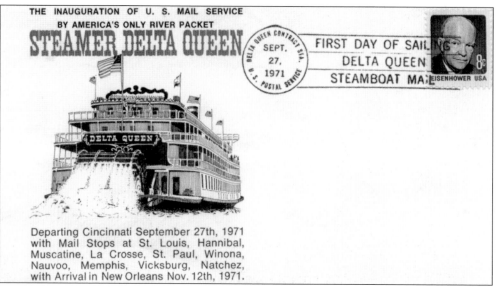

THE INAUGURATION OF U. S. MAIL SERVICE
BY AMERICA'S ONLY RIVER PACKET
STEAMER DELTA QUEEN

SEPT. 27, 1971

FIRST DAY OF SAILING
DELTA QUEEN
STEAMBOAT MAIL

EISENHOWER USA 8¢

Departing Cincinnati September 27th, 1971 with Mail Stops at St. Louis, Hannibal, Muscatine, La Crosse, St. Paul, Winona, Nauvoo, Memphis, Vicksburg, Natchez, with Arrival in New Orleans Nov. 12th, 1971.

Pictured here is a commemorative cachet and postmark of the inauguration of U.S. mail service on the *Delta Queen* on September 27, 1971, actually hand-cancelled aboard the boat. When a vessel is an official carrier of the mail, she gets priority preference over any other boats waiting to lock through.

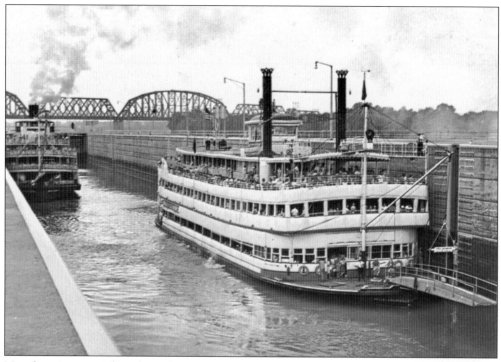

Now here is a rare sight—the *Delta Queen* and the *Belle of Louisville* locking through the McAlpine locks at Louisville at the same time. It appears that both boats are full of passengers. When the gates open, it would create a great opportunity for a race to break out.

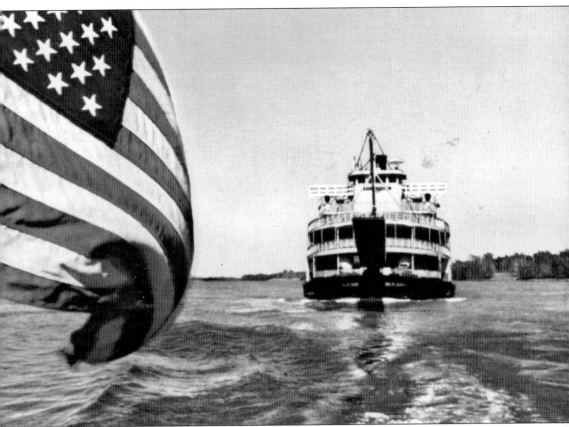

The *Delta Queen* has become an American icon, a symbol of the American way. The year 2006 is her 80th birthday. She is a World War II veteran, listed on the National Register of Historic Places, and a National Heritage Landmark. The boat is entitled to a little social security now. It is up to the citizens of the United States to make sure the president and Congress commit to her the protection and preservation worthy of the national treasure that she is. This image says it all. Operating under the national flag, the boat represents and symbolizes the determination, devotion, and dedication of every American to the principles and foundations of our country as set forth by our founding fathers.

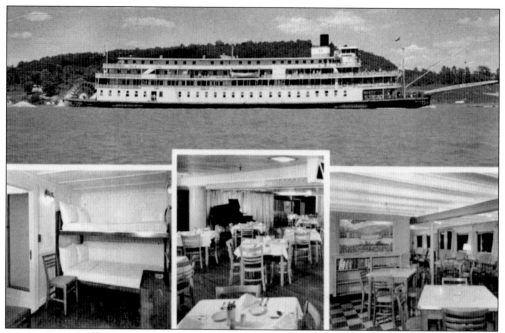

When the *Delta Queen* was completed in 1926, the final cost was $875,000, an unprecedented price tag for the times. She faithfully carried out her charge on the Sacramento River until terminated in 1940. Drafted by the navy in 1941, she became a Yard Ferry Boat.

At the end of the war, the *Delta Queen* was turned over to the U.S. Maritime Commission, who sold the boat at public auction to Capt. Tom Greene, president of Greene Lines of Cincinnati. After an action-packed journey to the Ohio River and an extreme makeover at Dravo boat yards, the *Delta Queen* was ready for work. Postcards and match books like these advertised this beginning of another Ohio River epoch.

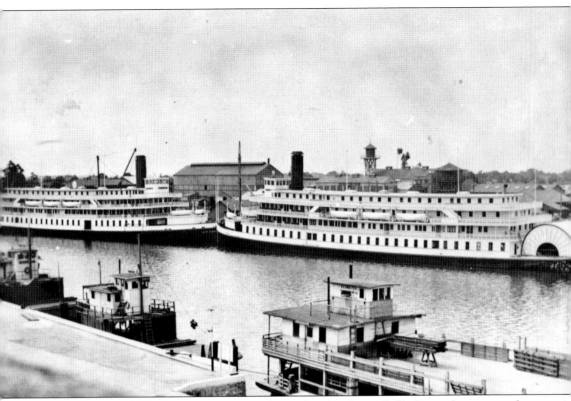

This very rare image of the *Delta King* (right) and *Delta Queen* (left) shows the two newly completed boats docked at the Stockton (California) Channel, ready for their inaugural passing of the torch from their predecessors, the *Fort Sutter* and the *Capital City*, in the overnight passenger service between Sacramento and San Francisco. Nicknamed "the million dollar boats" by the California press, that moniker wasn't far off the mark. After the added costs of items like furniture, beds, interior decorations, food preparation equipment, china, flatware, linens, and the like were tallied up with the construction price tag of $850,000 for each boat, the bottom line justified the nickname. In comparison, steamboats being built at shipyards along the Ohio were still coming in at under $75,000 each. These two boats were the first California boats to claim steel hulls, which soon would be the industry standard. In May 1927, the *King* and *Queen* celebrated their maiden voyages on the Sacramento River, not even suspecting that they were to be the very last to ever carry freight or passengers on California rivers.

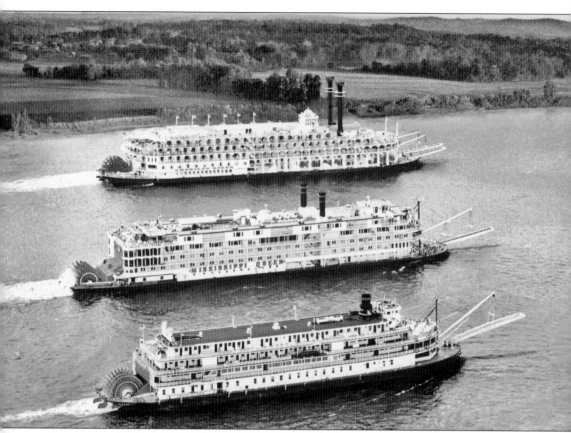

Here is seen the *Delta Queen* today (bottom of card) with the *Mississippi Queen* (1976) and the *American Queen* (1995). All three are authentically steam-powered stern-wheelers. The Delta Queen Steamboat Company dates back to 1890 when patriarch Gordon C. Greene founded Greene Line Steamers. The company remained in the family under the leadership of sons Capt. Chris Greene and Capt. Tom Greene, who purchased the *Delta Queen* in 1948. Tom's widow, Letha Greene, took over operations in 1950 and, overcoming some hard times, managed to continue into the late 1960s. Thanks to Captain Tom's insight and risk taking, the *Delta Queen* is the epitome of all things steamboating. New ownership in 1974 changed the name to the Delta Queen Steamboat Company. While the *Mississippi Queen* and the *American Queen* completely meet all the requirements and codes for overnight passenger service as mandated by the 1966 Safety of Life at Sea Act; the *Delta Queen* is still running on borrowed time. Her nine lives have been serving her well over the years, as she continues to dodge bullet after bullet. Long live the *Queen*.

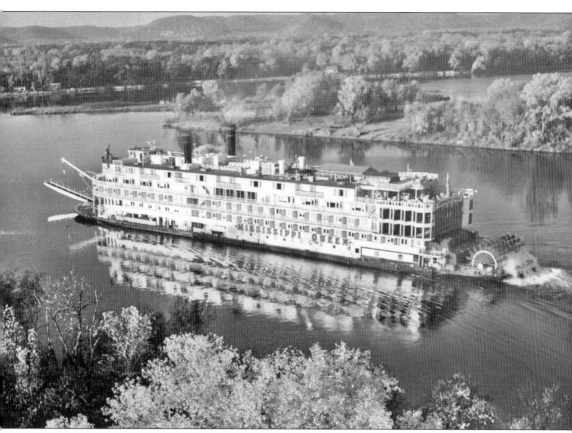

The *Mississippi Queen* was built at the Jeffboat Boat Yards in Jeffersonville, Indiana, between 1974 and 1976, specifically to replace the *Delta Queen*, whose tenure on the river was quickly being thwarted by Congressional grandstanding and reflexive reaction. After nearly half a century of service on America's inland rivers, the boat's wooden superstructure was suddenly seen as suspect. The *Mississippi Queen*'s all-steel compartmentalized hull and steel superstructure consciously addressed and met the new mandates. At first there were many bugs to deal with and eliminate. And the boat's shiny chrome and glass décor lacked that vital steamboat ambience that was so palpable on the *Delta Queen*. It's hard to fashion a fine mellow-toned violin out of stainless steel. However, a 1980s extreme makeover brought the nostalgia back into the equation, and it has remained ever since. Benefiting from this lesson learned, younger *American Queen* relied on the classic forms of steamboat architecture from day one.

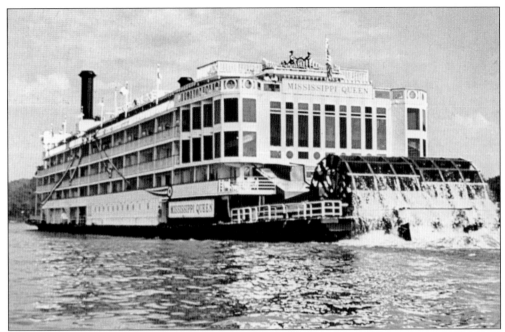

Mark Twain once commented, "someone, someday will build the biggest steamboat the world has ever known . . . and that one shall be the Queen of the Mississippi." In 1973, Greene Line Steamers did just that when they commissioned the building of the *Mississippi Queen* by Jeffboat in Jeffersonville, Indiana. That same year, they changed their company name to the Delta Queen Steamboat Company.

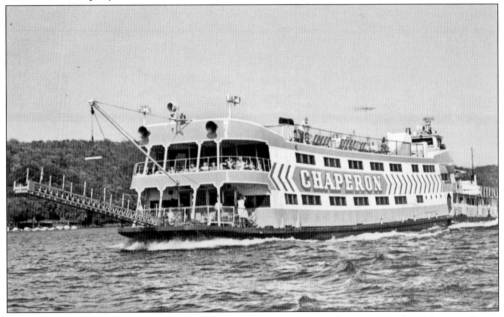

The *Chaperon* was one of two excursion boats operated out of Cincinnati by Johnston Party Boats in the 1950s, 1960s, and 1970s. This canary-yellow party boat was actually a three-decked structure built on a barge and powered by a diesel-powered towboat. She was rated to carry 600 passengers.

114

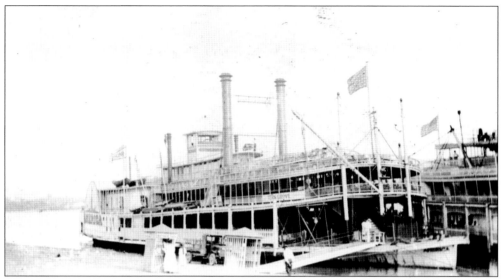

Public landings in the cities and towns along the river were all similar, much like train stations, bus stations, and airports today are similar. The activities associated with on-loading and off-loading of freight, embarking and disembarking of passengers, and the exchange of incoming and outgoing mail were all predictable and familiar.

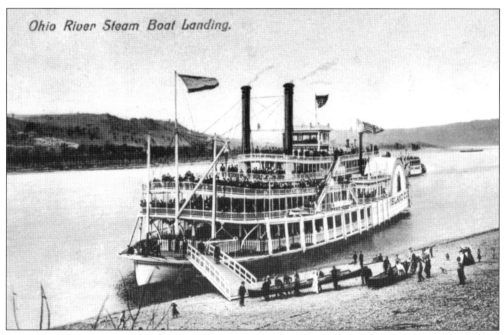

During the off-season, the *Island Queen* periodically would make tramping trips to river towns up and down the river, offering excursion trips to the folks who usually did not have the opportunity to enjoy the riverboat experience from Cincinnati to Coney Island. Here it appears that the passengers at this landing are also loading their canoes and skiffs so they can put off somewhere upriver and return home.

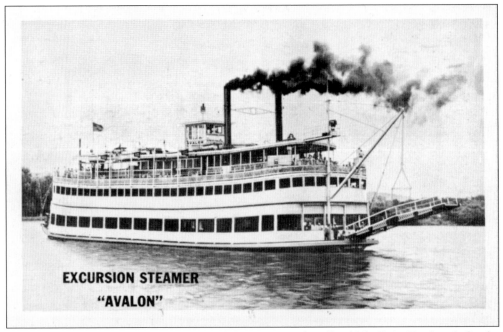

EXCURSION STEAMER
"AVALON"

The excursion steamer *Avalon* started out life in 1914 as the *Idlewild*, built in Pittsburgh for the packet and excursion trade. Granting the deathbed wish of her longtime master who began his career on a boat named *Avalon*, her name was changed to that in 1948. For the next 13 years, she was the most widely traveled steamer in the western waters.

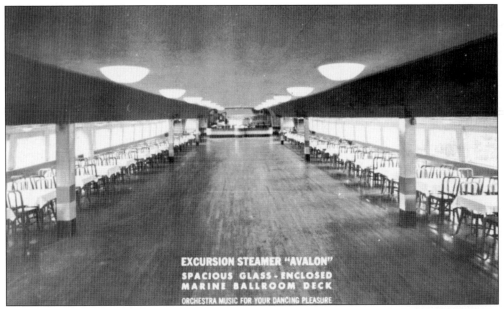

EXCURSION STEAMER "AVALON"
SPACIOUS GLASS - ENCLOSED
MARINE BALLROOM DECK
ORCHESTRA MUSIC FOR YOUR DANCING PLEASURE

In 1950, the *Avalon* was purchased by a Cincinnati interest, and she continued her tramping tradition under the management of the Steamer Avalon, Incorporated, who made some major improvements to the boat, like installing a 33-by-96-foot, hard-maple dancing floor and stage as well as glass enclosure of the main and boiler decks in order to lengthen her seasonal operation.

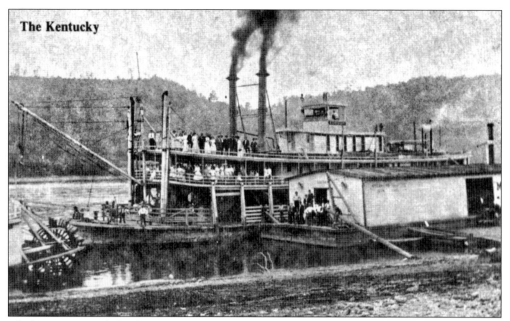

The Kentucky

The literature search for the *Kentucky* only confirms that a derelict boat has the same chance as any other boat to succeed. Built in 1907 in Madison, Indiana, the boat ran the Cincinnati–Madison trade as well as the Cincinnati–Louisville trade and, according to Way's Packet Directory 1848–1994, "drove away more business and made more money than any boat of her size and time."

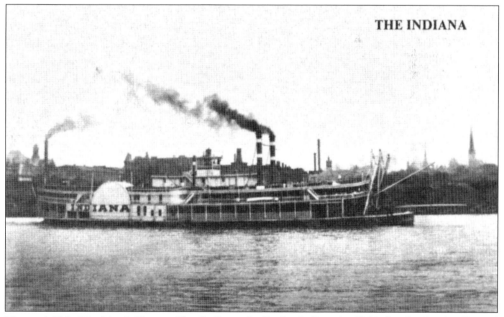

THE INDIANA

Howard Ship Yard in Jeffersonville, Indiana, built the *Indiana* in 1900 for the Louisville and Cincinnati Packet Company. She only drew 30 inches and, in times of low water, substituted for the *City of Louisville*. The boat never ventured below Louisville. In 1916, she caught fire at the Cincinnati landing and partially burned. After being rebuilt at the Howard Yard in Jeffersonville, she carried on as the *America*.

GENERAL INFORMATION

CHILDREN between the ages of five and twelve years when accompanied by two adults and occupying same stateroom will be charged half-fare. Child accompanied by one adult will be charged full fare and party given exclusive use of stateroom. Under five years of age, one quarter fare. Twelve years and over, full fare.

STATEROOMS contain single upper and lower berths. First person making reservation will occupy lower berth. Room for one person requires two full fares.

RESERVATIONS must be accompanied by a deposit of $5.00 per ticket; balance payable at least one week prior to departure.

CHURCH SERVICES may be attended early Sunday morning provided no unforseen navigating difficulties prevent.

DRINKING WATER in all fountains and used in the cuisine is pure water and is tested regularly by public health authorities.

CLOTHING. Informal dress is the rule. A light overcoat for cool evenings is suggested.

ELECTRIC RAZORS, electric irons and other electrical devices work perfectly aboard the steamer.

STEAMER will start receiving passengers two hours prior to scheduled sailing time.

SCHEDULE—The schedule is contingent upon fogs, strong currents and other unforeseen delays and is subject to slight variation with changing navigating conditions.

BAGGAGE consisting of suit cases and hand grips may be placed in passenger's stateroom.

SIGHTSEEING TRIPS which are optional and taxi service at points along the way will be at passenger's expense.

SUGGESTIONS. Be sure to take your camera and include one or two river books.

For additional information or reservation, address

GREENE LINE STEAMERS

Office — Foot of Main Street

MAin 1445　　　　CINCINNATI, OHIO

Beautiful

OHIO
and Great Kanawha
RIVER
CRUISES

GREENE LINE STEAMERS

Ever since its founding in 1890 by Gordon C. Greene, the Greene Line Steamers has owned a total of 26 different steamboats operating out of Cincinnati. Always a family affair, the company went from patriarch founder Gordon, to son Chris, to son Tom, and then to Tom's widow, Letha, who ultimately secured for the company the desired long-term outcome envisioned by father and sons. Despite the trends and the time, steamboating just had to survive. Today, thanks to the tireless dedication and determination of the Greene family, steamboating did indeed survive. This 1940 brochure touts all the positive benefits and amenities offered by the steamer *Gordon C. Greene* while enjoying the beauty of the upper Ohio and the great Kanawha. Coming soon to Greene Line Steamers would be the rescued *Delta Queen*, which would renew the overnight passenger business for the next generation.

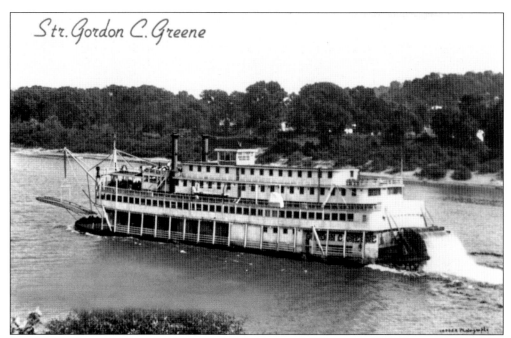

Str. Gordon C. Greene

The *Gordon C. Greene* was built by Howard Ship Yards in Jeffersonville, Indiana, in 1923 as the *Cape Girardeau*. She became a Greene Line boat in 1935 from the Eagle Packet Company in St. Louis and was unofficially christened the "family boat," providing a home for Captain Tom and family "down at the foot of Main Street."

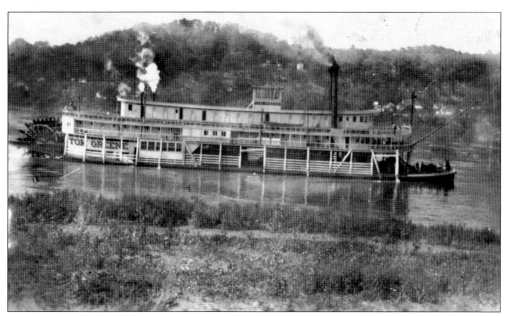

The *Tom Greene* was built in 1923 in Point Pleasant, West Virginia, for Capt. Gordon C. Greene for the Cincinnati–Huntington trade and named for his son Tom. When he died in 1927, Tom took over as captain and ran her in the Cincinnati–Pomeroy–Charleston trade along with the *Chris Greene*. In 1931, the boat entered into the Cincinnati–Louisville trade until 1947. She won two significant races in 1929–1930 in Cincinnati, Ohio, against the *Betsy Ann*.

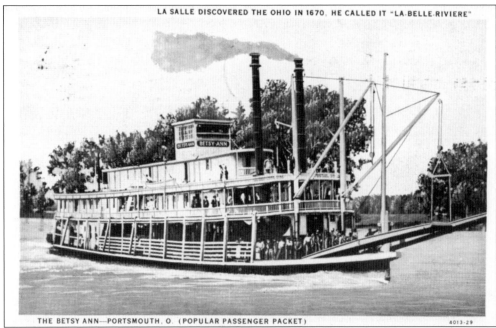

THE BETSY ANN—PORTSMOUTH, O. (POPULAR PASSENGER PACKET) 4013-29

The *Betsy Ann* was a stern-wheeled, iron-hulled packet built in Dubuque, Iowa, in 1899. During her long career, she ran in a lot of trades until she was dismantled in 1940 at St. Louis. She is best remembered on the Ohio for having run three different staged and promoted steamboat races against the *Chris Greene* (in 1928) and the *Tom Greene* (1929 and again 1930), leading to the rebirth of a very popular steamboating tradition.

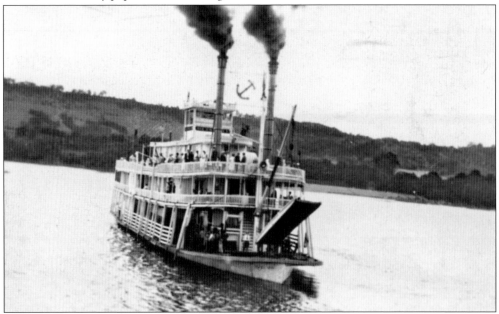

This unused real-photo postcard had written on the back: "Str. Betsy Ann backing for the 1930 race with the Tom Greene." Steamboat racing provided two very important components to the comprehensive steamboat tradition and heritage—bragging rights and a rack of antlers to proudly display in a conspicuously strategic location. The tradition lives on even today.

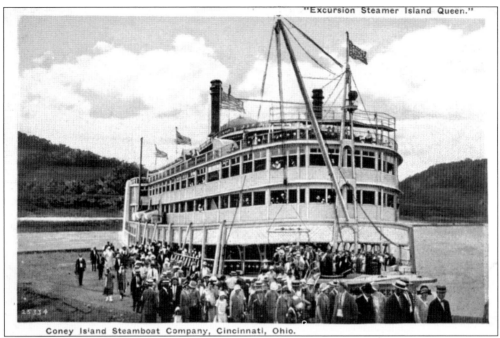

Coney Island Steamboat Company, Cincinnati, Ohio.

Excursions to Coney Island were indeed social affairs of high order. The way these patrons are sporting their Sunday best catches the eye more so than the majestic Cincinnati Coney Island Steamboat Company icon in this image. Suit coats, ties, and straw hats for the men and long summer dresses and flapper hats for the ladies was indeed the proper attire when visiting a *Queen*.

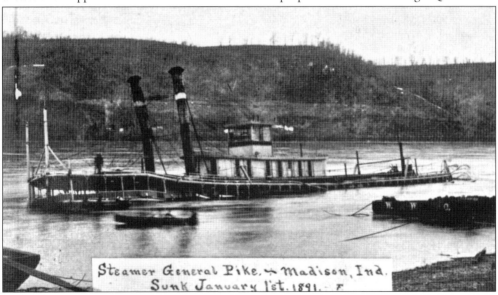

Steamer General Pike. → Madison, Ind.
Sunk January 1'st. 1891. F

Steamboats in general were not known to have very long life expectancies. Almost all steamboat histories include a chapter entitled "Steamboat Tragedies." Early on, boiler explosions accounted for most of these tragedies. Improvements in design and construction coupled by industry regulation and inspections improved this situation. However, there were plenty of other pathways to the boneyard. Here the steamer *General Pike* sinks in Madison, Indiana, the very town in which she was built in 1877, after backing into a fleet of coal barges.

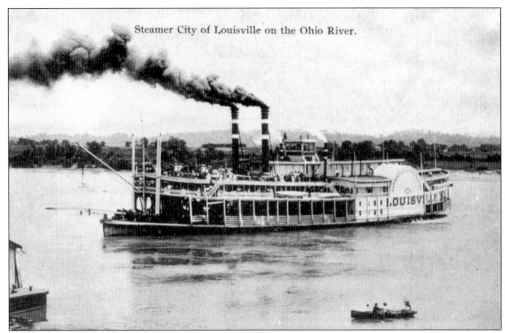

Steamer City of Louisville on the Ohio River.

The *City of Louisville* lasted 22 years before meeting her demise in the January 1918 ice jam at Cincinnati. She left quite an impressive legacy between Cincinnati and Louisville during her career of transporting freight, the mail, and overnight passengers back and forth in that trade. True to her work ethic and disposition, she fought valiantly that tragic day, having her steam up and both wheels working when she finally went down.

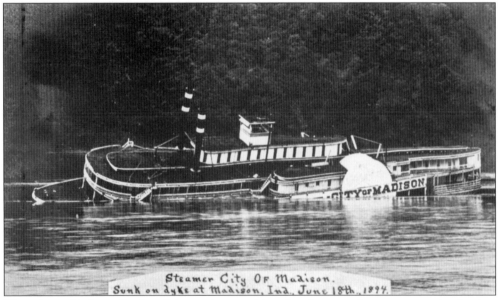

Steamer City of Madison.
Sunk on dyke at Madison, Ind., June 18th, 1894.

There is an old river pilots' tradition and superstition that the most dangerous stretch of a river is the one right in front of his own hometown. Here is photographic proof. The *City of Madison*, built in Madison in 1882, piloted by Madison-resident Wheeler Collier, sank at Madison on June 18, 1894, after she hit the quarter-mile-long stone dike extending out to about mid-river from the Kentucky shore.

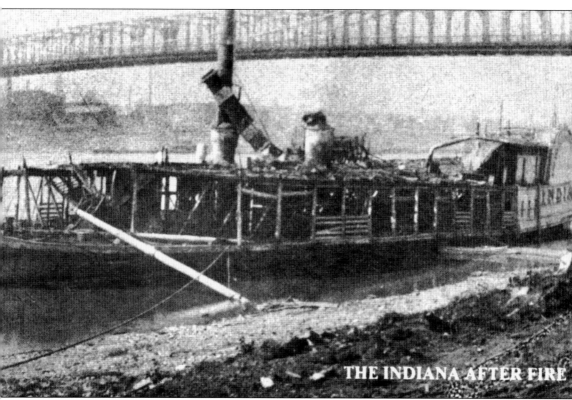

THE INDIANA AFTER FIRE

Fire is the giver of life and oftentimes the taker of life of a steamboat. Steamboat tragedies more often than not involve fire. Wayward sparks from a stack headed on an unexpected misadventure, boiler explosions, kitchen fires, even the ignition of a cargo of gunpowder have all accounted for a boat's untimely end. Fire is just as essential a crew member as is the pilot or the cook. Without fire, there is no steam. This image shows what is left of the *Indiana* (built 1900) lying at the foot of Main Street in Cincinnati after burning on May 1, 1916. However, she was fortunate enough to return to the Howard Ship Yard in Jeffersonville, Indiana, where she was originally built and was reincarnated, coming out with a new name. As the steamer *America*, she left Howard's in 1917 as a packet boat, complete with staterooms, and returned to the Cincinnati–Louisville trade. After several years of this, the boat was refitted to become a full-time excursion boat operating out of Louisville. Laid up above Jeffersonville, Indiana, for the winter of 1930, she burned once again. Arson was suspected.

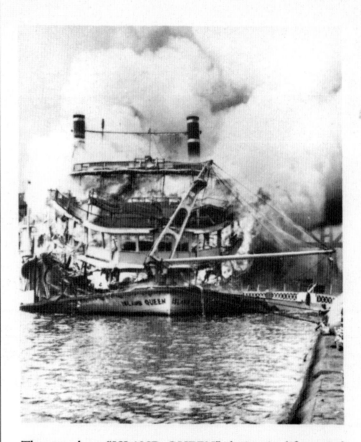

The steamboat "ISLAND QUEEN" during its life carried thousands of excursionists from Cincinnati, ten miles up the Ohio to the Coney Island Amusement Park. While at her berth in Pittsburgh on September 9, 1947, she exploded. Many people came to the Monongahela Wharf to see the spectacular though tragic fire. This floating pleasure boat reminiscent of sumptuous river days of the past, was a total loss. 19 persons were killed, many injured.

A spark from the chief engineer's welder made September 9, 1947, a day of infamy in steamboat history. The last *Island Queen* was fireproof; at least that's how the boat was marketed. After the regular season ended on Labor Day 1947, she made ready for her usual fall season tramping trip, usually between Marietta, Ohio, and Memphis, Tennessee. But this year, the boat had the ICC's permission to go as far as Pittsburgh for the first time. She was tied at the wharf at the foot of Wood Street after a nighttime moonlight excursion the night before. This day was slated to be an off day for the crew, with no excursions scheduled. As the chief engineer was welding a loosened steel stanchion to the bow's steel deck, the welding torch cut through the floor and ignited one of the volatile fuel tanks below. That explosion set off the remaining fuel tanks, resulting in an even greater subsequent explosion and fire that consumed the "Big Liz," as she was affectionately known up and down the river, in a matter of just 10 minutes.

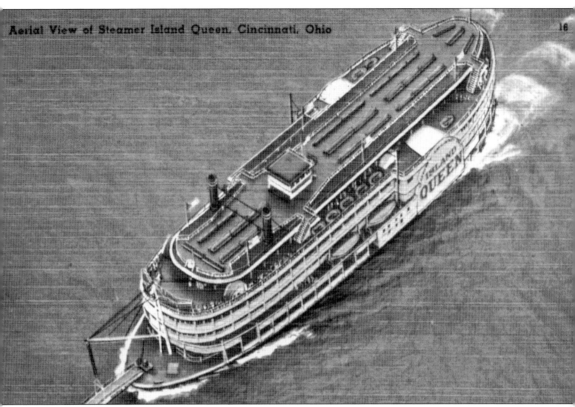

When the *Island Queen* left the Pittsburgh wharf on her final excursion, the boat was being towed by the diesel-powered stern-wheel towboat *Clipper*. It was Christmas Eve day 1947 when the boat was finally buoyant enough again for her trip to the boneyard at New Eagle, Pennsylvania. The hull was unusable and had to be patched before she could move. The famous and popular unsinkable and fireproof *Island Queen*, as seen in this image looking straight down onto her majestic circus-peanut form, is how most people want to remember her, not as the $10-per-ton scrap heap it became. The boat could easily be regarded the *Queen Elizabeth II* of the Ohio River. After all, she was the reigning queen of the Ohio; she was referred to by those in the river profession by her pet name "Big Liz," and the boat was the second *Island Queen* built specifically for the Cincinnati–Coney Island trade.

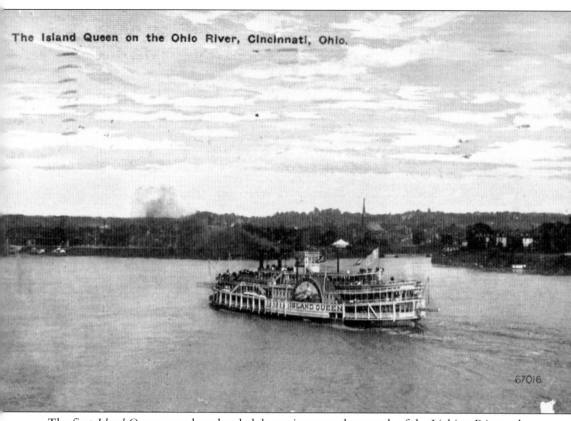

The first *Island Queen*, seen here headed downriver past the mouth of the Licking River where she was kept during the winter months, was built in 1896 in Cincinnati at the Cincinnati Marine Railway Company. She was designed and built specifically for the Coney Island Company as a 3,000-passenger capacity excursion boat to transport patrons to and from Coney Island amusement park. During the off-season, the boat made tramping trips up and down the river offering local excursions. She succumbed to fire on November 4, 1922, at the Cincinnati wharf along with her Coney Island partner, the *Morning Star* (which was purchased and refurbished to replace the *Princess* after she was destroyed by the 1918 ice on the Kentucky River where she was wintering with the *Island Queen*), and Greene Line's *Tacoma* and *Chris Greene*. That is the reason the second *Island Queen* had an all-steel hull and predominantly steel superstructure, so she would be unsinkable and fireproof. Both the first *Island Queen* and the *Princess* featured a huge Native American maiden painted on their wheelhouses.

126

In this image taken at Yeatman's Cover in Cincinnati, a crew member adjusts whistles on the *Jonathan Paddleford* at the 1992 Tall Stacks™. Started in 1988 as part of the City of Cincinnati's bicentennial celebration, Tall Stacks™ celebrates the Ohio River heritage of the community and in particular the steamboats of America. This premier event draws hundreds of thousands of people to the riverfront and is a must-see. (Copyright © *The Kentucky Post*, Dale Dunaway, photographer.)

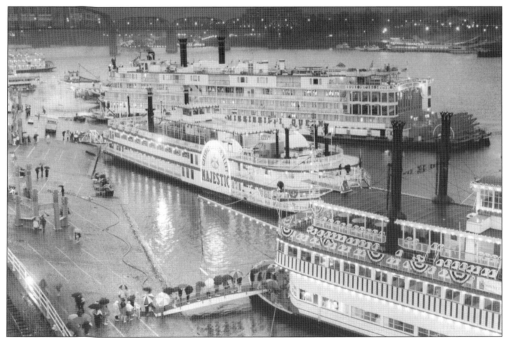

This is another view of the Cincinnati Tall Stacks™ celebration. The emergence of so many tall stack boats at one time in Cincinnati is history in the making. The celebration has expanded to a premier music festival hosting local and national acts in several days of excitement on the river. In this 1992 view, Tall Stacks™ patrons board the *Belle of Louisville* for an early morning tour. The *Majestic* and *Mississippi Queen*, rear, are pictured. (Copyright © *The Kentucky Post*, Dale Dunaway, photographer.)

ACROSS AMERICA, PEOPLE ARE DISCOVERING SOMETHING WONDERFUL. *THEIR HERITAGE.*

Arcadia Publishing is the leading local history publisher in the United States. With more than 3,000 titles in print and hundreds of new titles released every year, Arcadia has extensive specialized experience chronicling the history of communities and celebrating America's hidden stories, bringing to life the people, places, and events from the past. To discover the history of other communities across the nation, please visit:

www.arcadiapublishing.com

Customized search tools allow you to find regional history books about the town where you grew up, the cities where your friends and family live, the town where your parents met, or even that retirement spot you've been dreaming about.

Horns in
High C

H.C. ROBBINS LANDON

Horns in High C

A Memoir of
Musical Discoveries
and Adventures

with 42 illustrations

THAMES AND HUDSON

© 1999 H.C. Robbins Landon

British Library Cataloguing in Publication Data
A catalogue record for this publication is available from
the British Library

ISBN 0–500–01923–0

Printed and bound in Slovenia

Contents

Preface and Acknowledgments — 7

1 Massachusetts Bay Colony:
growing up in Lancaster 1926–1947 — 11

2 The Haydn Society:
Boston and Vienna 1949–1951 — 33

3 Behind the Iron Curtain
Haydn research in Eastern Europe 1958–1959 — 60

4 Broadcasting:
BBC radio 1954–1958 and television 1963–1982,
and other programmes — 75

5 Research in Austria and Germany:
Göttweig Abbey and Donaueschingen 1949–1957 — 95

6 Haydn opera revivals:
Holland Festival productions 1959–1970 — 106

7 Italian adventure:
living in Tuscany 1959–1973 — 121

8 Austrian cottage:
a writer's retreat in the Waldviertel 1975–1984 — 143

9 Welsh rectory:
teaching in Cardiff and elsewhere 1978–1984 — 151

10 French château:
at home in the Tarn 1984 to the present — 160

Index — 175

Preface

As many readers of these memoirs will already know, most of my career has been devoted to research into the life and work of Joseph Haydn, one of the pivotal figures in the history of music, but whose reputation until the mid-twentieth century was based on only a relatively small part of his œuvre. My ambition in life was to help rediscover the unknown Haydn and bring his music to a wider audience. Ironically, in 1997 a BBC Television crew came over to France to interview me, as part of a Mozart documentary programme. The director was Francesca Kemp, the daughter of an old friend of mine, Ian Kemp, who had been with Schott & Co. in London when we produced the first critical edition of Haydn's 'Nelson' Mass in 1962. While the crew were setting up their equipment in my living room, Francesca said, 'Well, Haydn hasn't made it, has he?', referring to the fact that the Mozart film was just one of a seven-part television series on great composers, and that of course Haydn had not been chosen (nor for that matter had Handel or Schubert). In the ensuing discussion about how such choices are made, Francesca put up her hands and said, 'Well, it was the American co-producers who had the ultimate say as to which composers should be included.' In other words, commercial rather than musical considerations play a large part in the process.

Interestingly, in the British context the 'Top 300' compositions as compiled by *Classic FM Magazine* (June 1998) shows Max Bruch's Violin Concerto No. 1 at the top of the list for the third year in succession, but there is not a single Haydn symphony, string quartet, piano sonata or piano trio. In fact, Haydn's name does not appear in these ratings until entry number 179 (the Trumpet Concerto), and then not again until number 223 (*The Creation*). This situation indicates to me that Haydn is gradually becoming what I predicted two decades ago: a musician's musician,[1] and perhaps this tendency was confirmed in a recent interview with the

British composer Peter Maxwell Davies, published in the *Guardian Weekly* (26 July 1998):

He has been going through a phase of *nouveau classicism* recently, inspired partly by his rediscovery of the glories of Haydn's string quartets. 'It's just the sheer brilliance of the man's musical mind, and I think some of that can't help but rub off,' he reckons.

If Classic FM's list of the 300 most popular compositions broadcast by that station might be considered a reflection of the notion of *vox populi, vox Dei*, then what about crossing the Channel and tuning into Radio Classique, to find a work by Haydn broadcast in France almost every day? A sample from the first ten days of July 1998 will suffice:

1 July Piano Sonata in E minor, No. 53 (Hob. XVI:34)
 Cello Concerto in C major (Hob. VIIb:1)
 Trio for piano, violin and cello in E flat, No. 36
 (Hob. XV:22)
2 July Divertimento (Hob. X:12; Quintet for baryton, 2 horns
 and strings)
 String Quartet, Op. 76, No. 2
4 July The Paris Symphonies (feature programme)
 Symphony No. 85 ('La Reine')
5 July Harpsichord Concerto in D (Hob. XVIII:11)
6 July Cello Concerto in C major (Hob. VIIb:1)
 Symphony No. 95
7 July Symphony No. 96
8 July Piano Sonata in E minor No. 53 (Hob. XVI:34)
9 July Symphony No. 103 ('Drum Roll')
 String Quartet Op. 77, No. 2
10 July Symphony No. 82 ('L'Ours')
 Piano Sonata (Hob. XVI:36)

This book is not, of course, entirely about Joseph Haydn, nor is it about the media. It may well be that Robert Layton, my old friend and erstwhile BBC producer, is right when he talks of our 'shallow, media-ridden age',[2] and indeed, as these memoirs point out, it is both instructive and

astonishing to see how quickly the media began to determine Haydn's relative popularity. But how can one explain the astonishing difference between Haydn's lowly ratings on Classic FM and those of Radio Classique? Are the statistics in England wrong? I doubt it. Is the French listing simply the result of the personal preference of some programming director? I doubt that too.

However, quite obviously we have to address the problem of the relative truth of what constitutes *vox populi*. Whose voice? And in which country? Can we equate Haydn's ratings in Austria, Germany, England, France and Italy? Certainly Haydn means less than nothing to the average music-loving Italian. Before World War II, Mozart's position would have differed just as widely between Austria and England, or Italy and Germany. In those days Mozart was a cult figure (as compared to Beethoven), but not in Austria and Germany.

So in one sense my own memoirs chart the course of Haydn's fortunes vis-à-vis the media, by which we mean not only radio and television but also gramophone records and especially CDs. With a work list of over one hundred symphonies, and dozens of string quartets, piano trios, piano sonatas, operas and so forth, it is difficult to know what to do with Haydn in the opera house or the concert hall; indeed during the whole of the BBC Proms season from July to September 1998 there is just one Haydn symphony to be found. However, Haydn on CD already includes most of his major works, and in that respect must be deemed a marked success, even from the commercial standpoint.

Certainly we will never again have an opportunity to 'discover' unknown works by a neglected composer of Haydn's stature as we were doing in the 1950s, 1960s and 1970s. No one wants to denigrate Hildegard of Bingen, but for all her sterling merit, she is after all no Haydn.

<div align="right">

H.C. Robbins Landon
Château de Foncoussières, August 1998

</div>

Acknowledgments

I owe special thanks to my astute assistant Siân Walters for her help in preparing the manuscript, and to my faithful editor at Thames and Hudson, Mark Trowbridge, for his tireless work in refining the text for publication. Small portions of the book appeared previously in *The Music Review*, *Ovation Magazine*, and the Sony Music *Vivarte* Series. All illustrations are from my personal archive with the exception of the following:

David Cooper 30; Anthony Dean 29, 32; Decca Record Company Ltd 23, 25, 26; Maria Austria/MAI Amsterdam 18, 19; Niederösterreichische Landesbildstelle 16; Vivianne Purdom 28: Thames and Hudson Ltd (photo Sarah Quill) 24; U.S. Information Service 7; Siân Walters 31.

I am grateful to the individual photographers and organizations for kindly allowing the use of this complementary material.

H.C.R.L.

Massachusetts Bay Colony: growing up in Lancaster 1926–47

One of the first things that impressed my parents when they bought a comfortable country house near Lancaster, Massachusetts, was the fact that their new neighbours walked a mile or two through the fields to leave their calling cards. We moved to Lancaster, a town thirty-four miles west of Boston on the old Massachusetts Central line (now largely abandoned), when I was just over two years old, in July 1928. Our new home had both central heating (with what were called 'registers', or hot-air vents) and excellently efficient open fireplaces in most of the ground-floor rooms as well as in the master bedroom. At first my aunt and uncle, H.C. Robbins, a well-known cleric in the Episcopal Church who was at that time Dean of the Cathedral St John the Divine in New York, lent us their chauffeur, whose name was Skibiski. However, my parents found that they could manage without his services and instead engaged his sister Marion as my younger brother David's governess. Apart from the Skibiski family (Polish immigrants who had settled in the Deerfield Valley in Massachusetts and who soon became prosperous farmers), our household included a series of cooks and parlour-maids, whose family backgrounds tended to be either Irish or Scottish. We had about thirty acres of hay-fields, woods and a large orchard (growing mainly apples, but also peaches, pears, plums and apricots, as well as several varieties of grape). I recall my father telling me that, during our first summer in Lancaster, one of our farmer neighbours paid us the then enormous sum of $250 to harvest the hay on our property. My father, who loved the country as much as he disliked city life, took over the farming of the land. We hired a local gardener who would help with outdoor tasks or assist my mother with her extensive rose garden whenever his services were needed.

Fig. 1 My parents' contrasting preferences for an ideal domestic environment, as sketched by my father, whose love of the country was matched by my mother's devotion to urban life.

Lancaster was a pretty, colonial town and just outside it lay the huge estates belonging to two families of the landed gentry, the Parkers and the Thayers. Our house had originally been built by a Parker, and our next-door neighbours (only in a manner of speaking, since their house was at least six or seven minutes' walk away) on one side were Parkers. In the other direction lay two Thayer estates, and my parents soon became great friends with one branch of the family in particular – they had four daughters of approximately the same age as my brother and myself.

Unlike my father, my mother was more at home in a city than in the country; she missed her subscription tickets to the Boston Symphony concerts under Serge Koussevitsky, as well as her 'sewing circle' of female friends who met regularly to gossip and, I presume, sometimes to sew. (When Erich Leinsdorf was appointed director of the Boston Symphony in the 1960s, he and his wife came to visit us at our house in Italy, where my mother was also staying at the time. She wanted to help the Leinsdorfs become established in Boston: 'I will recommend your wife to my sewing circle,' she told the maestro. The Leinsdorfs could not contain their astonishment on hearing this well-intentioned suggestion.)

There were many bedrooms in our house in Lancaster, and as a result we had a regular procession of guests, mostly from Boston, who came to visit at weekends. They would take the 4:52 p.m. train which was hauled by an 'Atlantic' (4-4-2) steam locomotive and had three or four carriages. It stopped at Cambridge, Waltham, Hudson, Clinton (a dreary mill-town) and was then diverted onto the Worcester-Lowell line to call at 'Thayer' (formerly known as South Lancaster, and renamed, typically, to honour our neighbours) and Lancaster, after which it returned to spend the night in a siding outside Clinton. Though dusty and dirty, the train was quite efficient, reaching Thayer a little after 6 p.m., and the guests were met there by my mother or father.

We had a very large kitchen garden, and my father's green asparagus (as distinct from the white variety) was celebrated for its delicate taste and its long season. My mother served aperitifs and cocktails, mainly sherry and 'Old Fashioneds' (based on whiskey and served with fresh fruit and a preserved sweet cherry), but except for Thanksgiving and possibly Christmas, wine was never served, either at home or by our friends or neighbours – apart from the odd sophisticated individual such as the

historian Samuel Eliot Morison in Boston. We had an endless succession of excellent fresh vegetables, which were served in a plain but by no means unappetising way: there were delicious red and white onions, but never any garlic, which was regarded then as a low-grade spice and used mainly by Italian immigrants. One of the enduring memories of my first visit to Paris in 1947, when I stayed with my great aunt, was the regular use of garlic and the serving of globe artichokes (the latter were too exotic at home and moreover not suitable for cultivation in the harsh New England climate), and of course the fact that wine was served with every meal.

My father's family, of French Huguenot origin, were bankers, lawyers and diplomats. They were very pro-English and, naturally, Francophile. Everyone who was eligible to fight in World War I did so. In 1918, half my father's family was killed in Paris on Good Friday, when a shell from the infamous German cannon 'Big Bertha' blew up part of St Gervais, the church in which they were worshipping. My father and uncle were spared only because they were away at the front, my father serving with the Royal Flying Corps and my uncle a captain in a New York regiment. Before the United States entered the war in 1917, my father had gone to France to volunteer, but as a citizen of a neutral country he was only allowed to do certain jobs. He was variously assigned to be a fireman on a munitions train, a chauffeur to a French general named César, a worker in an abattoir (whereupon he instantly became a vegetarian), and then a member of the Red Cross. In 1917, however, he immediately joined the R.F.C. and was trained as a pilot by Arthur 'Bomber' Harris, who wrote a glowing recommendation for him. (This I accidentally discovered in the attic one day, and triumphantly brought it down to lunch, much to my father's annoyance: 'Since when do you poke around in other people's papers?" he demanded.) The surviving members of my father's family forbade him to accept the offer made to him, upon cessation of hostilities, of becoming a test pilot.

My mother's family included a long line of churchmen. Her father, Francis Le Baron Robbins, was a clergyman and her brother (my uncle) was, as already mentioned, Dean of New York's Episcopalian Cathedral. On the whole they were less grand than the New York Landons and Grinnells (ex Grenelle – my father's maternal ancestors who were minor members of the French nobility, in other words long-established but not particularly distinguished in battle or out of it), but by no means

impecunious. My maternal grandfather collected paintings and my delightful uncle Francis Le Baron Robbins II, who owned a model farm on Long Island, was a successful army officer (a colonel) in World War I and a lawyer in civilian life.

The one thing that united both sides of my family was a love of art and literature and a passionate interest in music. When my father proposed to my mother, she agreed on the condition that he would learn the first movement of a Beethoven sonata, and so he did – the opening of the 'Moonlight'. In the evenings at Lancaster my mother would either sit at the piano and play a *pot pourri* of all our favourite pieces, including Beethoven, Brahms and Schumann, or read aloud from the classics or from a newly issued book. My father would draw his engineering designs, and these eventually resulted in an elaborate live-steam, quarter-inch scale model outdoor railway with four locomotives, encompassing a long tunnel and trestles. This beautifully fashioned railway was destroyed in the big storm of 1936.

Gradually, as the quality of the gramophone and of 78 r.p.m. records improved, we began to have recorded concerts at home. This was a particular joy for us, since the repertoire which we collected was largely made up of works that we were unlikely to hear in Koussevitsky's concert series, such as Mozart piano concertos; Haydn symphonies (although the Boston Symphony usually gave us a generous helping of Haydn) and quartets; Handel, and J.S. Bach (although, again, I recall with great pleasure performances conducted by Koussevitsky of the *St Matthew Passion* and the B minor Mass, featuring impeccable high trumpet playing, an unusual achievement in the 1930s and 1940s). Our collection of gramophone records also included gems such as the Beethoven contra-dances, which my father loved, Schubert's Third Symphony (which was hardly ever performed in concert) and harpsichord music such as Bach's 'Goldberg Variations', also a great rarity at that time.

At the age of seven I was sent to boarding school, an experience which I found bearable only because all the other boys were, so to speak, in the same boat. While at my preparatory school near Deerfield, I contracted double pneumonia, and the doctors told my parents that I must, if I were to recover at all, escape forthwith the New England climate. This resulted in a winter's stay in Tucson, Arizona, where I learnt horse-riding, followed by three school years at Aiken, South Carolina – an English preparatory

school where not only the masters but even the lady housekeeper were British, and our uniforms were made by Billings & Edmonds of London. Although the tuition fees were exorbitant, the standard of teaching was very high. In particular there was a superb Latin course, and we were also taught the art of public-speaking (which invariably required each boy to address an audience made up of highly critical school-fellows), a skill which I consider is something best learned while one is young. In any case it was a craft which was to prove essential to me in later life.

Another facet of school life at Aiken was the teachers' insistence on our learning literary texts by heart – passages from Shakespeare, the King James Bible, and so forth. It was the headmaster himself who led the morning chapel service (with the colonial hymn, 'From Greenland's icy mountains to India's coral strands', as our almost daily fare) and took classes in basic English literature. We were obliged to learn texts which he considered appropriate to our colonial education, such as Julius Caesar's 'Cowards die many times before their deaths'. The headmaster's attractive red-headed wife used, very occasionally, to come and visit us in our dormitories before the lights were turned out. She told us horror stories about the the Huns in World War I: 'My dears, even before hostilities began, the Germans had laid miles of railway track and covered them with earth to prevent them from being discovered. When war suddenly broke out, they uncovered these great lines and were able to use them for their troop trains. Nobody had suspected as much – that was how dreadfully devious they were.'

All this time I was taking piano lessons, and had progressed to the point where I could play all the latest hit tunes for my schoolmates. The son of the great pianist Josef Hofmann was a fellow pupil, and I remember being taken to the attic of a house in which he had lived in Aiken and being much impressed by piles and piles of telegrams and urgent letters concerning recitals, train times, concert fees and so forth – all lying forgotten in yellowing piles. The young Anton Hofmann was, however, rather eccentric and had a foreign accent. The other boys used to amuse themselves by twisting his ears until they turned red, while Anton screamed in pain.

We were also provided with a rather grim introduction to sex at Aiken, whereby we were witness to some unsavoury incidents. One of the older boys acquired a very young sex-object, and when finally someone 'squealed' to a parent, the older boy was summarily dismissed. ('But you know,' said

my mother six months later, 'he is now quite reformed and I am told he carries the crucifix in his church processionals.')

My family was accustomed to spending the winter months away from the freezing New England climate. Their love of the South coincided happily with the geographical location of my school, and they would spend their winters in Aiken, where they were joined by Aunt Molly, one of my mother's sisters. Thus at Christmas I would stay with my parents at Hankinson's Hotel in Aiken, and we would also sometimes move *en masse* to Winter Park, Florida, where two houses were rented for various members of the family; the big Buick touring car was transported to Florida by boat. At Winter Park we could row on the lake, which I had never done before. The Depression was at its height then, and a huge land speculation in Florida had collapsed. At Sarasota, where to our delight the famous circus Ringling Brothers/Barnum and Bailey spent the winter, there were whole sections of empty plots with half-finished roads and forlorn signposts for towns which have since become a vast suburbia. My father, who loved to take risks, piled us into his Buick one day and ventured out into the sand at the edge of the ocean, where we promptly got stuck. Rescuing my rather stiff grandmother from this undignified situation required finding some boards so that she could climb out safely without sinking.

My mother was restless, and one of her ways of giving vent to this restlessness was to repeatedly put me in and take me out of schools. Aunt Molly, who had rather leftish views, persuaded her that Aiken was a wildly snobbish and élitist school (which it was) and that it would ruin my character if I were allowed to continue there, so after three years I was summarily removed to Asheville School in North Carolina, where I underwent a sort of Saul to Paul conversion. I became a member of the school choir (Mozart's 'Ave, verum corpus' made a deep impression on me) and studied piano with the school's music master, Mathias Cooper. I remember working on Beethoven's 'easy' Sonata in G, Op. 49 No. 2, and other pieces, including some by Mozart. During that season (1939–40) in New York, there was a Sunday concert series given by the New Friends of Music and conducted by Fritz Stiedry, a refugee from Europe. The programme, in which the great Mozart scholar Alfred Einstein actively participated, included a whole series of newly resuscitated Haydn symphonies, most of which had never been heard before in New

CARNEGIE HALL SERIES

Orchestra of the New Friends of Music
FRITZ STIEDRY, Conductor

Assisting Pianists:

Webster Aitken	Eunice Norton
Kurt Appelbaum	Karl Ulrich Schnabel
Harry Cumpson	Frank Sheridan
Arthur Loesser	Rosalyn Tureck
Adele Marcus	Josef Wagner

PROGRAMS

FEBRUARY 26TH

Haydn Symphony No. 80, D minor
Bach Concerto for 2 pianos, C minor, No. 1
Frank Sheridan — Arthur Loesser
Haydn Symphony No. 67, F major

MARCH 5TH

Haydn Symphony No. 87, A major
Bach Concerto for 3 pianos, C major
Webster Aitken — Frank Sheridan — Rosalyn Tureck
Haydn Symphony No. 90, C major

MARCH 12TH

Haydn Symphony No. 56, C major
Bach Concerto for 4 pianos, A minor
Harry Cumpson — Josef Wagner — Eunice Norton — Adele Marcus
Haydn Symphony No. 77, B flat major

MARCH 19TH

Haydn Symphony No. 71, B flat major
Bach Concerto for 2 pianos, C major
Kurt Appelbaum — Webster Aitken
Haydn Symphony No. 96, D major

MARCH 26TH

Haydn Symphony No. 51, B flat major
Bach Concerto for 3 pianos, D minor
Arthur Loesser — Karl Ulrich Schnabel — Josef Wagner
Haydn Symphony No. 82, C major (L'ours)

APRIL 2ND

Haydn Symphony No. 7, C major (Le midi)
Bach Concerto for 2 pianos, C minor, No. 2
Rosalyn Tureck — Harry Cumpson
Haydn Symphony No. 91, E flat major

iv

Fig. 2 Concert programmes in the series broadcast live from New York in 1940; hearing these helped to focus my early ambition while at boarding school to make a career in music.

York, as well as all of J.S. Bach's multiple keyboard concertos. The Haydn symphonies created a profound impression and there were plans for four of them to be recorded, but in the event only two (Nos. 67 and 80) actually appeared. As far as a thirteen year-old schoolboy in Asheville, North Carolina, was concerned, the fact that one could listen to live broadcasts of these Sunday concerts on a commercial radio network was astonishing. I told my teacher about them and said that I would love to work in music. 'Well,' said Mathias Cooper, 'why don't you do something about Haydn?' 'Why Haydn?' I asked. 'For one thing,' he replied, 'Haydn has no *Gesamtausgabe* – you know, like Shakespeare's *opera omnia*.' 'But the others – Mozart, Bach, Beethoven and so on – they all have complete catalogues of their work, don't they?' I asked. 'Yes, as do even lesser-known masters like Heinrich Schütz and Dietrich Buxtehude.'

Whereupon Mr Cooper led me to the music cottage, a handsome little house standing all by itself on the campus and richly endowed with a grand piano, an expensive gramophone and a highly sophisticated collection of records. He picked out a set of Haydn's Symphony No. 93 conducted by Sir Thomas Beecham, which had recently been released. I listened, enthralled. 'Do you mean, Sir, that there are 104 symphonies by Haydn like this one?' 'More or less.' I was amazed, and wanted to know how I could go about becoming what Mathias Cooper called a 'Haydn scholar'; in other words, attend a conservatory rather than a liberal arts college, learn several instruments, and study orchestration, harmony, several foreign languages and history. Mr Cooper explained that for over a century nobody even knew for certain how many works Haydn actually wrote, and that nine-tenths of his output had not been printed. Whole operas in manuscript lay untouched and unread in the archives of the princely Hungarian family for whom Haydn had worked for much of his life. Now that World War II had started, who could say whether these precious sources would ever become available to scholars?

On an afternoon off, I went to visit a big department store in Asheville. Although its record section did not offer a very sophisticated choice, I did find a set of Haydn's Quartet in D minor, Op. 76 No. 2. For some reason this work was not in the school collection (despite its extensive repertoire, which included imported records that were unavailable in the USA), so I bought it. Then came the Easter vacation, and I went back to Massachusetts

with my copy of Haydn's Op. 76 No. 2 and announced to my parents that I wanted to devote my life to music, and specifically to Haydn. 'But we already have that recording,' my mother said, which of course was true, though I had never tried to find it. I believe my cousin Jean, a violinist, had given it to them the previous Christmas. Knowing that it was something of a family custom for Landon children to become bankers or lawyers, and the Robbins male offspring to follow their forebears into the Church, I was surprised and pleased at my parents' joint reaction. 'Haydn is a lovely composer,' they said, and recited all the works that they knew, quite a few from 'rolls' they had heard on the piano-player (as they called it) which sat at the head of the stairs on the first-floor landing. This had come from my father's family and included several Haydn sonatas. My father cautioned, however, that he considered it would be difficult to make a living researching Haydn, and that if this proved to be the case, they would be glad to assist me financially. In fact, this generous help continued right up to the time when I had to stop more or less all my other activities in order to concentrate on completing my five-volume biography of Haydn.

I graduated from yet another school, this time at Lenox, Massachusetts, an institution attached to the Episcopalian Church (the headmaster was a rector), and I decided to study next at Williams College, which some of my relatives had attended. However, the threat of war was increasingly felt and because of it the college's music department had simply closed. I now moved to Swarthmore College in Pennsylvania, which was run by the Quakers. W.H. Auden was Professor of English and there was a brilliant Russian/English Professor of Music named Alfred Swan, who in 1936 had conducted the first (private) recording of Haydn's late Theresa Mass of 1799, using Swarthmore forces. It was marketed by the Gramophone Shop in New York City, and I considered this sufficient grounds for enrolling at the college. In the event, my judgment proved correct because, despite the war and the pressure placed on the college by the presence of navy undergraduates, Swarthmore was a thriving intellectual centre. A group of us soon took over the running of the college radio station, and we persuaded Auden to write programme notes. One of his brilliant papers still survives (the handwritten text, addressed to me care of the college mail, is about Wagner's *Ring* cycle); it is now in the New York Public Library, though it remains unpublished.

It was amazing to find that Auden was a member of the faculty in wartime Swarthmore. He once gave a public lecture in the chapel, and, before he appeared in the pulpit, a trumpeter sounded a fanfare. Auden quietly mounted the steps. 'The three things I particularly loathe,' he announced, 'are war, physical jerks [U.S.: setting-up exercises; I am sure most of the students imagined he meant something quite different] and the music of Johannes Brahms.' It was my first introduction to the anti-Brahms tendency of Benjamin Britten, Peter Pears, and others which we students simply could not understand. But when I returned to New England, my mother confirmed that the anti-Brahms movement was legion, even in Boston. 'They walked out in droves,' she remarked apropos the subscription series of the Boston Symphony Orchestra, which had put on a Brahms 'Festival' after World War I. We students at Swarthmore found this odd to the point of eccentricity. To us Brahms was a major, recognized master.

I found my first girlfriend at Swarthmore, but our affair then became (foolishly, because we were just one of many student couples) so public that the College felt obliged to throw us both out, while simultaneously providing each of us with impeccable references. I took the train home and my parents met me at the station. I told them that I had been expelled from Swarthmore and explained why. Dead silence. We arrived at the house to be greeted by the maids, in their blue and white uniforms. 'I think we should have some tea,' said my father. When this had been served in the library, he continued, 'I don't suppose you can imagine that your news exactly fills us with joy, but it has to be said that even if you had murdered somebody, we would still go on loving you and you would always be welcome at home here with us.'

* * *

It was well known that the only real Haydn expert in America at that time was the Viennese professor Karl Geiringer, whose biography of the composer, written in German and published in 1932, was the most sophisticated and well-informed of its time. Geiringer was then teaching at Boston University, so I hastened there. On my arrival I found the renowned scholar on his knees choosing records to illustrate his next lecture. 'I have come to study with you,' I said, introducing myself. Boston accepted

me, and again I was incredibly lucky, not only in having Geiringer as my mentor, but also in being blessed with excellent teachers in harmony, counterpoint, orchestration and so forth. There was a student orchestra, in which I played kettledrums and sometimes piano, but we found the basic repertoire dreary and petitioned the rather astonished dean of the faculty to form a separate chamber orchestra for us, so that we would be able to give concerts featuring eighteenth-century music, which we thought unfairly neglected, as well as modern music, including first performances of works by my fellow students.

Geiringer took me under his wing and I became a kind of unofficial personal assistant to him. As a result I learned a vast amount from him, including purely practical matters. Geiringer was a firm believer in combining musicology with music-making. In class we performed Dufay's 'Gloria ad modum tubae', and I played one of the trumpet parts. I had decided that playing brass instruments would be a useful part of my education, and by chance found a Confederate army bugle in E flat, which could be adapted, by adding to it a length of hollow brass curtain rod (soldered together by my father), to a valveless D-trumpet on which I could practise Bach's B minor Mass, Handel's *Messiah* and, as it turned out, Dufay's 'Gloria'.

I graduated in June 1947, but before starting a Master's degree at Harvard I wanted to spend the summer in Europe. I landed a position as foreign music correspondent for the Intercollegiate Broadcasting System, which had offices on Fifth Avenue in New York. This was a radio network which planned to bring a new series, entitled 'Music in Post-War Europe', to colleges throughout North America. The programmes set out to recount what had happened in Europe between 1939 and 1945 – who the new composers, performers and scholars were in the field of music. We secured the co-operation of national radio networks in Europe – the BBC, French, Dutch and Belgian radio, and most luckily, the Austrian Rot-Weiss-Rot station, a collaboration which enabled us to relay concerts at the Salzburg Festival and to present interviews with all sorts of musicians, from Edwin Fischer to Karl Böhm. The Intercollegiate Broadcasting System covered my expenses, but I paid for the air fare to Europe. It was a very exciting business, since my activities ranged from covering Glyndebourne productions (Britten's *Albert Herring* and Gluck's *Orfeo* conducted by Fritz Stiedry, of

Haydn fame in New York, who had meanwhile become a friend) to making a series of programmes for French Radio, which also included interviews, on works by French composers.

By the time I reached Salzburg, I was convinced that I had to stay in Europe – no more theory and books at Harvard. Because I needed to remain in Austria, and knowing that I would be drafted into two years' military service, I arranged to go to Vienna after the Salzburg Festival and try to join the U.S. Army of Occupation. Fortunately, I found a sympathetic colonel at 'G-3' (Operation, Organization, Training) who wanted to know what I had written lately. I produced a long article that I had just completed for *Musical America*, a publication for which I had recently become a freelance European correspondent. The colonel explained to me that his office had recently undertaken to write the history of General Mark Clark's Fifth Army in the liberation of Italy. Piles of 'top secret' documents ('top secret' simply because no one had taken the trouble to declassify them) were lying around. I thought it a most interesting project, particularly considering the colonel's brief: 'Never make a statement of any kind without adding a supporting document,' he said; 'never rewrite the sources but let them speak for themselves.' This was a way of writing history to which I became immediately wedded and from which, I hope, I have hardly ever deviated. I was then given a rather perfunctory physical examination in the U.S. Army Hospital, and while waiting for my security clearance to arrive I familiarized myself with such documents as I was allowed to study. By Christmas 1947 I had become fully integrated into the U.S. Army of Occupation in Austria.

I was totally enthralled with post-war Vienna. The first thing I had noticed when stepping down from the train was the omnipresent pungent smell of burning *Braunkohle* (lignite, or brown coal). I installed myself in a small hotel next to the famous theatre (for the opening of which Beethoven composed the overture *The Consecration of the House*) in the suburb of Josefstadt. It was only a short walk from the hotel to the streetcar line that took me to the central building in which the U.S. Army of Occupation had established its headquarters.

The bomb-damaged Staatsoper (State Opera House) was being rebuilt, and at that time performances were given in the Theater an der Wien, where – dressed in uniform – I would squeeze in behind the timpani. I thus heard

the entire repertoire, most of it for the first time in my life. I noticed that sometimes, sitting in a box above me there was a handsome Russian officer, who clearly shared my passion for music. The Vienna State Opera also performed works by Mozart in the large Redoutensaal – the former Imperial Court Ballroom – preserving a magical eighteenth-century atmosphere from the era when Mozart and Haydn had personally conducted their magnificent German Dances and Minuets there.

In addition there was the Volksoper (literally, People's Opera), a company which put on all sorts of operas I had never previously heard, including Weber's *Der Freischütz*; I heard this work half-a-dozen times, always sitting in the big private box normally reserved for the Generals of the Army of Occupation who, it seems, had no interest in Weber. And of course there was also the famous Musikverein, still miraculously intact after the wartime bombing, and the Konzerthaus, where to my great joy and fascination a wide range of music that I had never had the opportunity to hear in Boston was performed. For a young man of 21 post-war Vienna was indeed a marvellous and inspiring place to be.

1, 2 The family house in Lancaster, Massachusetts, acquired by my parents in 1928: (above) myself with my father, William Landon, on the porch, *c.*1930; (below) the substantial property, set in 30 acres of fields and woodland, seen during the bleak New England winter.

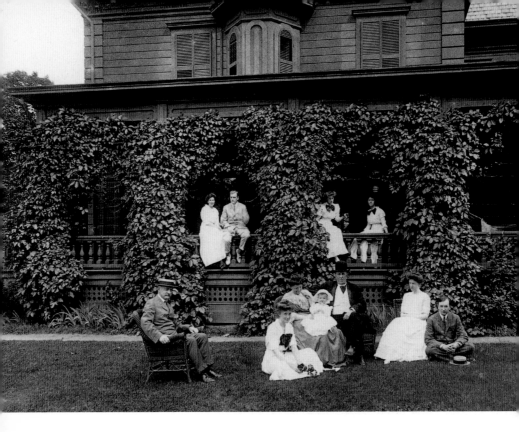

5, 6 Members of the Landon family, with
(in the centre of the group) my father, who
had volunteered to serve in the Royal Flying
Corps during World War I; (right) myself as
cowboy in the 1930s, while recuperating in
Tucson, Arizona, following a serious bout
of pneumonia.

Opposite
3, 4 The Robbins family at their home in
Sherwood in 1911, and (left) a studio portrait
of my mother dating from shortly before her
marriage.

7 The ruins of St Stephen's Cathedral, Vienna, part of the legacy of World War II which greeted me when I first came to Europe in 1947.

8 Army service in Vienna. At work in 1948 in the U.S. Army offices while assisting in the preparation of a history of the Fifth Army and its role in the liberation of Italy.

9–11 Post-war Vienna: (above left) with the conductor Jonathan Sternberg, whose recordings for the Haydn Society included a notable performance of the 'Nelson' Mass: (above right) myself amid the ruins of the city; (below) the wedding party after my marriage to Harriet Steinsberg in 1948, including the bride's mother and sister-in-law, and Mrs Julia Wadleigh and her son Richard, who acted as best man.

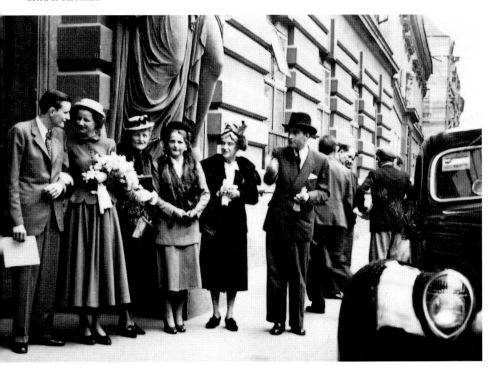

JOSEPH HAYDN
ORFEO ED EURIDICE
(L'Anima del filosofo)

Dramma per Musica, London, 1791

Libretto by Carlo Francesco Badini

ANALYTICAL NOTES

HAYDN SOCIETY·BOSTON

495

THE HAYDN SOCIETY

Wolfgang Amadeus Mozart

KV 527

DON GIOVANNI

Dramma Giocoso in Two Acts

NOTES BY

ALFRED EINSTEIN

A COMPLETE RECORDING

12–14 Products of the Haydn Society: covers of the booklets for Haydn's *Orfeo ed Euridice* and Mozart's *Don Giovanni*; (opposite) the original sleeve of the LP record featuring the first recordings ever made of two concertos by Haydn composed *c.* 1769, for cembalo in G (Hob. XVIII:4) and for violin in G (Hob. VIIa:4).

dn Society – Boston, Massachusetts

JOSEPH HAYDN

Cembalo Concerto in G

SOLOISTS:
Erna Heiller, Solo Cembalo
H.C. Robbins Landon, Continuo Cembalo

Violin Concerto in G

SOLOISTS:
Edith Bertschinger, Violin
Erna Heiller, Cembalo

ra Collegium Musicum, Vienna – Conductor: Anton Heiller

HSLP 1014

15 My second wife, Christa, in 1955, while visiting the East Tyrol, the Austrian province in which I had written part of my first major book, *The Symphonies of Joseph Haydn.*

16 Göttweig Abbey in Lower Austria, where several important discoveries were made by members of the Haydn Society in 1957 (see pp. 95–101).

17 Visiting Eszterháza in the Cold War era: myself (back to camera) and colleagues at the imposing gateway to the palace built by Haydn's patron, Prince Nicolaus Esterházy.

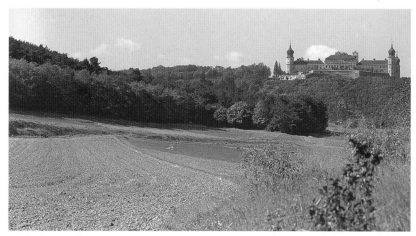

The Haydn Society:
Boston and Vienna 1949–1951

On leaving the army, I returned to Boston to begin postgraduate research. I was appalled by the fact that only a fraction of Haydn's output had ever been printed, let alone recorded. My friends and I decided that we really had to do something to put this deplorable situation to rights, so we formed the Haydn Society, with the initial intention of issuing records and also printing the new complete edition. The first set of records, released on 1 April 1949, was the 'Harmoniemesse' of 1802, which was supplemented by a facsimile of the first edition in score. This soon sold out. I then received a legacy from the estate of my uncle Francis Le Baron Robbins II, and with this money I returned to Europe, where I started systematically to record Haydn symphonies. The records began to sell very nicely indeed, and the Haydn Society would have been a marked financial success had we not had the complete edition to produce. This ambitious venture presented a considerable challenge: in the first year we managed four volumes, but only thanks to another devoted relative, an aunt whose generosity made it possible for us to print the third and fourth. We therefore turned the task of preparing the complete edition over to the Joseph-Haydn Institut, based in Cologne. This research institute was able to obtain financial backing for further publications, and now it is a flourishing organization which expects to fulfil its aim by the year 2020. Meanwhile, we issued the scores of many works, including the complete symphonies, the complete string and piano trios and all the string quartets, through various publishers. At least these works can all now be played; this was certainly not the case when I was young.

When I returned to Vienna in 1949 to make the first Haydn Society LP recordings, I decided that we should start with the symphonies. One of the

many reasons for this was that many good recordings of Haydn quartets had already been produced; the Pro Arte Quartet, for instance, had completed a whole series for Walter Legge between 1932 and the outbreak of war in 1939. Moving on to the choral works, we discovered that, unbelievably, no commercial recording of *The Creation*, nor indeed of any of the Masses, was yet in existence.

In the case of the symphonies, we were limited by the amount of orchestral material available. This was very odd indeed. Most of the symphonies had been published individually by Breitkopf & Härtel as a spin-off of their old *Gesamtausgabe*, which they had begun to issue as early as 1907, and revived in 1932. The firm had made available the first 49 symphonies in full score, but only a fraction of these works existed in orchestral parts, and since we were hardly in a position to produce the missing parts quickly, we were obliged to concentrate on those works for which the parts were at hand. This meant, for example, that we had Symphony No. 1 but not No. 2; Symphony No. 28 but not Nos. 27 and 29, and so forth. We also had recourse to some manuscript parts owned by the Vienna Philharmonic, including Symphony No. 22 ('The Philosopher'). We eventually produced three LPs – Symphonies Nos. 1, 13 and 28, all of which were available at Breitkopf, followed by Nos. 44 and 48. I remember very clearly that we recorded No. 44 ('Trauer') on a boiling hot day, 1 May 1949. We then went on to record Symphonies 31 and 34. In those days there was debate as to whether or not one should include a harpsichord continuo in the first forty symphonies; the general consensus was that one should, whereas nowadays there are good scholarly reasons to support the contrary view. At that time the Esterházy Archives in Budapest were not available to us, hence we did not know that it was actually the violin that Haydn played (simply in order to bring the string section up to strength), although there were many harpsichords available in the Esterházy establishment.

Encouraged by the enthusiastic response to our first ventures, I reassembled my old team to record the first Mass, the 'Mariazellermesse' of 1782, entitled on the autograph score *Missa Cellensis* (the Latin adjectival form *cellensis* refers to the Austrian monastic foundation at Zell). I had played timpani in a performance of this Mass on Easter Sunday 1948, while I was still in the army. My colonel called me in afterwards and asked, 'Landon, what's all this I hear about you playing drums in church? Sit down

and explain: what exactly are they doing there?' I told him that in the eighteenth century, settings of the Mass such as these by Haydn were customarily performed in church with full orchestra, including trumpets and timpani, and that on this occasion the timpani player had failed to appear. I had stepped in as a substitute. 'All right, Landon. I'll never understand the Austrians, but if you really want to do this, you may – *just not in uniform.*'

The mass was conducted by Hans Gillesberger, both then and in the subsequent recording session, with Anton Heiller at the organ. Heiller and Dr Josef Nebois became our regular staff organists. We used the Akademie Kammer-Chor, a young Viennese professional chamber choir who were ideal to work with since its members came fully rehearsed to every recording session. Unlike the singers at the Vienna State Opera and the Gesellschaft der Musikfreunde, with their wobbly sopranos, the members of the Akademie all sang in tune and were young and very idealistic. The soloists were up-and-coming singers from Vienna; Walter Berry, who at this point had not yet made his debut with the Vienna State Opera, was one of them. I remember that the fees were derisory: 500 Austrian Schillings per soloist (around $20 – a purely token amount). We also engaged a stupendous American tenor called Herbert Handt, whose voice was heavenly: if he were still singing professionally now, he would doubtless be performing Puccini and earning $4,000 a night.

Shortly afterwards we recorded Mozart's 'Coronation' Mass (K.317), again with Gillesberger conducting. We paid $400 for the entire recording, and this price included everyone's wages, from technicians to soloists (among them Herbert Handt and the young soprano Rosl Schwaiger). One of the main problems that I was determined to address in our recordings was that of balance in the performance of eighteenth-century works. I was convinced that modern exponents had got it all wrong. For example, making the trumpets and timpani sound as if they were toy instruments in another room was certainly not authentic performance practice. On the contrary, the addition of trumpets and timpani had always been celebrated in the past: when the symphonies were advertised in Paris 'avec trompettes et timbales', this meant that the sound of these instruments was something to be relished. I put these ideas into practice for the first time with the 'Mariazellermesse', recorded in late September/October 1949 in the big hall

of the Konzerthaus in Vienna, making the trumpets and timpani sound (despite the players' reluctance) as I thought they ought to – an innovation that caused something of a sensation. One reviewer in America commented that the timpani sounded like 'pure Beethoven', but in fact this was not the case at all – they were 'pure eighteenth century', though nobody living in the mid-twentieth century had ever heard them played in such a way before. Naturally we could only use modern instruments, but luckily I was still able to find plenty of small hand-tuned timpani in Vienna. The resulting sound was indeed spectacular.

We were also keen to start work on pieces which were not available in any form, either in full score or parts, and while putting these new works through the proof stage we very often recorded them (either preparing our own parts or coming to a working arrangement, by borrowing from the Vienna Philharmonic for example). We often split the cost with the Vienna Academy, which was situated next door to our offices in the Konzerthaus. The Academy was very pleased to have these 'new' works, and helped us by making available everything it had – a gesture that saved us a considerable amount of time and effort.

All the earlier recordings were produced by myself. In the Konzerthaus we had access to a technical organization called 'Sinfonia' (owned by the Vienna Symphony Orchestra), which produced our early recordings until 1950, when Vose Greenough joined us. He came at his own expense and took no fee for over a year. This generosity was typical of the members of the Haydn Society: all sorts of people contributed their services for nothing or for a mere pittance. I think it was our look of wild-eyed innocence that persuaded them! I was still in my early twenties, and my colleagues were not much older.

Having spent the legacy from my uncle's estate, we were again faced with an uncertain future. However, we soon experienced a great stroke of good fortune. One of the people working in the Society, Richard Wadleigh, had been in the economic section of the U.S. Military Government of Occupation in Austria, and it was a close friend of his, Erhard Jaeger, who soon offered the Society considerable financial aid to enable it to continue its work. In Vienna I was just one ride away from Wadleigh in the so-called *pater noster* (an open lift which moved continuously), so I used to go and see him quite often. A very cultivated and interesting man, he was also an

amateur singer. He lived in Vienna with his mother who, like him, was working for the U.S. Army. It was at their house that I first made the acquaintance of Herbert von Karajan – a very elegant, dapper, suave young man who spoke flawless English – and his young wife, whose family fortune came from a major sewing-machine company. We sat for a long while talking about music, and Karajan inquired as to what I was doing. He agreed that something really had to be done about making a recording of *The Creation*. Although we could never have afforded Karajan's services, he did later conduct two now historic recordings of the work, one live from the Salzburg Festival and the other in the studio; both are now standard interpretations of the work, and count among the most spectacular and original that I have ever heard.

Like Karajan, Erhard Jaeger was astonished by the absence of any commercial recording of *The Creation*, and after hearing our first recordings, as well as the 'Coronation' Mass, he decided to invest about $60,000 in our company. This capital really put us in business, and meant that we could not only expand the musicological side of the society to undertake research in Austrian monasteries and other libraries, but also issue the first four volumes of recordings to initiate what we then hoped would be the complete works of Haydn.

We got *The Creation* on the market by Christmas 1949, as well as the 'Mariazellermesse', and then moved on to record the 'Nelson' Mass of 1798, which was conducted by Jonathan Sternberg with, among the soloists, Lisa della Casa – a staggeringly beautiful soprano – and the bass George London, who was making one of his recording debuts as a classical singer. He had a fabulous voice and was moreover a charming and modest man. When he auditioned for us in the Konzerthaus, I accompanied him on the harpsichord, which was all we had in our room, while Jonathan Sternberg conducted, as it were. We were so overwhelmed at the end of his performance of the 'Qui tollis' – his big solo – that we were left temporarily speechless. London joked, 'Look guys, if you don't like me don't feel you have to take me on.' 'No, no, sign here, sign here!' we replied, engaging him on the spot.

The most important thing to realize about *The Creation* was that this work, in recent years a classical bestseller, had never been commercially recorded. However, I found out that there were in existence tapes of a

performance that Clemens Krauss had recorded with the Vienna State Opera and the Vienna Philharmonic, with famous soloists such as Julius Patzak – everyone's star in those days – so we decided to reissue them on three LPs. The tapes were owned by what used to be known during the war as the Reichs-Rundfunk (in other words the official German radio station in Vienna, which after 1945 became Austrian Radio). We gained permission to use them via an English music agent who had been a captain in the British army, which is why he was allowed to be in Vienna, and he kindly contacted the artists for us, informing them that they would all be given a percentage. At this point I met Clemens Krauss, who was absolutely charming and looked just like a figure out of a Hapsburg operetta, at once flamboyant and brilliant. We eventually issued both *The Seasons* and *The Creation,* originally recorded in 1944 and 1942 respectively for the Reichs-Rundfunk, in the big hall known as the Musikverein of the Gesellschaft der Musikfreunde. What was lacking in the recording of *The Creation* were most of the sections for Adam and Eve, I suppose because of timing limitations, so we simply recorded these passages with a German conductor called Erwin Baltzer, and a soprano and bass. These numbers were then inserted into the final part of the work, which made no appreciable dent in the overall situation since they had never been there in the first place. Thus we had a total of five soloists instead of the three specified by Haydn, and in the final chorus three principal soloists plus a fourth small, nameless part for a mezzo soprano whose participation on the whole is very limited.

Later, when the 'Nelson' Mass came out in New York, customers stood around in record shops open-mouthed, stupefied by the thought that music of such high quality had never been recorded before. We had tried to piece together something that would be an improvement on the known editions, which we knew to be full of mistakes (for example, the use of wind instruments that Haydn never included, and various textual details). So we sent somebody up to the Austrian National Library to copy out from the autograph the whole original organ part, which had never been printed, and we then removed all the extraneous wind parts in order to achieve something approaching Haydn's original sound. However, it was not until many years later that I could really clean up the edition and attempt to get all the little details right. The trumpet parts, for instance, were much more

flamboyant and spectacular in Haydn's original score than in the versions we knew in 1949.

* * *

I had first come across the name Herbert von Karajan in a small record shop in the Siegmund Haffner-Gasse in Salzburg, during the summer of 1947. At that time I was constantly on the look-out for new names, and when I made inquiries at the shop I was shown a record of the Overture to Johann Strauss's *Die Fledermaus* conducted by Karajan, on a label called Siemens Spezial. I played the record and found that both the performance and the sound quality were astonishing. The lady in the shop explained that a sophisticated new recording technique had been developed for Karajan, but that *Die Fledermaus* was the only record in the series that she still had in stock. I bought it with alacrity. (I later learned that, like me, Walter Legge first encountered Karajan in a record shop, this time in Hamburg). Because of the political climate in Europe in the post-war years, Karajan was only then about to be officially 'de-Nazified', and I had to wait until the autumn to hear him in live performance, at a remarkable concert with the Vienna Philharmonic (part of their subscription series in the Musikverein.) The sole piece was Bruckner's Eighth Symphony, and I was astonished at Karajan's superb control over the orchestra, the sumptuous sound of the strings and the brilliant panache of the whole performance. Earlier that evening, when I entered the hall in the company of a distinguished white-haired gentleman whose daughter, Harriet Steinsberg, I was to marry the following year, we had immediately noticed a huge number of brass instruments at the back of the stage – horns, trumpets, trombones and so forth. The players sat quietly throughout most of the performance, until, all of a sudden, they joined in at the final coda. The resulting sound was the loudest I had ever heard in my life, and when the orchestra stopped, the audience seemed numbed. At first no one wanted to applaud, but of course they did, finally, and Herbert von Karajan returned to the rostrum.

In those days Karajan seemed to be omnipresent. With rare fidelity to the works, he directed a Bach concert from the second harpsichord in 1950, in honour of the bicentenary of the composer's death. The speaker on that

occasion, one Erich Schenk, was so boring that the audience hissed him off the stage. We then heard the marvellous one-movement Cantata No. 50 'Nun ist das Heil', which of course brought the house down. At that time Karajan, who was an excellent keyboard player, often directed Baroque music from the harpsichord. However, some of his attempts to jolt the conservative Viennese public into the mid-twentieth century were less than successful. At a Vienna Philharmonic subscription concert, Karajan once programmed a Sibelius symphony to be performed after the interval. This was done (I believe) at the instance of Walter Legge, but the experiment failed, for when the interval arrived a large part of the audience left. A Bartók Concerto fared no better (a leading Viennese critic wrote 'One sees that it is not possible to stretch the bow beyond a certain point.').

Karajan of course conducted regularly at the opera. His Wagner performances were legendary, but his interpretation of Mozart, elegant and sleek, was equally noteworthy. I remember the occasion when Elisabeth Schwarzkopf and Karajan decided to perform the Countess's great aria at the beginning of Act II of *The Marriage of Figaro* in the highly ornamented version by Nancy Storace (who created the role of Susanna in the original performance in 1786). 'We won't tell anyone,' they promised in a private understanding with Walter Legge, 'and you'll see, not a single critic will notice.' And indeed not one did, much to my disbelief. My last contact with Karajan was when BBC Television sent me to Berlin to do a major interview with him in 1966, and I was again astonished by his meticulous organization and (sometimes ruthless) efficiency. When we arrived, several people were already waiting for him in the Berlin Philharmonic's artists' room. Karajan made instant appointments for later that day, allocating a time to each person in the group: '10.30, 11.15, lunch at 12.45.' These appointments were divided by a short shift of a pointed finger. We then proceeded to record the interview, which was conducted in English throughout. Occasionally, if he forgot something for a moment, he would call out, 'Cut the lights, thank you.' He would then put his hands over his eyes and there would be perhaps 30 seconds of silence while he concentrated his thoughts. Then suddenly, 'Right – lights, camera, action,' and off we went again.

* * *

At the Haydn Society it was always our intention to tackle works not only by Haydn but also by his predecessors and contemporaries. For the Bach bicentenary in 1950 we produced the Concerto for Three Harpsichords in C major (BWV 1064) and the Concerto for Four Harpsichords in A minor (BWV 1069), neither of which had ever been recorded before on harpsichords – only on pianos, which is quite a different matter altogether. Later on, the Society recorded a lot of the organ repertoire and more of Bach's harpsichord music with Ralph Kirkpatrick, but that was quite a few years after our efforts to complete the basic Haydn repertoire in Vienna. Encouraged by the financial backing from Erhard Jaeger, we then decided to produce Mozart's *Idomeneo*, including its ballet music, which had never been recorded complete. There was not even a proper set of score and parts available, so we contacted the Leipzig publishers Breitkopf & Härtel (whose premises had been bombed almost out of existence) and were referred to their Wiesbaden branch. They replied that their standard edition of the opera was in preparation at that very moment in Augsburg, and did not seem to think that we would be allowed to have access to their existing score, since it was necessary to refer to it every five days or so. We drove down at once to Augsburg and found that this was indeed the case. However, the situation prompted us to take drastic measures. One of the members of the Vienna Symphony Orchestra, a double-bass player called Josef Duron, told us that he thought that there were manuscript parts in the cellars of the Redoutensaal, the great dancing hall which had survived the war miraculously unscathed and in which were housed the archives of the old Vienna court opera. There we found the late eighteenth-century parts for *Idomeneo*, and recorded the opera from them. One would never dream of committing such sacrilege now, but in the old days we had to resort to similar methods on several occasions. In the event, our recording of *Idomeneo* caused a sensation since no one in living memory had previously heard a performance of the opera as Mozart had written it.

The other opera that we decided to tackle was Haydn's *Orfeo*, the original title of which was *L'anima del filosofo* (1791), later re-named *Orfeo ed Euridice* when the composer published extracts from it some years later. With this opera we had to start from scratch: neither parts nor a score were then available, so we were obliged to prepare these ourselves, in collaboration with Universal Edition who subsequently took on the publication of the

opera. After making the recording we organized the work's first complete performance in the history of music, at the Maggio Musicale in Florence, with Tygge Tyggeson in the title role, Maria Callas (just starting her career) as Euridice, Boris Christoff, and Erich Kleiber conducting. My friend Richard Wadleigh went to Italy to help produce the opera. We then went on to record the Prague version of *Don Giovanni*, supplemented with all the other music (i.e. from the later Vienna version) as an appendix on the final side. This recording was conducted by Hans Swarowsky, also a celebrated teacher at the Academy of Music next door to us in the Konzerthaus. By December 1950 and early 1951 we had released a large quantity of works, including the first recording of Mozart's 'Posthorn' Serenade (K.320) conducted by Jonathan Sternberg, as well as many more Haydn concertos, nocturnes and symphonies for which in some cases we even had to construct horns in order to be able to play them properly.

This brings us to the title that I have chosen for my memoirs – *Horns in High C*. In 1950, the Haydn Society recorded a series of what were then virtually unknown symphonies, including (in December) No. 56 in C, composed in 1774. However, the spectacular horn writing created a serious problem for the horn-players of the Vienna Philharmonic. What they had not realized was that the score included a pair of two long-forgotten instruments: C horns pitched an octave above the normal range. Since nobody in living memory had ever played these instruments, I decided to have two specially fashioned by a Viennese horn-maker and to present them to the orchestra. The orchestra's two horn-players refused to play them, thinking my idea quite ridiculous. However, the first trumpet, Helmut Wobisch, who was a friend of mine, asked if he could have a go; thereupon he took up one of the new instruments, inserted his trumpet mouthpiece, and successfully played over its full range. An uneasy silence followed. 'Come on, you can do it too,' he told the horn-players, who eventually, and very unwillingly, agreed to take the instruments home to practise on. Sure enough, they found that they could play them, and of course they soon became accustomed to and mastered these strange instruments – after all, they were members of the prestigious Vienna Philharmonic. In the end, we made our recording using the C alto parts, and we also included Symphony No. 52 in C minor with one C alto horn, thereby restoring this instrument to its proper place in Haydn's scores. The

Fig. 3 The opening of the difficult first horn part (in C alto) from Haydn's Symphony No. 48, one of several orchestral works by him featuring the use of horns in high C; from a set of parts copied by Joseph Elssler Senior now in the Musicological Institute, Bratislava.

success of this undertaking was a source of great personal pride for me. As for the public reaction to these recordings, the one big problem was that for the moment we could issue them only in America; war-torn Europe was not yet ready for a marketing operation.

The aftermath of the greatest war in history affected us in more than one way. For example, at the time when we had recording sessions in Vienna the electricity supply was erratic. Because of voltage fluctuations, one would sometimes be recording at 444, sometimes at 452. Legge had his way of dealing with this problem: he would use a petrol-run machine to stabilize the voltage, and Vose Greenough had a similar battery-operated machine in order to take care of any complete power failure. He would regularly call the *Bundeslastverteilung* (the organization which regulated the electricity supply in the city) and persuade them, in fluent German, to help us. (Being able to speak German was an absolute necessity in our artistic activities – in fact, everybody connected with the office was at least bilingual.) Vose Greenough had been in naval intelligence during the war and had been sent to Austria to investigate the possible existence of a Nazi hoard in a mysterious lake called the Grundlsee in the Austrian mountains.[1] I went up to the lake with him many years later, and it was indeed a dark, sinister and forbidding place, reminiscent of a bad B-movie. Deep-sea divers were eventually engaged some twenty years after the war, and they found, among other things, an enormous quantity of forged Bank of England pound notes which were so well manufactured that the Bank had to admit that if the Germans had flooded Europe with them, the British economy might have been seriously affected.

Walter Legge, who was very interested in all the Society's proceedings, adopted some of our catalogue for EMI (Electrical and Musical Industries, the biggest gramophone record combine in the world, encompassing the Parlophone and Columbia labels, together with His Master's Voice and its multi-lingual European, Japanese, South American and North American affiliates such as RCA Victor in America and Electrola in Germany). In the end quite a number of works were made available on 78 r.p.m. discs, but not on LP. The Haydn Society had been one of the first small companies in America to embrace the 33 r.p.m. LP, using CBS Records to press our discs; this they did in a charmingly unselfish manner – they treated us as if they were the parents and we the children, which in a sense we were.

I first met Walter Legge in Vienna in 1951. Following the completion of the de-Nazification process, Herbert von Karajan was now free to perform in public, and Legge was making a multitude of Karajan recordings which were beginning to conquer the world; these included Mozart's *Marriage of Figaro* and Symphony No. 33 with the Vienna Philharmonic, and the complete Beethoven Symphonies. The list was breathtaking and the results impressive. We started to attend each other's recording sessions, which in turn led us to an increasingly close personal relationship. There were not many good restaurants in post-war Vienna, but one extraordinary place noted for its food and its Martini cocktails was the Künstler-Club, in a street just behind the Hotel Bristol on the Ring. It was there that I had my first long evening meal in the company of Legge and two of his sound engineers. We drank Martinis followed by large flasks of local white wine, and in the end I was feeding Legge pieces of roast beef, but feeling unequal to the developing situation I rang Christa, my second wife, and she hurried down from our nearby flat to help. Together we managed to induce Legge to eat more and drink less. By midnight we had dropped off the exhausted engineers and found ourselves in the 'Splendid', a rather grand night-club near St Stephen's Cathedral, which had an energetic orchestra and served good (though expensive) brandy and whisky. By this time, Legge and Christa, who was an accomplished harpsichordist and continuo player, had become engrossed in the problems of 'realizing' (as it is called) the figured bass parts of Baroque music. Legge took a menu and started to sketch out his idea of the harpsichord realization in Henry Purcell's 'The Blessed Virgin's Expostulation', whereupon Christa, taking the sheet away from him, marked various changes. We left just before dawn. A few days later we invited Legge to our flat and played him test pressings of Haydn's *Missa in tempore belli* (1796) which we had just recorded. Legge was enthralled: 'I must show it to Furtwängler,' he said. Unfortunately, Furtwängler, who loved Haydn, died in November 1954, before he could find time to conduct the work.

Legge was the greatest *raconteur* I have ever met. His stories about Karajan were legendary. He once went to visit the conductor in the Tyrol, where one of Karajan's daily amusements was to take a bobsled and tear down towards the town at about noon, which was when the train from Vienna arrived, stopping in the town centre with the gates at the level

crossing closed. Karajan timed his downhill run so that as he reached the crossing, the train was pulling out and the gates opening. It was a close thing, and Legge was terrified when Karajan took him along:

'You're mad, Herbert.'

'Macht Spass, was?' ('Fun, isn't it?') yelled Karajan, as he slithered over the icy tracks with Walter Legge holding on for dear life.

Legge was trying to get Karajan to sign a contract with EMI, but Karajan procrastinated. They spent their evenings at Karajan's Tyrolean chalet, sitting in front of the open fire with hot toddies while they went over Beethoven's Ninth Symphony bar by bar, in preparation for a recording with the Vienna Philharmonic. Finally, after days of work, Legge again brought up the subject of the contract: 'You really must sign it, Herbert.' Karajan finally agreed and they both signed, whereupon Karajan elegantly tossed his copy into the fire. 'I don't need a contract with you, my dear Walter.' Even Legge was impressed.

Legge was a perfectionist, of course. He always said that the best thing a young record producer could do was to make one recording that he, the producer, thought was perfect. 'That should be your calling card,' he would say. As for issuing works by subscription, he said that one should first collect the subscriptions (as he had done with the recordings made by the Bach Society, the Haydn Society, the Hugo Wolf Society and so on) and then go to one's own company, which should take on the set with an assurance that there was no financial risk involved. That was the time, in the 1930s, when even recording Mozart operas was considered a risk, which was why the first recordings of *Figaro, Don Giovanni* and *Così fan tutte* were all issued as society sets by HMV. Afterwards, Legge thought it would be a good idea to get away from the rather precious atmosphere of Glyndebourne and do *The Magic Flute* in Berlin with Sir Thomas Beecham, who was a great friend in those days. They had to work within a tight budget, but at that time recording in Germany was relatively inexpensive, even with the best soloists, and they managed to record the work with a bit to spare. Legge told me that he achieved the sinister effect of Monostatos's aria, as he prepares to rape the sleeping Pamina, by turning the microphones down to half level. (On that occasion there was a beautiful young soprano in the chorus, Elisabeth Schwarzkopf, who was later to become an international star in her own right, as well as Legge's wife.) Beecham and Legge returned to

London and spent the remainder of their budget on a magnificent dinner, accompanied by the best available German hock.

One of the pre-war projects that involved Walter Legge, apart from the series by the Pro Arte Quartet series, was a set of Haydn piano trios played by Lili Kraus, Simon Goldberg and Anthony Pini, which came out in 1940. (Subsequently, Lili Kraus undertook a concert tour in the Far East and had the misfortune to be captured by the Japanese after war was declared; she was interned in a prison camp, an ordeal which she overcame and was able to survive.)

Whenever Christa and I went to London to see the BBC or my publishers, Walter Legge would always take us out to a splendid lunch or dinner. Once, when we were staying in a hotel in Russell Square (in those days the rooms were heated by way of coin-in-the-slot meters), Legge sent his company car around to take us to a marvellous fish restaurant near the docks: the car was a Rolls-Royce with the number plate 'HMV 2', which we thought was the height of chic (would Nancy Mitford have considered this 'U' or 'Non U'?). It occurs to me that in the quarter century of my acquaintance with Walter, I think I only paid for three of the meals that we ate together. He was generosity itself. This was the period when he commissioned Charles Mackerras to make up and orchestrate a volume of Christmas Songs for Elisabeth Schwarzkopf. Mackerras later told me that on being shown the score Legge was amused by the orchestration of one of the numbers, which seemed to him reminiscent of Mozart's 'Coronation' Mass. Suddenly, while going through the score in detail, he pointed to a passage featuring trombones (if I remember rightly). 'That won't sound,' he observed, and Mackerras assured me that Legge was quite right, so he changed it.

I used to attend some of Legge's recording sessions in the Abbey Road studio in London. At one of these, Carlo Maria Giulini was recording Mozart's *Don Giovanni*. Again, one was amazed at Legge's attention to detail, as well as to overall balance. He fussed over the score like a mother hen, and this was why, in the end, he had been obliged to form his own orchestra, the Philharmonia (whose first concert was conducted by Beecham in 1945) and later, his own Philharmonia Chorus. This was also the period when Legge resurrected Otto Klemperer and made a whole series of historic records with him, beginning in the late 1950s. Legge's repertoire of

Klemperer stories was vast, amusing and sardonic, as was his fund of Beecham stories.

Legge finally left EMI in 1964 and decided to retire to Switzerland. He imagined that his services would be snapped up by another recording company, but he also had a reputation for ferocious and ruthless dealing, a trait which I personally never ran up against, but which was certainly known to exist. Example: Legge phones his secretary in London:

Secretary: 'Walter Legge's secretary.'

Legge: 'No longer.'

It was even rumoured that when Deutsche Grammophon tried to hire Legge at this period, the company's other music producers threatened to resign *en bloc*.

I encouraged Walter to write his memoirs, which would have been absolutely fascinating. 'My dear Robbie,' came the answer on the back of a postcard, 'were I to take your kind advice, I should have to walk round London wearing a jockstrap of chain mail.' On moving to Switzerland, he first rented a house in Ascona, in the Italian region, near the home of Erich Maria Remarque, the famous German author who wrote 'All Quiet on the Western Front'. Next, he and Schwarzkopf bought a magical house outside Geneva, overlooking the lake. Legge immediately set about improving the surroundings by planting vast quantities of tulips and other flowers, but Elisabeth Schwarzkopf disliked everything French, even Walter's French-speaking Switzerland, and in the end they sold this magnificent place. While they still owned it, however, we used to visit them frequently. Once, Legge called me into his study and showed me the entire portfolio of his stocks and bonds that were deposited in his Swiss bank vault. It was awe-inspiring and I was touched that he trusted me with this kind of information. I examined the list and said I thought that he could do better. A few days later, his pretty Swiss secretary, Claire, came in at breakfast and asked, 'Can we borrow you for a few hours, Robbie?' We – Legge, myself and Claire – got into his red Mercedes and set off. We stopped first at a newsagents, whereupon I was given all the London and Geneva newspapers to read, then at Walter's bank in Geneva, where the two of them got out, leaving me with the papers. Half-an-hour later they came back loaded with suitcases and flanked by two smooth-looking gentlemen. Into the back seat beside me went the suitcases and off we whirled across Geneva to another bank.

Claire got out and disappeared into the building, and in a short time some more smooth-looking gentlemen came to escort Walter and the suitcases into the bank. When they came out, I asked what had been the purpose of all this activity. 'We've just moved our entire capital in cash, following your suggestion to invest it more wisely,' said Walter, lighting one of his famous fat cigars. Claire said: 'Walter, you're only supposed to smoke the occasional cigar!' 'But, my dear,' he replied, 'this is certainly a special occasion.' I asked what my role had been in the whole affair. 'My dear boy, you were my bodyguard. Your size inspires fear in the villains and confidence in us.'

Walter Legge was getting bored in retirement. Claire told me that one day, looking at his vast (and unique) collection of gramophone records, he decided it was of no interest to anyone. A few hours later, the gardener carted several crates over to his little private mooring, from which Walter proceeded to skim the records one by one into Lake Geneva. In 1970 I dedicated a book of essays to Walter; when we went to visit him shortly after its publication, he said to me after dinner, 'Now, dear boy, come with me to the cellar, where I have a small present for you both.' We descended and there, set out on a series of racks, was a very large quantity of fine wine. 'I think you were born in 1926, is that correct? Well, I've chosen a bottle of either Bordeaux or Burgundy for every year of your life from 1926 to 1950.' We took his magnificent gift back to Vienna and kept it for a whole year before opening a single bottle. Not one was corked. We saved two especially magnificent Burgundys to serve with dinner for some Italian friends, and my wife found a brace of good Austrian pheasants to go with them. On the day, we opened the bottles in the morning, and when we had finished the meal my friend from Florence said, 'Robbie, we will never in our lives taste wine like that again.' And indeed, we never have.

When Walter died in 1979, I gave the address on 6 June during the memorial service held in London at St James's Church, Piccadilly. I concluded by saying, 'Even this cursory description of Walter Legge's career will give you some hint of his extraordinary versatility. I have of necessity left out a sketch of the man himself – his love of life, his broad education, his ability to make lifelong friends. He was well-read in four languages. But I believe the most important part of Walter Legge's multi-faceted career is the making of those gramophone records which created musical history between 1932 and 1964. There are two factors which make these records

unique: (1) Walter Legge's flawless musicality and his keen, perceptive ear; and (2) the unswerving high artistic standards he always set himself and expected of others. Without his own fabulously trained ear, the result would have been useless, because the creation of those extraordinary records was intimately connected with the new position he created – a recording supervisor, or in German (which is, curiously, a more precise term), *Aufnahmeleiter*. The term, as Walter Legge created it, included an artistic presence behind the scenes which, with (and sometimes beyond) the conductor, helped to make the performance more perfect. It was like having a second, backstage brain to bring the scene to life before the curtain, and in the creation of this role I believe Walter Legge's position in musical history was at first unique, and until he stopped making records, unsurpassed. He was a great pioneer who, having created a new artistic concept, also brought it to a rare level of perfection.'

Vienna was an amazing place to be in the post-war years, and I must say that the Viennese were, and still are, extraordinary. The city was still under military occupation by the Russians, Americans, British and French on a rotational basis, and jeeps would drive around on patrol each night. (Once a Russian vehicle crashed into the car in which Legge, I and two others were sitting. I received a bad knock on the head, but nothing more; the Russian driver, characteristically, reversed into the slushy snow and fled at once up the Ringstraße.) The Viennese, however, being an irrepressibly gay and happy people determined to enjoy life to the full, continued their tradition of organizing large-scale balls, despite the fact that life under the Russians could be extremely tough. Red Army soldiers tended to get drunk and do terrible things; in fact, one even tried to kill me when I was still serving in the army. One evening. I was in uniform riding on a tram with a girlfriend, when suddenly a drunken Russian with a gun hauled himself up and started firing indiscriminately. The pair of us jumped off at once but got separated, and the Russian came after me. Fortunately, he was so drunk that he could hardly see straight. Eventually, I managed to lose my bearings somewhere in the city's second district, along with a British soldier I had linked up with. As for the Viennese passengers on the tram, they leapt off bridges into the Danube and did all sorts of spectacular things, so that in a couple of minutes there was nobody around except the drunk Russian. Afterwards, when I was summoned in the middle of the night to the

headquarters of the four occupying powers (a beautiful Baroque palace called the Palais Auersperg), a heavily built quadrilingual officer known as 'Tiny' told me in rather sinister tones, 'You were lucky.' 'I know!' I replied. Although unpleasant incidents of this kind could happen in Vienna, it was on the whole a very pleasant place to be, since the Viennese were very co-operative people. They loved the idea that we were recording Mozart masses and Haydn symphonies in their city. Years later, when we were reminiscing at a party, the trumpeter Helmut Wobisch intervened with a somewhat more practical recollection: 'It was a great way to earn some extra money!' – also a typically Viennese sentiment.

People would often ask me why I had chosen to make recordings in Vienna. My answer was that if there was any city associated with both Haydn and Mozart, it had to be Vienna; and I feel sure that I was right about this, since the modern Viennese audience took to the works we were recording (which were then largely unknown to them) like ducks to water. Although our activity took place a long time before the period orchestra revival, we did make all sorts of experiments along the same lines (reviving the use of C alto horns and so forth). As for the combination of chorus and orchestra, the result was of course a marvellous success thanks to the existence of a long, unbroken tradition going back to the eighteenth century. *The Creation*, for example, had been performed every year in Vienna since 1798 (the year of its first performance), and there were all sorts of musical traditions in performance that were not to be found in the printed score and parts at all. For instance, at one point in the opening 'Chaos', the timpani have in the score a continuous pattern of demi-semiquavers which in Vienna was played as a roll. When I asked the reason why, the reply was simply that they had always performed it in this way, and when I came to look at the composer's own sketches in the Austrian National Library, which nobody in living memory had studied, there was indeed a passage for the G timpani written thus

with a big wave-like trill above the stave. There were other similar examples, for instance the *appoggiature* which were correctly sung by the Viennese. After we had issued our recording of *The Creation*, I discussed this point

with Patzak, who had sung the tenor role in the Austrian radio performance of 1942. He told me that he and the conductor Clemens Krauss had insisted on adhering to the traditional Viennese practice.

Generally, the Viennese string sound was in the nineteenth-century Mahler tradition, but many of the smaller orchestras played with rather less luscious, continuous tones. For instance, the double basses never used vibrato: this practice is purely a late twentieth-century invention. Indeed, when I was in Vienna string players had never heard of such an idea, and in fact used relatively little vibrato. In the celebrated recording of *The Creation* made by Krauss, there were many places (such as 'Chaos' and the point when the sun rises for the first time) in which he used virtually no vibrato at all. This is certainly what Haydn intended. The use of vibrato was in fact a new invention in Haydn's time, created by the great violinist Giovanni Battista Viotti, and was therefore often referred to in the past as the 'Viotti portamento'. It took years, however, for the technique to reach Vienna, so it is very unlikely, for example, that Beethoven's Ninth Symphony was performed with the Viotti violins with raised bass bars and so on, or indeed with this kind of vibrato, the use of which would not have arrived in Vienna until the time of Schumann, at the earliest.

In such ways we benefited from these marvellous and longstanding Viennese traditions, including those of the choir which originated in Haydn's time, as well as from some very nice eighteenth-century organs. When the Society recorded Haydn's Organ Concertos (XVIII:1 and XVIII:8) in 1951, we found an absolutely beautiful instrument in the Franciscan church; it was tuned, however, in a manner which obliged the members of the Vienna Symphony Orchestra to play in B major while the organist played in D major, just so that we might land in C major. This result was achieved without any problem at all, and the works were again conducted by my friend Gillesberger, with Anton Heiller as soloist – all first recordings of course. At that time almost no one had heard an organ concerto by Haydn before. Although there had been one edition, the other concertos were not even published, and we therefore had to use the manuscript scores. We also produced the first recording of the newly discovered Concerto in A major for violin and orchestra called the 'Melk' concerto, which we had found in the archives of Melk in 1950 (this also needed to be prepared from manuscript). By that time almost everything that we were working on was from manuscript sources,

including all eight Notturni for the King of Naples, three or four of which had not been published at all. I remember that these charming works became a great hit in America, and the chief critic of the *New York Times*, Olin Downes, gave the records a very enthusiastic review. In fact, we were very fortunate in that our reviewers were most encouraging and loved everything that we were working on; furthermore, there was nothing else available to compare our records with. Although our performances were, I think, quite creditable, they could not have competed with recordings made by Karajan and the Berlin Philharmonic; had ours been issued ten years later, such a comparison would inevitably have been made. By the time I decided to leave the Haydn Society in 1951 in order to write my first work – *The Symphonies of Joseph Haydn* – we had already completed quite a substantial body of music. In America we had recorded a large number of Haydn quartets with the Schneider Quartet, and we had also made the first recording of a Mozart concerto (No. 17 in G, K.453), using a fortepiano rather than a modern pianoforte, with Ralph Kirkpatrick as our soloist.

Another important step was taken with our recording of Mozart's great Mass in C minor (K.427), which the composer never completed. I first heard this work conducted by Robert Shaw in New York in 1948, and thought it extraordinary that nobody had yet recorded it. After I returned to Vienna in 1949, we hired the Austrian conductor Meinhard von Zallinger, who had performed this Mass during my period of army service and was thoroughly familiar with it. He was then the First Kapellmeister of the Munich Opera, but still found time to record various works by Mozart for us, most notably the Mass in C minor and *Idomeneo*. Anton Heiller played a hired seventeenth-century *positiv* organ, which sounded superb, and we were also fortunate in having the services of one of the finest young sopranos I had ever worked with, Rosl Schwaiger, as well as George London, who sang the bass part for just 50 dollars: 'Can I have it in cash?' he asked.

Having just started to record the Mass in C minor, we reached a very moving passage in the Kyrie – the Christe eleison, which is known to originate in a *solfeggio* or vocal exercise written for Mozart's young wife Constanze. Our soprano started to cry, followed by the girls in the chorus. 'Stop that this instant!' I said. 'You know what happens when you cry – your voice dries up!' This they knew full well. 'Good,' I went on, 'we'll take

a break, and then you really must promise not to do that any more. You'll ruin our sessions – we can't afford it!' We did get through it in the end, but the experience was so moving that even our tough, professional musicians could scarcely believe that they were playing the 'Cum Sancto Spiritu' fugue; and even the old, formal von Zallinger was touched. He was a marvellously professional conductor – just what we needed in that kind of unforeseeable situation – and Heiller, too, was outstanding, reading the continuo part from the full score. They really were brilliant musicians who could do absolutely anything that was asked of them. We simply recorded the parts that Mozart himself had written (I omitted the other parts which had been written by various people – in other words the end of the Credo, the Agnus Dei and so on). When the time came to issue an edition of the Mass, in 1955, all I did was to add as discreetly as possible some notes where Mozart had not filled in the parts, such as the 'incarnatus est'. The idea was that one should scarcely hear the additions, and in that respect I think the result was fairly successful. In 1956 C.F. Peters published the score and parts, and Eulenburg brought out the miniature score.

We later turned our attention to another adventurous piece – Haydn's *Missa Sanctae Caeciliae* – which in its original form of 1766 was a Mass composed for the great Baroque pilgrimage church of Maria Zell. At that point in his career, Haydn had just been appointed full Kapellmeister by Prince Nicolaus Esterházy, and as far as we can reconstruct the situation, he asked the Prince (his patron) for permission to present the Mass in this church. Working outside the Esterházy chapel was permitted if the intention was to perform religious music, since this was for the glory of God rather than in honour of the Prince; and besides, the Princes Esterházy had their own very elaborate and beautiful chapel, constructed over a hundred years before, in Maria Zell, so presumably Prince Nicolaus Esterházy was only too pleased to allow his *Kapellmeister* to proceed. However, after Haydn had composed the Mass, his house at Eisenstadt burnt down, and it seems that a large part of the work was destroyed in the blaze, since when he came to reconstruct the composition the watermarks of the paper date it to about 1773. So the Kyrie, which we rediscovered long after the end of the war in Romania, is dated 1766, while the other sections such as the Sanctus and Benedictus have watermarks dating from 1773. It is believed that it was at this later date that Haydn renamed the work 'Missa Sanctae Caeciliae', since a large-scale

religious ceremony took place in Vienna each year on 22 November, feast day of the patron saint of music. It seems that on these annual occasions the entire Court choir and orchestra performed *gratis* for their patron saint, and there are contemporary descriptions of these festive, high masses which were performed in St Stephen's Cathedral. Haydn also rescored the work slightly: in the Benedictus he added two *obbligato* bassoons, which had previously played with the bass line. There are in fact many surviving manuscripts bearing the same title 'Missa Sanctae Caeciliae', but since our knowledge of the post-Maria Zell history of Haydn's setting is so limited, the history of the Mass is at best conjectural. A shortened version, published in 1807 by Breitkopf & Härtel, was well known, but the original score – which lasted an hour and a half – was too long for a performance during a normal church service. Undeterred, the editor of the church music series for the Haydn Society presented the Mass in its full-length version. We had a publishing arrangement with Universal Edition, who later issued the work in piano score. When we were preparing this full-length edition (December 1950), the parts had just been freshly copied, and the original, authentic version of the Mass was being heard for the first time in living memory.

At the same time we also tried to make recordings which would please listeners on a much less exalted spiritual level. For example, a marvellous pianist called Virginia Pleasants started to record many of the Haydn sonatas for us. One evening I was invited to dinner at the home of Virginia and Henry Pleasants. Among the guests present on that occasion, I can remember George London, recently engaged by the Vienna State Opera and already held in high esteem by Viennese audiences, who tend to elevate their star singers to a status comparable to that accorded sporting heroes in other countries. After dinner we discovered by chance that no one had ever asked Virginia to perform Mozart piano concertos, and I suggested that she include them in her repertoire, notwithstanding any reluctance on the part of impresarios. It so happened that she had an edition of the solo parts of all the Mozart concertos with the orchestral part reduced to a second piano part in small engraving below the solo line. She had two grand pianos placed end to end but no second copy of the score/piano part, so that evening she ended up playing half a dozen concertos at sight – flawlessly – accompanied by myself on the second piano playing the orchestral parts from memory.

Virginia Pleasants was, with Hans Swarowsky, one of the greatest sight-readers I have ever known. (Once, at Richard Wadleigh's flat, I witnessed Swarowsky reading at sight and *a tempo* the entire finale of Haydn's *Orfeo ed Euridice* which we had just had copied from the autograph manuscript.) In those days prospective BBC performers had to come armed with letters of recommendation, and would usually give a special recital in order to get their name on the corporation's books. I remember recommending Virginia to the BBC – citing this story of how she sight-read six Mozart concertos – and, slightly later, Alfred Brendel, who was then still unknown in Britain (although this would not be the case for long).

There were several other principles that we sought to adhere to in making the Haydn Society recordings. One was to avoid splicing as far as possible, that is, joining parts of different takes together, a procedure which can work up to a point if one is lucky, but which can also produce dreadful results. We therefore tried to record the longest sections in a single take. I remember at one time recording the end of the Credo of the *Missa Sanctae Caeciliae,* from the 'et resurrexit' right up to the end, in a single take. There is even a tiny mistake which I left in deliberately, since it did not really matter so very much, although nowadays one would of course edit it out. Anyway, I had the idea that this flaw would make the result seem somewhat more spontaneous. We also wanted to try to liven up the *tempi.* It will be apparent to anybody who listens to the planned new releases of the original Haydn Society recordings that in those early days the *tempi* we adopted were substantially quicker than anybody else's. For example, Anton Heiller's interpretation of the first movement of Symphony No. 56 was a real 'Allegro di molto' rather than the simple 'Allegro' that one would usually hear, and we were sure that this was the way forward. I listened recently to Karajan's recording of the Minuet in Mozart's 'Linz' Symphony, which I think is just too slow. The argument for his reading is that in *Don Giovanni* the real minuet danced on stage is not a symphonic minuet; the marking even goes up to Presto in Haydn's last quartets. I thought that our minuets should be quicker than they had ever been heard, but in that respect we were ruined, if I may say so, by Beecham who always played these minuets at a very lugubrious and, I was persuaded, inappropriate tempo.

There is one really interesting piece of contemporary evidence to support my theory. At Ezsterháza Castle the librarian, one Pater Primitivus Niemetz,

Fig. 4 Cover of the Haydn Society's Fall Catalog of works recorded on LP, 1951.

was also a cellist whose great hobby was the construction of musical clocks containing a tiny organ activated by a keyboard. Such clocks can almost be considered the gramophone records of their time. Niemetz perfected their construction and Haydn wrote a great deal of music for them; in many cases not only does the miniature clock survive (a miracle in itself since they are such fragile things), but also Haydn's autographs of the works it plays. One of the pieces originally written for miniature clock would later become the minuet in the 'Clock' Symphony (No. 101), and another the minuet in the Quartet Op. 54 No. 2, which exists not only as a real minuet but also in the clocks' (there are two) version. The *tempo* here is certainly a far cry from the slow Beecham approach, and since the clock is regulated mechanically, it provides proof of the *tempo* at which the piece was originally played. Many of these works were reused, or 'recycled' into larger works, again offering us a precise means of judging the correct *tempi*, and similarly the very short *staccati* of these little musical clocks with their exceedingly precise trills, some beginning on the lower note and some on the upper, provide another good indication of how to interpret the works. Haydn worked closely with Niemetz, giving him detailed instructions such as alternative versions for certain ideas. He even included quite substantial fugues in the music for the little clocks, this being one of Prince Esterházy's particular hobbies. Such considerations were important factors in determining our general use of faster *tempi,* especially in all of Gillesberger's recordings of Masses.

The last recording that we did with Gillesberger, probably his most spectacular, was Haydn's *Missa in tempore belli* ('Paukenmesse'), which had on its sleeve a photograph of the bombed-out St Stephen's Cathedral. This work became a very popular best-seller. In the quick movements the *tempi* adopted were very fast indeed – so much so that my Danish friend Mogens Wöldike, with whom we also worked, exclaimed, 'I just can't get used to these Viennese *tempi* – it's so difficult for us in the Protestant North!' And in a way he was right – the effect was indeed far from the solemnity of Protestant church services. Many years later, when the *Missa Sanctae Caeciliae* was performed for the first time at the University of Cardiff, my friend Ian Bruce, who conducted the work, told me, 'The girls thought that was very queer indeed – they asked me whether church music in Austria was really like that!'

Finally, I should also make a brief mention of our recording of Haydn's Trumpet Concerto, for which we used the autograph score. The solo part was played by my old friend Wobisch and the conductor was Anton Heiller, and for this performance Wobisch, who was a very sophisticated man, wrote his own, superb cadenzas. Haydn had written the solo part for a key trumpet, in other words an instrument which could produce all the notes of the chromatic scale. This record was to become our best-seller (we sold 30,000 copies in the first few months) and the Trumpet Concerto has remained extremely popular ever since.

* * *

Recently an old journalist friend of mine, Bernard Jacobson, telephoned me from America to inform me that all or most of the Haydn Society records were to be cleaned up digitally and reissued on CD. I was amazed to hear this, but it seems that there is a lot of interest in these early recordings (for example in April/May 1997 the BBC did a 'Composer of the Week' series on Haydn in which several of them were used); on that occasion I was asked what I wanted to do about my original notes. I replied that unless they contained any awful mistakes, they should be reprinted verbatim. Most of these notes were anonymous anyway, since in those days we almost never signed them (following, in that respect, the prevailing tradition of unattributed contributions to *The Times*), and this policy was only changed by the Haydn Society at the end of 1950. I think that in terms of their historical interest these re-releases may prove quite useful, since they demonstrate what one could and did produce as long ago as 1949, recapturing such important developments as the first ever use of a fortepiano in a recording of a Mozart concerto.

1 The Grundlsee is one of several lakes, of which the largest is the Alt Aussee which leads to the Grundlsee. An old Baedeker guidebook states: 'From the Gössl pier we may walk through the village to the dark forest-girt *Toplitz-See* ...; and row to its head in 25 min.; a walk of 5 min. more brings us to the wild and sequestered *Kammersee*' (Austria-Hungary ..., Leipzig 1911, p.159). These lakes are all very deep and hence interesting for people wishing to conceal things in them without risk of discovery. I seem to remember that all three lakes (Grundlsee, Toplitzsee, Kammersee) were suspected of harbouring treasures secreted by the Nazis during World War II.

Behind the Iron Curtain:
Haydn research in Eastern Europe
1958–1959

One of the many fortunate circumstances surrounding the Haydn Society was the active involvement of our 'Man in Budapest'. Most of the Esterházy Archives were located in Budapest, whereas the church music had remained in Eisenstadt, due to the fact that it had been in constant use there throughout the nineteenth century. No Western musicologist had attempted to catalogue this fabulous collection since the Danish scholar Jens Peter Larsen had carried out his valuable work before World War II. Although we were lucky enough to have a black-and-white photostat copy of his work, we also had much more – a Hungarian scholar named Dénes von Bartha, (the 'von' was quietly dropped after the Communist take-over in 1949). He made detailed note-by-note comparisons of the works preserved in Budapest – a vital stage in the preparation of Haydn Society publications – but would accept no fee for his work. When he came to Vienna, he stayed at the Hungarian Legation and we became friends.

In 1956, for the bicentenary of Mozart's birth, the Sorbonne in Paris (which then had as its director a highly civilized professor of music, Jacques Chailley) planned to hold a colloquium of international scholars, and I was invited to participate. So too was Dénes Bartha, who was even allowed to bring his wife along (an unusual concession by the Communist regime, though the rest of his family had to remain behind). For my own part, I found myself in something of a quandary, since earlier in the year I had been confronted with a dilemma which was to have a profound effect on the future course of my life. The Mozarteum in Salzburg – the composer's birthplace – had of course planned elaborate festivities for the bicentenary, and I was associated with the Zentralinstitut für Mozartforschung (Central

Institute for Mozart Research) there; this body was ultimately responsible for producing the *Neue Mozart-Ausgabe* (New Collected Works of Mozart), the first work for which– an offprint of the 'Jupiter' Symphony (K.551) – I had edited. The general editor, a German scholar named Ernst Fritz Schmid, and the publisher, Karl Vötterle of Bärenreiter-Verlag, had come to Vienna to recruit me in 1955, and I was delighted to be asked to participate in this noble project. (I remember editing the 'Jupiter' Symphony while returning to Europe after a visit to my parents; I was a passenger on the liner *Queen Mary* – a marvellous voyage across the Atlantic, during which caviar and other culinary delights were served every evening in the first-class dining room.)

My friend Otto Erich Deutsch, a great scholar now largely remembered for his pioneering work on Schubert (culminating in the publication of the definitive Deutsch Schubert Catalogue) but also a Mozart expert of distinction, had preceded me on the trip from Vienna to Salzburg for the first meeting of the Zentralinstitut that year. When I arrived, he hastened to speak to me and quietly confided, 'They are going to offer you the general editorship of the New Mozart Edition.' 'But what about Schmid?' I asked. 'They find him impossible,' was the reply. Later, when Dr Vötterle and my old friend the lawyer Dr Friedrich Gehmacher did in fact suggest that I take over from Schmid, I told them I needed time to think about it. They proposed a quite modest salary – I think it was DM 1,000 a month – and wanted me to reside in Augsburg, the old German town where Leopold Mozart was born and which was now one of the principal sources of financial support for the New Mozart Edition.

By the time I arrived in Paris in October 1956, I had still not made up my mind, and of course relations with Ernst Fritz Schmid could hardly be described as cordial. At the time a member of the Mozarteum, the former head of police in Salzburg, Bruno Hansch, was visiting Paris, and he tried to persuade me to take the job. While I was procrastinating, I drove him around the city in my yellow Opel convertible with the top down – it was a gloriously mild October – up the Champs-Elysées, around the Arc de Triomphe and back to the Place de la Concorde. Hansch was overawed: 'This is the most beautiful thing I've ever seen!' he exclaimed.

On a day off I drove Bartha and his beautiful wife to Chartres, where we spent hours visiting the cathedral. In those days one could drive right up to

the building and leave one's car outside without any problem. We climbed up onto the roof to look at the marvellous statues which had evidently been placed there 'soli Deo gloria', since they were invisible from below. It was a magical day, and the trip served to reinforce our friendship. Bartha urged me to visit Budapest, where I could personally examine the contents of the Esterházy Archives. 'We will do everything to smooth your way,' he promised. However, when we turned on the radio, we heard the first reports of an uprising in Budapest. Bartha was understandably alarmed and concerned for the safety of his children. It was then that I finally made up my mind, and resolved to visit Hungary, not only to study the Esterházy Archives (now in the National Széchényi Library in Budapest) but also to visit Eszterháza Castle which, Bartha assured me, was battered but still intact.

I had arranged to drive back via Kassel to see Dr Vötterle and his staff at Bärenreiter-Verlag, including my new friend Dr Wolfgang Rehm, a charming man who was Vötterle's assistant and who liked to recite Thomas Mann. On the way there we had the radio turned on constantly to listen to the latest news about the Hungarian Revolution. It all sounded mind-boggling, to say the least. On our arrival we met the Vötterles for a private dinner, and afterwards sat round the open fire drinking white wine and discussing what still seemed to me the novel idea that I should replace Schmid as general editor. Of course it was an enormous honour for a man still only thirty, but I had serious reservations about accepting the offer. I was not at all sure that I wanted to live in Germany, even in the sympathetic town of Augsburg. I loved Vienna dearly, and moreover there was the key question of Haydn: did I have the right to abandon him, as it were, in midstream? Although the Haydn-Institut based in Cologne was already in existence, this German research institute had no possible means of completing its own Haydn Edition before the year 2020, and I considered that with my various willing and indeed enthusiastic publishers, especially Universal Edition and Doblinger in Vienna, we could collaborate in issuing a large proportion of Haydn's œuvre much sooner. Vötterle leaned forward: 'Do you know what a repulsive man Schmid is?' he asked. I began to feel very embarrassed. 'Did you know that he has served a prison term in Germany?' I had heard vague rumours about Schmid, but nothing really concrete. 'Well, he has, and for having sexual intercourse with animals.' The cake in my mouth suddenly tasted rather odd, and it struck me that –

all things considered – I simply had no desire to live in Germany, a sentiment which was heartily endorsed by my half-Jewish Berlin-born wife, Christa. I let the matter drop until I had arrived home in Vienna, where I soon got caught up with Hungarian Relief (we received a whole freight wagon by rail from Kassel, filled with clothes and other useful items, which a charming and immaculately uniformed Austrian customs official cleared in about three minutes). I then formally declined the Mozart offer and have never regretted doing so, since I soon found other constructive ways of working with his music.

Naturally there was no way that I could carry on with research in Hungary in the midst of a full-scale revolution, but there were many other tasks, all connected with Haydn, to occupy my attention. I edited his opera *Il mondo della luna* for Bärenreiter, spending a large part of 1958 in Vienna working from the principal complete source, a manuscript preserved in the Austrian National Library. However, another event occurred which, as matters turned out, was to facilitate my journeys to countries in Eastern Europe quite considerably.

My friend Donald Mitchell was a music critic for *The Times* in London. He used to relate how he would return from a concert to the newspaper's office on Printing House Square, where he wrote up each notice in longhand (in those days he was paid one guinea per piece). The compositors and typesetters at *The Times* must have been exceptionally gifted, since Mitchell's handwriting is highly eccentric. Mitchell introduced me to the paper's chief music critic, Frank Howes, who, late in 1955, had written a very flattering review of my first book, *The Symphonies of Joseph Haydn*. Howes had suggested that I might like to write for *The Times* from Vienna, as well as from Communist-ruled countries. I accepted, and began with a critical piece on the Vienna State Opera in 1957. This caused a huge scandal locally and the matter was even raised in the Austrian Parliament. In those days correspondents wrote for *The Times* anonymously, and the Austrians suspected (and maintained) that the writer must have been an Austrian refugee who had come to live in England in 1938 and who was now venting his spleen on his native country. Soon I was writing from Hungary, Czechoslovakia and Romania, and graduated from being styled 'A Correspondent' first to 'A Special Correspondent' and subsequently – honour of honours – to 'Our Special Correspondent'. I loved writing up my

interviews with Zoltan Kodály (the newspaper gave this a whole page) or reviews of opera performances in the Romanian provinces. In those days *The Times* was held in the highest regard behind the Iron Curtain, and this prestigious association opened all sorts of doors for me. Although government officials thought that I had been very clever in organizing my research trips to Budapest and Prague at the expense of a major British newspaper, they had no idea how little *The Times* actually paid its correspondents.

And so my first trip to Budapest in 1958 was arranged. I took the train from Vienna and was met on my arrival by Dénes Bartha, who escorted me to the Hotel Astoria, which was situated within easy distance of the palace in which the music department of the National Széchényi Library was housed. The Astoria was an old-fashioned, charming hotel with English- and German-speaking staff, and I always stayed there when visiting Budapest. The food and service at this hotel were excellent; the telephone service, considering that all calls were monitored, was efficient, and I soon became friends with the operator. I used to bring her gifts of American cigarettes, and one morning she came up to me and said, 'If you would like to make the occasional call to Vienna without being overheard, just let me know.' A day or two later I went to take up her offer, but as soon as I appeared at the door of her office she dropped her apparatus and rushed out, putting her finger to her lips. 'Don't for God's sake come up here,' she whispered in my ear, 'otherwise I'll lose my job.' (I recall a similar occasion in Romania, when we were all staying in a hotel in Bucharest. Our rooms were situated along one side of a corridor. I noticed that a wire left each room, joining it to the one next door, so I followed it, soon landing at the telephone operator's office, where I stood in the open doorway, much to the horror and consternation of the operator herself.)

The morning after my arrival, I started work at the National Széchényi Library. The staff, with whom I conversed in German, were delightful and I soon made friends with the director of the music department, a composer named Jenó Vécsay. I had decided to concentrate on two particular aspects of the collection: the manuscript scores and parts of operas by other composers that had been revised by Haydn for performances at Eszterháza. These were works missing from the famous Larsen register of the 1930s. Although many of Haydn's beautiful insertion (or substitute) arias had been torn out of the scores, there were often traces of his hand among the vocal

and orchestral parts. Hence a marvellous and, as it turned out, unique copy of a soprano aria – 'Vada adagio, Signorina' – from an opera by Guglielmi which I had located at Donaueschingen (see Chapter 5) could be placed correctly in Haydn's performance material of the opera in question, which bears the delightful title *La Quaquera spiritosa* ('The Spirited Quaker Girl'). I also wanted to copy all the works composed for King Ferdinand IV of Naples, particularly the concertos of 1786, four of which were known only from surviving copies in Budapest. These unique copies had never been photographed, and had narrowly escaped destruction in 1956. One has to remember that the Esterházy Archives had remained a private institution owned by the Princes Esterházy until the Communist take-over, and had generally not been accessible to scholars at all, Larsen being a solitary exception. The German scholar Carl Maria Brand, whose book on Haydn's Masses was uniquely important in its time, had sought permission to examine the archives, but had been politely refused – a rebuff which naturally distressed him greatly.

Having prepared full scores of the entrancing concertos that had been written for the King of Naples from the parts in the Esterházy Archives, I met an important member of the musical establishment in the city, Professor Bence Szábolcsi. I would take these works to him and after tea or dinner we would play them together on his piano – almost certainly the first performances since 1786 in Naples or Eszterháza. Such moments made this a great time to be a Haydn scholar.

Later we went to visit Eszterháza, which was still standing – just. The castle, built over two decades by Prince Nicolaus I Esterházy and completed in 1784, had been used by the Red Army as a military hospital. The Russians had burned what they had regarded as excess furniture in the courtyard, and the blaze had been visible from miles away. Among the items that perished in the flames was the portrait of Haydn painted in 1762 by Basilius Grundmann, showing the composer in his blue and silver livery. An Esterházy official (János Hárich) later described the picture, which he had seen before 1945, and fortunately a black-and-white photograph also exists. The whole of the castle was covered with Red Army slogans, some encouraging the officers, some the men. The Hungarian authorities had decided to restore it, so they told me, not because it had once been a grand Baroque castle but because Haydn had lived and worked there. Two of my new friends from

the National Széchényi Library accompanied me on that memorable trip, the results of which astonished them as much as they did me. We stood in the ruins of the opera house which, after being rebuilt following a fire in 1779, suffered a similar fate in the nineteenth century; opposite it was the shell of the former princely marionette theatre. (Although the castle has since been restored to its former glory, both the opera house and the marionette theatre have yet to be rebuilt if and when funds are available.)

While I was in Budapest, Jenó Vécsay took me to the headquarters of the Hungarian State Radio, which had recently broadcast Vécsay's newly edited score of Haydn's *L'infedeltà delusa*, an opera originally performed by the composer in July 1773 in honour of the Dowager Princess Esterházy and then repeated the following September for the Empress Maria Theresa. I was deeply impressed by this exhilarating music and wrote an article about it for *The Times*. When I returned to Vienna, the British director of the music publishers Universal Edition, Dr Alfred Kalmus, immediately telephoned to commission me to edit the opera for them, which I did with the greatest of pleasure. We secured a prestigious performance, conducted by Alberto Erede, at the Holland Festival and the opera was subsequently given all over Europe during the 1960s.

By this time I was so well known to the Communist authorities that whenever I wanted to travel to Budapest, I only needed to telephone the Hungarian Embassy in Vienna to obtain a visa, which would be issued instantaneously. The press attaché in Vienna was more than co-operative, as was the press director of the Foreign Ministry in Budapest, Foty by name. The latter was amused by my connection with *The Times* and thought, as I have mentioned, that I had persuaded the newspaper to finance my Haydn research. One day when I was visiting Budapest, he asked me to come to his office, where he showed me an (of course anonymous) article in *The Times* dealing with politics and the Communist regime in Hungary. Its tone was not exactly what you would call pro-Hungarian. Foty asked me, very politely, whether I had seen the piece, to which I replied no, and whether I had written it. 'Certainly not,' I answered. 'No, we didn't think so, but can you find out who did?' said Foty. So off I went to announce myself at the British Embassy and to ask the Ambassador straight out. He laughed and admitted to having sent the article out via the diplomatic pouch, a practice which was of course strictly

forbidden. I always mailed the text of my own articles by ordinary post, and they would arrive in London promptly. The possible implications of the Ambassador's actions suddenly struck me, but despite the suspicions of the Foreign Ministry, its officials must have seen at once that the Ambassador's style of writing was very different from my own. The matter was soon dropped.

I was treated with what in retrospect seemed incredible forbearance by my Hungarian hosts. On one occasion the staff at the library invited me to an excellent fish dinner on the Danube, and I realized that they had little enough money to afford such hospitality. I also became friends with the Chargé d'Affaires at the American Embassy, Garret Ackerson, who had a beautiful daughter working in Vienna. When in 1959 the restored Eszterháza Castle was re-opened with great ceremony, Ackerson took us both there in his official limousine. The castle shone in the autumn sunshine and resounded to Haydn's *The Seasons*. Ackerson was an easy-going diplomat with bushy eyebrows and a wide smile. On my arrival at his house before our trip to Eszterháza, he had played a recording of Haydn's Symphony No. 96 (conducted by Bruno Walter) as a special send-off. As we drove towards Eszterháza we were stopped by the police, but after checking our papers they allowed us to proceed. 'They do this all the time, to annoy us,' remarked Ackerson without rancour.

During the Mozart festivities in Paris in 1956, there was present a delegation from Prague, whose members stimulated long political and cultural discussions over brandy in a pretty little bar on the Rue des Saints-Pères. At one point the composer Dobiás said to me, 'You must come to Prague. The Association of Czech Composers [of which he was the director] will support you completely.' He stood by his word, and three years later my friend Christopher Raeburn accompanied me there in my car. Our common aim was to carry out research – in my case on Haydn, and in Christopher's on Mozart – and although we stayed in different hotels, we would meet every evening at a small restaurant to discuss progress. Here, as we dined on delicious contraband Russian caviar, the First Programme of Austrian Radio blared forth in uninhibited fashion. My stay in Prague proved an incredible experience. Most of the manuscript holdings of the National Museum, of which the music section was housed in a pretty square in the old town, had never been catalogued, and I soon located a dozen

works by Haydn, previously presumed lost – notably wind-band divertimenti written when Haydn was Capellmeister at Lukavec in Bohemia. Because Haydn had listed these works thematically in his own catalogue of compositions, it was possible to confirm their authenticity at once. After the country came under Communist rule, the Czech authorities had confiscated all the music housed in castles formerly owned by members of the nobility and had deposited the scores in huge piles in the National Museum. There were also other manuscript sources of great importance – symphonies, masses, smaller church works, divertimenti and so forth – which were essential to the preparation of a critical edition of Haydn's works for Universal Edition and Doblinger. I had brought along a Leica camera specially prepared by my Viennese photographers to take microfilms in large numbers, in other words using film with 100 exposures per roll. My friends at the museum conceived a brilliant ploy:

'Why don't we give the films to the secret police to develop?'

'Why would they want to do that?'

'To see what you've been up to!'

A museum official accompanied me to pick up our films from the police headquarters, where in an outer office a young soldier with a machine gun was playing with a kitten. We were given the films in a bulky parcel, no charge, compliments of the Czech government. As we returned on foot, I said, 'What a charming young man.' 'Yes, but if provoked he'd shoot you dead without stopping to think twice,' answered my colleague.

The time had come for me to continue my travels in Czechoslovakia, so Christopher Raeburn (who had meanwhile discovered valuable items of Mozartiana) and I took leave of each other, and I set off for the provinces, heading in particular for Brno (Brünn), where a similar depository of musical manuscripts seized in Moravia was awaiting investigation. The treasures I found there were equally astounding, and I photographed away with delight and astonishment. I had already visited several smaller centres (Cheb/Eger), discovering not only works by Haydn but also contemporary manuscript copies of piano concertos by Mozart signed by Haydn's copyist Johann Radnitzky (these had been marketed by subscription by Mozart, and very few copies have survived).

Although I needed to work in Bratislava (Preßburg), I had already exposed two dozen rolls of microfilm, and none of the film used since

leaving Prague had yet been developed, so I considered it was time to return briefly to Vienna. I consulted my map and found that it showed a small border crossing nearer to Vienna than the one on the main Bratislava–Vienna road, which was always rather crowded. With some difficulty I found the right route and eventually rolled up nonchalantly at the border checkpoint, where I was immediately surrounded by guards armed with machine guns. I was detained and taken to a small room which, curiously, had a piano in one corner. They demanded to know why I was attempting to leave the country illegally at this border crossing. 'It's not illegal, the crossing is shown on the map,' I replied. This assertion was met with silence and then much conversation among the guards. 'You are under arrest,' said one, speaking in quite good German. 'I demand to speak to my Embassy,' I said. More conversation. Suddenly, a weasel-like official shot into the room. 'Who are you? Why are you in Czechoslovakia? How long have you been here? Why are you trying to cross the border illegally?' 'Stop!' I roared. 'Can you read? Well, if so, look at this map!' He looked. 'That crossing no longer exists.' 'How could I have known that?' I replied. 'I bought this map at the Tourist Office in Bratislava. And I demand to talk to my Embassy in Prague.' I went on glibly, explaining that I was a musician, arranging a concert in Bratislava for the following autumn. 'I'm a pianist,' I said, racing across to the piano and playing the beginning of a Mozart concerto. The weasel left and returned ten minutes later. 'Look, we're going to let you go, but only on condition that you follow the road back to Bratislava and leave via the proper border crossing.' Concerned for the safety of the undeveloped microfilms in the boot of my car, I left quickly and disappeared back to Bratislava and the correct crossing on the main road. I was rather pleased to return unscathed to Vienna, where I enjoyed a stupendous Italian meal at the Capri, washed down with liberal quantities of Chianti.

One day, Leopold Nowak, the crotchety old director of the Music Department at the Austrian National Library, showed me a slip of paper which he said had been sent to him by post from Romania. It bore a description of a Haydn Mass dated 1766, which Nowak and the writer believed to be the beginning of the Organ Solo Mass – a work always dated 1766 in the Haydn literature. I thought this a matter worth investigating, but first Universal Edition had to be persuaded to pay for the trip in the hope of finding the lost manuscript. In the glorious golden autumn of

October 1960, the four of us – myself, my Austrian lady friend, the Austrian composer Karl-Heinz Füssl (with whom I collaborated for ten years), and an English girl by the name of Renée King – set off from Vienna in my Opel and, after travelling through Hungary, soon reached the Romanian border. We settled in Grosswardein (Oradea Mare), where Michael Haydn (Joseph's brother) had been *Capellmeister* in the late 1750s. There we hoped to find a rich archive of musical material, bearing in mind the fact that Carl Ditters von Dittersdorf had also worked for the Bishop of Grosswardein. We managed to get into the Cathedral organ-loft, the floor of which was completely covered with books and pamphlets piled high in a state of total disorder. I found a few fragments, but that was all, since the former archives had been engulfed in the chaos at the end of World War II, when Soviet troops had occupied the Bishop's palace – with all too predictable results.

It soon became clear that we were going to have immense difficulties in Romania. We were asked what status we had, and I replied that we had come as tourists: 'That won't do,' I was told, 'you will have to go to Bucharest and obtain confirmation of some kind of official status.' The weather was remarkably good, so we opened up the car roof and duly proceeded towards Bucharest as advised. There was only one main road, and this had checkpoints at regular intervals; at each of these all cars were registered so as to ensure that travellers would not deviate from the straight and narrow. We had brought along the makings of a picnic and, when lunchtime arrived, pulled off onto a small side road, parked and spread out our rug under a convenient tree. Hardly had we begun to savour the local culinary delights before a police car with four armed guards roared up and screeched to a halt. Out leapt the police, who raced over to us and gaped at our innocent picnic lunch. Apparently, since we had not arrived at the next checkpoint within the expected time, the police, in a state of panic, had set out in search of us.

We had the private address of a composer living in Bucharest who, we thought, would put us in touch with the appropriate authorities. On our arrival we knocked on his door, but when he saw us he turned ash-white and got rid of us as soon as he could. He did, however, furnish us with an official address. Another problem we had to face was that our very short-term tourist visa had expired, so we had to renew it not as tourists but as scholars. We arrived at a chaotic office where we found six officials all talking

at once, either to hapless tourists like ourselves or on the telephone. Suddenly a British businessman entered the room and within ten minutes he had seated himself behind one of the official desks and was organizing everything. He told us that he had been in Siberia, where he was supposed to sell, among other items, brassieres to the locals, who had never before seen such a thing. Soon they were putting them on *outside* their clothing, and within days the amply endowed Soviet women were all sporting what they considered the latest piece of Western chic. It was positively hypnotic to witness this clever Englishman simply taking over the running of the Romanian office. Needless to say, we received our new visa stamps within a matter of minutes.

In our new capacities as music critic (myself) and scholar (Füssl) we decided that we needed a Big Brother to shepherd us back through the archives and opera houses, and in this respect we were lucky enough to have a charming young man with a chauffeur-driven car assigned to us. He organized hotel rooms, meals, opera tickets and so forth and we soon became great friends. He told us of the Romanian peasants' famed hospitality. 'If we stopped the car in a village, we would all be invited to lunch,' he boasted. 'Oh come on,' I said, 'you can't be serious.' Whereupon he leaned over and gave instructions to the chauffeur. As we drove through one of those typically sprawling villages, we decided to stop in the next square. I had lamented not having the opportunity to drink the marvellous Romanian sour milk in the typical semi-Western hotels which we had been frequenting, so our guide walked to the nearest farmhouse, and within minutes we were all drinking it out of wooden beakers. 'She says, will you stop for lunch?' said Big Brother. And indeed we were invited to eat with the peasants, but I regretfully declined as to do so would have necessitated a rather lengthy stop. The outcome was that we persuaded Big Brother to stop taking us to the bland, Western-type restaurants which he thought we preferred and to introduce us instead to traditional Romanian food. Luckily for us, he was completely familiar with the local delicacies, and had, as it turned out, escorted sundry Western visitors up and down the country to every special tavern and restaurant in the land. However, I do think that the authorities were very puzzled by our activities. Certainly Big Brother had to telephone his headquarters on a regular basis to report on our progress. On one occasion I remember him politely putting in his request for a trunk call in the local telephone office and flashing his official ID card

to the operator. On seeing it, the girl blanched, and within thirty seconds the call went through. 'It's revolting,' he said, 'I hate doing this, but if I didn't we would be waiting all day.'

'I must take you to a collective farm,' Big Brother said one day. We protested that we did not want to see a collective farm, but off we set nonetheless, across country on an appalling road, carefully avoiding the gigantic potholes, since if we had an accident there would be no hope of getting the Opel repaired. On our arrival we were offered the most spectacular local cheese, and the whole experience was delightful. We then moved on to Alba Julia nearby, where we met the local commissioner, attired in a snappy military uniform with long leather boots which he would swat with a leather whip. He found us all very entertaining. 'Why don't you just come and live here and we'll soon fix your manuscripts for you?' he laughed. The inn where all the locals were drinking was the kind of tavern that had been promised by Big Brother; the food was delicious and the cost virtually nothing. Nevertheless, Renée King came back from the toilet looking rather green, and when I took my turn I saw what she meant: the shit was six inches deep and you could hardly reach the lavatory bowl without wading through the stuff.

Our first real library with useful sources was situated in Sibiu (Hermannstadt), where Füssl and I simply fell over the manuscripts. I soon started examining the watermarks and, looking over my shoulder, I realized that the minders had meanwhile multiplied. I asked them if they could identify the watermarks and, after much rapid conversation, they replied, 'Wait until after lunch.' Imagine our individual and collective astonishment when a trembling white-haired professor from nearby was produced. He explained that the watermark which I had found but did not recognize was from a local eighteenth-century mill. The minders were stupefied – I really must be a scholar, not a spy. The identification of obscure eighteenth-century Romanian watermarks from a paper mill operated under the auspices of Baron Bruckenthal near Sibiu would certainly have been beyond the scope even of the CIA.

After that incredible episode we attracted two cars full of minders. Together we ate superb cheeses and *castravetz* (sour pickles, which have to be eaten to believed), and drank *mostul* in remote taverns. Eventually, we arrived back in Oradea Mare at the monastery where the Haydn manuscript

was supposed to be located. We talked to the monks, but they pretended never to have even heard of an autograph score of a Mass by Haydn dated 1766: 'Now I hear you live in Tuscany. How fascinating to be near so many Etruscan ruins. Have they made any progress with identifying the language?' Undeterred, I continued my prompting. 'The Haydn Mass …' 'Well yes,' said the Prior, 'I do have a small present for you.' We stepped forward eagerly, only to be given a book on the Etruscans. 'Let me assure you,' said Big Brother No. 1 later on, 'if that manuscript is in the country, we will have a photograph of it in your hands within the month. Those wretched monks, *they will talk.*' I asked him how he proposed to induce them to divulge their information. 'Well, we do have our methods, you know,' he concluded grimly. Later, when I ran out of fuel, one of the minders had to accompany me to the nearest petrol station, where he refused to allow me to pay the bill. When I protested, he said, 'It's my pleasure, and I'm only sorry that you didn't get to see the Mass. But you will.' When we arrived at the border, the two cars full of minders remained behind; as we left, they stood waving, as if in a Hollywood film, until we were out of sight.

In the end we did receive the film of Haydn's *Missa Cellensis* of 1766. The score had in fact been privately owned by a monk, which explained the other monks' reluctance to divulge any information, but diplomats at the Swedish Embassy in Bucharest finally persuaded him to disgorge the manuscript, and proceeded to have photographs taken and brought out of the country. A member of the Embassy staff who had come to Italy to visit relatives met me at Pisa airport, and handed the parcel directly to me as she stepped off the aircraft. We subsequently published a facsimile of this vitally important Mass fragment in the *Haydn Yearbook*.

Deciding to move to Italy, a country I loved, I had bought a house in Tuscany in 1960. The time had come to say farewell to all my friends in countries behind the Iron Curtain and diplomatic representatives who had been so helpful in recent years. I went to see the Press Attaché at the Hungarian Embassy in Vienna to tell him that I was moving, and showed him pictures of my new house. As we began to reminisce, the subject of espionage arose. 'Why were you never tempted?' he asked. 'Well, it wasn't for their lack of trying!' I replied. My friend turned and pulled out a bottle of peach brandy and two glasses. 'Are you sure you should be telling me this?' he asked. I replied that I had supposed it normal for someone in my

situation, with particular reasons for visiting Eastern Europe, to be approached as a potential recruit. 'Why did you refuse?' he asked, and I answered that firstly, I loathed spying as a matter of principle, and secondly, it seemed to me that to indulge in it would be a particularly dreadful way of repaying hospitality of the kind and quality which I had been shown, especially in Hungary. There ensued a rather long pause. The attaché concluded quietly, 'We always knew you were not a spy.' He stood up and we embraced. 'Come back to us soon,' he called out as I left his office.

* * *

When I crossed the Romanian border thirty-eight years ago, there was no reason to expect an end to the Cold War in the foreseeable future, and I never anticipated going back to Eastern Europe; in the event it was to Hungary that I first returned – long before the Berlin Wall fell – in 1978 to undertake research in Budapest and, later, in April 1989, to make a TV programme at Eszterháza with Christopher Hogwood and the Academy of Ancient Music. I visited Prague again only some years afterwards, but by the time I revisited Budapest in the 1990s everything had, of course, changed completely, and it was a delight to see young people moving about freely: one could hardly imagine that life in the city had ever been controlled by the secret police. We strolled about the old part of Buda and revelled in Hungary's new-found freedom. There was no longer any need to look over one's shoulder.

Broadcasting: BBC radio 1954–58 and television 1963–82, and other programmes

I was introduced to the BBC by Donald Mitchell, who was then music editor with the publishers Barrie & Rockliff. One of his many friends was Roger Fiske, the writer on music whose successful books for the classroom later enabled him to retire from his position as producer of radio talks for the BBC. My first meeting with Fiske was in 1954 and I began broadcasting for the BBC Third Programme that year. I had the idea of creating some very elaborate and expensive programmes which, I hoped, would introduce a new kind of 'advanced' musicology to radio audiences. It was a very bold idea at the time, but the BBC (with Roger Fiske as producer) decided to proceed with the project. The first series, broadcast in April 1956, consisted of four orchestral programmes which, with the help of live performances, illustrated the history of the pre-classical symphony. Much of the music had to be specially scored for the purpose, and when choosing the works to be included I enlisted the services of an American colleague, Jan LaRue, who was working in Vienna and making what he called a 'locator' catalogue for all 10,000 known classical and pre-classical symphonies (the 'cut-off' point being roughly the year 1800). A large part of the musical content of these four programmes was then completely unknown to modern audiences and had hardly been performed since the eighteenth century. The modern editions of the works published subsequently were based on the material used in the BBC programmes. In order to help convey some sense of the ambitious nature of the series of programmes, it may be of interest to set out in summary form their musical content and some of the points of historical importance which I included in my introduction to each of the works performed.

The first programme, broadcast on 5 April, featured the Kalmar Chamber Orchestra, conducted by Colin Davis and with Charles Spinks (harpsichord). Following recorded extracts from J.S. Bach's *The Art of Fugue* and Haydn's Quartet Op. 1, No. 1, which were used to demonstrate the great changes that occurred in the eighteenth century as the late baroque gave way to the 'pre-classical' style, the orchestra played Francesco Conti's Overture (Sinfonia) in B flat to the opera *Pallade trionfante.* Although the Sinfonia is in typical Italian form in three movements, the opera was first staged in Vienna (where the composer lived and worked for many years) and enjoyed considerable popularity there for some twenty years after its première in 1722. Significantly, the first movement of the Sinfonia, despite its baroque style, clearly anticipates sonata form when Bach was at the height of his powers in north Germany. The second work, Giovanni Battista Sammartini's Symphony in F for strings and harpsichord, is also in three movements. Taken from a volume published between *c.*1740 and 1744, this symphony was composed primarily as a concert piece. A characteristically south European feature of this symphony is the use of the relative minor in the second movement, marked Andante. In Viennese and Italian symphonies of that time the relative or tonic minor was generally limited to the slow movement, perhaps employed to suggest a touch of pathos but no real sense of passion; in north Germany, however, minor keys served to convey a feeling of seriousness, even tragedy. The final movement of the Sammartini symphony is marked Allegro assai and is in 3/8 time, this being a typical pre-classical tempo, also found in many of Haydn's early symphonies but which was gradually abandoned as the emotional scope of finale movements broadened.

The second half of the programme included performances of two pieces by Austrian composers written at about the same time as Haydn's earliest works in symphonic form. The first item was Florian Leopold Gassmann's Sinfonia in D from his three-act opera *L'Issipile*, written in 1758 for the Teatro San Moisè in Venice. This work, by a Bohemian-born composer resident in Italy, is remarkably similar to Haydn's Symphony No. 1 in D, also in three movements and almost identical in its overall layout, the first movement being significantly longer than the other two. A particularly striking feature common to both works is an opening Mannheim crescendo, which could well suggest that this device in fact originated in Italy. The

final work was an early example of the Viennese concert symphony, composed *c*.1760 by Leopold Hofmann. It consists of four short movements of roughly equal length, without the opening emphasis seen in Gassmann's Sinfonia and therefore with greater though not disproportionate weight placed on the finale. Hofmann thus stands at the threshold of the early Viennese classical style, which was to be explored further in the third programme in the series.

Meanwhile, the second programme, broadcast on 10 April, was given by the London Mozart Players under Harry Blech, again with Charles Spinks at the harpsichord. The focus of attention in the first half was the famous Mannheim orchestra, which Charles Burney described as being 'so deservedly celebrated throughout Europe' and which had impressed Mozart greatly when he visited the city in 1777. The orchestra was noted not just for the striking *crescendo* and *diminuendo* effects that we normally associate with the name Mannheim, but for the great precision and virtuosity of its players generally.

The opening work was a four-movement Symphony in D by Johann Stamitz (1717–57), a gifted and prolific Bohemian-born composer who made frequent and effective use of the famous Mannheim crescendo; he also regularly included a minuet movement and must have been a strong influence on other composers who adopted this practice. The symphony chosen was published in Paris in 1757 as Stamitz's Op. III, No. 2, but must have been composed several years earlier. This version lacked the minuet movement and the parts for oboe, trumpet and timpani, and the performance as broadcast relied on the complete manuscript parts preserved in the Prince Thurn und Taxis Library in Regensburg.

The second composer to be featured, Ignaz Holzbauer (1711–83), had a Viennese background and was Director of the Court Opera there from 1745 to 1747, and was later Kapellmeister at the electoral court in Mannheim (1753–78). His orchestral writing is never far from the opera, as seen in the second movement of his Symphony in E flat. This Adagio maestoso e grazioso, serious in tone and hinting at the intensity of works in the 'Sturm und Drang' vein of the late 1760s and 1770s, is strongly reminiscent of accompanied recitative, while the finale, marked 'La Tempesta del mare' is a programmatic movement that suggests Holzbauer's familiarity with the Mannheim style after having become acquainted with works by Stamitz.

The first of the two works making up the second half of this programme involved a geographical leap from south to north Germany, specifically to the court of Frederick the Great in Berlin and Potsdam, where J.S. Bach's second son, Carl Philipp Emanuel, spent much of his working life. Born in 1714, C.P.E. Bach was a close contemporary of both Stamitz and Holzbauer. His place in musical history is, however, assured more by his influential theoretical writings than by his compositions, among which the somewhat later Symphony in F of 1776 betrays a conservative style and outmoded features such as the retention of a (fully written out) part for harpsichord, while the slow movement is notable for its baroque quality. In essence this work, which is in three movements only, represents a reaction against the more progressive trends in much of the new music then circulating within Europe: thus the inclusion of a minuet movement is deliberately avoided.

In complete contrast to the more serious approach of C.P.E. Bach, the final composition was light-hearted in the extreme: Leopold Mozart's 'Toy Symphony' of *c*.1760 was receiving its first performance in the original version in modern times. The earlier attribution of this work – correctly a Cassatio in G – to Haydn had been superseded by the then recent discovery (in the Bavarian State Library in Munich) of a complete set of manuscript parts bearing the name of its true author; among these were parts for two horns (not previously known) in addition to the familiar strings and toy instruments. Thoroughly Austrian in feeling, this Cassatio is a typical example of the multi-movement divertimento of the pre-classical era, in this case featuring minuets, folk-tunes and a characteristic posthorn call.

The third programme in the series was heard on 18 April, the performers being the Boyd Neel Orchestra with Thurston Dart (harpsichord) conducted by Charles Mackerras. It continued the theme of the first programme – the symphonic form developed in Vienna based on Italian models and showing many features typical of the early orchestral works of Haydn and Mozart. One such symphony by Haydn, an unnumbered work in B flat composed betweeen 1757 and 1761, had in fact been published in Paris as a string quartet (Op. 1, No. 5), achieved by the simple expedient of omitting the wind parts (oboes and horns). I had been able to reconstitute the full score from a set of parts used for a performance at St Florian Abbey in 1767, and it was in this form that the work received its first British

performance in modern times. The symphony, in three movements, is historically interesting because it shows, among other things, Haydn's essential conservatism at this early stage in his career, evidenced by the absence of a minuet and by the work's old-fashioned orchestral texture. Haydn had yet to emerge as the leading figure among Viennese composers of the time; only in the early 1770s did his true stature become apparent.

Such was not the good fortune of Haydn's contemporary Carlos d'Ordonez (1734–86), born in Vienna of Spanish parents. Totally forgotten by posterity, he had been widely known in Europe during his lifetime. For this programme a Symphony in C major was chosen as an example of the great baroque antiphonal tradition, featuring many novel instrumental effects and a conscious attempt to connect the first and last of the three movements both thematically and rhythmically. Here the antiphonal use of three instrumental choirs has its roots in the old Venetian tradition, and this symphony – probably intended for performance in a church – may well have been the last of its kind.

Moving away from Vienna, the baroque tradition also continued into the mid-eighteenth century in the provincial – though not musically backward – town of Salzburg. Joseph Haydn's younger brother Michael was active there in the 1760s, but for the purpose of the broadcast a later work, an unpublished Symphony in D dating from the early 1770s was chosen. Two sets of manuscript parts had recently been discovered in the Benedictine monastery of Lambach, and a full score of this attractive piece was prepared from them. It reveals many points of similarity with Mozart's orchestral writing in the mid-1770s and in all probability would have been known to him. Another interesting feature of this symphony, in three movements, is that it opens with a slow introduction, a formal device which Joseph Haydn began to employ with increasing frequency from *c.*1774.

The last work in this programme was chosen to illustrate the 'Sturm und Drang' phenomenon of the late 1760s and 1770s, characterized by the frequent use of minor keys and intensified emotion. Rather than offer a symphony such as Mozart's No. 25 in G minor (K.183) or Haydn's No. 39 in the same key, we chose an example by one of Vienna's leading composers of the day, since largely forgotten, Johann Baptist Vanhal (1739–1813). His Symphony in G minor, catalogued by Breitkopf in 1771, is scored for four horns, not the usual two – a characteristic in common with the works by

Mozart and Haydn which enables the composer to write for two horns in G and two in B flat alto. By this means the composer has horns available in the relative major, and by clever manipulation of the available open notes of the harmonic scale he can create all manner of sustaining chords. In essence the use of minor keys is symptomatic of a fundamental change of symphonic writing, which now does not seek simply to entertain and delight the ear but reflects deeper intellectual concerns – a trend which would develop and continue into the nineteenth century via the later works of Haydn and Mozart and, after them, Beethoven.

The last of this series of programmes was given by the London Chamber Orchestra conducted by Anthony Bernard, with Charles Spinks at the harpsichord. The works chosen were intended to explore the concept of the 'galant' (typified by the courtly brilliance of Mozart's 'Posthorn' and 'Haffner' Serenades) contrasted with two further examples of 'Sturm und Drang' intensity. The opening work was an early 'galant' piece by Carl Friedrich Abel, probably written shortly after his arrival in England in March 1759 – his Symphony in F, published as Op. 1, No. 5. The concerts presented in London by J.C. Bach and C.F. Abel were a famous institution and the young Mozart will have heard their compositions during the family's visit in 1764–5. Abel's symphony is in three movements, the finale being an Allegretto in 3/8 time which retains a courtly minuet atmosphere both in its metre and tempo and in its melodic construction.

As a contrast, the next piece was a 'Sturm und Drang' work published in 1764, the Symphony in G minor (Op. 4, No.1) by the Belgian composer and violinist Pierre van Maldere, who travelled widely within Europe. This work is notable for its distinctly Austrian character, but the choice of key and the serious, intense style of the music ante-dates almost anything comparable in the Viennese context. The last two compositions represented an intensification of the 'galant' and 'Sturm und Drang' tendencies, exemplified by J.C. Bach's Symphony in E flat (Op. 9, No. 2) dating from *c.*1770 and Franz Beck's Symphony in D minor (Op. 3, No. 5) written before 1761, both of which contain the germs of what I termed 'unity within diversity', in the sense that each contains great diversity within its stylistic type.

J.C. Bach's music has a strength, grace and sense of form that reveal him as superior to his compatriot, Abel. Thanks to the efforts of the German

scholar Professor Fritz Stein, Bach's reputation was restored in the 1930s. No longer was he rated as merely superficial and inferior to his brothers, and the influence he had on Mozart – as well as the latter's glowing opinion of him – speaks for itself. Franz Beck, on the other hand, is virtually unknown today. An almost exact contemporary of Joseph Haydn (both men died in 1809), Beck spent most of his career in France, where he wrote some thirty symphonies in the space of less than ten years, the last of them being published in Paris in 1766. His music showed great originality, and the curious and involved harmonic structures he employed, as well as the violence and dramatic force of symphonies in minor keys, must have come as considerable shock to audiences accustomed to the typical Italian sinfonia with its lightweight finale in 3/8 time. Beck composed in minor keys in order to extend the emotional scope of his music, and the extreme dynamic range heard in the performance of his Symphony in D minor is based entirely on the original edition. Unfortunately, the parts for oboe and horn are missing and the performance was restricted to strings with harpsichord continuo. Nevertheless, the hope was that the inclusion of this unfamiliar, but characteristic work by a neglected composer would serve to stimulate fresh interest in his symphonic output as a whole.

Over forty years after the event, it is fair to say that for many reasons such an ambitious series could hardly be mounted today in any country, not even by the BBC. It is perhaps worth recalling that André Malraux once dreamed that radio and television would become the great disseminators of culture in the latter part of the century. His dream has not been realized and in reality the situation has worsened considerably, a contrast which is especially apparent when one looks back to the second series of expensive and elaborate programmes that Roger Fiske and I undertook for the Third Programme, namely the five-part Haydn series of 1958 ranging from opera to chamber music. As had happened previously, much of the music that was featured in that series had to be specially scored with newly prepared parts for live performances.

* * *

In 1964 Hans Keller, who was then a producer for the BBC Third Programme, suggested my name to Humphrey Burton, a producer of arts

programmes at BBC Television. After a long series of negotiations, mostly on the telephone between London and Vienna, we worked out an agreement satisfactory to both parties (this was before the days of agents, at least for unimportant individuals such as myself). The following list shows the hour-long feature films on individual composers that I planned for BBC Television, but does not include the single programmes, mostly of topical interest, that we made together during the period.

1964: Haydn 'Workshop' series – with Raymond Leppard, harpsichord (Concerto in D major); BBC Symphony Orchestra conducted by Charles Mackerras; producer Humphrey Burton; director Barrie Gavin; repeated 13 April 1965.

1965: Vivaldi 'Workshop' series – with BBC Symphony Orchestra conducted by Charles Mackerras; director Francis Coleman.

1965: Mozart 'The Rise and Fall of Wolfgang Amadeus Mozart'; co-production with Austrian Television and with a complete German-language version also introduced and narrated by HCRL. Directed by Barrie Gavin. Also shown in the USA, where an abridged version is commercially available on cassette.[1]

1966: Monteverdi; co-production with Austrian Television and others. Shortlisted for Prix d'Italia in 1967. Directed by Christopher Burstall, filmed on location April–November 1966 in Venice, Mantua, Cremona, Buggiano Castello etc.

1969: Three films on Beethoven, directed by Barrie Gavin.

1981: Mozart series for BBC2 (producer Mervyn Williams):
5 July 'The Taste of Death on my Tongue'
documentary on Mozart's last year, filmed in Vienna and elsewhere
5 July Mozart workshop, with Sir Colin Davis
also with artists from the Royal Opera House, Covent Garden, preparing a new production of *Don Giovanni*
8 July Quartet in C major, K.465 ('The Dissonance')
with the Amadeus Quartet, recorded at Tredegar House in Gwent

9 July Masonic Funeral Music, K.477; Adagio and Fugue in
C minor, K.546; Symphony No. 39 in E flat, K.543
BBC Welsh Symphony Orchestra conducted by
Andrew Davis, recorded in Llandaff Cathedral, Cardiff

10 July Serenade No. 13 in G for strings, K.525 ('Eine kleine
Nachtmusik'); Symphony No. 38 in D, K.504 ('Prague')
Academy of Ancient Music co-directed by Jaap Schröder
and Christopher Hogwood

11 July *La Clemenza di Tito*, K.621
Filmed in the ancient Forum of Rome and the baths of
Caracalla with Eric Tappy, Carol Neblett, Tatiana Troyanos,
Anne Howells, Catherine Malfitano and Kurt Rydl; Vienna
Philharmonic Orchestra conducted by James Levine

12 July Requiem in D minor, K.626
Workshop and performance including sections
completed by Eybler as well as those by Süssmayr; with
Meryl Drower, Eirian James, John Elwas and Stephen
Varcoe, and the London Classical Players; introduced
and conducted by Roger Norrington

14 July Piano Concerto in D minor, K.466
With John Lill, and the BBC Welsh Symphony
Orchestra conducted by James Lockhart, recorded in
the Brangwyn Hall, Swansea

17 July Mass in C minor, K.427
With Margaret Price, Marie McLaughlin, Ryland Davies
and Gwynne Howell; BBC Welsh Symphony Orchestra
conducted by James Lockhart, recorded in Worcester
Cathedral

17 July Concert performance of arias from Mozart's later operas
With Kiri Te Kanawa, Stuart Burrows and Thomas
Allen; BBC Welsh Symphony Orchestra conducted by
Robin Stapleton

1982: Haydn series for BBC2 (producer Mervyn Williams):
31 March '…the result of dire necessity'
Documentary on the early years of Haydn's life and
musical career, filmed in Austria

1 April Quartet in C major, Op. 76, No. 3 ('Emperor')
With the Amadeus Quartet, recorded at Tredegar House in Gwent

2 April A Haydn Recital
Four Welsh folk-song arrangements – first performance in modern times, with Stuart Burrows, John Constable, Ralph Holmes and Raphael Wallfisch. Baryton Trio No. 4 in D (Hob. XII:5) with Riki Gerardy, and Andante con Variazioni in F minor with Linda Nicholson (fortepiano)

3 April *The Creation*
With Margaret Marshall, Robert Tear and Gwynne Howell, and the BBC Welsh Symphony Orchestra conducted by Andrew Davis, recorded in the Brangwyn Hall, Swansea

5 April *Missa in tempore belli* ('Paukenmesse')
With Marie McLaughlin, Helen Watts, Wynford Evans and Willard White, and the BBC Welsh Symphony Orchestra conducted by Raymond Leppard, recorded in St David's Cathedral, Pembrokeshire

7 April Symphony No. 44 in E minor ('Trauer'/'Mourning')
The Academy of Ancient Music conducted by Christopher Hogwood

8 April Trumpet Concerto in E flat; Symphony No. 104 in D ('London')
With Maurice Murphy (soloist), London Symphony Orchestra conducted by Sir Colin Davis, recorded in Llandaff Cathedral, Cardiff

1984/5: How *Messiah* was born – a film about Handel's oratorio, mostly shot in Ireland but also in Chester and Parkgate (formerly a small port), through which the composer passed en route to Ireland.

* * *

I had met Hans Keller, that extraordinary Austrian-born musician, through Donald Mitchell, who was his collaborator on a sophisticated journal entitled *The Music Survey*. A few years later Mitchell and I edited a *Mozart*

Companion (1956), to which Keller contributed a long article on the chamber music. His mind was, as they say, rapier-sharp and his command of English positively phenomenal. Unlike most musicians of the day, he admired Haydn and Mozart in equal measure. He would even insist – wrongly, I think – that Haydn was the greater composer. My assistant Siân Walters remembers her own childhood experience of being taken by her parents to a lecture at the Yehudi Menuhin School, where Keller was discussing this very subject. When a member of the audience, encouraged to ask questions or comment, dared very modestly to query his assessment, Keller grew furious and raged at the unfortunate and very embarrassed man for several minutes. This kind of thing happened frequently – indeed, on one occasion at University College in Cardiff, Professor Michael Robinson was subjected to a similar harangue. My own experience of Keller's strongly held view came in the form of a comment scribbled in the margin of a paper that I had written, discussing the comparative virtues of Haydn and Mozart: 'How *can* you say that Mozart is a greater composer than Haydn?' he demanded.

When Keller joined the BBC Third Programme, I was often asked to devise programmes for him to produce. We worked well together and often met socially, and it was then that I really got to know the man and his intense loyalties for persons, ideas and ideals. This was a particularly Jewish trait, he used to maintain. He defended the music of Mendelssohn to the death and considered that the Violin Concerto was the very best of its kind. With this fierce loyalty went an almost vindictive hatred for everything else that did not conform to the Kellerian standard. Most of early Mozart was 'abominable'; Vaughan Williams's analysis of Beethoven's Ninth Symphony was savaged, and the Danish scholar Jens Peter Larsen was annihilated (Larsen thereupon forbade his students to consult *Music Review*, a publication to which Keller was a regular contributor). All of a sudden, thanks to Keller, the BBC was playing music by Berg and Schoenberg, while the 'soppy' English school was relegated to the back shelf.

I never quite understood why Keller approved of me. In a professional capacity, he read my first book, *The Symphonies of Joseph Haydn*, making excellent comments and giving constructive advice, particularly on the translations of eighteenth-century German into English. Later he agreed to act as co-editor for my new critical edition of Haydn's string quartets for

Doblinger, but unfortunately he had read the proofs for only one set of the works before his untimely death in 1987. He was a brilliant critic and I am sure it is true, as many of his former colleagues maintain, that he set an entirely new standard of musical criticism in England. Naturally, he made fierce and bitter enemies. Once, my late and delightful friend Alec Hyatt King invited us to dinner with Alan Frank, then music editor for Oxford University Press. 'What have you been doing?' Frank asked me. I told him that I had been working on a *Mozart Companion* with Donald Mitchell and Hans Keller (Keller was supervising the translations of texts by German contributors, of whom there were several). 'Oh, with the shits,' said Frank. 'Pity, we would have been delighted to publish that book.' In reality, OUP would certainly never have taken on the book, at least not in the form in which we had written and edited it.

Keller's *Lebensgefährtin* was the artist Milein Cosman, and they made a delightful couple. I never had a dull evening or lunch, or even working session in their company – they seemed to set off a perpetual shower of sparks. One of the last times I saw them together was in 1980 at a brilliant reception given to celebrate the completion of my five-volume biography, *Haydn: Chronicle and Works*. The chairman of Thames and Hudson, Eva Neurath, hosted the party which was held in her eighteenth-century house in Highgate, and I remember thinking that it would be a long time before I could hope to see such a scintillating group of intellectuals together again: a gathering like this would have been difficult to match in any other country. I worked out that at least half the guests present on that memorable occasion could speak three languages fluently. We were staying with Eva, and later that weekend we went to a one-woman show by Milein Cosman, where I bought a striking sketch of Igor Stravinsky which now hangs in the upper corridor of my home in France.

The main principles that characterized the BBC in those years are particularly apparent in retrospect, since almost all the ideas and precepts have changed dramatically. At that time the BBC was a completely non-commercial organization, dedicated to culture and to spreading the intellectual ideas which it believed were important via the medium of television. This was why the kind of programmes that involved my participation came to be made, for they could hardly be described as best-sellers in terms of audience figures. The BBC displayed a great sense of

adventure in the 1950s. It was a fairly new idea to make composer films on such a scale, and for the Haydn and Vivaldi programmes entire orchestras were used for live performances, with solos on such instruments as the harpsichord (played by Raymond Leppard in the Haydn film). The films were therefore not cheap to produce; on the contrary, a lavish amount of time was spent on perfecting every detail. For example, we often needed to show original documents, and the BBC went to enormous trouble to secure the correct equipment for what was then called 'bench work' – the propping up of the material in question so that it could then be photographed. All in all, great precision was required of everyone concerned, and particularly of the editor once the filming was over.

The BBC was also extremely generous, not particularly with regard to remuneration, since like everyone else I was paid quite modest fees at that time, but in other respects. For example, they would readily fund long periods spent filming on location; when we were working on the Monteverdi film, we spent six months in Italy, living very comfortably in charming hotels where delicious food was served. When the filming came to an end, the crew were very sad to leave, since we had all become very fond of each other, as often happens on these occasions. The great rains of 1966 which were to lead to the disastrous Florence flood had just started and, as we were about to depart from Venice my assistant, Christine Swenoha, had tears streaming down her face. One of the rather hardened camera assistants tried to cheer her up, saying, 'Come on, it's not the end of the world.' To this she replied quietly, 'It's the end of *mine*.'

The flooded condition of the Italian rivers at that time made it impossible for me to contact Christine for the next six weeks, since she was stuck on one side of the Po and unable to get across. Ours was one of the last cars to cross the river before it became impassable, and I remember that there were police all around watching closely to make sure that we did not get swept away. When we arrived home we looked out over the parapet of our house, situated on the edge of a hill town in Tuscany, and saw that the entire valley below was flooded to such an extent that it resembled a vast lake. When it became evident that the city of Florence was indeed in dire straits, a friend of mine suggested that I become the President of the Anglo-American committee, formed to raise money to save its treasures. We set about writing letters to various people, including Herbert von Karajan, who

agreed to give a concert in aid of this cause, and the organizers of the Salzburg Festival. The mayor of Salzburg donated two marvellous snow-machines which, when operated in reverse, would suck up water and then disperse it elsewhere, out of harm's way. Everybody who could do something practical to help did so. In Budapest the authorities had no money to send us, but they arranged for the services of an expert book-restorer to be made available; he stayed for over a year working on the restoration of the ruined bindings of books from the Florence libraries. Our offices were in the British Consulate, whose director at that time was Christopher Pirie-Gordon, a most elegant and sophisticated man with wonderful ideas. Edinburgh, Florence's twin city, kindly sent us an enormous quantity of items such as paraffin stoves for use in the homes of flood victims. We used the American church of St James as a centre for storing the goods before they were collected for distribution. This we did ourselves without charge, as we were all volunteers. The fact that no payments had to be made meant in turn that we were not liable to pay any taxes on the operation. Naturally, the Italian authorities were delighted to receive our help during such a critical period. In response to my request, George Szell sent a generous donation which he asked us to devote to the saving and restoring of musical instruments, and my family in America were equally liberal with their gifts of money.

Although most of our BBC film projects were completed in collaboration with other companies, this was not the case at the filming stage, but only after the programmes had been edited. It was while making the Monteverdi film that the BBC producer, Christopher Burstall, taught me to speak to the camera without the aid of a teleprompter or autocue. We were in Mantua at the time, and I was doing a quite complicated sequence using a teleprompter. Because he was not at all happy with the result, Burstall suggested that I speak *ad lib*, but arranged for a small slate with important dates written on it to be placed near the camera for reassurance. The first day was terrible, the second day was slightly less awful, but by the third day I had learned how to do it. Since then I have never used notes for any programme or lecture.

The film turned out to be rather a success, and it marked the end of an important period for the BBC since Humphrey Burton, who had produced my Haydn series in 1964, left his post as Head of Music and Arts

Programmes and was succeeded by John Culshaw, the former head of Decca Records, who was interested in concentrating on other projects. For example, he was responsible for persuading Britten to write *Owen Wingrave*. As a result of this change of direction, I did not work again for the BBC for quite some time. Meanwhile I sold my house in Italy (which was really far too big to manage) and moved first to a cottage in Austria to finish my Haydn biography, then to Wales to take on the position of John Bird Professor of Music at University College, Cardiff. While there, I received an unexpected telephone call one day from the locally based BBC producer Mervyn Williams, who was keen to work with me on a project in which a series of programmes would be dedicated to one particular composer and transmitted in each case within the space of a week. These two elaborate and successful series of programmes for BBC2 were followed by a film on Handel's *Messiah*, the making of which led to some hilarious moments. We spent some time on location in Ireland, where Guinness was consumed in quantities that, even now, do not bear discussion. Again, when the filming was over we were all very sad to part and go our separate ways; in my case this involved the decision to stop teaching and settle in France.

One of my last films for BBC Cardiff was bound up with the curious story of a set of string quartets known as Haydn's 'Opus 3', published in Paris in 1777. These quartets included the famous 'Serenade', but the trouble with the Opus 3 set was that no one was fully convinced that it was genuine Haydn. True, Haydn's pupil Ignaz Pleyel, who lived in Paris for the latter part of his life and became a successful music publisher, had included Opus 3 in the first collected edition of Haydn's quartets; true, a thematic list of this Pleyel edition had been entered by the composer's copyist Johann Elssler into the list of 'authentic' quartets recorded in the so-called 'Haydn Catalogue' of 1805. Nonetheless, there was something very odd about these works: they did not ring true. Musically, they sounded like Haydn, but were somehow slicker and smoother. Furthermore, there was not a single contemporary manuscript source for any of them. If we consider other Haydn quartets of the period, specifically the so-called Opus 1 and Opus 2, there are literally dozens of contemporary manuscript parts including several corrected by the composer, but for Opus 3 there was nothing before the print of 1777.

One day in 1963, my colleague Alan Tyson informed me over drinks at his London home that he had just purchased a copy of the first edition of Opus 3. I eagerly waited for him to produce it, and when he did so I held it up to the light to check the watermarks. Great was our astonishment when we found the following – 'Quartetto per due Violini Alto e Basso del Signor Hofstetter [*sic*] / Violini Primo [etc.] / No. 1 [etc.]' – clearly engraved underneath the name of Haydn. This first edition, by Bailleux of Paris, had arrived in the French capital under the name of Hoffstetter, but when it was realized that the music was 'Haydnesque', Hoffstetter's name had been removed from the engraved plate and substituted with that of the far more popular Haydn. Tyson and I published the new attribution, much to the astonishment of the scholarly world, in *Musical Times*.[2]

One can easily imagine the sudden interest aroused by this new name in the Haydn galaxy. He turned out to be Pater Roman(us) Hoffstetter (1742–1815), a monk at the monastery of Amorbach in southern Germany who had been a passionate admirer of Haydn's music. A long correspondence between Hoffstetter and a friend was discovered and published, and in a short space of time a great deal of information about this modest German monk came to light.

To commemorate the 150th anniversary of Haydn's birth in 1982, Mervyn Williams decided to do a documentary on Opus 3, engaging me as narrator and scriptwriter and the Endellion Quartet to perform the musical examples. We went to Amorbach with the intention of filming the project with narrative in English, German (for a television station in East Germany) and Welsh. Amorbach, with its grey abbey church and beautiful eighteenth-century monastery precincts, proved to be thoroughly photogenic. It was a memorable film trip, but when we returned to edit the programme it became clear that BBC headquarters in London did not approve of the project at all – no one quite knew why and the film was not allowed to be shown on television. This outcome was regrettable, since we had managed to film not only the beautiful German monastery but also the original Hoffstetter/Haydn plates of the first edition, in which the altered attribution could be clearly seen superimposed on the Hoffstetter original.

CBS in New York had at one time initiated a scheme to make a television programme or a series on music in Venice, but in the end nothing came of the idea because, as usual, commercial television companies in America

were (and still are) very sceptical about finding sponsors for programmes devoted purely to classical music. I had written an outline draft treatment which I deposited with my London literary agent, Hilary Rubinstein of A.P. Watt. He soon came up with someone who thought that the idea could be realized and sold to British television as a series – even as a commercial enterprise. It was with this project in mind that the amazing, swashbuckling and delightful figure of Tony Sutcliffe, an experienced film producer and director, entered my life.

Tony worked freelance and had directed a large number of films for all sorts of companies. He always had a beautiful young woman in tow, and indeed had pursued women all his adult life. He once told me a story that sums up Tony *à la chasse* perfectly. He had been chasing a very well-connected girl who lived in a stately home in the north of England (she also had sundry other suitors, being an exceptional catch), and was invited to stay overnight at a house party, together with several other young men. It grew late, and Tony, who had consumed a great deal of wine and whisky, managed to find his way upstairs to his room and flop down on the bed, falling asleep within minutes. In the early hours, he woke up needing to relieve himself, but to his horror could not remember where the bathroom was. He peeped out into the hall, only to find a formidable number of doors, all alike and every one of them shut. He came to a sort of alcove and decided to take a chance. He was in mid-flow when the door slowly opened, revealing his potential father-in-law, the urine gaily splashing over his ancient toes. 'I think you had better leave, Tony,' said the girl at breakfast later that morning.

Tony was beginning to prepare a budget for the Venice series and needed more information from me. We had just moved to Foncoussières, our new home in the Tarn, but the furniture had not yet arrived. The previous owners had kindly left us some furniture in the maid's room but we were not in a position to put anyone up, so Tony had a room at the local hotel, the Pré Vert, where my wife and I had stayed happily in 1985 while sorting out the contract for the house purchase. In the evening, we would sit on the steps in front of the house, drinking the local wine and working on the budget. As well as an enormous capacity for hard work, Tony had a healthy appetite for life, and as time went by it became an increasing pleasure to work with him. Our film series slowly began to take shape, and we decided

to make five programmes arranged chronologically. Each one would concentrate on one of five centuries – the sixteenth, seventeenth, eighteenth, nineteenth and twentieth – and feature a specific composer, respectively the Gabrielis, Monteverdi, Vivaldi, Verdi and Stravinsky. Naturally, the Vivaldi programme did not exclude Cimarosa, but we considered that every programme must have a particular focus. It was also imperative that each be shot on location in Venice itself.

When he returned to France in 1988, Tony brought along his new American girlfriend, Jillian Robinson, whose parents had been in the film business in Chicago. She was good-looking, intelligent and very sharp. They decided to get married and proceeded to form a new company in England called Robclif Productions (an amalgamation of their surnames). Within a short space of time Channel 4 and a French television network (La Sept) had taken on our project, which could now finally become a reality. Meanwhile, I had travelled to Hungary to take part in a series about Haydn for Decca and the ITV South Bank Show, with Christopher Hogwood and his period orchestra, the Academy of Ancient Music. This very costly series was filmed at Eszterháza Castle, and while most of the participants were put up in various hotels in the neighbourhood, a few had the great privilege of staying in the castle itself. It was a happy occasion and Christopher was a delight to work with.

When I returned from Hungary, Tony decided that he wanted to feature me in the Venice films not only as a scriptwriter and musical consultant, but also as a presenter. I shared this particular role with Viscount (John Julius) Norwich, whose love of Venice is second to none, and he and I became like brothers, laughing so much that the crew and script girls were infected by the general mood of hilarity. While working on location, I was put up in a magnificent hotel on the Grand Canal, near Vivaldi's Pietà. My room had a view across the canal to San Giorgio Maggiore; when I opened the shutters in the morning, it was like being on a film set. (We actually filmed the regatta from a vantage point on the roof of the hotel.) Nearby there was a restaurant run by an Italian whose wife hailed from Texas; it was a place where we enjoyed the most wonderful meals.

We filmed in all parts of Venice – from remote, abandoned factories to San Marco itself. To facilitate our work, Tony arrranged for the basilica to be closed to visitors for one evening. John Julius and I positioned ourselves

high up, close to the fabulous mosaics, and talked to each other across the vast depths of the building, which had been elaborately lit for the occasion. We also filmed in San Giorgio, San Rocco, the Pietà and Torcello Cathedral (which has always been one of my favourite buildings – I find its tranquil setting on a remote island hauntingly beautiful). One weekend some wealthy friends of mine held a celebration party at an incredible hotel on Torcello, the likes of which I will certainly never experience again.

When we arrived in Venice in 1990 to film the twentieth-century programme, the composer Luigi Nono had just died and there were placards and even a manifesto by the Communist Party (with which he had been closely allied) pasted up on the walls. I was reminded of an earlier visit when, as a correspondent for a Vienna newspaper, I was sent to Venice to report on the première of Nono's opera, *Intolleranza 1960*, conducted by Bruno Maderna. On that occasion there had been an ugly manifestation outside, which for a time stopped the performance at La Fenice. Afterwards, Nono left the theatre and stood, disconsolate and alone in the square. My publishing house, Universal Edition, was represented by its famous director Alfred Schlee (although he was not to be the publisher of *Intolleranza*). He found it very sad that there seemed to be nobody to look after Luigi Nono and decided there and then to entertain us all with a celebratory dinner at a local restaurant. I included this story, spoken to the camera, as part of our final programme.

In planning the Venice series we had taken a great deal of trouble over the choice of musicians, who would have to participate live on camera. One of Tony's coups was to recruit the then practically unknown Robert King, with his excellent ensemble – the King's Consort – playing either on original period instruments or on exact modern copies. At one point they had arranged for an eighteenth-century harpsichord to be used, but this could only be done once the instrument had been moved to the church where the filming was due to take place. At the crucial moment, a storm arose and the harpsichord almost fell into the Grand Canal. Thankfully, I was not present to witness that hair-raising incident. Shortly afterwards there was a meeting in the lobby of my hotel. Jillian Sutcliffe, armed with a clipboard, appeared and asked, 'Where is X?' 'He's gone to see a man about a dog,' I answered. Jillian frowned, and examined her notes. 'I didn't know there was a dog in the scene,' she said, with an air of puzzlement.

In the final days of filming, everyone became sentimental. The night before the last day of shooting, we had an uproarious final supper held at the Italian-Texan restaurant, and as they used to say about the American troops liberating Paris in 1944, no one slept alone that night. Subsequently, Tony was able to sell the series to (literally) dozens of television networks in various countries, and the project turned out to be Channel 4's most successful undertaking devoted to classical music.

1 Time/Life Multimedia, 1970, 1979, 1 cassette (U/matic) b & w, 35 mins.
2 'Who composed Haydn's Opus 3?', *Musical Times* 105 (1964), pp. 56f.

Research in Austria and Germany: Göttweig Abbey and Donaueschingen 1949–1957

In March 1957 a small research team made up of former members of the Haydn Society went to Göttweig Abbey, the imposing Benedictine monastery situated on a hill overlooking the Danube valley and Krems and Stein. The author of the standard catalogue of Mozart's works, Ludwig Ritter von Köchel (1800–77), was born in Stein; he was a scion of a local patrician family, and his house still exists. Our team lodged in a beautiful old inn in a nearby town called Dürnstein, a former centre of monasticism where Richard the Lionheart had been imprisoned and rescued by Blondel, singing under his window.

The Benedictine monks of Göttweig had long supported music, and from the middle of the eighteenth century this foundation had been a great centre for the cultivation of compositions by both Joseph Haydn and his younger brother Michael. Towards the end of World War II the collection of musical manuscripts had suffered great tribulations when it was transferred to a nearby monastery called Altenburg and badly damaged in the process. When the music was rescued, it was found to be in a state of almost complete confusion. After the cessation of hostilities, the collection was returned to Göttweig where it became clear that it would take months to get everything back into order. In the case of one Haydn symphony, for example, the parts had become separated and were eventually located in different places, mixed up with other works such as masses.

Since 1949 the Haydn Society had been conducting research at Göttweig, primarily into its unique Haydn collection, but with the wider aim of assembling the parts of works by other composers in such a way that they could be used by interested scholars. Our little team in 1957 consisted of

myself, my wife Christa and the composer Karl-Heinz Füssl, as well as Stefan Harpner (from my publishers, Universal Edition) who happened to be available and was interested in seeing how we worked. Each evening we would return to the hotel in Dürnstein for dinner and to relax, after working all day up in Göttweig.

In the monastery we found a great thematic catalogue listing the music manuscripts in its collection. This uniquely important record had been compiled in 1830 by one of the monks.[1] The fact that this was a comprehensive list of works then owned by Göttweig provided us with evidence of Haydn pieces that had subsequently been lost. Among them was the Violin Concerto in D, the score of which was known to have been in Göttweig until the 1860s, but had since disappeared. Because the catalogue was thematic, it was at least possible to identify all the surviving, but jumbled, scores.

My task was to identify the instrumental parts that had become separated, that is to say those of the Haydn symphonies, and this required the systematic sifting of manuscript scores, scattered all over the place in huge piles. My wife and Karl-Heinz Füssl would then assemble each work neatly and label the scores so that they could be passed on to the marvellously eccentric Abbot of Göttweig, Dr Wilhelm Zedinek, in a much more orderly and improved state.

We noticed two things in particular in the Göttweig catalogue. First we identified a symphony attributed more recently to Beethoven; then we spotted an *incipit*, or thematic beginning, of what we believed to be a Haydn mass. Haydn had personally entered this setting of the mass – known as the 'Missa Rorate coeli desuper' (*c*.1749) – in his own catalogue; yet suddenly, listed under unknown authors, we noticed the identical opening phrase. Was it possible that the parts were still there? We started a systematic search and gradually – part by part – we pieced together this unknown mass; we finally located even the title page, which was in fact just a folder indicating on the front that the work was a mass but – most importantly – bearing Haydn's name, albeit crossed out. Having examined the contents, we felt confident that we really had the entire lost Haydn mass in front of us.

For the purposes of stylistic comparison there was another Haydn mass of the same period: the Missa Brevis in F major, scored for two solo

sopranos, choir, small string orchestra and organ. A *missa brevis* is a typically Austrian and South German form which was used, for example, during the Advent season and was, as the name indicates, a very short setting. One of the curious features of this abbreviated form is the practice of 'telescoping' the text, so that, for example, the Gloria had four separate texts sung simultaneously by different sections of the choir. This treatment was naturally frowned upon by the Vatican, since the listener could scarcely comprehend the overlapping texts of the mass when sung by four different voices at the same time. The *missa brevis* setting in G major which we had discovered displayed the same characteristic. Curiously, however, this 'telescoping' of the text was never applied to the Kyrie, Sanctus, Benedictus or Agnus Dei, but only to the Gloria and Credo, which are the longest sections of the ordinary mass. When we asked the now fascinated Dr Zedinek if he could explain the rationale for this curious practice, he replied, in Austrian dialect, 'Es war heut kalt in derer Kirche', meaning simply 'It was cold in those churches' – a perceptive remark revealing typical Austrian pragmatism.

Our next objective was to prepare a full score from the individual parts, so we returned the following day to complete this task, which Füssl accomplished in the space of two days. Meanwhile, the abbot had been considering how to make use of this rediscovered mass; he decided to have it performed on 16 June 1957, as part of the abbey's Trinity Sunday celebrations. The service was broadcast live by Austrian Radio and subsequently issued in its entirety by a Swiss record club. It was thus possible to listen to the Gregorian chanting separating the sections of the mass, as well as Bach's *Alla breve* in D for organ (played by my old friend Anton Heiller), Haydn's Offertorium 'Non nobis, Domine', and the Cantilena pro adventu 'Ein' Magd, ein' Dienerin' (solo soprano Emmy Loose).

Incidentally, the words 'Missa brevis alla capella' were noted on the title page of the Ms. The phrase 'alla capella' does not have the same meaning as 'a cappella' (or 'without instrumental accompaniment') but refers rather to the original function of the work when it was performed in St Stephen's Cathedral, Vienna, where the young Joseph Haydn wrote the mass while serving as a chorister there: it was probably in one of the cathedral's side-chapels, known as the 'Gnadenbildkapelle' or Chapel of the State of Grace (where separate small masses were sung on Sundays with a tiny orchestra

ZUR AUFFÜHRUNG DER WIEDERGEFUNDENEN „RORATE-MESSE" VON JOSEF HAYDN
IM RAHMEN EINER HEILIGEN MESSE, AM SONNTAG, DEN 16. JUNI 1957, 10 UHR
VORMITTAGS, IN DER STIFTSKIRCHE GÖTTWEIG

Josef Haydn's verschollene „Rorate-Messe" wurde vor kurzem von dem amerikanischen Musikwissenschafter H. C.
Robbins Landon im Musikarchiv des Stiftes Göttweig in einer alten Abschrift aufgefunden. Das Werk war 1785
in Göttweig zum letzten Mal aufgeführt worden.

Fig. 5 The printed invitation from the Abbot of Göttweig announcing the first performance in
modern times of Haydn's early *'Missa Rorate coeli desuper'* on 16 June 1957; shortly before, the parts
had been rediscovered in the Abbey by former members of the Haydn Society.

and choir), that Haydn's abbreviated setting had its first hearing. There were
no soloists in the G major mass, only a small choir, whereas in the Missa
Brevis in F major the two solo soprano parts may well have been sung by
Joseph and his brother Michael, whose time as boy choristers at St Stephen's
did overlap for a short while.

Since Universal Edition had decided to publish the rediscovered mass, it was left to Karl-Heinz Füssl to oversee its new lease of life while I went to England to work for the BBC for a month. As it happened, several other copies of the mass were discovered, some under the name of Haydn's teacher, Georg Reutter Junior, and one attributed to the organist of St Stephen's, Ferdinand Arbesser. That some of the Reutter copies still existed meant that ours was not the only copy of the mass.

The title that Haydn gave the mass in his own catalogue – 'Rorate coeli desuper' – is a quotation from the Old Testament (Isaiah XIV:8: 'Drop down, ye heavens, from above, and let the skies pour down righteousness: let the earth open, and let them bring forth salvation, and let righteousness spring up together; I the Lord have created it.'), signifying that, since this was a text appropriate to the pre-Christmas season, the work must have been composed to be performed during Advent. In fact, the very beginning of the Kyrie in G features an old Gregorian melody:

a - pe - ri - a - [tur]

and confirms that the work was indeed intended as an Advent mass. Some time afterwards, another copy of the mass under Reutter's name was discovered in Brno in Czechoslovakia, this one specifically listed as 'Missa Rorate coeli desuper'. How was this possible? How could Haydn have written in his catalogue the thematic beginning of a work that was listed as a composition by Reutter? I believe that the solution to this mystery is in fact fairly simple.

In Haydn's time professional copyists would always try to sell music under the best authorship possible. This meant for example that in the 1770s they would sell 'Haydn symphonies' by the dozen, whereas in reality they may have been composed by contemporaries such as Joseph's brother Michael or Leopold Hofmann; if music would sell better as the work of Haydn, the copyists simply took advantage of that fact. Furthermore, around 1749 and 1750 when the two masses were presumably composed, the teenage Joseph Haydn was still completely unknown, whereas his teacher Reutter (who was Cathedral Chapelmaster at St Stephen's) was very well-known and highly respected as a composer. Reutter is known to have helped Haydn with his

composition and to have taught him various tricks of the trade, so it is likely that he aided him a little with the mass. This leads me to suspect that, as unscrupulous a character as he was (and as other known examples of similar behaviour tend to suggest), Reutter simply appropriated the Missa Brevis in G and sold it as his own. In my opinion, copies of this mass exist under Reutter's name and under that of the organist Arbesser, because at the time both men were much better known than Haydn.

There are also some curious mistakes in the G major mass (parallel fifths, consecutive octaves, odd laying-out of the voices, and so forth) which are more easily attributable to a young, inexperienced Haydn still learning how to compose than to an experienced musician such as Reutter. Despite these technical imperfections, however, the mass has a very endearing quality, and its two most impressive sections, the Crucifixus and the Agnus Dei, are incredibly forward-looking. In fact, the Agnus Dei, ending with the 'Dona nobis pacem', is, in the context of 1749, an extraordinary achievement for a young composer.

Today of course the little G major mass, or 'Missa Rorate coeli desuper', has become part of the established canon of Haydn's masses and a recording of it is included in the latest complete retrospective of all the masses produced by Decca (1996). As a footnote to this story it is worth mentioning that there were in fact two lost Haydn masses, both entered by Haydn in his own thematic catalogue; the second of these, a work in D minor, was rediscovered later and in even more curious circumstances (see Chapter 9).

Another interesting story lies behind the discovery of the 'Beethoven symphony'. In 1909 the distinguished German musicologist and conductor Fritz Stein, who was also a renowned teacher at the Berlin Royal College of Instrumentalists, discovered a previously unknown symphony which he thought was by Beethoven. Because the score had come to light in the university town of Jena, Breitkopf & Härtel subsequently published the work as the Jena Symphony. It acquired a considerable life of its own and was played and discussed quite often; a recording was issued during World War II and through this medium many people had the opportunity of hearing the music. If one listens to it attentively, however, it becomes clear that extensive passages are lifted straight from Haydn's first London symphonies. This would not have seemed so extraordinary if one takes into account the fact that Beethoven was studying with Haydn in 1793, just after

the latter's return to Vienna from the first of his two London visits. The young Beethoven had gone to Vienna to accept – as it was said at the time – Mozart's spirit from Haydn's hands. In 1957, however, the very same symphony turned up in Göttweig, not under Beethoven's name but under that of Friedrich Witt, a minor composer who had been employed at the court of Prince Krafft Ernst of Oettingen-Wallerstein in Bavaria and about whom little was then known. Not surprisingly, the discovery of this work at Göttweig created a considerable stir at the time. My friend Karl-Heinz Füssl, who as well as being a composer also worked as a journalist for the well-known Vienna paper *Der Abend*, went round to the 'APA' – the press agency used by the Austrian government for issuing official statements (political and otherwise) – where he issued a statement about the mass, followed by another about the Jena Symphony, so as to disseminate accurate news of our discoveries as rapidly as possible all over the world.

In the intervening years more information about Witt has come to light. It is now known that authentic copies of most of the first six London symphonies, specially prepared and carefully corrected by Haydn in his own hand, arrived at Wallerstein Castle while Witt was employed there. Haydn had sold the copies to the prince, who maintained his own orchestra, and with whom the composer had been on amicable terms for some years. In 1790, Haydn had actually stayed at Wallerstein while en route for England, in the company of the impresario Johann Peter Salomon, and while there had organized at least one concert, with performances of the symphonies he had previously sent – Numbers 90–92 (including the one that later came to be known as the 'Oxford'). Thus, Witt (who was a cellist in the prince's orchestra) must have been one of the first outside London to hear the London symphonies – a fact which would account for his use of them as models when he started to write his own symphonies. The only change that had been made was a slight variance in the *incipit*.

* * *

While we were working together on the BBC pre-classical symphony series in 1956, Charles (later Sir Charles) Mackerras told me about an interesting trip that he had made to Donaueschingen, the family seat of the Princes Fürstenberg in Southern Germany. Today, Donaueschingen is known to

most musicians as the centre of a thriving festival devoted to modern music, but Mackerras had gone there to visit a vast and little-known music archive at Fürstenberg Castle, in which the majority of the manuscripts had not yet been been subject to scholarly examination; one exception was Mozart's *Le nozze di Figaro* (an early Prague copy which had been used by the great Mozart scholar Alfred Einstein, editor of the 3rd edition of the Köchel catalogue). According to Mackerras, the archive contained hundreds of other manuscripts, including many copies of works by Mozart and a great deal of music by Haydn. My friend Christopher Raeburn, who was working on Mozart operas, was also very curious to study the sources at Donaueschingen, and he succeeded in arranging for us both to have access to the manuscripts, and moreover to be provided with accommodation in Fürstenberg Castle, where the guest rooms gave onto a long corridor and name cards were placed on each door. (We were in illustrious company: 'Prince Schwarzenberg', 'Mr Landon', 'Mr Raeburn'.) In the evenings we repaired to a local *Gasthaus* where the beer was excellent and the food better than expected (although Christopher succumbed one night to a severe bout of mushroom poisoning – an allergic reaction). A young German colleague, Dr Hanspeter Bennwitz, was also part of our entourage.

I prepared a complete thematic catalogue of all the instrumental music in the archive, and this enabled us to assign a number of doubtful Haydn works to the correct authors. As well as a wealth of actual source material, Donaueschingen owns a valuable thematic catalogue dating from 1803–4, together with several other non-thematic catalogues which are of the utmost historical importance. From these we learned that the Court Theatre had once owned performance material for Haydn's *Singspiel* (originally a marionette opera) *Philemon und Baucis*, which was finally destroyed in the early nineteenth century when it was considered obsolete. The castle also contains perhaps the largest extant library of late eighteenth-century wind-band music, from which we were able to establish that the Octet in F major for 2 oboes, 2 clarinets, 2 horns and 2 bassoons attributed to Haydn (Hoboken II, F-7) was actually a *Parthia* by Wranitzky (either Anton or Paul, both of whom were active in Vienna during Haydn's lifetime).[3]

The archive included several scores of operatic and oratorio arias by Haydn, some of which appeared to be completely unknown. One of these (Mus. ms. 646) is the aria from *Il ritorno di Tobia*, 'Come se a voi parlasse';

at the end the manuscript is signed 'artaria' (Haydn's publishing house) and it is probably an authentic copy. Another (Mus. ms. 669) is an insertion aria in B flat for soprano in Pietro Guglielmi's opera *La Quaquera spiritosa,* entitled 'Vada adagio, Signorina'. Transcribed in full score by the composer's copyist Johann Elssler and performed at Eszterháza in 1787, it is the only known copy; the Esterházy Archive in Budapest has an autograph 'short score' in the material relating to the opera, but nothing else. This aria turned out to be a delightful composition. It was performed for the first time since the eighteenth century at the Salzburg Festival in 1959, conducted by Bernhard Paumgartner and with Rita Streich as soloist. It proved such a success that Universal Edition decided to publish all Haydn's insertion arias written for operas by other composers; these were issued over a period of several years and proved to be a veritable treasure trove.

For his part, Charles Mackerras found a work (Mus. ms. 667) which he played subsequently on the BBC Third Programme, a *Recitativo e Rondo* 'Se ti perdo' with solo viola and cor anglais. The parts were written by three copyists, one of them the so-called 'Kees Copyist', and the source is Viennese; yet two factors suggested that, interesting though the piece is, Haydn was not the composer. The first was external: Haydn's name was added to the title page by the Donaueschingen copyist and there was no trace of a composer's name on any of the parts, indicating that the source material must have been sent to Donaueschingen anonymously. Secondly, the work was not stylistically convincing. Among other finds, Mus. ms. 668 contained the parts of Haydn's soprano aria 'Caro, e vero' from the opera *Armida,* while Mus. ms. 646, in piano score, was a Viennese copy of 'Come lasciar potrei' and was described as a 'Favorite Arias [*sic*] Del Sigre Gius. haydn 794 [1794]' (this turned out to be by Giovanni Paisiello). There was also a series of *solfeggi* (vocal exercises) for soprano and *basso continuo,* Viennese manuscripts which, though anonymous, appear – on the basis of both external and internal evidence – to be lost works by Mozart.

The principal find at Donaueschingen, however, was eleven of Haydn's twelve London Symphonies in contemporary copies, almost entirely written by Haydn's copyist Johann Elssler, which had been thoroughly corrected and revised by the composer himself. The only inauthentic copy is that of No. 100, the 'Military' Symphony, which suggests either that the original copy was used so frequently that it had to be replaced, or that Haydn did

not supply the work (which seems doubtful). Curiously enough, the parts of the other symphonies were written on different types of paper, some Italian and some English, the latter dated 1794. On this evidence, my initial theory, namely that Haydn sent the works from England, had to be discarded, for if that had been the case all the parts would have been written on English paper. A second theory was that Haydn visited the castle on his return journey to Vienna in the summer of 1795 (very little is known about the routes taken by Haydn on his journeys to and from England). While I was examining the manuscripts, Christopher Raeburn kindly went through every issue of the local Donaueschingen *Wochenblatt* published between July and December 1795 – Haydn's visit would almost certainly have been reported in the paper. Although he was unable to trace any mention of such a visit, he did find another news item which, I believe, solves the mystery. The *Wochenblatt* of 2 December 1795 includes the following:

Vienna, 19th November.

Prince Karl von Fürstenberg arrived here safely from Prague on the 12th and on the 15th and 16th paid his respects to the Imperial Minister and Ambassador, His Excellency Landgraf von Fürstenberg, and was presented as his future son-in-law.

At that time the late London Symphonies were not yet known in Vienna, and on 18 December 1795 Haydn arranged a concert ('grosse musikalische Akademie') in the Redoutensaal; on that day Beethoven played one of his own piano concertos (probably No. 2), and Haydn's own Symphonies Nos. 102–104 received their first performance in Vienna. It seems very likely that Prince Karl heard the new works and asked Haydn for copies of all twelve of the London Symphonies. Haydn, who probably guarded these works very carefully, had Elssler copy out some of the parts again (on Italian paper), while he gave the Prince the parts which he had brought back with him from London. It is also probable that those parts written on paper bearing British watermarks were first used in performances given at the Hanover Square Rooms and the King's Theatre under Haydn's personal direction. A complete textual analysis is included in my *Collected Edition of Haydn's Symphonies* (Universal Edition) but a few interesting points may be mentioned here. One is that there was no room for the clarinet parts in the autographs of Symphonies Nos. 101 and 104; Haydn's own manuscript of

No. 104's clarinet parts has survived while that of No. 101 has not, and it was not certain whether the parts had been composed and added by one of the two German publishers – Johann André and J.J. Hummel – who issued the first edition of the complete orchestral works. The Donaueschingen copy of No. 101, however, *does* include clarinet parts recognizable from the early prints, and Haydn has given these his personal stamp of approval by adding a '*fz*' to Clarinet II towards the end of the Finale.

During the 1778–9 season Donaueschingen had witnessed a performance of Haydn's lost German *Singspiel* entitled *Der krumme Teufel* given (with or without Italian arias) by the visiting Franz Grimmer Troupe. Naturally we hoped to find a copy of this crucially important first opera, but Christopher Raeburn's search among the printed and handwritten (as opposed to musical) sources, and my own search through the musical manuscripts proved fruitless. The German publishers Bärenreiter were planning to publish *Der krumme Teufel* had we been successful, but unfortunately it remained stubbornly lost.

En route to Donaueschingen, Christopher Raeburn and I stopped at Stuttgart to see Wieland Wagner's impressive production of his grandfather's first opera *Rienzi*, which he was considering as an addition to the repertoire of the Bayreuth Festival.[4] On our return journey we invented ribald and irreverent songs to fit Mozart melodies. As we sped up the *Autobahn* towards Augsburg, where Ernst Fritz Schmid of the New Mozart Edition (and sex-with-animals scandal) lived and where there was a library which we needed to visit, we roared at the tops of our voices, 'Agnus Schmidi qui tollis peccata mundi, miserere nobis …'.

1 Catalogue in two volumes, the first entitled 'KATALOGUS / OPERUM MUSICALIUM / in / Choro musicali / MONASTERII / O.S.P.B. GOTTWICENSIS/ R.R.D.D./ALTMANNO / ABBATE per R.D. / Henricum / Wondratsch / p.t. chori regentum, conscriptus. // Anno MDCCCXXX Tom I'; the catalogue consists, with a few exceptions, of a list of all the MSS. then in the music archives, and includes the title, orchestration, the name of the copyist and date, in so far as these were known. Since most of the actual MSS. have long since disappeared, the catalogue is of unique documentary value. It was subsequently published in facsimile, edited by F.W. Riedel, '*Der Göttweiger Thematische Katalog von 1830*', *Studien zur Landes- und Sozialgeschichte der Musik*. ii–iii (Munich/Salzburg 1979).

2 The facsimile of the title page and the entry in the Göttweig as well as the first page of the Violino Primo part may be seen in my article on the subject in *The Music Review*, May 1957 and reprinted in *Essays on the Viennese Classical Style*, London 1970, pp. 152ff.

3 Cat. Mus. Ms. 2062.

4 Frederic Spotts, *Bayreuth, A History of the Wagner Festival*, London 1994, pp. 223f.

Haydn opera revivals: Holland Festival productions 1959–1970

In 1954 Carlo Maria Giulini conducted a performance of Haydn's comic opera *Il mondo della luna* for Italian Radio (RAI), with my friend Herbert Handt as the principal tenor. The version that he used lacked the final act, the score of which was preserved in a manuscript copy in the Austrian National Library and was therefore available for me to edit. So when Peter Diamand, intendant of the Holland Festival, arrived in Vienna and expressed an interest in performing a Haydn opera for the 1959 season to commemorate the 150th anniversary of the composer's death, and in view of the prevailing excitement caused by the Soviet success with the Sputnik space satellites, what better choice than to stage *Il mondo della luna* in its entirety? I persuaded Bärenreiter-Verlag to publish the opera and in the course of 1958 worked my way through the manuscript, 'realizing' the harpsichord part in the *secco* recitatives and adapting the only (alto) castrato part Haydn ever composed to a baritone voice, a process which was tricky only in the ensemble sections. We performed extracts from the opera in our 1958 BBC series on Haydn conducted by Charles Mackerras, and this proved to be very successful. We decided to use a real male alto, so in the end I provided Bärenreiter-Verlag with an alternative version in case any of the theatres to which we hoped to sell the work wanted to return to the original scoring. In those days, however, countertenors, male sopranos and altos were extremely rare, at least on the Continent, and at first all the interested theatres preferred to use the transposed part for baritone. There were in fact many existing versions of the opera with different orchestrations and vocal transpositions, and it seems that Haydn continued to revise the work even after he had established a working score for the 1777 season at Eszterháza.

The Holland Festival production was also conducted by Giulini, who proved to be an ideal collaborator; it was produced by Maurice Sarrazin and designed by Jean Denis Malclès, who provided the highly imaginative stage sets. The principal singers were Marcello Cortis (Ecclitico), Luigi Alva (Ernesto), Michel Hamel (Buonafede), Mariella Adani (Clarice), Biancamaria Casoni (Flaminia), Bruna Rizzoli (Lisetta) and Paolo Pedani (Cecco). The production was shared by the Aix-en Provence Festival, where the opera was staged later on in 1959: it was an instant hit. Since we were producing the first performance of an authentic text since Haydn's lifetime, we held a series of press conferences organized by Kitty (who later became the wife of the press secretary, Jo Elsendoorn), at which I spoke about the opera and answered questions in four different languages. Many German theatres sent representatives to Holland to hear the opera, and we secured the services of the conductor Hans Swarowsky to prepare a German translation so that the libretto would be ready for their use when they booked in for the coming season. In the event, the brilliant production at the Holland Festival persuaded many German conductors and stage managers to take the work into their repertoire at once. *Il mondo della luna* was performed subsequently at the Salzburg Festival and could thus be considered to have been fully launched.

Following this initial success, we decided to make the staging of Haydn operas a regular event at the Holland Festival, and this in turn necessitated my editing many of the newly discovered works, either unpublished or available only in corrupt nineteenth-century texts. Our next collaboration concerned *L'infedeltà delusa*, originally performed in July 1773, which I had heard in a performance recorded for radio while visiting Budapest (see p. 66) and which I felt sure would prove a success. I arranged for Haydn's autograph manuscript to be photographed in the Esterházy Archives, and having meanwhile moved to Italy, thanks largely to the profits made from performances of *Il mondo della luna*, my first major task was to prepare a performing edition. As well as the autograph, I also had a copy of the original printed libretto produced for those present at the première (dedicated to the Dowager Princess Esterházy), which I had discovered in the Library of the Conservatory of Santa Cecilia in Rome.

The second Haydn opera was ready to be launched at the Holland Festival in 1963, when it was conducted by Alberto Erede and staged by a

Swiss director, Werner Düggelin. Its cast of fine singers were chosen carefully by the festival organizers for their fluent and accent-free Italian (some of them actually being native Italian-speakers): Reri Grist as Vespina, Jeanette van Dijck as Sandrina, Peter van der Bilt as Nanni, Nicola Monti as Filippo and Umberto Grilli as Nencio. Once again I went to help with the press conferences: this time Universal Edition undertook to publish the opera, and they also took on the final two Haydn operas destined for the Holland Festival. As before, many German theatres sent representatives, and this time the publishers were ready not only with a German translation of the libretto, but also an elegant English text prepared by the famous music critic Andrew Porter. Soon we were selling performing rights to theatres all over the world, especially in Germany where, in the joint theatres of Düsseldorf and Duisburg, the work remained in the repertoire for some ten years and in the event proved to be one of their most successful eighteenth-century opera productions.

We soon organized the first recording. This took place in Rome, conducted by the late Antonio de Almeida, with Edmund Purdom, the actor-turned-sound engineer, as recording supervisor. The cast in this performance consisted of Emilia Ravaglia (Vespina), Elisabeth Speiser (Sandrina), Umberto Grilli (Nencio), Giorgio Grimaldi (Filippo) and Robert El Hage (Nanni), and the record was issued by Le Chant du Monde in Paris and the Haydn Foundation in Vaduz. Over the years, *L'infedeltà delusa* has proved to be the most popular of all Haydn's operas from a commercial point of view. My edition is available as a miniature score (published by Philharmonia) and there are four performances on record, the most scintillating being the one conducted by Antal Dorati for Philips, produced by Erik Smith. Within the context of eighteenth-century opera the work is extraordinary in that the only characters on stage are *contadini*, peasants in the castle town of Ripafratta, near Lucca. There are no princes or aristocrats in the cast; the only suggestion of an upper class is Vespina's imitation of a cruel and sinister *marchese*.

Tony de Almeida persuaded French Television (RTF) to make a documentary film about *L'infedeltà delusa*, and this was shot on location at Ripafratta and in the surrounding countryside. We mounted the camera on top of my Opel and moved through the hills and fields in and around Lucca. The actual castle of Ripafratta, which was still standing, was owned

by a charming elderly couple named Nuñes who fed us at their villa when it became too cold for us to film outside. The entire scenario seemed just as improbable to the French director, Jacqueline Muller, as it did to me, but it was an amusing interlude and – viewed in retrospect – an adventurous undertaking that would be impossible even to contemplate today.

Our third Haydn opera was a large-scale reconstruction. I had examined the autograph of *Le pescatrici* (with libretto by Carlo Goldoni) when I was in Budapest in 1958. Although the score was incomplete, I thought the extant music delightful and full of imagination. The original libretto of 1770 was also available in an accurate copy made by the great nineteenth-century Haydn scholar C.F. Pohl and preserved in the Gesellschaft der Musikfreunde in Vienna, so at least we knew the words from the missing sections. (Subsequently, a complete copy of the printed libretto came to light in the Conservatory Library in Trieste, and this was reproduced in the *Haydn Yearbook* [1]). It had been some time since any scholar had attempted to reconstruct so large a part (approximately one third) of a major eighteenth-century piece of music. Could it be done? I believed it was possible, and my publishers (Universal Edition) agreed to support the project, as did Peter Diamand of the Holland Festival, this time in collaboration with the Edinburgh Festival.

In 1964 I went to visit my parents at their remote country cottage in western Massachusetts, and I spent weeks there working quietly on the reconstruction. I devised a tonal scheme for the whole opera and by the time I returned to Italy in the autumn I had finished *Le pescatrici*. My next task was to set about completing *Lo speziale*, another opera with libretto by Goldoni, which Haydn set to music in 1768. Universal Edition wanted to replace an old version of the work which had been edited by Robert Hirschfeld, with, as it now transpires, the help of Gustav Mahler.[2] My own attempt at reconstruction is primarily concerned with Act III, and it was exhilarating to write the score on a succession of magical Italian autumn days with the sun streaming through the windows of Buggiano.

We decided that *Le pescatrici* should be launched in 1965 without revealing to anyone in advance which parts of the opera I had written or added to, and which were exclusively by Haydn. Most of the critics got the answer wrong, but that was largely because they were unfamiliar with Haydn's operatic style. At any rate, the new production was another popular

success, so much so that the Holland and Edinburgh Festival organizers decided to repeat the work during the 1966 season. Our cast list was: Ruza Pospis (Eurilda); Ugo Trama (Lindoro); Maddelena Bonifaccio (Lesbina); Umberto Grilli (Burlotto); Adriana Martino (Nerina); Giacomo Aragall (Frisellino); and Carlos Feller (Mastricco). A new German translation was provided by my longstanding collaborator Karl-Heinz Füssl, together with Hans Wagner. Once again, the Holland Festival proved an ideal 'launch-pad' for *Le pescatrici*, which was soon being performed and broadcast in German-speaking countries. Austrian Radio put on a Haydn opera series performed in a castle outside Bregenz, and this included my reconstructions of both *Lo speziale* and *Le pescatrici*.

There was something of a time lag between the staging of *Le pescatrici* and the final opera which we introduced at the Holland Festival – a delay that was due to a simple block in the production line. We had discovered the score of a Haydn opera called *La fedeltà premiata* which, like *Le pescatrici*,

Fig. 6 Title page of Act 1 of Haydn's opera *La fedeltà premiata*, composed in 1780, from a manuscript copy including corrections and additions made by the composer. The discovery by Albi Rosenthal of two bound volumes containing much of the work revealed the version of an aria previously known only in piano score.

was believed to have been partially lost. This work was written in 1780 for the opening of the new theatre at Eszterháza Castle the following year; the original theatre had burnt down in 1779, but was soon replaced. I had arranged for the finale of Act I to be copied out and broadcast in 1958 by the BBC in one of my Haydn series, and it was so well received that Peter Crossley-Holland encouraged me to carry on with the work. I did so, and in 1970 we were ready to launch our fourth Haydn opera production for the Holland Festival. *La fedeltà premiata* was the most complex and intricate Haydn opera we had ever attempted – it involves a large cast, a big orchestra and many scene changes. The festival organizers secured the services of the eminent French stage designer Jean-Pierre Ponnelle, retaining Alberto Erede as conductor. Under Ponnelle's expert supervision Haydn's opera, with its plot involving sacrifices to the goddess Diana and the presence of a mythical monster, was brought vividly to life (as too was Mozart's *Idomeneo* at the Metropolitan Opera in New York, when performed in a new production by Ponnelle in 1982).

To my delight, this final production was even more of a success than the other three operas staged at the Holland Festival. The principal roles on this occasion were sung by Sophia van Sante (Diana), Frangiskos Voutsinos (Melibeo), Romana Righetti (Celia), Pietro Bottazzo (Fileno), Helen Mané (Nerina), Eduardo Gimenez (Lindoro), Eugenia Ratti (Amaranta) and Renato Capecchi (Perrucchetto). After the first performance, as one curtain call followed another, Ponnelle's beautiful German wife came up to me and insisted that I go on stage. I was completely taken aback, but honoured to share the applause with Ponnelle, Erede and the cast. *La fedeltà premiata* was given its first German-language performance at the theatre in Karlsruhe, from where it spread to cities all over Germany. The opera was also performed at Glyndebourne, where it was conducted by Bernard Haitink, and staged with reputedly beautiful sets which, alas, I never saw.

Soon after the completion of our pioneering work at the Holland Festival, Antal Dorati had the extravagant idea of recording a whole series of Haydn operas, using the best singers available. That was how *L'infedeltà delusa*, *L'incontro improvviso*, *Il mondo della luna*, *L'isola disabitata*, *La fedeltà premiata*, *La vera costanza* and *Armida*, together with numerous 'insertion' arias and multiple-voice inserts (trios and so forth) came to be performed in association with Radio Suisse Romande and issued by Philips on LP

(later successfully transferred to CD). Today these operas represent an important legacy as one of the greatest achievements in gramophone history – hardly surprising, when one pauses to consider the august list of singers who participated, including Arleen Auger, Luigi Alva, Jessye Norman, Benjamin Luxon and Barbara Hendricks.

1 See facsimile in *The Haydn Yearbook* XX, 1996
2 See *The Haydn Yearbook* XXI, 1997 – a brilliant discovery by my colleague Otto Biba.

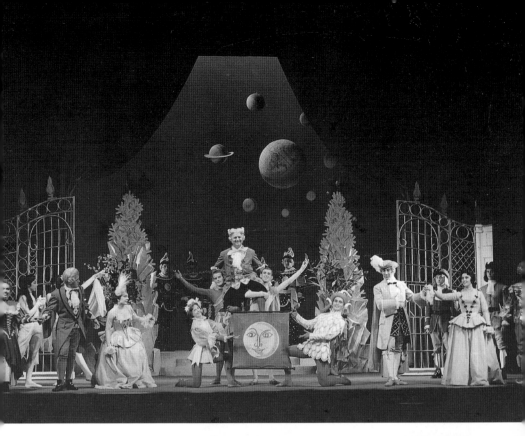

18, 19 Modern revivals of Haydn
operas at the Holland Festival:
(above) the full cast of *Il mondo
della luna* against a backdrop of
heavenly bodies (1959); (right)
Renato Capecchi and Eugenia
Ratti in the roles of Perrucchetto
and Amaranta in the most
ambitious production, *La fedeltà
premiata* (1970), based on my new
edition of the work.

20–22 Buggiano Castello: (above) interior of the main drawing-room, with the life-size wooden statue of St James of Compostela; (opposite) orange trees in the courtyard and the panoramic view across the plain as seen from the upper terrace, and myself with my third wife, Else, conferring in the study.

23–26 Performers and
presenter: (above) Georg
Solti and the producer John
Culshaw at a recording
session of Wagner's *Ring*
cycle in Vienna in 1960;
(left) John Julius Norwich
and myself, co-presenters
of the Channel 4 television
series *Maestro*, while filming
on location in Venice in
1990; (opposite) the
Academy of Ancient Music
under Christopher
Hogwood performing at
Eszterháza in 1989 for the
ITV South Bank Show, in
which I also participated
as consultant.

27 Albi Rosenthal, recipient of an honorary degree at Oxford University in 1979, flanked by Else and myself outside the Sheldonian Theatre.

28 In conversation with my old friend and colleague Christopher Raeburn and the pianist András Schiff at Mondsee in Upper Austria, 1995.

29 Lunching *al fresco* with Marie-Noëlle Bechetoille while visiting the former director of radio programmes at the European Broadcasting Union, Anthony Dean, at his home in Geneva in 1992.

30 Signing books at the Bridgnorth Festival, June 1995; seated on the right facing the camera is Anne Cooper, who has contributed in many ways to the success of each year's events.

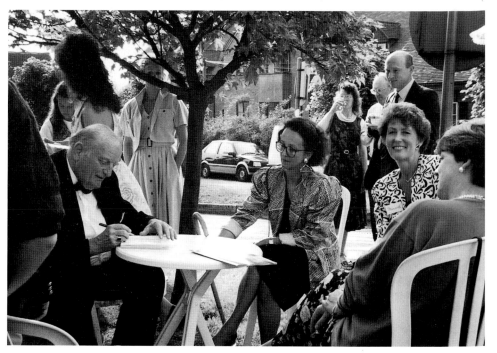

31, 32 French château: Foncoussières, my home since 1984. View from the south-east in winter, and the 'salon rouge' on the first floor, with Haydn's Longman & Broderip piano of 1795.

Italian adventure:
living in Tuscany 1959–1973

On my first trip to Italy in 1952 I was blessed with some excellent travelling companions – my wife Christa and I were joined by the conductor Hans Swarowsky and his young wife Doris. Swarowsky was a famous professor at the Vienna Academy, where his pupils included the likes of Zubin Mehta and Claudio Abbado. He had conducted the world première recording of Haydn's *L'anima del filosofo* (*Orfeo ed Euridice*) for the Haydn Society, as well as his Symphonies nos. 87 and 89 and Mozart's *Don Giovanni*. Aside from Swarowsky's mordant wit and brilliant conversation, what fascinated all of us on this visit was his profound, and indeed professional knowledge of Italian art and architecture, particularly that of the Renaissance. Travelling in our little convertible Hillman 'Minx', we followed an itinerary planned by Swarowsky which took us through northern Italy as far south as Siena. His Baedeker-like knowledge of churches, towns and art galleries enthralled us. When we disembarked from the *vaporetto* near St Mark's in Venice, he told us to close our eyes and led us in a procession like three blind mice (somehow anticipating the opening sequence of the James Bond film, *Dr No*) until we were actually in the square. 'Now open your eyes,' he said to his three pilgrims, and there before us lay the piazza and basilica in all their splendour. Unable to contain her emotions, Doris burst into tears; for me too this was without doubt one of the most sublime moments of my life. Swarowsky later played the same trick when we arrived in the Piazza del Campo in Siena, and with equally dramatic effect on his three now devoted followers – real *seguaci* in the Berensonian sense. We then drove from Florence to Lucca on Mussolini's two-laned *autostrada*, past the town of Buggiano

with, on its outskirts, the huge red villa which would in due course become my home for nearly fifteen years.

As a young man I had always been fascinated by Italy and its cultural history, but after this trip I made up my mind to settle there as and when circumstances permitted. However, the time was certainly not yet ripe for such a bold move. Soon after starting to research the Haydn symphonies, I realized that woefully little had been written about them, and I decided to write a comprehensive study of the subject and to include a catalogue of all the sources known at that time, both manuscript and printed. I persuaded Universal Edition to take on this Herculean project in collaboration with the London publishers Barrie and Rockliff, whose music editor was Donald Mitchell. The central office of Universal in Vienna often agreed to cover the costs of my long research trips, which involved visits to obscure Austrian monasteries where the principal manuscript sources of many of the symphonies were preserved. Some of the monasteries were so remote that the existence of their collections was almost unknown to scholars.

My mother was visiting us when we went for the first time to the Abbey of Schlierbach in Upper Austria. My first step, as usual, was to ask to see the organ-loft in the abbey church, and sure enough we discovered there some eighteenth-century manuscripts of Haydn symphonies. Schlierbach was too remote for us to arrange for a photographer to visit (although there was one in Vienna who worked with us), so I approached the tall, austere and saintly-looking abbot. I explained the purpose of my research, and he offered to lend me the manuscripts to take to Vienna, where they could be studied properly. He even went to fetch some brown paper and string. My mother was stupefied, and asked me later on whether such a generous gesture was common practice. I told her that on one occasion, when Austria was still under military occupation, we had removed all the music manuscripts from the loft of the Parish Church (later Cathedral) in Eisenstadt and carried them to Vienna, where they were placed in the Austrian National Library for safe-keeping. The director, Hofrat Nowak, had objected strenuously: 'It's Church property,' he growled. 'Yes, but Eisenstadt is in a Russian zone and those manuscripts are just not safe there,' I replied. This was no exaggeration – they would certainly have disappeared if the Soviet authorities had known that among them lay a signed and authentic copy of a previously unknown *Motetto di Santa Tecla* by Haydn.

At one time we even had the entire collection of Bach first editions from Göttweig Abbey in our small Vienna apartment, where we proceeded to catalogue them.

My book *The Symphonies of Joseph Haydn* was published in 1955 and comprised some 900 pages (a large part of it, set in smaller type, contained the list of sources and other such information). I was lucky enough to receive flattering reviews even in London daily newspapers, despite the fact that the book was purely scholarly – a 'ball crusher', as Walter Legge put it, 'not suitable for bedtime reading'.

When I returned to Vienna in the late autumn of 1955, the State Opera had just re-opened and, since the signing of the State Treaty and the departure of the occupying troops, much to the amazement and joy of the Austrian population, the city was beginning to shine anew. To this day, no one realizes quite how the Austrians managed to persuade the Russians to leave and to relinquish their control over most of the oil reserves in Lower Austria. At the time, delightful cartoons were published showing the Chancellor, Ingenieur Leopold Figl, handing out large green glasses of local wine to the representatives of the bemused occupying forces, including the Bible-quoting John Foster Dulles (Secretary of State) who was present on behalf of the Americans.

By the end of 1959, the sesquicentenary of Haydn's death had – as already noted – produced the spectacularly successful revival of *Il mondo della luna* conducted by Carlo Maria Giulini, and my finances had improved to the extent that I could now seriously consider moving to Italy, where I would be able to continue my research in an atmosphere of greater tranquillity; for in my flat in Vienna the telephone seemed to ring every five minutes. My publishers, Ludwig Doblinger and Universal Edition, had decided to issue a critical edition of all 107 Haydn symphonies, as well as the orchestral parts and miniature scores. They divided up the work-load more or less evenly, with Doblinger taking on the first forty-nine symphonies plus two youthful works not included in the official 104, and Universal Edition publishing Numbers 50 to 104, together with the Sinfonia Concertante in B flat (Hob. I:105). I needed a great deal of peace and quiet to concentrate on editing these works from roughly five thousand pages of sources and to explain in an extended critical report how I had reached my decisions concerning the choice of readings.

One of my friends was an interesting Polish singing teacher called Sergei Radamsky, who had taught for a time in America and then taken his prize pupils first to Paris and from there to Vienna, where he was Professor at the Music Academy and also owned a large private studio. He was in the process of setting up in Italy, and had become acquainted with the mayor of a pretty town called Pescia, situated between Florence and Lucca. Radamsky wrote to the mayor to enquire about properties in the area, and received the reply from his wife that there were indeed many impressive houses for sale in the Tuscan hills around Pescia and nearby Montecatini Terme, a spa town known for the healing properties of its waters, and famous for its association with Giuseppe Verdi. On New Year's day in 1960 my third wife Else and I moved into a small hotel in Lucca called the Albergo della Luna and started looking for houses in the company of the mayor's wife. There was an enchanting farmhouse in the hills above Pescia, but negotiations fell through because the owner could not make up his mind to sell. There was also a large villa in the plains, and a house in the hilltop village of Buggiano a few miles away. The second of these, though not very expensive, was well located right in the centre of the village. However, we discovered that the large villa – a massive Renaissance building with extensive formal gardens and a spectacular view – was also for sale. It turned out to be a famous 'haunted' castle with origins in medieval times, and a part of the cellars dated from the eleventh century. Each of its many rooms was crammed with eighteenth-century engravings, oil paintings, beautiful furniture and even some silver. At a cursory glance, we saw that the library shelves were filled with eighteenth-century books and libretti (I immediately spotted a complete Metastasio); there was also a collection of clocks. The bedrooms came complete with mattresses and linen, and the the roof had recently been restored. The price of the house and several farms, as well as a huge Gothic tower next door, was apparently very reasonable, but when we returned to our hotel the prospect of such a purchase seemed all of a sudden very extravagant and unrealistic.

Our new friends in Pescia were much more enthusiastic, reasoning that the farm could be separated from the villa and the tower sold to the undertaker already living there – that way I would be spared any 'agricultural headaches', as they put it. The bargaining began and, to our astonishment, the vendors agreed within a matter of days to sell the villa as a separate

entity. We signed a preliminary contract on 7 January 1960 and, as the waters spouted from the fountains and the winter sun shone down, we acquired first rights to Buggiano Castello in the province of Pistoia for 7,500,000 lire (about $11,000), complete with all its contents. The sale was to be finalized in April, which allowed us enough time to verify titles and deeds and to prepare contracts. We engaged a local notary to do the necessary. Of course, our decision was utter madness, but I felt sure that we had made the coup of our lives – and so it turned out to be.

We had to take stock of our new situation, and were not able to move into Buggiano straight away since there was no central heating. Fortunately, our friend, the American tenor Herbert Handt (who had sung with such resounding success in many of our Haydn and Mozart recordings) had offered us the use of his flat in Rome for the winter. I had just started to translate and edit *The Diary of a German Soldier*, the blood-curdling memoirs of Wilhelm Prüller, an Austrian lieutenant who had served in the German army during World War II. With a friend, the brilliant Austrian journalist Sebastian Leitner, I had acquired the English-language rights for the book, and it was subsequently published by Faber and Faber (with whom Donald Mitchell was closely associated) and later in other countries, but never of course in the original spine-chilling German original. We moved to Rome and, following a strict schedule that I established, I worked solidly for ten hours a day, allowing myself one day off each week for sightseeing, which we would spend strolling along the Via Appia Antiqua outside Rome, which was completely empty during the week, or climbing up the dome of St Peter's. We led a monastic yet very full existence – what with finishing the diaries and getting to know the city of Rome and its surroundings (Palestrina, Ostia and so forth). Once the work was completed, we travelled to Austria to rendezvous with our friends the Leitners on the Aachensee, where Sebastian and I had planned to write the introduction. I relied on his expertise for this complicated task since, like the author of the diary, he had been in Russia and could therefore supply details which, being American, I knew nothing about (what was a 'Stalin organ', for example?).

In order to obtain a permit to reside in Italy I registered as a journalist. Not only did I write pieces for *The Times* and *The Daily Telegraph* (for which I was fortunate enough to review Callas's performance in Donizetti's *Poliuto* at La Scala), but I also became European correspondent for the American

gramophone journal *High Fidelity*. The articles I wrote required much travel and specialized research into, for example, Vivaldi's Venice and Monteverdi's Mantua, and my services were rewarded with a handsome monthly salary. These were magnificent opportunities to pay extended visits to the cities in question, quite apart from conducting interviews with such noted musicians as Vittorio Gui, who lived in a splendid Renaissance villa situated between Florence and Fiesole. He and his wife came to visit us once in Buggiano, and at one point during their stay we walked up to the ancient parish church to admire the view. 'Benedetta Italia,' murmured Gui softly, leaning on the parapet and looking out over the vines, olive trees and little villages perching on nearby hills. We met frequently in the 1960s and early 1970s, but towards the end of his life Gui became very frail. I never, alas, had the chance to work with him, for by the time we became acquainted he had more or less retired from Glyndebourne, and his programmes with the Florence orchestra and various Italian theatres lay well outside the scope of my work.

* * *

After we went to live in Buggiano, I continued to work outside Italy, having decided to spend the winter months in Vienna since, although the central heating was gradually being installed in the villa – one floor at a time – winters in Tuscany tended to be damp. I also had technical matters to discuss with my publishers regarding the Haydn symphonies. A sojourn of several months in Vienna after Christmas allowed me to leave again at Easter and return to Buggiano. I had decided not to undertake any work for radio or television in Italy, since I was confident that my time there would be much improved if I did no internal professional work apart from any journalistic articles that I might be commissioned to write about the country. As a result, I had a happy and relaxed relationship with my Italian colleagues, who never had cause to feel that I was breathing down their necks. Moreover, the annual stay in Austria meant that I could also write for Central European journals, as well as forge contacts that would not have been possible in Italy.

One such contact was the conductor George Szell. When I was at school in Massachusetts during World War II, he had just arrived in America, and

I heard him conducting a radio broadcast with the NBC Symphony Orchestra. The programme was highly original: Schumann's Fourth Symphony, Haydn's Symphony No. 97 in C major, and Richard Strauss's *Till Eulenspiegel*. In those days Haydn's No. 97 was rarely played, and Szell's electric performance was a revelation. Later, when I was a college student in Boston, a group of friends and I appeared as 'supers' (supernumeraries) during the annual visit by the New York Metropolitan Opera. One of our memorable experiences was taking part in Wagner's *Die Meistersinger* conducted by Szell. Most of the time we 'supers' were offstage, so I found a secluded spot in the wings from which I could observe Szell's economic, authoritative and magisterial style. We wondered how it was possible that eminent conductors like George Szell and Fritz Stiedry could be used so relatively seldom in the Met pit, while mediocre individuals hacked their way through what the then still unbelievably provincial New York opera world used to call 'resuscitations' of Mozart's *Figaro* or *Don Giovanni*. (In those days they performed more Donizetti than Mozart at the Met.)

It was later in 1955, as I remember, that I first met Szell and his wife personally at the house of an old friend, Felix Prohaska, in Hietzing, a suburb of Vienna. When we were introduced, I remarked casually, 'I was under you at the Boston performance of *Meistersinger*.' Szell looked at me. 'As what?' he asked. 'As a super,' I replied. Szell did not smile. His sense of humour did not really embrace such situations. He asked me politely what music I was editing, and I told him I was working on the last three Mozart symphonies for the *Neue Mozart-Ausgabe*, whereupon he immediately started to discuss textual details, revealing an encyclopaedic knowledge of the scores. Prohaska procured a miniature score of the Jupiter Symphony and I showed Szell the Trio and commented that, contrary to the printed versions, where the slur in the first violin part begins at bar 17, Mozart's autograph shows it beginning a bar earlier:

'You mustn't change that,' Szell remarked. 'Mozart *often* begins his slurs slightly too far to the left,' and he began to cite examples chapter and verse. We talked at length and then a maid came in to say that Szell's car – a huge

hired Cadillac – awaited him. We took him to the door, and as we parted he turned to me and said, 'You mustn't leave that slur starting on the E: it has to start on the D sharp, promise me!' I went home, and after thinking about it for the rest of the day, I restored the slur to the reading of the 'naughty old' (or rather new) scores.

As time went on I often met Szell, usually in Salzburg. On one occasion, at a January concert given by the Vienna Philharmonic, he played the solo part in Mozart's Piano Concerto No. 23 in A major (K.488). It was a brilliant performance, and afterwards I went backstage to talk to him. I asked him why he now played so little in public. 'No time to practise,' he replied curtly. At that same concert, he provided a stupendous interpretation of Haydn's 'Oxford' Symphony (No. 92). I was sitting in the *Kuratoriums-Loge* with Friedrich Gehmacher, the *spiritus rector* of the Internationale Stiftung Mozarteum. Afterwards, as the applause thundered around us, he turned to me, speechless with admiration, his eyes shining. Finally he said simply, 'So etwas, so etwas!' (Really something, really something!).

On another occasion at Salzburg, Szell had to work with a third-rate French orchestra. I was still writing for *The Times* and reviewing the Salzburg Festival performances. 'Come to the rehearsals,' Szell said, and I took him up on his invitation. The orchestra was unbelievably casual. Some members were reading newspapers when they had longer sections of rests, and others sat with yellow cigarettes dangling from their lips. Szell, who had the reputation of being a terror at times during rehearsals, was as gentle as a lamb. In the interval I asked him how he could put up with this situation. 'You'll see,' he replied, 'we'll knock them into shape.' He spoke quite calmly, and in the event the concert was a great success.

Szell also invited me to rehearsals to advise him on certain technical and textual details of Mozart's 'Haffner' Symphony (No. 35), the autograph of which was owned at that time by a philistine New York millionairess who would not allow anyone, including Szell (who referred to her disparagingly as 'that pig of a woman') to examine the manuscript. We removed sections of the bassoons' *col basso*, as we believed that the autograph must have been misread. Szell had all the scores he loved in his mind and heart, and he studied them devotedly. He was, however, very selective. 'Posterity has made up its mind about which works are the great masterpieces,' he used to say, 'and that's why there are no real "rediscoveries" in the world of music.'

In 1956 the autograph of Haydn's 'Oxford' Symphony became available in Paris, and it was for this city (despite the title it acquired later) that the work had been composed in the fateful year of 1789. Szell immediately procured a copy. The next time we met at the Goldener Hirsch in Salzburg, he took a menu and wrote out bars 193–4 of the parts for violins I and II in the first movement. 'How do you explain the fact that the second violin is bowdlerized in all known editions?' he asked. 'I don't,' I replied. 'It must be a mistake,' said Szell, who also did not believe in the original 'bare' version of the finale (bar 1, etc.) of the same symphony. This was our first and only point of contention.

Although I was never to see Szell again after moving to Italy, I naturally followed his career with great attention. I remember in particular a couple of episodes which, it seems to me, were typical of his alert and unconventional mind. In 1966, when the terrible flood occurred in Florence, George Szell, as I have already mentioned, was one of the first to respond to our appeal by sending us a large donation to restore musical instruments damaged in the disaster. Somewhat later, in June 1968, I was teaching at an English summer school and as I was driving through London on the way back to Italy, I turned on the car radio. A Promenade concert was being broadcast, but I had missed the introductory announcement. I listened, spellbound, as the orchestra gave a brilliant, scholarly reading of Bach's Third Suite (or Overture) for Orchestra, with double-dotting, *notes inégales*, ornamentation, trills on the upper note – all directed by a Baroque expert who had clearly studied the latest literature on this incredibly complex subject. At the end of the performance, the announcer revealed that Szell had been the conductor. In this performance he had displayed a whole new side of his complicated and profound musical nature – Szell the scholarly epicure, relishing the double-dotted Baroque tradition and harpsichord continuo.

A final recollection concerns the last recordings that Szell made – the first six London Symphonies (Nos. 93–98) by Haydn – with the Cleveland Orchestra. I had written the sleeve notes for one of these records and in due course received a complimentary copy. It arrived one morning in Buggiano, and when I played it I could scarcely believe my ears. It was Symphony No. 96, in the recently published edition using Haydn's own orchestration, and played, moreover, as I had never previously heard it. In

particular, the Minuet struck me as being one of the finest performances of eighteenth-century music that I had ever heard. I made a mental note to write to Szell and congratulate him, but put it off, as one tends to, and suddenly it was too late – Szell was dead.

My stay in Vienna also brought me into regular contact with Leonard Bernstein, whom I had known for many years, ever since he had recorded various Haydn symphonies in my new edition. I remember one particular scene which took place at a party held in the Decca apartment above the Sophiensaal. Bernstein had just arrived in the city and was recording a Mozart piano concerto with the Vienna Philharmonic. The Austrian pianist Friedrich Gulda was also present at the party. 'Robbie, don't let him start playing jazz [i.e. improvising],' Lenny begged me at one point. 'He thinks it's marvellous, but it's disgusting!' As the evening grew merrier, my old friend, the trumpeter Helmut Wobisch, appeared at my side and beckoned me to follow him. Wobisch had become an official with the Vienna Philharmonic and hence by osmosis with the Vienna State Opera. He took me to a little alcove and whispered in my ear, 'Bernstein likes you, doesn't he?' 'Well, I don't really know him that well,' I told him. 'Macht nichts [doesn't matter],' said Wobisch. 'We want him to conduct at the Staatsoper. Go and ask him if he would like to.' After a discreet interval, I sneaked over to Bernstein (who had of course observed our little pantomime). I put the question to him as instructed, and he found all the intrigue most amusing. He did not reply directly, but countered by saying, 'Ask him if they'll do Meyerbeer's *Vasco da Gama*.' I shuttled over to Wobisch and repeated this somewhat eccentric question. 'Jesus Christ!' Wobisch exclaimed. 'What does he want to do that for? But all right, if that's what it takes, we'll damned well do it.' The result was a typical Viennese compromise: they did *Fidelio*.

The Vienna Philharmonic had the reputation in those days for being rather anti-semitic: indeed there was not a single Jew in the orchestra (in contrast to the 1920s and 1930s, when there had been many). However, with Bernstein conducting, the players showed no signs of prejudice towards him. Since the end of World War II the Vienna Philharmonic had played scarcely any Mahler, notable exceptions being when Bruno Walter made guest appearances with the orchestra (I remember a magical *Das Lied von der Erde* with Kathleen Ferrier, whose health was already in decline when

she sang it in the early 1950s at the Musikverein). Under Bernstein his symphonies were played once more, and in magnificent style.

I recall in particular a series of televised performances of the nine Beethoven symphonies in the Musikverein, produced by Humphrey Burton. Considering Bernstein's normally exuberant personality and beat, it was astonishing how chaste and distinguished these interpretations were. As a conductor, Bernstein had a reputation for being rather vulgar, but his readings of Haydn and Beethoven were austerely classical in the best tradition. Indeed, he was a much more remarkable figure than many people believed, and I am pleased to note that his reputation is being reassessed.

At about that time Burton was also in the process of making a film, *Ring Resounding*, with the mercurial Georg Solti, who was recording Decca's most famous project of the 1960s, Wagner's *Ring* cycle. One of the most pleasant aspects of working with gramophone companies in Vienna was that we used to drop in on each other's recording sessions. Christopher Raeburn and Erik Smith would come and listen to Max Goberman recording the early Haydn symphonies which I was producing for the Library of Recorded Masterpieces based in New York (we managed to put forty-five works on to tape before Goberman died in 1961), and I used to be a spoiled guest at the Decca apartment above the Sophiensaal, where they made most of their records. I particularly relished the opportunity to attend Solti's *Ring* sessions. I remember very clearly being in the control room when they were making the final takes of the end of *Götterdämmerung*, and being deeply moved by the magnificent sound (supervised by Gordon Parry and produced by John Culshaw). Solti, dripping with sweat, came in with Birgit Nilsson to listen. At the end, Culshaw said very quietly, 'Now can we have it just a bit slower – it's too frenetic, George' (pronouncing his name in the English fashion). Solti immediately went back to the podium and took it 'just a bit slower': the result was perfect and entirely justified the presence of a skilled *Aufnahmeleiter* or recording supervisor.

Shortly after, we were all relaxing in the Decca apartment over a glass of wine when Solti remarked casually, 'Think, you could put all twelve Salomon symphonies into less than half the time it takes for the *Ring*.' I had never thought of it in that way, but the comparison was of course true. Later, when Solti did record Haydn's last twelve symphonies for Decca, I

found them very good readings, and wrote to tell him as much. Gradually, he began to entrust me with writing notes to accompany his recordings, or would telephone at odd times, day and night, to ask my advice on various obscure technical matters – from solo cello passages in Bruckner to repeats in Haydn's Symphony No. 104 ('London'), which he had programmed with Beethoven's Eighth Symphony for the Salzburg Festival ('What intriguers!'). I was always amused to hear his voice on the line: 'My dear friend,' he would begin, rolling his 'r's' in typical Hungarian fashion.

* * *

I had promised myself that, while living in Italy, I would explore as much of the country as possible, so whenever we had the opportunity we would organize a three or four-day trip, to Umbria or the Marches for example. We usually made these excursions off-season, particularly in late autumn when travelling was delightful and there were chestnuts and truffles to look forward to. I was especially taken with the remote parts of Calabria, and that fascinating yet relatively unknown area between Naples and Benevento (the birthplace of our maid at Buggiano), where many aspects of daily life had changed little over the past three hundred years. In faraway towns such as Città di Castello, we were able to acquire antique furniture at bargain prices, including a dated, seventeenth-century bookcase which was so heavy and cumbersome that it would hardly pass through our front door.

One day, while still in the process of restoring Buggiano, I thought I detected a small dash of colour on the large expanse of whitewashed ceiling in the billiard room. I took off my shoes and, holding a damp cloth, climbed on to the billiard table. After rubbing the surface for a few moments, I uncovered a naked foot. I immediately climbed down and called in our decorator who, with the help of his assistant, carefully washed down the ceiling and all the walls to reveal a series of bare-breasted women depicted as cameo portraits but in fresco, and spaced around the walls at regular intervals. The decorator was very amused: the portrait had obviously been overpainted some time during the nineteenth century, when the depiction of naked females was less appreciated than it had been in the carefree century that preceded it. He then pointed out that the figures had been carefully obliterated in such a way as not to damage the bosoms. It had proved easy

to remove the layer of whitewash, and before long we were uncovering other frescoes, almost all of which were revealed intact.

Buggiano held other secrets. Some years later, my wife Else, normally sensible and pragmatic (in keeping with her Austrian roots), said to me one day, 'I'm being followed by a ghost.' 'There aren't any ghosts here, and you know it,' I replied reassuringly, but she persisted, complaining that on the second floor she often had the feeling that someone was watching her. Then a friend came to visit. She walked through the front door and stopped in her tracks: 'Questa casa e piena di spiriti' ('This house is full of spirits'), she pronounced darkly. Later, my friends Russell and Mary Foreman stayed in the house when I had to go away on business, and on my return they related all sorts of strange stories. I myself had never encountered the ghost and my father-in-law, who was fascinated by the unlikely idea that the house was haunted, even stayed up one night in the (unrealized) hope of seeing it.

Then came the curious story of my assistant Christine, whose boyfriend was a distinguished young viola-player and an eminently sensible young man. One night they were preparing to go to bed in the corner room on the second floor, where they kept a cat for company. Suddenly, the cat howled and, with its fur bristling, rushed under the bed. Christine opened the door of their room and screamed. Gigi, the boyfriend, refused to believe that there was a ghost outside. However, when he went to the door to see for himself, he hastily banged it shut. 'What was there?' I asked him next morning when he related the story at breakfast. Apparently they had both witnessed a ghostly apparition – long, white and amorphous.

The house was a historic monument and we often had to show people round it. One day, after the word had spread about our ghostly goings-on, we opened the door to a young couple who told us that they had come to see 'the haunted room where the lady was killed'. Some months later, we were invited to dinner with a group of Italian friends at a villa near Florence. Else was seated next to a distinguished looking doctor and in conversation she mentioned to him that we lived in Buggiano Castello. 'You mean the haunted red house?' he asked. It transpired that the doctor had been the regional health officer in World War II and knew all about our house: legend has it that during the Crusades, the knight of Buggiano rode forth to fight in the Holy Wars, leaving his sorrowful wife behind. When he returned

unannounced some years later, he found his wife in bed with an unknown lover and had them both skewered forthwith. The scene of this tragedy became the 'haunted room', though I slept in it for many months without ever being aware of the presence of the unhappy spirit.

However, while we were filming the Monteverdi programme for the BBC and the house was littered with tracks for the camera and mountains of equipment, I found myself alone one evening after the crew had gone home. Feeling rather tired, I happened to be sitting in the big hall with a nightcap when suddenly, next to the Gothic wooden statue of St James of Compostela (where previously many guests had thought they had seen something mysterious), I noticed a white form. Naturally I was startled, but the odd thing was that the apparition did not frighten me at all. I drank up my whisky and went straight to bed. This may well have been the ghost that we had been told so much about, for I had heard that it was known for showing curiousity about new things or people in the house. I assume that it approved of our filming activity, however, because I never encountered the apparition again. No one told the present Swiss owners about these incidents, and when we went to visit them several years later they did not mention the subject. Somehow ghosts and the stolid Swiss do not seem a plausible mixture.

In nearby Montecatini there was an antiques shop that catered mostly to bored visitors who had come to take the cure, or to passing tourists. One day, to our surprise and delight, there appeared in the shop window a ravishingly beautiful eighteenth-century Italian harpsichord with a first-rate painting on the wing, and embellished on the side with the coat of arms of a cardinal. With the help of the German Institute in Florence, we were able to identify the painting as a work by Francesco Trevisani and the coat of arms as that of the famous Cardinal Pietro Ottoboni, patron of Corelli (who was his 'house' composer) and Handel. We purchased the instrument and had it restored in Vienna by Professor Josef Mertin, a renowned expert on old organs and harpsichords. Ours was a single-manual harpsichord and had that peculiarly dulcet and beguiling tone typical of eighteenth-century Italian instruments; sentimental people like to say that you can hear the sun in the sound-board. My late friend Michael Thomas attributed this quality to the fact that Italian keyboard-instrument makers used to glue the sound-board to the corpus outdoors under the blazing sun,

whereas nowadays they generally resort to using artificial ovens for the drying process.

I organized a work-schedule for myself in Buggiano, whereby I rose at 5 a.m. and went to my study for four hours of concentrated work on the Haydn symphonies. Just to amuse myself, I edited the last twelve – the London (or 'Salomon') symphonies – in chronological rather than numerical order. On reaching No. 104 – on the autograph of which Haydn had inscribed (in English), 'The 12th which I have composed in England', dating it 1795 – I felt very moved as I checked the sources for the final bars. It was early summer and the sun had not yet risen; as I put down my pen, my mind turned to Gibbon finishing *The Decline and Fall of the Roman Empire*. Like him, I went out into the garden, looked up at the stars as the new day dawned and contemplated the glory of God. It struck me at that moment that this was the last time anyone would have the privilege of 'rediscovering' a major composer like Haydn, many of whose works had still not been collected together in a proper critical edition. It was a humbling thought.

* * *

In Milan I used to visit a music shop owned by a collector named Natale Gallini, where I would often come across interesting old prints and music manuscripts, including a whole first edition of Gesualdo and a series of church music scores by members of an unknown eighteenth-century family called 'Di Donato' (the names could not even be found in any music dictionary or encyclopaedia). One sunny August morning, I woke up and suddenly had a strong presentiment that I must go to the shop. 'You can't go all by yourself,' said Else, who decided to accompany me to ensure that I would not fall asleep while driving on the *autostrada*. It was a long, hot trip of about 200 miles, but well worth the effort; when we finally arrived at Gallini's shop, I found two volumes of a manuscript copy of Haydn's opera *La fedeltà premiata*, though not bearing the composer's name. I started to leaf through the volumes, and realized immediately that the score was covered with corrections and additions in Haydn's own hand, including tempo markings, dynamics and an occasional Italian text. Else was stunned. 'How could you possibly have known?' she asked incredulously. Gallini's

wife informed us that the 'maestro' would not be coming in until the next day, but that he would more than likely be pleased to sell us the manuscript. We spent a rather nervous night in a hotel before returning next morning. Gallini was his usual charming and cultivated self. 'It's curious, that manuscript,' he remarked, 'it looks just like Haydn.' I agreed. He then consulted an Italian opera dictionary, but fortunately for me *La fedeltà premiata* was not listed. 'Well,' he said, 'it's not complete, whatever it is, so would 70,000 lire [about $110] be all right?' I signed a cheque straight away and we departed. We drove north-west to a peaceful town above Lake Maggiore, where I could study the work in peace and quiet.

Years later, and long after we had given up all hope of locating the missing companion volumes, my dear friend Albi Rosenthal sent me by fax a list of musical manuscripts that he had found in Locarno on the Swiss-Italian border. It included a two-volume manuscript copy of *La fedeltà premiata*. Since any Haydn manuscript score is bound to be of special interest, I ordered the volumes at once. Subsequently, however, Albi telephoned to say that his assistant had lost them and I resigned myself to the thought that nothing more would be heard of them. Then, about a month later, another fax arrived: 'Eureka, we've found it again!' The two volumes were sent on to me and did indeed include the beginning of the opera, plus almost all the rest of the work contained in the Gallini manuscript. Not only was this copy covered with Haydn's autograph corrections and additions, but it also included an aria, no other copy of which was known in its complete form. I photocopied some specimen pages and faxed them to Albi with the details. His answer – quoting the second-century grammarian Terentianus Maurus – read simply, 'Habent sua fata libelli.'[1]

* * *

While I was living in Italy, frequent attempts were made to lure me away to lecture in America. I turned down all such offers assiduously, but in the spring or early summer of 1968 my assistant Christine took me unawares one day with the disturbing news that we were about to go bankrupt. I was of course astonished to find myself in this situation, which had come about because most of the people who owed me money for work I had done had

simply failed to pay up on time. This horrible habit of delaying payment for as long as possible had begun to occur with increasing frequency, and Christine decided to cope with the problem by sending reminder telegrams to the people she thought would pay most quickly and owed the largest outstanding sums. Over the next few months some of the money did begin to flow into my depleted coffers, but my financial situation was still precarious and Christine eventually advised me to consider accepting the next offer to teach in America. Aside from my involvement in the final Beethoven film (see p. 82), I had more or less stopped working regularly for BBC Television by this time, so when the City University of New York offered me a teaching position for the Spring semester in 1969, I decided to accept. In due course my wife and I, together with Christine, moved temporarily to New York City.

My work at Queens College and City College (both constituent colleges within the City University of New York) was divided into several sections, and one seminar that I taught at CCNY (City College's abbreviation) was particularly interesting because it involved the collaboration of three of my students. I decided to prepare a new edition of Mozart's 'Haffner' Symphony (K.385), the autograph manuscript of which had not been consulted for the old complete edition of Mozart published by Breitkopf & Härtel, but had been used for the first time in an edition published by Ernst Eulenburg in the 1930s. The manuscript was acquired by a private collector in New York, and although it had been kept under lock and key for some time, it was by then available for study in the New York Public Library. Even in the case of the Eulenburg score, it soon became obvious that there were many details that required urgent attention, and this was why we undertook the project, producing an edition that was published in 1971 by Faber Music. Each movement was edited separately and signed by one of my pupils; for once, students received full recognition for the contribution that they had made, and the edition proved to be something of a landmark in the Haffner Symphony tradition, which stretched back to 1782, when the work was first composed. In order to offer some insights into the atmosphere of excitement surrounding the findings of our students, I quote extracts from my own Foreword (written at Buggiano in 1969) to the Faber edition. In tracing the background to the symphony I relied on a series of letters written by Mozart to his father in Salzburg in 1782 and 1783. It will be recalled that Wolfgang

had settled permanently in Vienna in 1781; the first mention of Leopold's request for a new symphony occurs on 20 July 1782.

... The writer of this foreword happening to be in New York City during the Spring Semester of 1969 (February–May) teaching a graduate seminar at the City University of New York on the editing of music of the classic period, it was decided that the students should compare the autograph of K.385 – which had just appeared in a handsome facsimile [with Introduction by Sidney Beck] – with the Eulenburg miniature score. The results were so astonishing – several hundred wrong notes, mistakes in dynamic marks, misplaced phrasings, omitted phrasings, etc. – that we felt an immediate publication of an 'Urtext' score to be an urgent necessity. Our astonishment was even greater when we realized that the authentic first edition in parts which Mozart entrusted to the Viennese firm of Artaria & Co. – the British Museum owns a copy from the Hirsch Collection [IV.56] – had likewise never been used for any critical edition whatever of the Symphony. At least one reading in the Artaria – the controversial bars 222/228 in violin I of the Finale – looks very much like a second thought on Mozart's part. It is also clear that the Artaria edition was not simply copied from the autograph but quite obviously represents a copy of the original orchestral material from which Mozart conducted the Symphony in various Viennese 'academies' in 1783 and 1784

The occasion for which Mozart was to write the new music was the granting of a title of nobility to Sigmund Haffner (1756–1787), son of the Bürgermeister of Salzburg; Mozart had previously written a beautiful Serenade in D (K.250), with accompanying March (K.249), to celebrate the marriage of the Bürgermeister's daughter Elise, and the music became known as the 'Haffner' Serenade

Mozart scored the new Symphony for two oboes, two bassoons, two horns, two trumpets, kettledrums and strings; one of the two minuets seems not to have survived (or possibly both were later discarded)

As Mozart's fame grew, he was called on to produce many 'academies' [in Vienna] for which numerous symphonies were required. He wrote to Salzburg, asking his father (in a letter of 4 January 1783) to send him several early works, among them the Symphonies K.201, 182 and 183 as well as the Serenade in D, K.204. In a previous letter of 21 December 1782, he had written: '...I also asked you [in an earlier letter] to send me by the first opportunity which presents itself the new Symphony which I composed for Haffner at your request. I should like to have it for certain before Lent [1783], for I should very much like to have it performed at my concert ...'.

In the afore-mentioned letter of 4 January 1783, he notes that it '...is all the same to me

whether you send me the symphony of the last Haffner music, which I composed in Vienna, in the original score or copied out [i.e. in parts] …'. On 5 February 1783, he writes again, '…please send the symphonies, especially the *last one* [K.385], as soon as possible, for my concert is to take place on the third Sunday in Lent, that is, on March 23rd, and I must have several duplicate parts made. I think therefore, that if it is not copied already, it would be better to send me back the original score just as I sent it to you; and remember to put in the minuets.' On 15 February he acknowledges receipt of the score from Leopold: 'My new Haffner Symphony has positively amazed me, for I had forgotten every single note of it. It must surely produce a good effect …'.

The first Viennese performance – indeed, the first public hearing – of the new 'Haffner' Symphony took place on 23 March 1783 at the Burgtheater, in the presence of Emperor Joseph II ….

For this Viennese 'Academy', Mozart added flutes and clarinets to the corner movements, the flutes on the top (hitherto empty) staff of the autograph and the clarinets on the bottom (also hitherto empty) one. The Minuet which has survived is written on paper with different watermarks from the rest of the music, which has led some scholars to suggest that it might have been a brand new piece for the Vienna version, and that Mozart discarded the other two minuet movements for Salzburg; but one decisive factor suggests that the surviving *Menuetto* was in fact one of the original Salzburg movements, for it is scored for the original Salzburg orchestration and the flutes and clarinets have not been added. Naturally, we have retained the supplementary flute and clarinet parts, though the first edition by Artaria omitted them, probably because they thought it easier to sell a symphony without clarinets (which instruments were not included in many court orchestras, e.g. Salzburg and Haydn's band at Eszterháza); and the flutes were 'expendable' anyway.

Obviously Mozart had a set of manuscript parts prepared, from which he conducted not only the first public performance on 29 March 1782, but also later performances, e.g. at his 'Academy' on 1 April 1784. The 'Haffner' must have been a great success, as was another, earlier work composed in Salzburg in 1779; the endearing B flat Symphony K.319, for which Mozart added the Minuet for the Viennese public in 1782. Mozart's principal Viennese publishers, Artaria & Co., brought out the two 'new' Symphonies, K.385 and 319, in 1785, along with the three piano Concertos K. 413–415, the six string Quartets dedicated to Haydn (K.387, 421, 428, 458, 464, 465) and the Fantasia and Sonata in C minor (K.475 and 457), during the year 1785.

As we have hinted above, Artaria used as copy for his engraver the set of manuscript parts – not the autograph – of each of the two symphonies. Artaria, as we know from Haydn's letters and from close scrutiny of his many Haydn editions, was a notoriously

careless publisher; his editions always crawl with printer's errors; Mozart, moreover, was not a very accurate proof-reader – odd, when one considers how beautifully accurate his autograph scores always were. Thus, the Artaria edition of the 'Haffner' Symphony could not exactly be described as a scholar's, or indeed player's, delight; despite that fact, it is indispensable for any critical edition …

The facsimile edition of the autograph contains all the necessary descriptions of the manuscript, its previous history, etc …. Suffice it to say that there was no original title by Mozart himself; the present title is from the hand of Leopold …. Mozart's description of the instruments is '2 flauti, violini, viole, 2 oboe, 2 Corni in D, 2 Clarini [trumpets] in D, Tympani, 2 fagotti, Bassi, Clarinetti in A'. The autograph is beautifully and swiftly written, with very few corrections and only an occasional wrong note (e.g. Finale: timpani at bar 12, a mistake also repeated in Artaria – perhaps Mozart never 'picked it up' at all …) ….

In our edition, we have added phrasing marks, staccato dots, and the like only from parallel passages. Editorial material added by us has been placed in square brackets [], material from the Artaria edition in round brackets (). Our notes are intended to serve a twofold purpose: first, to show any changes we made and to record divergencies between the autograph (=AUT) and Artaria (=ART); and secondly, to show the changes between our score and the only other score ever to use (albeit incompletely) the autograph, *viz.* Eulenburg. Thus, conductors may correct their Breitkopf or Peters (or whatever) parts using this score in conjunction with the notes. Mozart's notation of the horns, trumpets and timpani in C–G (transposing) has been, obviously, retained. Those students who are acquainted with the problems involved will see, upon examination of our score and the notes thereto, how urgently a new critical edition was required, and how many mistakes, great and small, have crept into the text of the Symphony over the years.

For nearly a decade my academic work in America was an annual event, and consisted either of conducting seminars or delivering series of lectures across the country. Sometimes I gave seminars devoted to a single composer – for example, at the University of California, Davis, I concentrated on Mozart. At other times I taught a range of different courses, sometimes lasting for a full semester, sometimes less. This annual pilgrimage to America continued until 1978 when I was appointed the first (part-time) John Bird Professor of Music at University College, Cardiff, and my time was then divided between Middlebury College in Vermont, Princeton (Westminster College and University) in New Jersey, and Cardiff. However, I found that this hectic teaching schedule was preventing me from concentrating on

serious scholarly writing and research, particularly the completion of my biography of Haydn, and therefore I gradually migrated back to Europe, where I had enough time to finish the remaining volumes on the composer. These were published between 1976 and 1980 by Thames and Hudson. Before giving up lecture tours altogether, however, I completed the most extensive and ambitious of them all: the series of Mellon Lectures on eighteenth-century music in Europe, given at the National Gallery in Washington, DC, in 1975. These were very complicated presentations since they required the involvement of other people to organize the musical examples and the slides used to illustrate my texts. In Washington I had a superb team of assistants, all members of staff at the National Gallery, and we would rehearse the lectures thoroughly beforehand to ensure that everything ran smoothly. The texts were utilized for teaching purposes by various universities in America and were broadcast by the BBC.

* * *

One of the many fortunate circumstances that arose from living in Tuscany was the opportunity to mix with a truly international community – apart from the Italians, who naturally constituted the great majority, there were also Finnish, German, Austrian, Swiss, American, English and French residents. This proved a successful and happy combination because we were all there for the same reason – out of personal choice. The leading Italian families in the area would often invite us to their feasts and parties ('How many of you will be with us next Sunday noon?'). Herbert Handt and his sculptress wife Laura Ziegler moved to a house outside Lucca, where they organized a flourishing and unconventional festival, and some of the activities that they planned took place in a pretty eighteenth-century opera house in a nearby hill town called Montecarlo. I recall the fabulous local white wine, most of which was sold to a grand restaurant in Turin called Il gatto nero ('The Black Cat'), where we occasionally dined and were invariably spoilt for choice. In Montecarlo itself a tiny restaurant specialized in *giro arrosto* – various delicacies cooked on a spit. The chef was an eighty-year-old character who loved to quote excruciating Tuscan proverbs – for example, 'Quando fu fatta la donna, fu fatta anche la miseria' (When woman was made, misery was made too) – while simultaneously roaring with laughter.

My next-door neighbour in Buggiano, Alessandro Giuntoli, was the chief 'ingegnere' (commissioner of works), for the city of Florence, and a most amazing man. Our two families (he had a son, a beautiful daughter-in-law and two small grandchildren) became great friends. Giuntoli once told me the story of how he had helped to frustrate an attempt to round up the Jews in Florence during the German occupation (as a high-ranking civil official, he had met the Führer when he visited the Tuscan capital – apparently Hitler had a 'fishy hand'). One day an SS officer came to see Giuntoli and asked politely for a large-scale, detailed map of the city. When Giuntoli asked why the map was needed (was it to locate sewers, bridges or electricity-generating sites, for example?), he was told that all the Jews in Florence were going to be rounded up two days later. 'Well,' said Giuntoli, 'what you need is a B-61 map. I'll have it sent to your office this afternoon.' The SS officer snapped to attention, and as soon as he had left, Giuntoli telephoned the Cardinal and conveyed the news to him in a pre-arranged coded message: 'The grass is going to grow very high the day after tomorrow.' A series of precautions was at once implemented in the city records office, again according to a pre-arranged plan. All the Jewish families' addresses were removed and transferred elsewhere – for example, Giuseppe C. who lived at Via Santo Spirito 29 was inserted at Piazza Pitti 4. Thus Christians and Jews were hopelessly intermingled, and when the sinister SS trucks arrived at dawn on the appointed day the German troops could trace scarcely a dozen Jews among the several thousand living in the city. 'Why did you do it?' I asked. 'It was a monstrous idea,' he replied. 'Why, in the First World War my batman was a Jew and he was just as Italian as I was.' In other words, the humanitarian operation was instituted not because of some complicated political or moral stance, but because the proposed round-up amounted to a crime against humanity, and *umanità* is a word you often hear in Italy. For me, this was one of the many elements that made the country such a special place.

1 Terentianus Maurus, *Carmen heroicum*, line 258.

Austrian cottage:
a writer's retreat in the Waldviertel
1975–1984

It had become clear that my plans for the immediate future would involve a considerable amount of research in Vienna and Budapest, and therefore Else and I decided to move back to my flat in the Austrian capital. While we were in the process of selling Buggiano, one new factor in particular influenced us in this decision: the provincial government of Burgenland, the capital of which was Eisenstadt, seat of the princely Esterházy family, had decided to put on an annual Haydn festival in the town. We would have at our disposal a choir, an orchestra, vocal soloists; we would also have the possibility of playing chamber music, as well as the use of both the cathedral (formerly the parish church of St Martin) for large-scale choral works such as Haydn masses, and the great hall in the Esterházy Castle for performances of works requiring substantial orchestral forces. The charming smaller hall in the castle – the 'Empire-Saal' – would be a venue for chamber music, lectures and other more intimate events. At one point we even persuaded the Vienna Philharmonic to come to Eisenstadt and play Haydn dance music, the Twenty-Four Minuets for Orchestra [Hob.IX:16], which I had edited and which Doblinger had recently published for the first time. The chief difficulty we faced was how to overcome the apathy of the inhabitants of Eisenstadt, who simply could not be persuaded to attend festival events. The lady owner of 'Trachten-Tack', a fashionable clothing and sports shop on the principal square, put it quite simply: 'If we want to hear music, we go to Vienna.' (It is only an hour's drive from Eisenstadt to the centre of Vienna.) I remember one very grand concert in the cathedral – really a very distinguished interpretation of Haydn's *Missa Sancti Bernardi de Offida* ('Heiligmesse') – and we sold just sixty tickets. I also persuaded

James Mallinson of Decca Records to give a talk on his experiences as a recording supervisor, in particular while working with Antal Dorati on the recently completed series on LP of all Haydn's symphonies, but this attracted an audience (apart from ourselves and family) of only three.

Later, we fused the festival with a project undertaken by an American conductor, Don Moses, who organized a very successful seminar on classical music in Eisenstadt which he managed to fill with American students (he was then Professor of Music at the University of Iowa, and his wife a professional soprano). With his involvement the halls began to fill up – but only marginally. Major events held in the great hall of the castle were not always full, even during the Haydn Year in 1982, which marked the 250th anniversary of the composer's birth. It took the determined efforts of Walter Reicher (the present Intendant of the annual Haydn-Tage) to get the original Eisenstadt Haydn Festival back on its feet; it was gratifying to note that in 1997 two performances of the opera *Il mondo della luna* were sold out. One year a staged version of Haydn's marionette opera *Die Feuersbrunst* was performed in the great hall at Eisenstadt, and this proved to be a great success, as did *Le pescatrici* conducted by Don Moses in 1982. Four performances of *L'isola disabitata* given in 1998 also attracted full houses. The Austrians love opera, and those by Haydn will perhaps continue to be the mainstays of the festival.

* * *

The logistical problems posed by moving from a forty-room Italian *castello* into a four-room Vienna apartment were, of course, insurmountable. Admittedly we had sold most of the large pieces of furniture when we left Italy, but even what remained presented us with difficulties. Fortunately, our friend Hannah Adler (F. Charles's widow) offered us a very happy solution. She had doctor friends who owned an unfurnished farmhouse which they were prepared to let. This was situated in a small town in the Waldviertel or 'wooded district', a large province of Austria that lay between Vienna and the Czech border and had been part of the Russian zone of occupation. The railway line which served the town proved very useful, although there was only one track instead of the original two. The second line had been torn up after the Russians left when the volume of traffic

declined to only a fraction of what it had been before the war and even during the occupation years.

Hirschbach was a delightful place. There was a local *Gasthaus* which served a decent Wiener Schnitzel, and the local wine, imported from an area further towards Vienna, was (just) drinkable and very cheap. The town was set in a beautiful but very remote part of Austria, with dark lakes and miles of mysterious forests where one could walk for hours without meeting anybody except an occasional wood-cutter. The old town of Hirschbach did not even have a policeman since there was no crime. I lived there for nine years, writing away in a small room overlooking a field, and it was here that I completed my five-volume biography of Haydn. As before, I treated myself to a break every fourth or fifth day. However, the Waldviertel is bitterly cold in winter, with heavy snowfalls, so we would spend the season in Vienna, returning briefly to Hirschbach to spend magical Christmases in the country. Our Italian friends who came to visit us at Christmas would trudge along obligingly with us through the snowy fields, but they obviously thought that we were mad. With the arrival of spring, I would move back to Hirschbach, taking with me any reference books that I needed. The people of Hirschbach were both friendly and open-hearted, and of course being a Haydn scholar was for me a great advantage in Austria, where the composer is a national hero.

I was able to complete my Haydn biography, therefore, in peaceful, idyllic surroundings. The content was presented chronologically in five volumes, and the first to be released (although the third in the eventual complete set) was *Haydn in England*. I knew when I started writing in 1969 that I would need to go back to Hungary at some stage to look up more sources in the Esterházy Archives, in order to complete two of the volumes devoted to the periods that Haydn spent in princely service – between 1761 and 1790, and between 1795 and 1809. Hence we published the individual volumes in the following sequence:

III: *Haydn in England 1791–1795* (1976)
IV: *Haydn: The Years of 'The Creation' 1796–1800* (1977)
V: *Haydn: The Late Years 1801–1809* (1977)

These three volumes were finished while I was still living in Italy. Having then made an extended visit to Budapest to search for further material concerning

Haydn's early career, I was able to publish the remaining two as follows:

II: *Haydn at Eszterháza 1766–1790* (1978)
I: *Haydn: The Early Years 1732–1765* (1980)

It was a formidable project for any publisher to undertake, and I was very lucky to have Thames and Hudson as my partner. I inherited one editor, Charles Ford, from Faber and Faber (who had intended to publish the work but found it too daunting) and had Mark Trowbridge from Thames and Hudson as my principal editor. He stayed with me when I extended my writing to include Mozart, and proved to be an author's dream – meticulous, self-effacing, diligent and unfailingly good-humoured. He would often go off to libraries to confirm points of detail, and occasionally he would send me some famous old Haydn recording which he thought I might appreciate or simply find amusing (for example, Karl Haas conducting Haydn's *March for the Prince of Wales*, long since deleted from the record catalogue).

On my last research trip to Budapest I needed to use the Esterházy Archives for two purposes: to examine all the Haydn opera fragments of 1761–3 which had never been published and search for extracts with which to illustrate my book; and also to look through documents in another part of the archives located in Buda. There I found entrancing contemporary records, such as details of the princely expenditure for clothes for a given year in the 1760s, and descriptions of how the forbidden publications of the French Enlightenment, such as the works of Voltaire, were smuggled into Austria-Hungary. (I could imagine the prince laughing sardonically when he heard about this clandestine activity.) In the course of the same trip I needed to examine the contents of a fascinating Haydn collection that I had helped to identify some years earlier – the manuscripts from the Festetic family in their castle on Lake Balaton, which was now a well-known resort for German tourists. All the hotel rooms were booked up, but by dint of a packet of coffee bought from the local shop catering for travellers with foreign currency, I managed to bribe the lady in the tourist bureau and we were given a room in an elegant hotel further up the lake.

I had identified Haydn's handwriting in many of the manuscripts in the Festetic archives, which of course immediately made the entire collection inestimably valuable. It contained the only authentic sources for almost all the early, pre-Esterházy symphonies, most of the string quartets and some

of the divertimenti and string trios, and its interest was increased by the stamp of its owner, Lieutenant-Colonel Joseph von Fürnberg, a member of the family which commissioned Haydn's first string quartets, performed in about 1757 at Weinzierl Castle in Lower Austria. I made up my mind to examine all the holdings – not only the works by Haydn – in the collection, and this search yielded the autograph parts of a hitherto unknown Symphony in F by Johann Michael Haydn, which his brother Joseph had sold on his behalf along with his own music. I traced the watermarks and the obliging custodian photographed the manuscripts for me there and then. Later, I was told the amazing story of how a Russian army officer (in civilian life a schoolteacher from the Ukraine) had been among the troops which had captured the castle in 1945 and, recognizing at once the value of the library and music manuscripts, had had that part of the castle walled up. As a result, when the next, very tough Red Army troops arrived on the scene, they were not aware of the existence of the precious library and the priceless Haydn collection that it housed. Many scholars will have had occasion to bless that Soviet army officer, whose presence of mind probably ensured the survival of the most important sources for Haydn's compositions of the Fürnberg-Morzin period.

We will never know how and why Fürnberg put together his collection, but it must have happened after Haydn wrote his first symphonies for Count Morzin in the later 1750s. At Lukavec, the Bohemian castle where these works were first heard, there was not a single piece of music to be found when I visited it in 1959, and the Morzin Archives for the period had already disappeared by the middle of the nineteenth century, when the great Haydn scholar C.F. Pohl searched for them.

All this was essential material for the volume of my Haydn biography that covered the composer's early years, the completion of which kept me occupied during 1978 and 1979. Thames and Hudson were magnanimous publishers and allowed me to include unlimited musical examples – extremely important when dealing with unpublished music which no one had heard or seen for two centuries. We took great pains over the choice of illustrations, which I (unlike most of my colleagues) have always considered a highly necessary accompaniment to documents and music from remote ages. How can we place Haydn, Mozart and Beethoven in their surroundings convincingly if we do not make a point of featuring

contemporary portraits, landscapes, street scenes, castles and instruments?
I have never understood why so many of my contemporaries objected to
this aspect of my publications. My old friend Dr William Ober nearly
foamed at the mouth when my illustrated book *Beethoven: A Documentary
Biography* appeared in 1970. 'Don't ever do that again!' he admonished, as
if the collection of documents, both visual and printed, would somehow
tarnish my reputation as a scholar. I am eternally grateful for the example
set by my late friend Otto Erich Deutsch, and also by Ernst Fritz Schmid,
who showed how utterly essential this aspect of biographical research has
proved to be.

The Vienna Haydn-Tage was another annual event which occupied my
attention whilst living in Austria. It was the brainchild of Dr Otto Biba,
archivist of the Gesellschaft der Musikfreunde (or Society for the Friends
of Music, founded in 1812), which put on the first series in 1984. I used to
give lectures or introduce the latest gramophone records, and concerts took
place in the various halls of the Musikverein, including the Brahms-Saal
(excellent for chamber music), the even smaller Schubert-Saal, and
frequently the archive rooms. In addition to organizing musical events, Dr
Biba would often mount very enlightening expositions which soon attracted
a large number of followers. Various well-known conductors also came on
these occasions – Nikolaus Harnoncourt, for example, gave a highly
successful performance of *L'infedeltà delusa,* and he also conducted a whole
series of masses and other church music by Haydn in the great hall, all of
which attracted large audiences. The programmes offered at the Vienna
Haydn-Tage have included many surprises. On one occasion in 1986 Dr
Biba put on a special concert for my sixtieth birthday, organizing the
preparation of performance material for two cantatas which Haydn
composed for Prince Nicolaus Esterházy in 1763 and 1764, works which
were still unpublished and had not been performed since Haydn's lifetime.
'Destatevi, o miei fidi' (XXIVa:2; 1763), composed for the prince's name-
day in December 1763, contained some amazing music, including a stormy
D minor aria for soprano which riveted the audience. These performances
were elaborate affairs in Haydn's day and involved the full Esterházy
orchestra, the principal vocal soloists available at the time, and the composer,
who conducted from the harpsichord. The second cantata, 'Da qual gioja
improviso' (XXIVa:3; 1764), was composed in celebration of the Prince's

return from Frankfurt, where he had been attending the coronation of
Joseph II. The orchestra required for this piece includes flutes, oboes,
bassoon, two horns and strings, with a solo harpsichord part originally
composed for Haydn himself to play which occurs during an extraordinary
vocal quartet. A third cantata, 'Qual dubbio' (XXIVa:4), composed for the
prince's name-day in 1764, likewise features an elaborate harpsichord part
for Haydn; this was published by Doblinger in 1982 after I had located the
final chorus, which is missing from the autograph score (now in the Library
of Congress, Washington). It was incredible that music of such importance
could be receiving its first 'public' performance more than two hundred
years after its composition. I am happy to say that the sophisticated Haydn-
Tage in Vienna, managed by Dr Biba and magnanimously supported by
Dr Thomas Angyan, Director of the Gesellschaft der Musikfreunde,
continues to flourish.

* * *

I always felt rather frustrated with regard to Mozart research – how could
I undertake anything more ambitious than the occasional article or edition,
given the all-embracing work on Haydn to which I had happily and
willingly dedicated my entire scholarly life? However, even in the 1970s I
could sometimes find the time to turn my attention to music's greatest
master. I therefore accepted with alacrity an offer made by Sir John Tooley,
then General Director of the Royal Opera House, Covent Garden, whereby
I would participate in a grand Mozart weekend which he planned to stage
in 1981. The programme included several Mozart operas, a lecture by myself
on the Da Ponte operas with recorded illustrations, and another lecture on
the chamber music. When I found myself placed in the middle of the stage,
I must admit to feeling a little weak at the knees as the curtain opened to
reveal the audience in the auditorium. The lecture on chamber music was
much easier to deliver and less formal altogether, with my old friend William
Glock joining the ensemble on stage when we performed piano quartets.
All this whetted my appetite for doing something for Mozart on a much
larger scale, and although Donald Mitchell and I had edited a quite
successful *Mozart Companion*, published in 1956, it occurred to me that
there were still aspects of Mozart's work to which, one day, I could turn my

attention if the circumstances proved to be propitious. For the moment, however, I was still deeply involved in checking endless galley proofs of the Haydn biography. To get away from the telephone, even in remote Hirschbach, I used to take refuge from time to time at Saturnia Terme, a marvellous spa between Siena and Rome where the sulphurous and slightly radioactive waters flow continuously into a pool that had been used for therapeutic purposes since Etruscan and Roman times, at a constant temperature of 38° C. While there I would retire to the bridge room to read the Haydn proofs in the mornings, then take the afternoons off to wander around the ancient Etruscan towns.

It was at this point, as has been mentioned earlier, that I received a telephone call at Hirschbach from the musical director of BBC Wales, who asked me to prepare a documentary television film on Mozart. I was coming ever closer to establishing working arrangements in Britain in one form or another, but in 1978 Alun Hoddinott, who was then Professor of Music at University College, Cardiff, put forward a proposal which would make this plan a reality. While house-sitting in Italy for my friend, the Australian writer Russell Foreman, who had gone back to visit his native country, I was joined by Alun Hoddinott, his wife, his son and his son's girlfriend. Every year since 1971 Hoddinott had invited me to lecture in Cardiff, where his hospitality was legendary and the music students delightful. The University of Wales had just inherited the freehold of a supermarket site in Cardiff and had sold it to the local government authority. The John Bird Fund was established out of the profits from this sale, and the investment income used to help endow a new chair at the college. Hoddinott proposed that I be appointed to the part-time position of John Bird Professor of Music and suggested that I might teach in Cardiff without salary for one whole term in each academic year. In return, the University would rent a house for me in some pretty village nearby and pay my expenses, an arrangement which would enable me to avoid tax problems in my dealings with the Inland Revenue. Everything was settled, and from that time on my attachment to Great Britain grew steadily greater. One of the happiest periods of my life was about to begin.

Welsh Rectory: teaching in Cardiff and elsewhere 1978–1984

I had always enjoyed working with music students in the UK and used to give occasional lectures or conduct seminars at universities other than Cardiff. I found the brightest students at Cambridge and at nearby Bristol, where I taught day-long seminars for 'outside' audiences. These activities were a world apart from the teaching that I had undertaken during my time in America. For example, at the University of California, Davis, I once conducted a seminar on *Idomeneo*, in the course of which I related the story of Mozart's return visit to Salzburg in 1783, when he introduced his new wife Constanze to his father. While there they performed the famous quartet 'Andrò ramingo' in Act III, but, as Mary Novello (who visited Constanze in 1829 with her husband Vincent) recorded in her diary, Mozart 'was so overcome that he burst into tears and it was some time before she [Constanze] could console him'.[1] Rosemary Hughes, who edited the Novello diaries for publication in 1955, describes the scene being enacted, 'in which the young Idamante faces exile [in Crete] and disaster ...[and] their performance had brought upon [Wolfgang] a wave of overwhelming and unaccountable emotion, like a presage of woe.'[2] Mozart was of course then himself an exile, living in Vienna. After I had played the quartet to the students and added my commentary, silence ensued; then a young woman raised her hand and commented – to the dismay of her fellow students – 'Gee, Professor Landon, I guess Crete wasn't a nice place to be an exile in those days.' It was, alas, all too typical a response. On another occasion, during one of my visits to the City University of New York, I took a 'field trip' to study the enthralling collection of old keyboard instruments at the Metropolitan Museum. The curator himself, Emanuel Winternitz, escorted

us round and played the Cristofori piano, an instrument of unique historical importance. He then showed us another piano which could, if one moved a lever, transpose up and down by a note. Winternitz, an elderly Viennese gentleman, sat down and started to play the Adagio from Bruckner's Seventh Symphony. 'Do you know what that is?' I asked my students. They all shook their heads – none of them had ever heard the symphony before. Afterwards, I related the story to the head of the music department, Professor Barry Brook, who told me that this situation was quite normal: 'Bruckner is hardly known in New York and certainly not to those students.'

I was astounded by the limited extent of musical knowledge among American students, and pleased, therefore, to come and teach some of the brightest music students of the Anglo-Saxon world. At the time, the head of music studies at Cardiff was a distinguished colleague, Ian M. Bruce, with whom Else and I became close friends. Professor Alun Hoddinott was temporarily absent on a sabbatical (although actually living at home nearby), and Ian Bruce was running the department in his place.

Because my tenure of the John Bird professorship was unsalaried, the University of Wales had contracted to provide rented living quarters for Else and myself, and they were fortunate in finding the ground floor of the Old Rectory in Wenvoe, a village near Cardiff. The house was owned by the head of the department of archaeology, Professor R.J.C. Atkinson, who was well-known for having discovered the carvings on the mammoth standing stones of Stonehenge. He also served for many years on the University Grants Committee and was Mrs Thatcher's 'hit-man' in her drive to reduce staff in universities and colleges all over the country, a task which he loathed, but thought it better that he (as a sympathizer) should fill the position rather than someone likely to be far more ruthless. Atkinson did succeed in saving the occasional department that had been threatened with closure. He and his wife Hester proved to be entertaining and charming hosts. We enjoyed living in Wenvoe, which had its own post office and village shop, and we loved its beautiful and unspoilt surroundings, its farms, lanes and ancient hedgerows. While living in Wales we made a point of exploring much of that extraordinary, atmosphere-filled principality, and the more we did so, the more we grew to like it. We also had one unexpected advantage: because I was American and Else Austrian, we were generally treated like special guests, and I was fortunate enough to receive all manner

of invitations from BBC Wales to give radio and television lectures. I soon became friends with Mervyn Williams and Huw Tregelles-Williams, the respective heads of music for television and radio.

After Mrs Atkinson died in 1981, the Professor remarried and I began to suspect that his new wife would like to have the use of the whole house in Wenvoe. One day, I bumped into her in the garden as she was pruning the roses and took the opportunity to ask her if this was the case. She said that it was, so I assured her that vacating the ground floor would pose no problem. I had seen many pretty houses for sale in and around Cardiff, and felt sure that we would find something attractive. And we did – another former rectory, this time an eighteenth-century house in Chepstow, where our kitchen and back garden faced the flamboyantly long castle walls. The house itself had been impeccably restored, and only the garden remained unfinished. When the owner and I signed the contract, he promised to have this put right before we moved in, and he was as good as his word. Our Old Rectory was on Bridge Street which led to the Wye, the river that divides Wales from England. (The street is now a cul-de-sac and the fragile old bridge has been replaced by a new one downstream.) On our street, or just off it, there was a marvellous antiques shop where we picked up many local treasures, and when the owner registered our interest he went on searches for us and found still more. There was also a second-hand bookshop where I came upon all sorts of useful old material, such as an invaluable eighteenth-century Latin-English dictionary which I have used ever since. Further up, in the old square, there was a fishmongers where the staff would dress crabs for us (anyone who has tried to dress a crab will know what a blessing it is to have someone competent do it for you). We even had a small garage which came with the house, a great asset since Bridge Street was subject to parking restrictions, though these were enforced in a typically lenient fashion – the police never troubled any of our guests when they came to dinner and parked their cars outside the house.

While we were living in Chepstow, part of the autograph score of Haydn's 'lost' *Missa 'Sunt bona mixta malis'* was discovered unexpectedly in an Irish country house. This happened in the wake of the Haydn celebrations of 1982 (the 250th anniversary of his birth). Every music scholar dreams of 'discovering' a major work by one of the great masters – Bach's Passion according to St Mark, the Beethoven Oboe Concerto, Mozart's

Trumpet Concerto, and a whole series of works by Haydn fall into this category. In Haydn's case, several authentic thematic catalogues exist, and these are an invaluable source for the *incipits* of such lost works. One such catalogue was begun by Haydn and his copyist Joseph Elssler *c.*1765 and continued by the composer, sporadically, until *c.*1800. It is known to scholars as the *Entwurf-Katalog* (or Draft Catalogue) because it was thought, with some justification, to be the principal source for the great thematic catalogue which Haydn later drew up with Johann Elssler (son of Joseph), known as the *Haydn-Verzeichniß* or *Elssler-Verzeichniß* and completed in 1805. Both these catalogues contain a list of all fourteen settings of the mass which Haydn had composed, but two of the works had been presumed lost. The first was the *Missa brevis* in G, which I had discovered in Göttweig Abbey in 1957, but the second was listed, intriguingly, in Haydn's own handwriting in the earlier catalogue, and identified by the first five bars of the tenor and bass parts and the title, to the left, 'Missa Sunt bona mixta malis'. The work is listed among a whole series of instrumental and vocal works from the years 1768 and 1769, including the overture to the opera *Le pescatrici*, the overture to *Lo speziale*, and Symphonies nos. 26 and 41.

However, the case of the *Missa 'Sunt bona mixta malis'* (an old Latin adage meaning 'Good things are mixed with bad') was curious. In the *Entwurf-Katalog* another mass is listed just below it: the *Missa in honorem Beatissimae Virginis Mariae* of about 1768 or 1769. Like all the other known settings of the Haydn mass, this one existed in literally dozens of contemporary manuscripts. By contrast the *Missa 'Sunt bona mixta malis'* remained stubbornly lost, with only a tiny fragment available to tantalize scholars and Haydn lovers.

After World War II, when I began systematically to catalogue the surviving music in the great Austrian libraries for the Haydn Society, I always harboured the hope that a mass would come to light somewhere, and especially so after the lost Haydn Violin Concerto in A was discovered at Melk Monastery in 1950. However, none was forthcoming. Then, in 1955, I received a letter from Rosemary Hughes, who had edited the diaries of

Vincent and Mary Novello. Mozart scholars were dumbfounded by the amount of new information which the diaries revealed, since both Mary and Vincent independently wrote down the conversations they had with the Mozart family in Salzburg in 1829. Even greater, however, was the astonishment of Haydn scholars when Vincent Novello's entry, written in Vienna on Wednesday, 28 July 1829, came to light:

[The Vienna publisher] Artaria has the original MS of Haydn's Kyrie from Mass No. 5, (of) No. 7 in G complete, and the Kyrie and part of the Gloria of a mass in D minor entitled 'Sunt bona mixta malis' which has never been published. These I purchased of him for 6 florins.'³

Investigations were immediately undertaken at Novello's publishing house in London, but the score was not to be found there either. Finally, one memorable evening in the autumn of 1983, I picked up the telephone and was greeted by the sound of background laughter and a babble of conversation which grew louder and softer by turns. In the middle of all this I could just make out the voice of Albi Rosenthal, the doyen of music antiquarian booksellers and an old friend of thirty years' standing. 'Robbie,' he said, 'I'm at a big party given by Christie's [the British auction house]. Let me read you something.' There was a moment's pause. Then he continued: '*Missa, Sunt bona mixta malis, a quattro voci alla capella, del Giuseppe Haydn manu propria 1768.*' 'My God!' I exclaimed, 'is it really the lost Haydn mass?' 'It is indeed,' replied Albi, 'and I've arranged for you to come up and examine the manuscript tomorrow morning.' The autograph score was in fact the whole of the Kyrie and the first part of the Gloria of the elusive mass. It was auctioned in London, with live television coverage, at noon on Wednesday, 28 March 1984, and was sold to a German collector for £140,000, which was £120,000 more than Christie's had expected it to fetch.

This early mass is a stern and uncompromising work, in the so-called Palestrina style, scored for *a cappella* choir with *basso continuo*, that is, organ, cello and double bass. The year in which the mass was composed (1768) also witnessed the disastrous fire in Eisenstadt which destroyed Haydn's little house. Was the rest of the *Missa 'Sunt bona mixta malis'* consumed by the flames, with many other Haydn autograph scores? Is the work a kind of votive offering, like Mozart's great unfinished Mass in C minor (K.427)?

The words 'Sunt bona mixta malis', written in the composer's own hand, were definitely a later addition to the rest of the title page. Perhaps we may connect these words to the incredible fact that Haydn's noble and magnanimous patron, Prince Nicolaus Esterházy, paid for the rebuilding of the destroyed house – a happy outcome reflected, perhaps, in the words 'sunt bona mixta malis'.

When the auction was over, a director of Christie's approached me and asked whether it was true that I had declined to accept a fee for my work on the Haydn mass, as Kate Pafford, the young woman in charge of the music department, had told him. I had done a certain amount, it was true, including the preparation of a longish entry for inclusion in the auction catalogue, but Kate Pafford had been absolutely charming and I was content to make my contribution as a favour. The director then spotted Else, and asked me, 'Does your wife drink?' 'Sir!' I cried with mock horror. 'Come on, she must like something,' he persisted, to which I replied that she did enjoy a glass of champagne. Later, when we arrived back in Chepstow, the local undertaker (who was also our next-door neighbour) flagged us down with the news that a number of packages had been delivered for us. Rather taken aback, we followed him into his hall, where an express delivery company had deposited dozens of bottles of Veuve Clicquot Brut for us, courtesy of Christie's. 'Well, it was the least we could do,' said Kate Pafford with her usual charm when I telephoned her. We subsequently recorded the mass fragments for the first time in the Parish Church of Bad Tölz, with Bruno Weil conducting the Tölzer Knabenchor; the *basso continuo* accompaniment was provided by Anner Bylsma (violoncello), Anthony Woodrow (double bass) and Bob van Asperen (organ), and the CD appeared in 1994, produced by Wolf Erichson for Sony Classical.[4]

In 1982, not long before the exciting rediscovery of the mass, a flurry of activity for the anniversary of Haydn's birth gave rise to a number of concerts, TV series (see p. 83) and radio broadcasts throughout the UK. In a sense, those celebrations marked the culmination of all our efforts on behalf of Haydn – the hugely successful series of symphonies recorded for Decca by Antal Dorati; the complete Haydn quartets, also with Decca; the complete editions of much of his music; my five volumes, published by Thames and Hudson and so forth. Haydn had been put well and truly back on the map.

Fig. 7 The opening of the Kyrie from Haydn's *Missa 'Sunt bona mixta malis'*, composed in 1768 and headed – as was the composer's custom – 'In nomine Domini'; the surviving sections of the autograph score were auctioned at Christie's on 28 March 1984.

Indeed, it was in that bicentenary year that a British violinist named John Reid, who had played at Covent Garden under Solti, telephoned me with a remarkable proposition – to put on what he wanted to call an 'English Haydn Festival' at Bridgnorth, a small town in Shropshire which, in all my British peregrinations, I had never visited (although I had been to nearby Shrewsbury in the 1950s). Reid came to see me to discuss the matter further, bringing with him Paddy Harvey who, with her husband, has become one of the mainstays of the Festival, as has John's delightful assistant Sandra Day. We started, modestly and sensibly, with a long weekend in 1983, since when the English Haydn Festival has grown and prospered, and now lasts for ten days (see p. 168) thanks largely to Reid's phenomenal ability to organize and raise funds (local firms or individuals sponsor every one of the concerts).

* * *

Soon after the Christie's sale in 1984, I received a telephone call from my tax adviser in London: 'The UK tax people have just been on to me,' he began ominously, 'and they say that although they appreciate all the work you are doing for Cardiff and so on [I took no fee from other universities either], you can't be domiciled here without paying income tax. I'm afraid you'll have to sell your house and move.' I believe that the authorities acted entirely appropriately: although I did pay U.S. Federal taxes, I could see their point quite clearly. So we moved out of the Old Rectory and made a long trip through Europe in search of a new home. Most countries proved impossible, however – in Italy property prices were prohibitively expensive, and in Switzerland we were told by a tax consultant in Ancona that we were not rich enough to be granted a residence permit. The only ray of hope he could offer was to suggest that we might try Graubünden, an isolated and usually freezing part of the country.

Just as all this depressing news had begun to sink in, my cousins from south-west France telephoned and urged us to buy a house over there. Hugh, a Canadian artist, and his wife Jean, whom he had met during World War II in London, still had a flat on St Peter's Wharf in Hammersmith, but lived in a farmhouse near Montcuq where we visited them. They showed us half a dozen attractive houses in the area and we felt very tempted, but

they sounded a note of caution: 'Much as we'd love you to settle near here, you must take your car and go further south. We have an Atlantic climate – you'll see. As soon as you pass through a kind of invisible curtain, you'll be in the Mediterranean – the climate, the people, everything changes.' It was October 1984 and there was just one more house to see before we were due to leave. It was a misty day with a distinct chill in the air, and the house – situated on a hill – was enveloped in swirling fog.

A couple of days later we headed south and, after driving for about three hours, we found ourselves in brilliant sunshine. The people were in their shirt-sleeves and everyone seemed to be smiling. We reached a small town near Toulouse called Graulhet, and started to make enquiries. House prices were all absurdly cheap there compared to those in Italy, Austria and Switzerland, and we were enthralled – we had not been in or near Toulouse since 1963 and it felt like coming home again. We soon had three agents searching for suitable properties. One of them, Madame Mericq, had an office in Lavaur, and after two days she said, 'I know just what you're looking for. Go back to England and give me a month: I'll ring you.' Accustomed as we had grown in Italy to such promises, we did not seriously expect to hear anything further and returned to Chepstow. Four weeks later, however, we were delighted to receive a telephone call from Madame Mericq, who announced, 'J'ai une douzaine de maisons pour vous.' We flew at once to Toulouse, hired a car, and in a short space of time viewed eleven magnificent properties ranging from large châteaux to delightfully restored farmhouses. Then, one golden, sunny afternoon in late autumn, we fell in love with the twelfth at first sight. It was a small château between Toulouse and the cathedral town of Albi in the Tarn region. Twenty-four hours after viewing the property, we had signed the preliminary papers.

1 *A Mozart Pilgrimage, Being the Travel Diaries of Vincent and Mary Novello in the year 1829*, translated and compiled by Nerina Medici di Marignano, edited by Rosemary Hughes, London, 1955, p. 115.
2 Op. cit., p. 114.
3 Op. cit., p. 203.
4 SXX 53122, issued with Haydn's Offertorium 'Non nobis, Domine' (XXIIIa:1).

French château:
at home in the Tarn 1984 to the present

While we were still in the process of seeking a new home, my old (and much-lamented) friend Roland Gelatt, for many years the editor of *High Fidelity* (for which I had become European Editor while living in Italy), became a 'roving' editor for Thames and Hudson in London. He went to Prague to report on the filming of *Amadeus* under Milos Forman's direction. I had seen the Peter Shaffer stage play in London with Roland and had been very impressed; of course, it was a fantasy, a dream with Mozart at its centre, but I could sense that it had enormous potential. Roland came back from Prague mesmerized, but also appalled. 'It's going to be a raving success,' he announced, 'and there are many brilliant aspects, especially the reconstruction [easier to achieve in Prague than elsewhere on the continent] of eighteenth-century *Mitteleuropa*.' Most other cities associated with Mozart, including the greater part of Vienna, had been so extensively rebuilt in the nineteenth and twentieth centuries that hardly anything of the composer's world remained intact. Prague, however, still has streets and squares where one could easily imagine Mozart appearing round the corner. With a vast budget at their disposal, the film makers simply redecorated shop fronts and repainted modern Czech signs in German to recreate the atmosphere of the Austro-Hungarian Empire. They also removed overhead cables for telephone and electricity – one could obtain permission to do this kind of thing in Communist Czechoslovakia by the simple expedient of flashing dollar bills at the authorities. The handling of the film script was a quite different matter. 'It is beginning to have little to do with Mozart,' said Gelatt. 'There's even a scene at the end where Mozart is dictating the Requiem to Salieri ...' 'What!' I interrupted. 'You're making this up.' Not

so. Gelatt had brought along a copy of the shooting script of the film (written by Peter Shaffer), so I sat down in far-away France to read it at leisure. A shooting script indicates how and what the camera is supposed to shoot, and provides not only the actors' lines, but also descriptions of what the characters are thinking and feeling – in other words, it is there to help the development of the film not only graphically but also, as it were, mentally. It was indeed a very superior script, despite its departures from historical reality.

In due course, the film *Amadeus* had its première in Vienna, and I was asked to review it for the *Sunday Times*. After my first viewing, I forecast 'Five Oscars' (in fact, this proved to be an underestimation). The film was truly a stunning achievement and even very moving, but of course the film medium had contrived to make a fantasy of the story, sometimes completely divorcing it from eighteeenth-century reality: the improbable scene mentioned by Gelatt, in which Mozart is shown dictating the Requiem to the scheming, villainous Salieri, is a case in point. The new situation created by the release of the film produced a fresh challenge. Roland was adamant that I should write a book about Mozart to set the record straight – otherwise, he thought, people would really start to believe 'all that rubbish about Salieri being a sinister Italian intriguer'. Although I thought his idea a mad one, I promised, when he continued to insist, that I would draft some trial chapters.

I had begun to develop the idea of writing a documentary study of events in 1791, the final year of Mozart's short life. Crucial background details about the composer's career had still hardly penetrated the consciousness of Mozart scholarship. For example, the fact that Mozart had received the commission to compose the opera *La clemenza di Tito* (to be performed at the festivities in Prague for the coronation of Emperor Leopold II as King of Bohemia) was a consequence of Haydn's absence in England that year. When Prince Anton Esterházy wanted to commission a work to mark the occasion of his own appointment as *Obergespann* (Governor) of the county of Oedenburg (now Sópron, Hungary), the long-serving *Kapellmeister* was unavailable, so the Prince offered the job instead to Salieri's star pupil, Joseph Weigl, who was an assistant at that time at the Vienna Court Opera. So in the summer of 1791 Weigl went off to Eszterháza Castle to work with the singers who had been specially engaged, leaving Salieri with the extra burden

of artistic and administrative duties at the Opera. When the impresario who was to produce the Coronation opera for Prague offered the well-paid commission to Salieri, he had to decline the invitation: in a long letter to Prince Esterházy he explained the circumstances that made it impossible for him to accept, flattering though the offer was. Only then, less than two months before the coronation, was an approach made to Mozart. Such background material had been included in our documentary series from the Esterházy Archives, currently being published in instalments in the *Haydn Yearbook*. However, it has long been a lamentable fact of musicology that Mozart experts have often tended to ignore the findings of research by Haydn and Beethoven scholars, and as a result such curious and authentic information as the story about *La clemenza di Tito* have never become widely known. There were also some very revealing details about payments made by Artaria & Co. (Haydn's, Mozart's and later Beethoven's Viennese publishers) to Haydn for works that they were to publish – figures which accurately reflect the level of fees paid for German Dances ('Deutsche Tänze') and orchestral Minuets just at the time when the company was issuing similar works by Mozart. It was never reported that he was probably earning a tidy income from such publications – again, the Mozart experts did not analyze the significance of relevant information unearthed by Haydn scholars.

Still, all this information, valuable though it may have been, did not amount to a book, and I remained highly sceptical about the idea. Nevertheless, I retired to my Vienna flat, where I could have easy access to any sources I might need, and started to write some specimen chapters. I completed three and gave them to my astute wife Else to read; she commented, 'Interesting, but too many footnotes.' We then set off for Italy, where I gave the chapters first of all to my friends Gordon and Elizabeth Morrill, who were living in Florence and who had read and commented on all the chapters of my five-volume Haydn biography. Of the Mozart experiment they too considered my approach too scholarly. From Florence we proceeded to Camaiore, where Eva Neurath of Thames and Hudson had a holiday house. 'It's too weighed down with its scholarly apparatus, but we can fix that', she told me, adding encouragingly, 'I'm good at sniffing out this sort of thing, and I have a distinct hunch that it could well become a best-seller.'

With this incentive, Else and I went back to France, where I laboured hard at my newly compelling project, getting up at five o'clock every morning and working quietly until breakfast at nine, when I would hand the manuscript over to my secretary to type up. In the afternoons, relaxing around the swimming pool, I would read portions aloud, encouraging whoever was there to make comments and suggestions. By Christmas 1986 the writing was almost finished, and I received the expert advice of an editor at Thames and Hudson with whom I had not previously worked – Barry Millington. It was he who sensibly suggested placing part of the research material – the scholarly 'back-up' for the main text – in several appendices at the end of the book. *1791: Mozart's Last Year* appeared in 1988 and sold well; to my surprise, it was subsequently translated into nine foreign languages – a thoroughly gratifying outcome after my initial doubts about Roland Gelatt's proposal.

Meanwhile, I had been concentrating on another Mozart book, this one my own idea. I prepared a draft outline and went to visit Eva Neurath again at Camaiore, taking along a selection of the many illustrations that I had assembled to enhance the book, particularly from the standpoint of authentic and/or contemporary manuscripts, persons, places, views and so forth. I thought that the book should deal with the events of Mozart's last decade, which I termed his 'Golden Years' – from 1781 to 1791, after he left Salzburg for Vienna. Again, I had managed to find a considerable number of previously unnoticed documents, including many unpublished manuscripts concerning the activities of the Freemasons and the Austrian government's fear of their influence – tainted, as they suspected, with French Revolutionary thought. My other idea was to write the book not for a specialist readership, but in an approachable style for a general audience.

Because we wanted to provide a wide choice of illustrations, Else and I built up a very extensive photographic archive, a process which often necessitated the purchase of a document, map or engraved portrait in order to secure the particular photograph required for reproduction purposes. Seeking out such materials from antiquarian booksellers all over the world was not only instructive but also occasionally very amusing. Some documents would turn up on market stalls in France, others in Hungarian or Romanian shops. We had to have open minds and ready cash to make an instant purchase whenever the opportunity arose.

This second Mozart book, entitled *Mozart: The Golden Years 1781–1791*, was completed in France in July 1988. I had found several editions of a fascinating book describing life in Vienna during the 1780s written by a fellow Freemason, Johann Pezzl, and although I had planned to include a substantial extract from it in translation to supplement my own account, when the text was completed it was decided that this would make the book too long. Thames and Hudson then turned Pezzl's account into a separate book which, with some additional material, was published under the title *Mozart and Vienna*, appearing just after *The Golden Years*. A year after the initial success of *1791*, my second book – *The Golden Years* – also became a best-seller; eventually it appeared in nine different languages and paperback editions are still on sale in English and French.

While we were engrossed in Mozart, Thames and Hudson came up with yet another major project – a comprehensive 'dictionary' or 'compendium' dealing with every aspect of the composer and his music, and featuring contributions by some of the world's leading authorities. The project was managed by Barry Milllington, myself and a most efficient Austrian assistant, Ulrike Hofmann (working at Foncoussières), and required a large-scale operation of co-ordination and co-operation. The first edition came out in 1990, in English and French. My French publishers, Jean-Claude Lattès, had an extremely clever music editor, Odile Cail (now sadly dead), as well as a gifted translator, Dennis Collins, who, thanks to his accuracy and swiftness, was an author's dream. The publishers managed to get me included in a well-known literary discussion programme on French television, where my fellow participants, whom I had never previously met, swathed me in a protective cocoon, concerned that I might become confused when trying to express ideas in French ('Don't worry,' they assured me, 'we'll take over if you have any problems.') During the week following my television appearance, the French edition started to sell in prodigious quantities and after another six weeks, by Christmas 1990, some 20,000 copies had been sold at 500 francs apiece. All my publishers were astounded by the demand for the *Mozart Compendium*.

Sales were helped by the fact that I appeared in chat shows and press conferences all over Europe (including a major show on Italian television). Lattès persuaded the largest book-selling chain in France, FNAC, to send me all over the country accompanied by two assistants – an attractive young

woman and a powerhouse of a young man. On arriving at each destination, we would be thrown immediately into a hectic schedule involving an interview for the local TV channel, lunch with the press, an afternoon chatting or lecturing at the local FNAC bookstore, another meal with more reviewers and then a radio interview. I had never participated in such a mammoth press launch before, and was fascinated to see how it all worked. As for the radio interviews and my endless conversations with the press, I had never been treated so nicely in my life – men and women with reputations for being fierce were only ever gentle when dealing with me. Some interviewed me in the relaxed atmosphere of Foncoussières, some in Paris.

Lattès put me up at Le Marronnier, a handsome eighteenth-century hotel near their offices, and my stay there proved another unique French experience. A large garden behind the dining room provided me with the perfect place to sit when the weather was fine, and here I would wait for the streams of journalists to arrive and conduct their interviews. It was of course an exhausting business, but I could appreciate that this was the only really satisfactory way to ensure that the book was properly brought to the public's attention. I was supposed to entertain these correspondents, so a steady supply of coffee or tea was constantly available, as well as a delightful white 'house wine' from south of Bordeaux, which the hotel kept chilled in readiness. I would often take members of the press to lunch at an excellent Italian restaurant nearby – and I simply sent the bills to Lattès. I had often read of the particular brand of friendship shown by French publishers towards their authors, and I now found myself experiencing their bounty to the full.

One successful publicity coup was to persuade *Elle* magazine to put *The Golden Years* on the short list for their 1990 Book of the Year award. *Elle* started to collect votes from the provinces, and soon afterwards I was advised by telephone that *The Golden Years* had won the nomination. I had some extraordinary early-morning radio interviews on Europe 1 with El Kabach, a famous French journalist, who made the formal presentation at an *Elle* reception in Paris; the ensuing publicity guaranteed a marked increase in the sale of my books. Somehow this method of marketing books on Mozart was entirely different to those used in Germany, England or America. For one thing, it is generally accepted in French society that women play a genuinely important, indeed vital role. Recourse to feminist tactics to fulfil their aspirations is therefore not necessary. I considered it a unique honour

to be chosen by the readers of the magazine as their favourite author for that year.

* * *

Foncoussières was a rustic, unpretentious, sprawling château of manageable proportions which, when I bought it, already had central heating and five bathrooms (with the fixtures for several more stored in the cellar and ready to be installed). The first building to have been constructed on the site is registered in the local records under the year 1568, but the present edifice consists of an eighteenth-century reconstruction with the addition of an early nineteenth-century 'loo tower'. What immediately recommended itself to me was the reduced amount of surrounding land – the outlying farms had been sold off – and the cosiness of the house, as well as the fact that it contained so much potential office space. Eventually, we created an office for myself, one for my wife and a third for assistants and secretaries; at one point, when we were involved in producing television films and writing books at the same time, I needed three full-time secretaries to cope with the extensive number of scripts, correspondence and telephone calls.

The house stands just next to a handsome old market town, with our much-loved hotel, the Pré Vert, close at hand, along with a doctor, dentist, post-office, small supermarket and the offices of my indispensable notary, Didier Nègre. The pharmacy is as up-to-date and well-stocked as in any large town. I was enchanted by Rabastens, with its Saturday market stalls loaded with vegetables, fruit and bread; now and then I would come across an eighteenth-century music manuscript or print there (no longer, unfortunately). The local doctor, the chemist (who loves music) and the notary (not just 'notary public' but in France a kind of magistrate) have never charged me a penny. A gardener of many talents (a marvellous *bricoleur* or handyman as well as tiller of the earth) came with the house and grounds, as did the housekeeper Madame Fargues, who continues to take care of everything without needing to be directed, and Madame Fournier who helps at weekends and other times according to need. Foncoussières is a terrestrial paradise; I wake up every morning and count my blessings.

The house has a strong practical advantage – I could see straightaway that it would be ideal as a location for filming. The salons with their eighteenth-

century furniture and the Italianate garden façade were perfect for documentary films about eighteenth-century life; indeed, we used them when working on productions for the BBC and for French and Italian television. Foncoussières is also an ideal place to write and study – silent at night and peaceful during the daytime. In these surroundings I have completed the better part of six books, as well as numerous articles and TV scripts.

It is difficult to write about France – perhaps, along with Italy, it is the most over-described country in Europe. But I *will* say that one particular advantage of living in the relatively remote French *département* of the Tarn is that this area is one of the most unspoilt places in Western Europe, yet it lies next to the bustling, thriving city of Toulouse with its excellent Orchestre du Capitole conducted by Michel Plasson; an opera house where I have seen performances of many works previously unknown to me (*Cendrillon* by Massenet, for example); fabulous churches (including Saint Sernin, the largest Romanesque church in the South of France) and art galleries, and one of the prettiest eighteenth-century squares in France – the Place du Capitole. There are hourly flights to Paris from the local airport, which lies conveniently just outside the city.

There is a special *qualité de vie* in the Tarn which reminds me of living in Italy, not least because of the large non-French community in the area – Swedish, British, Dutch, American and Polish friends who settled here simply because they love this part of the world. There is a spirit of freedom and tolerance which serves as a reminder that, apart from Great Britain, France is the only European country without compulsory police registration for foreign residents, a restriction that was abolished by the late President Mitterrand in one of his grand political gestures. (However, this relaxation of former regulations does not make the police happy, for they are now faced with a much more difficult situation in dealing with international crime and terrorist activities.) If you keep your ears and your eyes open, you will soon come to realize that in France the great ideas and *droits de l'homme* of the 1789 Revolution are closer to hand than the chronological distance of 200 years would seem to suggest. Was it an accident that Mitterrand persuaded Jessye Norman to sing the Marseillaise during the 1989 bicentenary celebrations in Paris?

* * *

While living in France I have reduced my commitments in other countries, but I regularly attend the annual English Haydn Festival, held in Bridgnorth. The principal venue for concerts there has been a beautiful, redundant church called St Leonard's which can hold up to 750 people. From its beginnings in 1983, the festival has been an 'un-social' or un-snobbish event, and only in the last few years have we started to attract white dinner-jackets, long evening dresses and picnics *à la* Glyndebourne, although this new breed of audience tends to patronize our so-called 'gala' evenings where the prices are raised. One of the remarkable and indeed very successful features of the festival is that all the concerts given in St Leonard's Church have an interlude of some 90 minutes for supper, which is provided by caterers in an adjoining marquee. Although the weather is generally fine in early June, when we put on most of the concerts, it has proved on occasion to be a great blessing that the church has central heating.

There are a number of churches and country houses in the vicinity of Bridgnorth where, thanks to the kind hospitality of local families, chamber music recitals have been given. These venues include Dudmaston Hall (Sir George and the late Lady Labouchère), Stockton Church (Lord and Lady Hamilton), Glazeley Church (Mr and Mrs Robert Arbuthnott), Acton Round church (Mr and Mrs Huw Kennedy) and Claverley Church (Mary and Francis Palmer). Shropshire has a wide variety of such charming churches, and they seem to exert a powerful effect on our audiences, since these more intimate concerts are regularly sold out.

John Reid is good at persuading local people to serve the festival in various ways, and always on a voluntary basis. Contributions range from distributing brochures and selling tickets to acting as ushers or selling books and records. Among the many charming and delightful volunteers (and these include the Harveys) we grew especially fond of David and Anne Cooper, who spoiled us in countless ways and sponsored concerts at Dudmaston Hall. Anne took charge of the floral arrangements at St Leonard's – a task that is more important than one might think, for one has only to see the church undecorated to realize what a difference flowers really do make.

When visiting Bridgnorth, we stay in an enchanting old hotel called The Croft on St Mary's Street, just off the picturesque main square in the

upper part of the town. Bridgnorth, with its charming wattle and daub houses, is made up of two areas – the lower town on the River Severn and the upper part where St Leonard's Church stands, surrounded by antiques shops, silversmiths and second-hand bookshops. The town is also served by a privately owned and well-maintained steam railway which, in the summer, transports crowds of tourists through the scenic Severn Valley to Wolverhampton.

Over the years we have invited all sorts of chamber music ensembles to play at the festival, including the Salomon Quartet and the Quatuor Mosaïques, both performing on period instruments. We have also aimed to include a few outstanding soloists each year to draw in the public; these have included Steven Isserlis, Crispian Steele-Perkins, Willard White, Ian Partridge and Catherine Bott. In 1997 Bruno Weil, director of the well-known group Tafelmusik, came to conduct the first of Haydn's London Symphonies, and in 1998 the performers included the excellent Russian cellist Ivan Monighetti and the Dutch fortepianist Ronald Brautigam.

In 1996 Reid decided that in future the Festival Orchestra, which he leads, should consist of period instruments, the players of which mostly come up from London. There is a spectacularly good trumpet and trombone section, which was especially important when we decided to hold an autumn festival devoted to Mozart's sacred music in October 1997, in conjunction with the celebrated boys' choir from Bad Tölz in Germany (the Tölzer Knabenchor) which performed under its permanent conductor, Gerhard Schmidt-Gaden. For reasons that no one has been able to explain, fewer tickets were sold for the Mozart weekend than for the Haydn Festival. When I told Bruno Weil about this recently, he was not at all surprised – as he said, 'We know that Haydn has a special place in the affections of British audiences.' Possibly, but why is the same not true of Mozart, the darling of everyone?

Our Haydn programmes at Bridgnorth have always sought to provide performances of much-loved favourites such as *The Creation*, the 'Nelson' Mass, the Trumpet Concerto and the London and Paris Symphonies, but also to feature the lesser-known earlier symphonies (a cycle of Nos. 6–8, 'Le Matin', 'Le Midi' and 'Le Soir'), as well as string quartets and arias, piano sonatas, trios and songs. In addition we have included examples of early Beethoven and occasionally works by later composers. Now that the

festival relies on the use of period instruments, we try to avoid the Tchaikovsky tigers for piano recitals, but even in a relatively small venue such as St Leonard's, the projection of a fortepiano (not to speak of a strong double-manual harpsichord solo) is bound to prove problematic. We have available an excellent *positiv* organ which is brought in for performances of religious music and the occasional organ concerto.

We have considered the possibility of putting on a Haydn opera at Bridgnorth, but even with a semi-staged performance, the logistical problems of using St Leonard's as a venue are innumerable and probably insoluble. We have, on the other hand, managed to feature Mozart's incidental music to *Thamos, König in Aegypten* (K.345) in its fullest version of *c.*1780, with the participation of the local choir led by John Moore. It was always our intention to include in festival programmes examples of lesser-known music by Haydn's best musical friend, Mozart, just as our Mozart Festival of Sacred Music in 1997 concluded with Haydn's *Missa Sancti Bernardi de Offida* ('Heiligmesse') – a concert which took place on a Sunday and, interestingly enough, was far better attended than the previous Friday's exclusively Mozart programme.

* * *

The year 1991 heralded the 200th anniversary of Mozart's death and, thanks to my involvement in many special events, was particularly hectic. The organizers of the Albi Festival invited me to design their overall programme of events, and the resulting commemorative concert given by a Polish orchestra included a performance of the Mozart Piano Concerto in C (K.467) with Elena Mouzalas as soloist; the performance took place in the courtyard of the Archbishop's Palace. For the following year's festival we put on Haydn's opera *L'infedeltà delusa* with a Hungarian company which had previously given semi-staged performances in Hungary and Slovenia. Unfortunately, as was happening all over the country, the Albi Festival encountered major financial difficulties and had to be discontinued, much to the dismay of the local population.

In the course of the Mozart bicentenary celebrations I was asked to participate in many conferences and to give various talks and interviews both in France (including an extensive countrywide series of lectures) and

elsewhere. I was also involved as musical consultant in a number of projects organized to coincide with the commemorative events of that particular year. One day I received a call from my old friend Sir Georg Solti who asked me, with his customary directness, what reasons I could give him for performing my version of the Requiem. I told him that he should have all the available versions sent to him (Richard Maunder's, Beyer's and so on) and examine each one. My edition, published that year by Breitkopf & Härtel, had the one important distinction of making as few changes as possible to the versions left by Mozart's pupils (Süssmayr, Eybler and Freystädtler). I could not see the advantage, for example (*pace* Maunder), of omitting the Sanctus and Benedictus on the grounds that these sections had been written wholly by Süssmayr. It is thought nowadays that Mozart sketched out the vocal parts for some of both these sections and also large parts of the Agnus Dei, and that these sketches were subsequently lost. Solti asked me to go to London to discuss all these matters with him, and told me on the telephone that Decca were planning to record the entire Requiem live at St Stephen's Cathedral in Vienna on 5 December 1991, two hundred years to the day since the composer's death. Produced by my old friend Christopher Raeburn, this performance was to be a very grand occasion.

We discussed all the salient points regarding my edition (which in the event he had decided to use) during a working session one morning at Solti's house in London. He was extremely organized and had made an accurate list of everything that he needed to know; I was particularly impressed by his acumen and sense of style. At the performance the soloists were Arleen Auger (who was dying of cancer), Cecilia Bartoli, Vinson Cole and René Pape, and they were accompanied by the Konzertvereinigung of the Wiener Staatsopernchor and the Vienna Philharmonic, conducted by Solti. The entire event (recorded on audio-visual tape and CD, which proved to be a huge commercial success) was a moving memorial service for the greatest musical genius the world has ever known. Much of the service was in Latin – there was no time for arguments to determine in which language it should be presented – with some portions, touchingly, in German: 'Herr und Gott, nimm die Gebete und Gaben, die wir für das Heil deines Dieners Wolfgang Amadeus darbringen, gnädig an.' ('Lord, mercifully accept our prayers and offerings for the salvation of thy servant Wolfgang Amadeus.') And then in Latin, 'Memento famuli tui Wolfgangi Amadei quem ad te ex hoc mundo

vocasti ...' ('Remember thy servant Wolfgang Amadeus, whom thou hast called from this life ...'), and so forth.

The subsequent year, a dignified and appropriate reception was held at Buckingham Palace for Sir Georg's eightieth birthday, followed by a concert at which the great Wagnerian singer Hans Hotter was one of the performers. I particularly recall the attentiveness of the waiter who served me during dinner – when I asked him if I could possibly have white wine instead of red, he brought some at once, and throughout the meal was quick to replenish my glass. It so happened that the Queen was on tour in Australia at the time, but other members of the royal family were present, including Prince Charles and the radiant Princess Diana. When we left, a liveried attendant was calling for the cars: 'Lady – ; Viscount – ' and so forth. I spotted a policeman and asked him where I could find a taxi. He pointed me in the direction of his colleague, who promptly stepped out into the traffic, flagged down a cab and gave us a salute as we climbed in. It was all very English and extremely civilized.

Solti was a deeply modest man. Like Haydn, he was fully conscious of his professional prowess and status, but at the end of the day considered his artistic gifts heaven-sent and therefore inscrutable, inexplicable and non-discussible. In life you worked hard and did your best; the rest was up to God and the angels.

* * *

For some years now Vercelli, a pretty town between Turin and Milan, has been the venue for an annual competition (*concorso*) for pianists which takes place in the handsome old theatre. The competition, for which I am one of the jurors, is organized and 'stage-managed' by a distinguished Italian critic, Giuseppe Pugliese, whose wife Alessandra is an ex-pupil of mine and has a soprano voice ideally suited to Beethoven's 'Ah perfido'. The outskirts of Vercelli are flat, with extensive rice paddies, but the land soon rises into enchanting hills with remote villages where we have found welcoming bars and tiny restaurants serving local delicacies at ridiculously low prices: truffles with spaghetti for example, a dish often served at the marvellous restaurant in the small hotel where we stay during the competition. When I first arrived in Vercelli, I was still able to go everywhere on foot. The hotel proprietor

took one look at my conspicuous yellow convertible Volkswagen parked outside and spirited it away without further ado to the safety of the courtyard of his nearby house, where it remained for the duration of my stay.

Piano competitions can be deadly of course – I recall with amusement the Vercelli jury's interminable discussions in the evening after hearing thirty Japanese and Korean students play Mozart's Piano Sonata in A minor (K.311) one after the other – but the ambience of those I attended at Vercelli was so stimulating that I enjoyed each stay, and besides, every now and then we would come across exciting new talent, as was the case with a young man from Serbia in 1996. I also remember a talented soprano whom I first encountered in Cyprus. When I heard her, I insisted that she be given a *borsa di studio* to enable her to study in Venice under the supervision of my friend Pugliese and his wife. I am told that since then she has been progressing from strength to strength.

Among the jurors at Vercelli was my colleague from Salzburg, Peter Lang, whose father had been my friend for years at Lambach Monastery. Peter was a child prodigy whom I had the pleasure of watching as he grew up; he is now Professor at the Mozarteum in Salzburg. He has an extraordinary knowledge of Mozart's piano style (the *concorso* at Vercelli had Mozart as its focus for some years) and his criticisms have always been sharp and accurate. When a group of Japanese music students objected to the fact that none of them had won a prize, it was Lang who was elected to talk to them and explain, as best he could (in this type of situation language was always an almost insurmountable problem), that there were aspects of the music to be considered that were not to be found simply in the notes on the printed page. I tried to do the same on another occasion, but I am sure that the students understood little or nothing, since I was speaking German – the only possible language in which we could attempt to communicate. Despite this difficulty, however, I have often been struck by the remarkable technical progress made by Japanese students over the last fifty years – nowadays there is nothing that they cannot master in matters of technique. In fact, even stylistically, many of the English, French, German and Austrian competitors now play Mozart with a real understanding of the problems involved.

On the whole, therefore, I have very much enjoyed participating in the Vercelli competitions. I believe that, isolated as I am in the Tarn, it is a good

idea to get out and listen to what the young people have to say – and this is why in recent years I have always maintained close links with the Conservatoire in Toulouse, where I am honorary professor of the 'Old Music' department, acting as an adjudicator for the occasional thesis.

<p style="text-align:center">* * *</p>

It seemed impossible, but there it was on the calendar: 6 March 1996, and I was seventy. My friends at the Musikverein in Vienna, led by Otto Biba, gave me an unexpected reception in the Brahms-Saal, during which, to my complete surprise, Mark Trowbridge, representing my publishers Thames and Hudson, formally handed me a handsome volume entitled *Studies in Music History, presented to H.C. Robbins Landon on his seventieth birthday*, jointly edited by Otto Biba and my former colleague in Cardiff, Dr David Wyn Jones. The book contained a variety of interesting articles (some in English, some in German) contributed by colleagues and friends, and supplemented by a bibliography of all 516 of my publications (including 28 books), some of which I had totally forgotten about. (In the Köchel catalogue of Mozart's works, this number is allocated to a particularly sombre quintet in G minor, a coincidence which I hope does not anticipate the mood of my own end.) A short while later, there were further birthday celebrations in London, at Eva Neurath's house in Highgate, and also at Foncoussières, arranged by my dear Marie-Noëlle Raynal-Bechetoille, who shares my life here. At the second of these parties a live concert was arranged by friends from the Bridgnorth Festival – John Reid, Roger Woodward and the Greek counter-tenor Aris Christofellis, who sang Haydn's *Arianna* to words that had been written specially for Foncoussières.

If I look back over the course of my life, the one thing I have to say is simply that I consider myself to have been extremely lucky throughout it, both professionally and privately. There was no logical reason why I should have had the good fortune to find all those Haydn manuscripts, live in such beautiful houses, enjoy the company of so many marvellous friends and be blessed with the most efficient assistants and secretaries, not to mention my devoted publishers and my brilliant translator, Dennis Collins. There is no rational explanation for it all, and I can only assume that I must have been born under a very lucky star.

Index

Abel, Carl Friedrich 80
Ackerson, Garret 67
Aiken (S. Carolina) 15ff.
Albi Festival 170
Asheville (N. Carolina) 17, 19
Atkinson, R.J.C. 152f.
Auden, W.H. 20f.
Augsburg 41, 61, 62

Bach, C.P.E. 78
Bach, J.C. 80
Bach, J.S. 15, 39, 41, 129
Baltzer, Erwin 38
Bärenreiter-Verlag (publishers) 61,
 62, 105, 106
Bartha, Dénes (von) 60, 61f., 64
Bechetoille, Marie-Noëlle 174,
 pl. 29
Beecham, Sir Thomas 46, 47f., 56,
 58
Beethoven, Ludwig van 15, 23, 45,
 46, 52, 82, 100f.
Berlin 40
Bernstein, Leonard 130f.
Berry, Walter 35
Biba, Otto 148f., 174
Blech, Harry 77
Böhm, Karl 22
Boston (Mass.) 11, 13, 21, 33;
 Symphony Orchestra 13, 15,
 21; University 21f.
Brand, Carl Maria 65
Bratislava (Preßburg) 68f.
Breitkopf & Härtel (publishers) 34,
 41, 100
Brahms, Johannes 21
Brendel, Alfred 56
Bridgnorth Festival 158, 168ff., 174,
 pl. 30
British Broadcasting Corporation
 (BBC): radio 56, 59, 75ff.,
 85; television 7, 40, 81ff.,
 86f., 167
Britten, Benjamin 21, 22, 89
Brno (Brünn) 68, 99
Bruce, Ian M. 58, 152
Bruckner, Anton 39, 152
Bucharest 64, 70f.
Budapest 60, 62, 64ff., 74, 109,
 146
Buggiano Castello 121f., 124ff.,
 132ff., pls. 20–22
Burstall, Christopher 88
Burton, Humphrey 81f., 88f., 131

Cardiff 89, 140, 150, 151, 152ff.
Casa, Lisa della 37
Chailley, Jacques 60
Chartres 61f.
Chepstow 153, 156
Christie's (auctioneers) 155f.
Christofellis, Aris 174
Collins, Dennis 164, 174

Cologne: Joseph-Haydn Institut
 33, 62
Cooper, Anne 168, pl. 30
Cooper, David 168
Cooper, Mathias 17, 19
Cosman, Milein 86
Covent Garden 149
Culshaw, John 89, 131, pl. 23

Daily Telegraph 125
Dart, Thurston 78
Davis, (Sir) Colin 76, 82, 84
Decca Record Co., 92, 96, 130,
 131f. 144, 156
Deerfield (Mass.) 11, 15
Deutsch, Otto Erich 61, 148
Diamand, Peter 106, 109
Ditters von Dittersdorf, Carl 70
Dobiás, Václav 67
Doblinger (publisher) 62, 86, 123,
 143
Donaueschingen 65, 101ff.
Dorati, Antal 108, 111, 144, 156
Downes, Olin 53
Dufay, Guillaume 22

Eisenstadt 54, 122, 143f.
Elle (magazine) 165
Elssler, Johann 103, 104, 154
Elssler, Joseph 154
EMI (Electrical and Musical
 Industries) 44, 48
Erede, Alfredo 66, 107, 111
Esterházy (family) 54, 65, 143, 148
Esterházy Archives 34, 62, 65, 103,
 146, 162
Eszterháza (palace) 56f., 61, 64, 65,
 67, 74, 92, 103, pls. 17, 25, 26
Eulenburg (publisher) 54

Figl, Leopold 123
Fischer, Edwin 22
Fiske, Roger 75, 81
Florence 87f., 142
Foncoussières (château) 91, 166f.,
 174, pls. 31, 32
Ford, Charles 146
Foreman, Russell 133, 150
Frank, Alan 86
Fürnberg, Joseph von 147
Furtwängler, Wilhelm 45
Füssl, Karl-Heinz 70, 71, 96, 99,
 110

Gallini, Natale 135f.
Gassmann, Florian Leopold 76
Gehmacher, Friedrich 61, 128
Geiringer, Karl 21f.
Gelatt, Roland 160f., 163
Geneva 48f.
Gillesberger, Hans 35, 58

Giulini, Carlo Maria 47, 106, 107,
 123
Giuntoli, Alessandro 142
Glock, William 149
Glyndebourne 22, 46, 111, 126
Goberman, Max 131
Goldberg, Simon 47
Göttweig Abbey 95ff., 123, pl. 16
Greenough, Vose 36, 44
Guglielmi, Pietro 65, 103
Gui, Vittorio 126
Gulda, Friedrich 130

Handel, George Frideric 22, 84, 89,
 134
Handt, Herbert 35, 106, 125, 141
Hansch, Bruno 61
Hárich, János 65
Harnoncourt, Nikolaus 148
Harvard University 22f.
Harvey, Paddy 158
Haydn, Franz Joseph 7ff., 15, 17ff.,
 21, 65, 81f., 92, 95ff.,
 143ff.
 WORKS: concertos 7, 52, 59, 84,
 pl. 14; dances 33, 34f., 38, 45, 54ff.,
 58, 73, 84, 96ff., 143, 153ff.;
 musical clocks 56; operas and
 arias 41f., 63, 66, 102f., 105,
 106ff. 135f. 144, 148f., pls. 12,
 18, 19; oratorios: The Creation
 7, 37f., 51f., 84; The Seasons
 38, 67; piano trios 47; string
 quartets 34, 53, 85f., 89f.;
 symphonies 33f., 42f., 63, 67,
 76, 78f., 84, 85, 101, 103ff.,
 122f., 129f.
Haydn, Johann Michael 79, 95, 98,
 145
Haydn Society 33ff., 60, 95ff.,
 pls. 12–14
Heiller, Anton 35, 52, 54, 56, 59
High Fidelity 126
Hirschbach 144f.
Hoddinott, Alun 150, 152
Hoffstetter, Pater Roman(us) 90
Hofmann, Anton 16
Hofmann, Ulrike 164
Hogwood, Christopher 74, 83, 92,
 pls. 25, 26
Holland Festival 106ff., pls. 18, 19
Holzbauer, Ignaz 77, 78
Howes, Frank 63
Hughes, Rosemary 154

Intercollegiate Broadcasting
 System 22

Jacobson, Bernard 59
Jaeger, Erhard 37, 41
Jones, David Wyn 174

Karajan, Herbert von 37, 39f., 45f., 56
Keller, Hans 81, 84ff.
Kemp, Francesca and Ian 7
King, Alec Hyatt 86
King, Renée 70, 72
King, Robert 93
Kirkpatrick, Ralph 41, 53
Klemperer, Otto 47f.
Köchel, Luwig Ritter von 95
Koussevitsky, Serge 13, 15
Kraus, Lili 47
Krauss, Clemens 38, 52

Lancaster (Mass.) 11ff., *pls. 1, 2*
Landon (family) 11ff., *pl. 5*
Landon, Christa 45, 47, 63, 96, 121, *pl. 15*
Landon, Dorothea (*née* Robbins; mother) 11ff., 17, *pl. 4*
Landon, Else Radant 124, 133, 135f., 162f., *pls. 22, 27*
Landon, William Grinnell (father) 13ff., 17, 22, *fig. 1, pls. 1, 5*
Lang, Peter 173
Larsen, Jens Peter 60, 64f.
LaRue, Jan 75
Lattès, Jean-Claude (publisher) 164f.
Layton, Robert 8
Legge, Walter 34, 39f., 44ff., 123
Leinsdorf, Erich 13
Leitner, Sebastian 125
Lenox (Mass.) 20
London 47f., 63; Buckingham Palace 172
London, George 37, 53, 55
Lukavec (castle) 147

Mackerras, (Sir) Charles 17, 78, 101ff., 106
Maderna, Bruno 93
Mahler, Gustav 52, 109, 130
Mannheim 77
Milan 135f.
Millington, Barry 161, 164
Mitchell, Donald 63, 84, 122, 125
Montecatini Terme 124, 134
Monteverdi, Claudio 82, 87, 88, 126, 134
Morison, Samuel Eliot 14
Morzin, Count 146
Moses, Don 144
Mozart, Leopold 78, 137, 140
Mozart, Wolfgang Amadeus 15, 37, 41, 46, 47, 60f., 77, 79, 80, 82f., 102, 137ff., 151, 160ff., 170ff.;
 WORKS: dances 162; Mass settings 35, 53f., 69f., *Requiem* 171; operas 40, 41f., 45, 46, 47, 149; piano concertos 55f., 59, 128, *pl. 13*; serenades 80; symphonies 61, 127, 137ff.
Music Review 85

Nebois, Josef 35
Nègre, Didier 166
Neurath, Eva 86, 162, 174

New York 17ff., 38, 137f., 151f.; Cathedral of St John the Divine 11, 14; Metropolitan Opera 127; Public Library 20
Niemecz, Pater Primitivus 56, 58
Nilsson, Birgit 131
Nono, Luigi 93
Norwich, John Julius (Viscount) 92, *pl. 24*
Nowak, Leopold 69

Ober, William 148
Oradea Mare 70, 72f.
Ordonez, Carlos d' 79

Paris 14, 60ff., 165
Parker (family) 13
Patzak, Julius 38
Pescia 124
Peters, C.F. (publisher) 54
Philharmonia Orchestra 47
Philips (record company) 108, 111
Pini, Anthony 47
Pirie-Gordon, Christopher 88
Pleasants, Henry 55
Pleasants, Virginia 55f.
Pleyel, Ignaz 89
Pohl, C.F. 109, 147
Ponnelle, Jean-Pierre 111
Prague 67, 74, 160
Prohaska, Felix 127
Purcell, Henry 45

Radansky, Sergei 124
Raeburn, Christopher 67, 68, 102, 104, 105, 131, 171, *pl. 28*
Reicher, Walter 144
Reid, John 158, 168f., 174
Reutter, Georg 99f.
Robbins (family) 11, 14f., 20, *pl.3*
Robbins, Francis LeBaron (II) 11, 15, 33
Robinson, Michael 85
Romania 69ff.
Rome 125
Rosenthal, Albi 136, 155, *pl. 27*
Rubinstein, Hilary 91

Salzburg 23, 37, 39, 60f., 88, 103, 107, 128f.
Sarasota (Florida) 17
Schenk, Erich 40
Schiff, András *pl. 28*
Schlee, Alfred 93
Schlierbach Abbey 122
Schmid, Ernst Fritz 61, 62, 105, 148
Schubert, Franz 61
Schwaiger, Rosl 35, 53
Schwarzkopf, Elisabeth 40, 46, 47, 48
Shaffer, Peter 160f.
Shaw, Robert 53
Sibiu 72
Solti, (Sir) Georg 131f., 171, 172, *pl. 23*
Spinks, Charles 76, 77, 80
Stamitz, Johann 77, 78
Stein, Fritz 100
Streinsberg, Harriet 39, *pl. 11*

Stiedry, Fritz 17, 22, 127, *fig. 2*
Strauss, Johann 39
Sutcliffe, Tony 91ff.
Swan, Alfred 20
Swarowsky, Hans 42, 56, 107, 113
Swarthmore College 20f.
Swenoha, Christine 87
Szábolsci, Bence 65
Szell, George 88, 126ff.

Thayer (family) 13
Times, The 59, 63f., 66, 125, 128
Tooley, Sir John 149
Toulouse 167
Tregelles-Williams, Huw 153
Trowbridge, Mark 146, 174
Tucson (Arizona) 15, *pl.6*
Tyggeson, Tygge 42
Tyson, Alan 90

Universal Edition (publisher) 41, 55, 62, 66, 69, 93, 108, 109, 122, 123
University of California, Davis 140, 151
U.S. Army 23, 36f., *pl. 8*

Vanhal, Johann Baptist 79f.
Vécsay, Jenö 64, 66
Venice 90, 91ff., *pl. 24*
Vercelli 172ff.
Vienna 23ff., 33ff., 122f., 126, 130ff., 144ff., *pls. 7–11*; Austrian National Library 38, 63, 69, 122; Gesellschaft der Musikfreunde 35, 38, 109, 148, 149; Redoutensaal 24, 41; St Stephen's Cathedral 97, 99, 171, *pl. 7*; Vienna Philharmonic Orchestra 34, 38, 39, 40, 42, 45, 46, 128, 130, 143,171; Vienna State Opera 23f., 35, 38, 123, 130, (chorus) 171; Vienna Symphony Orchestra 36, 41, 52
Viotti, Giovanni Battista 52
Vivaldi, Antonio 82, 92, 126
Vötterle, Karl 61, 62

Wadleigh, Richard 36f., 42, 56, *pl. 11*
Wagner, Richard 40, 127; *Ring* cycle 20, 131, *pl. 23*
Waldviertel (district) 144f.
Walter, Bruno 67, 130
Washington, DC 141
Weber, Carl Maria von 24
Weil, Bruno 169
Weinzierl Castle 147
Williams, Mervyn 82, 83, 89, 90, 153
Winternitz, Emanuel 151f.
Witt, Friedrich 101
Wobisch, Helmut 42, 51, 59, 130
Wöldike, Mogens 58
Woodward, Roger 174

Zallinger, Meinhard von 53, 54
Zedinek, Wilhelm (abbot) 96, 97